CROWDFUNDING THE FUTURE

Steve Jones
General Editor

Vol. 98

The Digital Formations series is part of the Peter Lang
Media and Communication list.
Every volume is peer reviewed and meets
the highest quality standards for content and production.

PETER LANG
New York • Bern • Frankfurt • Berlin
Brussels • Vienna • Oxford • Warsaw

CROWDFUNDING THE FUTURE

Media Industries, Ethics, and Digital Society

Edited by Lucy Bennett,
Bertha Chin, & Bethan Jones

PETER LANG
New York • Bern • Frankfurt • Berlin
Brussels • Vienna • Oxford • Warsaw

Library of Congress Cataloging-in-Publication Data

Crowdfunding the future: media industries, ethics, and digital society /
edited by Lucy Bennett, Bertha Chin, Bethan Jones.
pages cm. — (Digital formations; vol. 98)
Includes bibliographical references and index.
1. Cultural industries—Finance. 2. Crowdfunding. 3. Fans (Persons).
4. Online social networks—Economic aspects. 5. Information society.
6. Mass media—Economic aspects. I. Bennett, Lucy Kathryn.
HD9999.C9472C76 338.4'3—dc23 2015003542
ISBN 978-1-4331-2682-6 (hardcover)
ISBN 978-1-4331-2681-9 (paperback)
ISBN 978-1-4539-1546-2 (e-book)
ISSN 1526-3169

Bibliographic information published by **Die Deutsche Nationalbibliothek**.
Die Deutsche Nationalbibliothek lists this publication in the "Deutsche
Nationalbibliografie"; detailed bibliographic data are available
on the Internet at http://dnb.d-nb.de/.

Cover concept by Bethan Jones

The paper in this book meets the guidelines for permanence and durability
of the Committee on Production Guidelines for Book Longevity
of the Council of Library Resources.

© 2015 Peter Lang Publishing, Inc., New York
29 Broadway, 18th floor, New York, NY 10006
www.peterlang.com

Printed in the United States of America

Contents

List of Illustrations

List of Tables

Acknowledgements

All three of us have been contributing to crowdfunding campaigns since 2010, supporting friends who are independent filmmakers, who have projects on crowdfunding platforms like Kickstarter and Indiegogo. But it wasn't until the phenomenal success of the *Veronica Mars* movie campaign that the world seemed to sit up and take notice of crowdfunding. Amid conversations and discussions conducted with each other and via social media, we wondered if any academic work had been done on the topic. And if not, why not? Thus, our journey into editing this volume began. We couldn't have done this without the support and encouragement of several notable colleagues. First, immense gratitude and thanks to Steve Jones, for believing in us and giving us the opportunity to embark on this endeavour, for his encouragement, advice and guidance on the first draft of this collection. We would also like to thank the contributors, who worked to an extremely short deadline and were gracious in making the changes we asked them to. We are also indebted to Paul Booth and Will Brooker for their support during the editing of this collection. Thanks must also go to Mary Savigar and Sophie Appel at Peter Lang for their help and advice throughout the process of writing and submitting this manuscript.

Individually, we also have people we would like to thank. Lucy would like to thank her parents for their constant and incredible support; her friends: Iñaki Garcia-Blanco for all his kindness and encouragement through the years; Bertha and Bethan for being so supportive and enthusiastic; Janet Harris and Ellen Kirkpatrick for being there through the process; Matt Hills; Amanda Brook; Cheryl and Claire; plus all her other friends, family and colleagues who have supported her in any way. Bertha would like to thank her parents, aunt, and uncle for their continued support, and her brother for bouncing ideas about the book title. Numerous friends and colleagues, such as Matt Hills, for always being there and generous with his advice; Lori Morimoto

and Selmin Kara for their constant cheerleading; Holly Dignard and Lisa Wilson-Wright, for introducing her to the concept of crowdfunding; and last, but not least, to her two co-editors, Lucy and Bethan for always being patient and supportive. Finally, Bethan would like to thank her family and friends for their love and support: Matt Hills for his advice and guidance, PhD-related and otherwise; Lucy Bennett and Bertha Chin for their patience and enthusiasm – both academic and fannish; and Tony for his unending belief and encouragement.

Introduction: Funding the Future? Contextualising Crowdfunding

LUCY BENNETT, BERTHA CHIN, AND BETHAN JONES

Introduction

This edited collection stems from our initial efforts in editing a themed issue for *New Media & Society* (2015) on the concept of crowdfunding, where grassroots creative projects are funded through micro-payments by backers through websites such as Kickstarter and Indiegogo. This practice has been steadily gaining attention in the last few years, across numerous different sectors of society. As media and fan studies scholars, we had engaged in discussions on the topic with friends and colleagues, in person and via social media, about the impact that crowdfunding may wield on the future of media studies. We contributed to these discussions in journals (see Chin et al., 2014) but the absence of scholarship on crowdfunding surprised us, which led us to connect with *New Media & Society* and successfully propose a special issue. We received a huge response to our original call for papers for the issue, with the proposed articles covering a breadth of disciplines and topics. To that end, and with the idea in mind of creating *the* work on crowdfunding, we felt a broader overview of the subject and the global discussions taking place within it would better suit an edited collection. Therefore, this anthology seeks to examine and unravel the international debates around crowdfunding and thus brings together contributors from a wide range of academic disciplines and countries. We include papers that offer different perspectives on the processes of crowdfunding projects: from analyses of the crowdfunded projects themselves, to the interaction between producers and audiences, the civic possibilities opened up by crowdfunding and the role that Kickstarter plays in discussions around fan agency and exploitation, as well as the ethics of crowdfunding itself.

A Short History of Crowdfunding

Crowdfunding appears to have come into the public consciousness with the launch of the *Veronica Mars* (UPN/CW, 2004–2007) movie Kickstarter in 2013 (and indeed, many of the chapters in this book refer to this). Creator Rob Thomas and star Kristen Bell explained to fans in their March 2013 Kickstarter video that their $2 million funding goal would get a small movie made and demonstrate to Warner Brothers that fan interest in the show remained strong. The 30-day crowdfunding campaign actually raised $5.7 million, making it (at the time of its launch) the largest and most successful film project in Kickstarter's history (Bennett, Chin, & Jones, 2015). Since then, successful crowdfunding campaigns have been spearheaded by musicians such as Amanda Palmer (Potts, 2012; Williams & Wilson, forthcoming), director Spike Lee, and actors Zach Braff and LeVar Burton. Despite its permeation in popular and digital culture, hardly any definitive work has concentrated on crowdfunding itself. Daren Brabham (2013) dismisses crowdfunding as uncreative, and it only appears briefly in Henry Jenkins, Sam Ford, and Joshua Green's *Spreadable Media* (2013) as another potential disruption to the traditional relationship between audience and producers. Yet, the chapters in this volume demonstrate that crowdfunding is not limited to the creative industries, and as the practice matures, content creators in various fields such as journalism, local communities, and even academia, who turn to crowdfunding are finding more critical and innovative ways of engaging with and strategising crowdfunding campaigns.

Section One: Crowdfunding Platforms and Ethics

Section One examines the various different crowdfunding platforms and the ethics associated with both these and the practice itself. Ethical discussions around the nature of copyright and ownership were at the fore in many of the articles we have read about crowdfunding, and many of these – particularly in relation to Kickstarter – are tied into the platforms used to host the campaign.

This section opens with Talia Leibovitz, Antoni Roig Telo, and Jordi Sánchez-Navarro's examination of the bonds between promoters and backers in audiovisual crowdfunded projects. The authors note that industrial and political discourses on crowdfunding tend to emphasise the economical efficiency and embedment of the consumer into the media product, while neglecting the question of affective engagement among cultural agents in a creative process. However the authors argue that a clear relationship between a strong personal network and the success of a crowdfunding campaign exists. The chapter

highlights the results of the authors' online survey of backers of audiovisual projects on one of the main Spanish crowdfunding platforms, Verkami, as well as exhaustive data analysis from the platform. Leibovitz, Roig, and Sánchez-Navarro demonstrate that, while those who become early supporters of a project show strong personal ties with project promoters (informally known as the three Fs: family, friends, and fools), as collaboration extends across time and across different projects, the interpersonal bond becomes weaker and further reasons for collaborating arise. The authors conclude that crowdfunding can be approached as a creative practice where users put into play affective engagements and social values, drawing a complex picture that goes far beyond an economic model based only on pecuniary contribution.

Chapter 2 examines the role that narrative plays in the crowdfunding of the objects of fandom. Cochran begins by examining the impact that narrative has on fans – the reasons why we may become fans of one text over another, and the ways in which the text may affect our psyche once we have become fans. Cochran further ties the role of narrative into the choices we make as fans and, using the "Fake Geek Girl" argument as an example, asks how in fan communities do fans' choices directly or indirectly impact the object of fandom. Just as important, however, is the way in which objects of fandom directly or indirectly impact upon the fan community and Cochran asks how the narrative impact of the fan object and the fan community function in a space where narratives, individual morals and collective values converge and sometimes clash. Here, Cochran uses the *Veronica Mars* Kickstarter as a key study, analysing responses to the campaign from backers, fans, and critics. In this chapter Cochran raises important questions about the ethics of narrative and the effect that crowdfunding may have on an object where everyone – producers and backers, fans and Hollywood insiders – feels they have a stake. Cochran concludes by reiterating that the potency of the *Veronica Mars* narrative was weakened by "fan-ancing" (Scott, 2013) the *Veronica Mars* film, but acknowledges that the crowdfunding campaign was about more than just the story. Her question whether a text has to be the best art doing what art does best to be meaningful or enjoyable is a key consideration for media scholars.

Cochran deliberately steps aside from media scholars' primary concerns about the ethics of crowdfunding in chapter 2, but chapter 3 sees these placed front and centre as Anne Kustritz examines how crowdfunding exploits fan labour. Kustritz unpacks the discourse surrounding crowdfunding as simultaneously a champion of digital capitalism, an innovative collectivist economy, a niche project irrelevant to the larger system of exchange, and a means of exploitation. She notes how crowdfunding is often framed as a "rebellious

triumph" yet the rewards system offered on platforms like Kickstarter turns backers into customers, reframing the activity as another form of capitalist consumption. Projects that offer access or symbolic rewards, however, point toward the need to create alternate social and economic imaginaries to fully explain the phenomena. Concepts like patronage and the role of subcultural capital (Thornton, 1995) come into play here, as does the desire to create a fundamentally new or different, alternative financial system. Discussing the latter, Kustritz uses the examples of the Oculus Rift and *Veronica Mars* projects to examine the challenges of carving out space for truly radical micro-economies within the larger field of global capital. Both projects were faced with controversy over capital investment and corporate buyout and Hollywood exploitation respectively. Kustritz concludes an important chapter with the need for Oculus Rift and *Veronica Mars* to amplify a different story about the collective authorisation of a digital economic narrative that prioritises creativity, innovation, reciprocity, and community.

The final chapter in this section is also concerned with questions of power and inclusion. David Gehring and D. E. Wittkower begin by acknowledging that among the benefits of crowdfunding models is increased creative and financial autonomy for creators, but point out that this does not extend to the fan funding base. Gehring and Wittkower argue that the visual and textual rhetoric used in discussing crowdfunding often draws from ideation of community and a set of motivating commitments shared in common by the artist and donor. In addition to being a moral claim upon which artist support is predicated, this idea of community is also a product being sold to donors: the CD that is purchased through the higher-risk upfront exchange of crowdfunding only has value added relative to a store-bought copy insofar as it comes along with perceived intimacy. The authors suggest that crowdfunding is strongly based in the symbolic exchange of membership within an ideational community that is specifically *excluded* from realisation in order to maintain the artist's autonomy. They conclude with the argument for an ideology of crowdfunding, in which the values of community and autonomy are put forth as foundational to the model even though the latter is only gained through the destruction of the former.

Section Two: Civic and Social Crowdfunding

This discussion on the ethics of crowdfunding leads into Section Two, in which civic and social crowdfunded projects are examined. This section builds upon issues of ownership and activism, but broadens the debate to examine how, and the extent to which, crowdfunding is a viable form of

raising money for civic projects, and why citizens in a given community may wish to crowdfund a project rather than rely on corporate or public sector backers.

The first chapter in this section, chapter 5, authored by Rodrigo Davies, examines a previously understudied area: crowdfunding for civic projects – in other words, projects that involve the creation of local community assets and facilities. These can be focused on the development of shared community resources that are accessible as a public asset, a community-owned resource or a public-private partnership, and can sometimes involve government. Davies contextualises civic crowdfunding within the history of community fundraising and unravels its developments to contemporary society, focusing on case studies in the U.S. and UK, and conducting interviews with platform owners and campaign promoters. After doing so, this chapter argues for, and proposes, an alternative typology for civic crowdfunding that encompasses four "civic roles" that these projects could perform: (1) community agency, (2) a signaling device to government, (3) an expansion of the public-private partnership model and (4) an alternative infrastructure to reductions in public investment. Davies concludes that these four roles work to reflect the intrinsic tensions in processes of planning: the complex and complicated balancing between the interests of governments, the private sector, communities and individuals, and public spaces. This chapter makes strong inroads into exploring the processes within civic crowdfunding, and delivers an important contribution toward understanding the nuances of contemporary civil society. As Davies ruminates in the conclusion, civic crowdfunding is likely to become a more controversial and disputed activity as the ambitions of campaign promoters may expand to a wider span of projects – thus, this research gives a valuable insight into the growth of particular forms of civic funding practices.

Chapter 6, by Marcelo Träsel and Marcelo Fontoura, examines another area of crowdfunding convergence with civic and social issues, by examining Spot.Us, a grassroots journalistic crowdfunding platform. Within the platform, the financing of news stories and suggestions came directly from individual users, which encourages a focus on, and embracement of, community driven news. This process, then, unravels a curious new form of engaging in journalism, occurring during difficult times for the profession, in light of the challenges raised by new media and the financial crisis across media outlets (Hunter, 2015). Träsel and Fontoura analysed the content of news pitches and published stories on Spot.Us, comparing the themes with those in the coverage of daily and weekly American press. The study demonstrates that the crowdfunding of news stories on the Spot.Us platform can be a viable

alternative for publishing a greater breadth of points of view, in addition to subjects and themes across news stories. In essence, the authors argue that this form of journalistic crowdfunding, rather than replacing daily sources of information, becomes a process that diversifies the news that citizens consume, through stories that complement established media outlets and fill, otherwise empty, gaps of information from mainstream media coverage. Thus, the authors conclude that the crowdfunding of journalistic news stories is a viable alternative to the pluralisation of the news.

A similar thread surrounding civic issues and journalism, but from a different vantage point, is traced and discussed by Giovanni Boccia Artieri and Augusto Valeriani in chapter 7. The authors examine the case of a Twitter microcelebrity in Italy, Claudia Vago, who achieved a successful crowdfunding campaign to report on the U.S. Occupy Wall Street movement – a prospect that generated much debate and discussion within Italian media. They question the ethics surrounding this campaign, featuring the funding of a non-journalist web-celebrity, and demonstrate that a crowdfunding campaign can also generate dispute and conflicts, resistances and tensions within specific sectors of society. The authors show how new figures are emerging within journalism, without being fully accepted as authentic, and argue that the success of Claudia Vago's journalistic crowdfunding, in addition to its criticisms, demonstrates that the strong online authority wielded by these individuals can be capitalised well – pleasing supporters, but fostering tense conflicts within the broad media system.

The section is closed by chapter 8, by Deb Verhoeven and Stuart Palmer, which focuses on a different, but equally complex, element of social and civic life; the crowdfunding of university research. The study explores and questions the meaning of scholarship in a digital culture where social networking and connections can be strongly linked to research opportunity and success, and how university research might be re-approached in a networked society that blurs personal and professional identities. Focusing on *Research My World*, a successful pilot project for crowdfunding university research that was initiated by Deakin University and the crowdfunding platform pozible. com, the authors contemplate the challenges and benefits of the process, examining the digital mobility and social impact required by university researchers to achieve successful campaigns. Ultimately, they raise important broad questions within the landscape of industrial transition in the university and academic sector, and also surrounding financial support and community agency – important and timely threads that run constant throughout this section.

Section Three: Fandom and the Media Industries

The final section moves on from civic and social issues, to discuss the role of fandom, audiences, and content creators in crowdfunding in the media industries. This section looks at the complex relationship between crowdfunding campaign creators and their audiences, and at the fine line between intimacy and distance when fans are not merely consumers of the content creators' products but potentially their financial backers as well. The section also examines the sustainability of crowdfunding as an alternative business model as the fragmentation of media platforms and audiences means that industry professionals like journalists and filmmakers are looking at alternative financial resources to fund their projects. Section Three also adds a different perspective to the more straightforward scholarly articles in prior sections by featuring two reflective pieces from Kickstarter campaign creators who successfully launched and ran a crowdfunding campaign.

Ethan Tussey first looks at the *Veronica Mars* movie Kickstarter project in chapter 9 – the crowdfunding campaign that not only introduced the concept to a wider, public consciousness but also set the editors on the road to create *the* work on the topic of crowdfunding in the field of media, communication, and cultural studies. In this chapter, Tussey argues that fans learn about the TV industry, specifically the complex relationship among TV ratings, networks, studios, and affiliates from interacting with one another on fan forums. Through these interactions, fans learn about the power relationship between their value as an audience member and the cultural products they are fans of. This knowledge can be seen executed via the campaign to save the cult TV show, *Chuck* (NBC, 2007–2012) where fans astutely made themselves visible and targeted the show's sponsors (particularly, the sandwich shop, Subway) during renewal season in attempts to have the show renewed. The knowledge and understanding fans gain of their roles in relation to the media industry prompt Tussey to suggest that *Veronica Mars* fans who contributed to the movie Kickstarter campaign were making an informed political decision. Thus it would be callous to imply, as many commenters have done, that fans are being exploited when they are asked to contribute to crowdfunding campaigns by content creators. Tussey argues fans understand that contributing money to a project such as the *Veronica Mars* movie enables them to be part of the creative process (access to exclusive Kickstarter updates) and to have a say (via comments on the Kickstarter campaign page), and that crowdfunding should be perceived as another form of fan activism that is reacting against the television ratings system and network executives.

In chapter 10, Larissa Wodtke turns to the music industry, studying the strategies, especially the crowdfunding pitch videos, made by musicians Amanda Palmer and IAMX as they appeal to their fans for funding. Wodtke argues that these appeals usually draw on emotion, as fans are assured that by donating, they are contributing to a moral cause. This leads Wodtke to suggest that the strategies these musicians employ are akin to those used by public service broadcasting while appealing for funds. Both Palmer and IAMX position themselves as authentic alternatives to the corporate music industry, and by donating to their crowdfunding campaigns, fans are essentially gaining intimate access to them. Wodtke concludes that the musicians' attempts at intimacy to appeal to fans creates a complicated relationship whereby both musicians and fans are labourers – the musicians are constantly performing, inviting fans in to ensure that fans are making the right investment in them, while the fans are simultaneously labouring to fund these projects for their beloved fan subjects.

In journalism, Tanja Aitamurto tells of journalists who turn to crowdfunding, and who are no longer merely reporters of news, but now also have to play the dual role of publicist and promoter in order to achieve funding targets. Chapter 11 argues that the rise of crowdfunding in journalism is a reaction to the growing number of freelance journalists as the industry goes through a transition. As subscription revenues are falling and the audience is fragmenting, traditional business models in journalism are turning to crowdfunding as a possible alternative business model. Looking at different journalism-centred crowdfunding platforms such as Spot.Us and Contributoria, Aitamurto explores the various ways journalists have used crowdfunding and questioned whether it can be considered a legitimate, sustainable business model in journalism and whether there is any value in crowdfunded journalism. Aitamurto signals the industrial turn in this third section of the book, as the following chapter by Carlos A. Scolari and Antoni Roig Telo uses accounts from filmmakers to evaluate the benefits and limitations of using crowdfunding as a financial resource.

Chapter 12 sees Scolari and Roig Telo using the case studies of two Spanish films, *The Cosmonaut* and *Panzer Chocolate*, which turned to crowdfunding at different stages of production. Both films were made by first-time filmmakers and used transmedia storytelling, with *The Cosmonaut* being conceived initially as a monomedia product but turned into a transmedia project as part of the filmmakers' crowdfunding strategy. Scolari and Roig Telo were interested in discovering the benefits and limitations the filmmakers faced as they turned to crowdfunding during the films' production. Using personal interviews with the production team, they looked at how the films' production and distribution

change and develop as crowdfunding is added into the financing equation. The piece also provided an intricate look at how crowdfunding fits into the overall production of the film, as the filmmakers reflect on the challenges they faced when it came time to delivering perks to funders. Scolari and Roig Telo also argue that in their case studies, transmedia storytelling is not just a narrative strategy for content creators to expand their stories across different platforms; in their case, transmedia storytelling is also utilised as a financial strategy when combined with crowdfunding, suggesting that a more complex relationship exists between crowdfunding and transmedia storytelling.

In chapters 13 and 14, both Gavia Baker-Whitelaw and Will Brooker respectively reflect on their rationale and experience in turning to crowdfunding as content creators. As Managing Editor of Big Bang Press, Baker-Whitelaw writes about how she and her fellow editors view Big Bang Press as an alternative to mainstream publishing houses, and as a small press, their aim was to publish original novels by fan fiction authors. As a genre, fan fiction is often dismissed by mainstream publishers, but Baker-Whitelaw argues that this does not affect the quality of the written work she had encountered as a fan. Often, fan fiction authors merely need an opening to showcase their talent in original fiction, and crowdfunding offers Baker-Whitelaw and her fellow editors the opportunity to gauge audience interest in the product they were offering. As such, her reflection gives thought to – much like chapters such as Scolari and Roig's, and Wodtke's in this section – the benefits and limitations of turning to crowdfunding for a start-up publishing company.

Will Brooker begins chapter 14 by recalling the moments that led to his creation of the critically-acclaimed comic book, *My So-Called Secret Identity*. The comic was launched via its own website in 2013 and a Donate page on the site enabled fans to show their support by making a small donation. In the first month, Brooker notes that they accumulated enough funds to sustain production of the next three issues. But as with other content creators in this edited collection, Brooker similarly reveals that they were doing things differently in comparison to the mainstream comics industry, that he was drawing on notions of the gift economy and social capital that was more familiar to fandom than mainstream media industries. The turn to crowdfunding to produce the fifth and final issue, as well as a print edition of the comic in its entirety, continues with the system of gifts and favours. Brooker's reflection notes that their crowdfunding strategy also continues in this essence of collaborative spirit: networks, contacts, gifts and friendship rather than contracts and monetary exchange, but on a more sober note, postulates that these connections are often made possible because of the privilege position he holds, and the personal investment he has devoted into the project.

Crowdfunding the Future

As the first edited collection on crowdfunding, the range of essays included provides a detailed and comprehensive introduction to the platform and the issues faced in using it as a financial model. We further hope that this collection, and the international perspectives within, will help shape the new popular discourse about the role of crowd- and fan-funding practices that Paul Booth refers to in his afterword. Booth continues many of the themes explored in this collection in his afterword, examining some of the tensions that emerge from crowdfunding campaigns and illustrating how these have shaped – and will continue to shape – both the development of crowdfunding and the larger neoliberal socio-economic climate. Booth's analysis is a timely interjection into discussions around the role of crowdfunding and its positive and negative impacts, and he draws on slacktivism, affect, and the distinction between fans and crowds to complicate both crowdfunding and discourses surrounding it.

The future of crowdfunding is yet to be determined, as Booth rightly notes, and new questions are being asked as new platforms and projects are being launched, and ethical debates take place. In this light, we hope this collection will set the impetus for further scholarly work that critically examines the relationships, practices and platforms that entail crowdfunding.

References

Bennett, L., Chin, B., & Jones, B. (2015). Crowdfunding: A New Media & Society special issue., *New Media & Society,* 17 (2).

Brabham, Daren C. (2013). *Crowdsourcing.* Cambridge: MIT Press.

Chin, B., Jones, B., McNutt, M., & Pebler, L. (2014). Veronica Mars Kickstarter and crowd funding. *Transformative Works and Cultures* 15. Retrieved March 30, 2014, from http://journal.transformativeworks.org/index.php/twc/article/view/519/423

Hunter, A. (2015). Crowdfunding independent and freelance journalism: Negotiating journalistic norms of autonomy and objectivity. *New Media & Society,* 17 (2).

Jenkins, H., Ford, S., & Green, J. (2013). *Spreadable media: Creating value and meaning in a networked culture.* New York and London: New York University Press.

Potts, L. (2012). Amanda Palmer and the #LOFNOTC: How Online Fan Participation Is Rewriting Music Labels. *Participations: Journal of Audience & Reception Studies,* 9 (2), 360–382.

Scott, S. (2013). More on Veronica Mars "fan-ancing" and Netflix's temporal approach to TV. Revenge of the Fans. Retrieved September 14, 2014, from http://www.suzanne-scott.com/2013/03/29/more-on-veronica-mars-fan-ancing-and-netflixs-temporal-approach-to-tv/

Thornton, S. (1995). *Club cultures: Music, media and subcultural capital.* Cambridge: Polity Press.

Williams, J. A. & Wilson, R. (forthcoming). Music and crowdfunded websites: Digital patronage and fan-artist interactivity. In Whiteley, S & Rambarran, S. (Eds.) *The Oxford handbook of music and virtuality.* Oxford: Oxford University Press.

Section One:
Crowdfunding Platforms and Ethics

1. Up Close and Personal: Exploring the Bonds Between Promoters and Backers in Audiovisual Crowdfunded Projects

TALIA LEIBOVITZ, ANTONI ROIG TELO, AND
JORDI SÁNCHEZ-NAVARRO

Introduction

The nature of cultural production and consumption continues to undergo profound changes. New platforms, new media, and new types of cultural agents, coupled with easier access to the means of production and promotion, have generated a multitude of emergent media forms, redefining the production and consumption of cultural products, and altering the relationships between media, industries, and audiences (Jenkins, 2006; Deuze, 2008; Schafer, 2011). As a means of communication and production, and as a source of entertainment, the Internet has been a driving force behind the transformations in processes of creation and exchange (Braet & Spek, 2010), forcing us to reconsider traditional boundaries between the various agents involved in cultural production.

Beyond celebratory discourses, this new ecology must be characterised in terms of change, but also of continuity, even if in an unstable and conflictive relation between practices, business models, and cultural agents. In the end, this is about the proliferation of spreadable content, the emergence of new cultural agents, transformations of cultural consumption patterns, but also power relations, the roles of public and private cultural institutions in promoting culture, controversies on diversity and public participation, audience fragmentation, and uncertainty over business models.

Participation has become a key concept in the understanding of these emerging media practices in a context of cultural productivity at all levels. One of the most popularised expressions used to refer to this environment is

"participatory culture," defined in terms of "low barriers to artistic expression and civic engagement, strong support for creating and sharing one's creations [...] informal mentorship [...], members [who] believe their contributions matter, and feel some degree of social connection with one another." (Jenkins, 2010: 238). However, Jenkins' position has generated controversy related to the actual scope of participatory culture, its interdependences with established media power structures (Deuze, 2008), and his own conceptualisation of participation (Fuchs, 2011a; 2011b). As Deuze states, not all participation is the same, nor is it equally distributed across user groups or media forms:

> [M]uch of this participatory culture is heavily regulated, constrained or embedded within company processes and practices that strive to "harness" rather than "unleash" participation. [...] Thus, the role participation plays in the media industries' move online can be seen as an expression of the convergence of production and consumption cultures [...] as well as in the corporate appropriation of the technology. (Deuze, 2008: 31).

One of the manifestations of participatory culture is the popularisation of platforms that enable users to upload and to share content, blurring the traditional delimitations between producers and consumers. A high-profile instance of the redrawing of boundaries between producers, cultural products, and audiences is the phenomenon of crowdfunding. It is not just about changes fostered by technological innovations, but also about shifting mind sets and realities around new forms of process organisation, providing more or less radical alternatives to the traditional organisation of cultural production (Bannerman, 2012). Thus, crowdfunding allows for a closer relationship between the producers and consumers of audiovisual products than in earlier models, wherein individuals would consume artefacts that had been previously financed either by industry, by the state, or a combination of the two (Kappel, 2009). With crowdfunding the audience becomes a cultural agent in a model that binds cultural production to both producers and consumers in a relationship of co-dependency (Kappel, 2009; Jenkins, 2006; Roig Telo, 2010; Leibovitz, Sánchez-Navarro, & Roig Telo, 2013).

The idea of crowdfunding finds its roots in the broader concept of crowdsourcing (Estellés & González, 2012), which appeals to the crowd to make voluntary contributions to obtain ideas, feedback, and solutions in order to develop corporate activities (Howe, 2006; Belleflamme, Lambert, & Schwienbacher, 2010). Crowdsourcing aims at the involvement of the crowd by means of various processes of the production stage of a product or activity. From this viewpoint, the financing process may be understood as a type of crowdsourcing in that it makes an allusion to the collaboration of the crowd for the success of a critical process.

Following Schwienbacher and Larralde (2008) we understand crowd-funding as "an open call, mostly through the Internet, for the provision of financial resources either in the form of donations or in exchange for some form of reward and/or voting rights in order to support initiatives for specific purposes" (2008: 4). Tim Kappel adds some important specifications, defining crowdfunding as "the act of informally generating and distributing funds, usually online, by groups of people for specific social, personal, entertainment or other purposes" (2009: 375). This approach is remarkable, as it does not make references to the benefits or rewards received by the sponsors for their donations. Both agree on the importance of the Internet and mainly the web 2.0 (Brabham, 2008) to mobilise a large number of people, "the crowd," and make possible the communication and networking between entrepreneurs and investors (Lambert & Schwienbacher, 2010; Bannerman, 2012).

There are basically four types of crowdfunding (De Buysere et al., 2012; Bannerman, 2012): donation-based, reward-based, lending-based, and equity-based. It is possible to consider two more, which are not mutually exclusive (Belleflamme et al., 2011): direct crowdfunding, where the financing recollection process is carried out independently, and indirect crowdfunding, which is mediated by specialised platforms dedicated exclusively to promotion of projects like Kickstarter, Indiegogo, or Verkami.

Crowdfunding platforms have facilitated the mobilisation of ideas, the interconnection of funders with creators, the bringing together of ideas and resources, and new organisational possibilities (Bannerman, 2012). In this modality, trust becomes a drive for agreement, as there are no legal constrictive modalities that ensure the compliance of these agreements. In the creative industries, crowdfunding has been taking place mainly in a reward-based form through specialised platforms.

As a multi-faceted phenomenon, crowdfunding enables us to reflect on many different sides of participatory culture; thus, contributing to the financing of such projects not so much as an economic activity than an act of symbolic exchange. Fully aware of the fact that they are unlikely to see a return on their investments (in the case that this possibility is even considered), contributors effectively act as the traditional patrons of the arts did: that is, sponsoring art for art's sake, rather than for potential monetary reward (Frederick, 1964). The return is usually channelled through rewards with symbolic value pointing out to the engagement of the crowd with the project, which they can identify themselves with (Wojciechowski, 2011). In economic terms, the rewards are not usually equivalent to the pledge. A key difference is the collective nature of crowdfunding; joint action is needed because of the high amounts of money needed to fund even a small audiovisual production.

In terms of the creative process, crowdfunding turns what we might pre-viously know as a creative practitioner or an artist into a finance manager. Such figures differ from their forerunners insomuch as they must cultivate relationships with the public prior to executing their creative practice—al-though the public still exerts little or no direct influence over content once a project is in production. Furthermore, crowdfunding serves a function of community building by forging a common bond between those individuals who donate to a project and also follow its development (Leibovitz, 2013).

As a relatively new phenomenon, crowdfunding has only recently drawn scholarly attention, with early studies tending to emphasise economic issues over production and creative processes. Therefore, scholars tend toward studying crowdfunding as a potential viable alternative to traditional financ-ing systems, and to ascertain the conditions that favour the success of some particular calls. It has been suggested that difficulties in accumulating suffi-cient contributions to fund a production indicate that it might best serve as a complement to traditional financing systems; as a means of facilitating larger contributions by entrepreneurs, companies, and state bodies (Braet & Spek, 2010). Furthermore, as Chris Ward and Vandana Ramachandran (2010) have shown, crowdfunders are influenced by the success or failure of related projects, as well as by the choices made by their peers who backed projects previously.

From another point of view, scholars have pointed to the relevance of the personal network as the grounds and prime support involved in the crowd-funding process. In this direction Belleflamme, Lambert, and Schwienbach-er (2010) question the elements involved in crowdfunding as a model for entrepreneurs. The results of their research conclude that the model high-lights the importance of community-based experience for crowdfunding to be a viable alternative. Small entrepreneurs without access to venture capital have traditionally relied on their primary support network, informally known as "friends, family, and fools" (the three Fs) or bootstrap financing (use of personal finances as opposed to loans or venture capital) (Kotha & George, 2012; Bannerman, 2012). From this perspective, crowdfunding may be seen as a wider concept other than merely fund collecting.

Agrawal, Catalini, and Goldfarb (2010) focused their research in the role of the geographic distance in an online platform for financing early stage artist-entrepreneurs. They found out that investment patterns over time are independent of geographic distance between entrepreneur and investor, sug-gesting in their conclusions a reduced role for spatial proximity in online relationships (Agrawal et al., 2010). However, they emphasise the important role that friends and family may play online and offline in generating early

investment in entrepreneurial ventures. Later, investors may use this initial boost in order to increase the likelihood of further funding by way of accessing distant sources of capital (Agrawal et al., 2010).

Tim Kappel (2009) goes further and argues that *Ex ante* crowdfunding can lower the risk for the creators, not only by distributing the initial investment between creators and fans, but also by providing a mechanism that ensures that the production becomes popular and therefore more likely to be commercially successful (in Bannerman, 2012).

Through our research on backers of audiovisual projects funded via crowdfunding, carried out mainly through quantitative data analysis, we propose a more nuanced approach to analyse the affective engagement between backers and creators. The research is focused on motivations and perceptions regarding the crowdfunding backing process along time, which allow us to get a much deeper insight of what is going on during such cultural processes.

Our results show that personal connection between creators and backers is the main reason to engage with an audience in a reward-based crowdfunding project. However, as collaboration extends across time and across different projects, interpersonal bonds get weaker and other reasons for collaborating arise. Thus, new factors like quality perception, offered rewards, or shared interest emerge. Moreover, the engagement with the creative project tends to rely on a larger interconnected crowd.

This way, crowdfunding can be approached as a creative practice where users put into play affective engagements and social values, drawing a complex picture that goes far beyond an economic model based only on pecuniary contribution.

Data Collection

The present study is based on data obtained from several sources, using quantitative research techniques. The starting point is the Spanish crowdfunding platform Verkami who provided data related to their first years of operation (from 2010 up to 2013). These data entail information about the projects carried out, as well as the donations received from all the sponsors. As we'll see later, this allowed for the identification of two main typologies: "occasional" and "frequent" backers.

The second phase of the research was aimed at gathering perceptions about collaboration practices, motivations toward crowdfunding and the way in which the campaigns were carried out, on the part of the backers of the platform. Bearing this in mind, an online survey was carried out between June and July 2013.

Data were gathered by means of a web-based questionnaire, which was distributed to crowdfunders primarily via Verkami crowdfunding platform administrators and through an open call on several social networks like Facebook and Twitter. This call provided a link to an online questionnaire, using the Netquest survey platform for this purpose.

As our research was focused on audiovisual production, the universe of the study is comprised of all of those who collaborated with at least one audiovisual project in Verkami whether they supported another project or not. The total of completed surveys was 134, which made up the sample for the second phase. The questionnaire was anonymous and self-administered.

The survey included a set of twenty-five close-ended questions about different elements involved in crowdfunding. In order to measure crowdfunders' attitudes toward multiple dimensions of crowdfunding, a rating scale (the Likert scale) was used in some of the survey questions. Once the data were collected a quantitative analysis process was performed using the computer statistic software SPSS (Statistical Software for the Social Sciences).

The Verkami Platform

Verkami is a crowdfunding platform specialised in the crowdfunding of cultural projects. It is based in Catalonia, and it was set up at the end of 2010 as part of an entrepreneur project incubator, becoming one of the first Spanish platforms specialised in this type of financing. Verkami based its model on similar initiatives such as Kickstarter or Indiegogo in the United States. Up to date, Verkami is considered one of the biggest crowdfunding platforms at a national level.

As of June 2013, the platform has collected around €5,000,000 distributed in 1,581 projects already carried out, with a success rate of nearly 70%. These figures, in comparison to the results obtained by Kickstarter, may be seen as insignificant; nevertheless, these results are obtained within a field of continuous expansion and accelerated growth.

It is not the objective of this research to carry out an in-depth analysis of the results of the projects carried out in the platform. Therefore, we will focus on the sponsors with the aim of examining the practices and dynamics of mediatised collaboration for digital platforms aimed at audiovisual production. An important aspect deals with the sponsors' frequency of support, where we differentiate between those who have contributed more than once and those who have done it occasionally. This will help us to reflect on the elements involved in the process while keeping track of the differences that may arise between both groups.

Findings and Discussion

Repeated collaboration may be understood as an indicator of the possibilities of crowdfunding becoming a consolidated model of cultural production, because it implies a collective of sponsors who are willing to undertake a longer-term cooperation. But most of all, repeated collaboration means a commitment to the possibilities of cultural consumption that crowdfunding offers, and therefore, it supports the consolidation of the model in the future. A committed audience that understands sponsorship as a practice would support the model, the platform, and the projects. Thus, it is fundamental to understand the behaviour of this population of repeating collaborators, since it is the basis for thinking that microsponsoring can be seen as a stable financing model through time, replicable for all sorts of cultural production.

According to the data provided by Verkami, up to the first semester of 2013, 129,955 donations had been made and distributed among the 1,581 projects that have been able to end their campaign. Nevertheless, these donations come from a total of 98,776 sponsors, which means that there are a considerable number of sponsors who back more than once, whether by repeating their donation in the same project or supporting other projects within the same platform. This corresponds to 17% percent of the collaborators. Although there is a large proportion of sponsors who collaborated more than once, this does not mean that the collaboration was carried out in different projects. The analysis of the data about donations, with emphasis in the supported projects, shows a slight variation that has to be accounted for. Thus, we see that 88% of the sponsors have done it; which shows a 5% increase in relation to the previous portion. This figure helps us to establish a general parameter of the frequency in the collaboration with crowdfunding campaigns. In the survey provided to members of the platform focused on audiovisual production, the proportion changes considerably. This way, the proportion of sponsors who supported one project is 34.3%, whereas 64.7% have supported more than one project.

The distinction between collaborators who are frequent from those who are occasional allows us to establish the differences inside the population—an interesting matter worthy of further study. Through the results of our survey, we have noticed a favourable tendency toward cooperation among those having supported more than one project; this is why we consider them under the category of frequent backers.

The survey revealed a number of reasons given by backers for financially supporting a project (see Table 1.1). It showed that interpersonal relationships play a key role in successful crowdfunding initiatives; sixty-seven percent (67.3 %) of the surveyed donators had previous relationships to one or more of the applicants.

Table 1.1: Reasons for donating to a project.

	Occasional Backer	Frequent Backer	Total
I know the filmmaker or someone in the team personally	65.5%	68.1%	67,3%
I like the idea behind the project	55.2%	68.1%	64,4%
I like to support independent projects	13.8%	45.8%	36,6%
I know about the career of the filmmaker or someone in the team	13.8%	29.2%	24,8%
I would like to receive the offered reward	3.4%	20.8%	15,8%
I am in solidarity with other film-makers like me	6.9%	16.7%	13,9%
I know a friend/relative of the filmmaker or someone in the team	17.2%	9.7%	11,9%
Other	0.0%	1.4%	1,0%

Another important factor in donating to a project is the idea behind the project. The data show that there is a solidarity based on personal ties, but also subjected to critical evaluation. The relevant fact is that 64% of the sample acknowledged that the content of the project (embodied in the idea) was a motivating factor. While prior personal relationships are the basis of the partnership, it does not mean unconditional help: here is also a search for content based on certain interests, which eventually materialised in the success of a campaign. An established relationship between an applicant and a donator by no means guarantees that a donation will be forthcoming.

An interesting case to point out is *The Cosmonaut*[1], a transmedia film directed by Nicolás Alcalá in 2011. The project raised over €300,000 from 5,000 contributors. It was the first crowdfunded film in Spain and helped to pave the way for the foundation of the Spanish platforms we can see today. From €2 on, people could be part of the founders group who "Saved the Cosmonaut." It was a cutting-edge project that caught the attention of a new group of sponsors by its innovative approach.

Conversely, potential rewards do not appear to be a driving force behind donations, with only sixteen percent (15.8%) of respondents suggesting that material or financial returns had inspired them to crowdfund.

Even if the analysis focused on the type of collaborator highlights important differences, the significance of previous personal relationships is maintained without substantial differences. This way, the idea behind the project was the second most important motivator of support after personal ties. In the group of frequent donors this becomes even more important, turning out to be as important as personal ties (68.1% in both groups). Frequent collaboration goes a step forward seeking certain characteristics, opening the door to different subjective ways of evaluation based on personal taste and preference.

The most imperative difference is found in those who say they are motivated by solidarity with the independent film creation. For those who are occasional backers, this is only considered important by 13.8% of those surveyed. In the case of the frequent collaborators, the proportion augments to 45.8%, a very significant difference.

The director's background or the members of the filmmaker's team is not considered important in the context of occasional collaborators (13.8%). It is more present, though, in those who have done it frequently (29.2%). Solidarity between independent directors also shows some changes: for those who are occasional directors, solidarity is recognised as a motivating reason to collaborate in 6.9% of the cases. For those who have done it more than once, the percentage increases to 16.7%.

The rewards, which in the general context of the survey do not show a significant relevance, are considered by frequent collaborators to be more important (3.4% in the case of occasional sponsors and 20.8% for the frequent ones). The opposite effect is seen in the importance attributed to indirect personal relations, that is, with a friend or acquaintance of the director or member of the team of the project, which is viewed as more important for the occasional sponsors (17.2%) than for those who have done it more frequently (9.7%).

This way, some reasons that might be initially considered as secondary, such as solidarity with independent creation, the filmmaker's background, or the reward acquire a bigger prominence, while the quantity of supported projects increases. Meanwhile, personal relations lose strength as the frequency to support increases. These differences reveal that the more the sponsors are familiarised with collaborative practice – as in the case of frequent backers – the more changes happen regarding motivations for collaboration.

This suggests the existence of certain values, which might be related to subjective perceptions of quality, which begin to appear as the collaboration is repeated over time. This trend coexists with other elements underlying

collaboration based on personal relationships. These elements will reshape the collaborative practice as time and collaboration progresses.

Please note that our current research is not focused on specific projects but on a general overview of perceptions toward collaborations through crowdfunding. A deeper focus on a specific project may show different approaches to collaboration and backers dynamics. Thus, we have observed how singular projects, like *The Day After* (*L'endemà*, about the process of political independence of Catalonia)[2] show a different pattern, as they are capable of attracting occasional backers not personally attached to the creative team but actively involved in the thematic subject of the project (not unlike other similar cases like *Veronica Mars*, see Chin, B., Jones, B., McNutt, M., & Pebler, L., 2013). Actually, this is the biggest project funded in Spain so far, being supported by more than 8,000 backers.

Going deeper, Table 1.2 show the importance granted to some factors involved in the crowdfunding practice.

Table 1.2: When supporting a project, what importance do you grant to the following factors?

	Very important	Important	Of medium importance	Little importance	Not important
Theme/Idea	73.52%	21.56%	4.9%		
Reward	12.74%	21.56%	33.33%	20.58%	11.76%
Quality of the project	54.9%	39.21%	4.9%	0.98%	
Amount of support received	1.96%	9.8%	28.43%	43.13%	16.66%
Information available in the web site of the project	39.21%	34.31%	21.56%	2.94%	1.96%

As it can be observed, for all the groups of respondents (occasional and frequent backers) the factors granted as having the highest importance in collaboration are: idea behind the project and quality perception. The notion of perception is important because it allows us to highlight a certain kind of subjective construction of preference and even taste, bearing in mind that most of the projects are in the initial phases of production (Leibovitz, Sánchez-Navarro, & Roig, 2013). Furthermore, the importance granted to project contents (idea) and quality standards helps to keep collaboration as a matter of informed personal choice. All in all, these elements make us think on the emergence of a cooperation model based on personal expressions of interest while collaboration is repeated over time.

Again, the reward does not stand as particularly influential at the time of leaning the balance toward collaboration or augmenting the amount of contribution. For a majority of respondents, reward is not considered as something important when collaborating. Thus, contrary to what is suggested by Ward and Ramachandran (2010), the previous support received by the project does not appear to be of relevant importance or considered as a previous antecedent for collaboration; therefore a "contagion effect" does not seem significant.

Another interesting issue is related to the sources of information that make up the project support campaign. This is an important variable at the time of determining previous relationships between the sponsors and the projects, as well as in order to analyse the elements that provide the basis for these collaborations in depth. The literature reviewed shows that there is a strong connection between the majority of the sponsors and the creators they are supporting.

The table below summarises the case of the occasional collaborators.

Table 1.3: Sources of information.

	Frequency	Valid percentage
Because of a friend/ acquaintance who is part of the project	29	62.2
Saw it in Facebook / Twitter of a friend/ acquaintance	5	11.1
Saw it in a web site/ blog / Twitter/ Facebook of the project	4	8.8
Other; which one?	3	6.6
Through the page of the crowdfunding portal	2	4.4
Through a friend / acquaintance who supported the project	1	2.2
Saw it in a newspaper, television, or radio	1	2.2
I don't remember	1	2.2
Total	46	100

For the occasional sponsors group we can see that the previous personal relationship between the sponsors and the creative team is the basis for the transmission of information, which coincides with the main motivation to support. The survey data show that 63% (62.2%) of this group know about the project through some friend or acquaintance who is part of the project. This forms the first core support group (Belleflame et al., 2010), that is, those who become involved in the funding of the project by virtue of those pre-existing relationships. The rest of the possible ways to transmit information are then marginal, because the second majority of answers also allude to a previous acquaintance that could be understood as a personal relationship based on weaker ties.

In the case of those who have collaborated in more than one project, we can observe that the circulation of information is distributed differently. The survey inquired in the way in which the collaborators had heard or found out about the project, making a distinction between the first and the last supported project (when not having the possibility of asking for each one of them).

The first thing that caught our attention was that the data were distributed in the same way for the occasional sponsors and for the first project supported by frequent collaborations. It seems like when doing their first

donation/collaboration they were in similar conditions as those of the first group (occasional sponsors).

The graph below shows the distribution of the answers and their differences in terms of the repetition of the support over time.

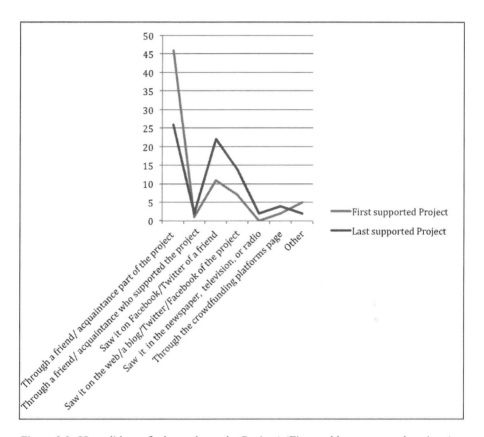

Figure 1.1: How did you find out about the Project? (First and last supported projects).

As for the last supported projects, we find certain differences that show us how the sources of information have changed as the collaboration is repeated over time. The pre-eminence of personal relationship networks seems to get diminished, hinting at the emergence of other means perceived as equally effective and based on weaker connections.

It is unquestionable that a network of acquaintances of the members of the project is the basis for the support for a crowdfunding campaign. As in the case of the occasional collaborators, we can observe that the great majority heard of the first project because of their relationship with one of the members

who belonged to the project (62%). Conversely, this changes radically in the last supported projects, with only 37% of the surveyed respondents stating that they heard of the project by means of their relatives.

With occasional collaborators, as well as with frequent ones, the second most answered option deals with social networks and the circulation of information. In this case, 16% of the survey respondents found out about the first project they supported via Facebook or Twitter, or through some friend or acquaintance. This percentage increases to 27% for the last project. The interesting fact is that it implies expanding the network of acquaintances one step further. So, in this case, it can still be considered a personal relationship but in a more indirect way.

Thus, we see that the percentages pointing at information sites double, be it web pages, social networks of the projects or the crowdfunding platforms themselves. Thus, we see certain consistencies with the fluctuations in the motivations portrayed previously. For the occasional collaborator, the sources of information on the projects are strongly determined by the circle closest to the project promoter, other sources being less relevant. This is very similar to what happens in the case of the first project supported by the group of frequent collaborators. However, for the latest projects, other sources of information become important, in a similar way with repeated collaboration. This may be the reason why social networks and crowdfunding platforms, as means of information, acquire more importance. Ultimately, it is again about expanding the circle of acquaintances.

Conclusions

Throughout this chapter, we have seen the role of personal bonds as a source of engagement with a crowdfunding project, as well as its evolution through time. Initially, a support network based on previous interpersonal relationships exerts a positive influence toward collaboration. However, other factors, like the perception of quality, the project's topics, and scope, further enrich this relationship and become more and more important. In the end, we are witnessing the creation of a support network with shared interests that lie beyond pre-existing ties. It must be stated that this is not an unconditional support; on the contrary, it is more a convenience support network based on shared interests, and therefore, connected to a cultural experience. Hence, there is a potential for expanding the network beyond the primary circle, thus becoming a bigger and more diversified group.

But as collaboration in crowdfunding projects is repeated through time, motivations also evolve. Thus, the previous personal relationship based on

affective engagement is progressively blended with other kinds of engagement more oriented toward tastes and preferences, which could be considered as "weaker" ties and closer to the kind of interest more fitting to archetypical audiences. Thus, elements like rewards, content, or social issues exert a larger role once the backer becomes familiar with the system. These changes affect mainly motivations for collaborating and, consequently, point to other project information sources.

Consequently, affective engagement, seen as the prime motivation to back cultural projects through crowdfunding, becomes just one more variable. This way, the relationship between promoters and backers become more diverse and more aligned with the one established between producers and audiences. As our online survey shows, this evolution, where affection and personal bonds are still present but to a lesser extent, is key toward maintaining a sustainable relationship through time.

Notes

1. http://en.cosmonautexperience.com/
2. http://www.verkami.com/projects/4171-l-endema

References

Agrawal, A., Catalini C., & Goldfarb, A. (2010). The geography of crowdfunding. *NET Institute Working Paper* No. 10–08. Retrieved July 17, 2012, from http://dx.doi.org/10.2139/ssrn.1692661

Bannerman, S. (2012). Crowdfunding culture. *Wi: Journal of Mobile Culture* 6 (4). Retrieved April 18, 2014, from http://wi.mobilities.ca/crowdfunding-culture

Belleflamme, P., Lambert, T., & Schwienbacher, A. (2014). Crowdfunding: Tapping the right crowd. *Journal of Business Venturing*, 29 (5), 585–609.

Brabham D. C. (2008). Crowdsourcing as a model for problem solving: An introduction and cases. *Convergence: The International Journal of Research into New Media Technologies*, 14, 75–90.

Braet, O. & Spek, S. (2010). Crowdfunding the movies: A business analysis to support moviemaking in small markets. *Proceedings of the 8th international interactive conference on Interactive TV & Video*, pp. 221–228. New York: ACM.

Chin, B., Jones, B., McNutt, M., & Pebler, L. (2014). *Veronica Mars* Kickstarter and crowd funding. In M. Stanfill and M. Condis (Eds.), Fandom and/as Labor, special issue, *Transformative Works and Cultures,* 15. Retrieved June 2, 2014, from http://dx.doi.org/10.3983/twc.2014.0519 http://dx.doi.org/10.3983/twc.2014.0519

De Buysere, K., Gajda, O., Kleverlaan, R., & Marom, D. (2012). *A Framework for European Crowdfunding.* Retrieved January 14, 2013, from www.crowdfundingframework.eu

Deuze, M. (2008). Corporate appropriation of participatory culture. In N. Carpentier & B. De Cleen (Eds.), *Participation and media production: Critical reflections on content creation*, pp. 27–40. Newcastle upon Tyne: Cambridge Scholars Publishers.

Estellés, E. & González, F. (2012). Towards an integrated crowdsourcing definition. *Journal of Information Science*, 38 (2), 189–200.

Fuchs, C. (2011a). Against Henry Jenkins. Remarks on Henry Jenkins' ICA talk "Spreadable Media." *Information – Society – Technology & Media*. Retrieved May 20, 2013, from http://fuchs.uti.at/570/

Fuchs, C. (2011b). The contemporary World Wide Web: Social medium or new space of accumulation? In D. Winseck & D. Yong Jin (Eds.), *The political economies of media: The transformation of the global media industries*, pp. 201–220. London: Bloomsbury Academic.

Jenkins, H. (2006). *Fans, bloggers, and gamers: Exploring participatory culture*. New York: New York University Press.

Jenkins, H. (2010). Afterword: communities of readers, clusters of practices. In M. Knobel & C. Lankshear (Eds.), *DIY media: Creating, sharing and learning with new technologies*, pp. 231–254. New York: Peter Lang Publishing.

Kappel, T. (2009). Ex ante crowdfunding and the recording industry: A model for the U.S. *Loyola of Los Angeles Entertainment Law Review* 29: 375–385.

Kotha, R. & George, G. (2012). Friends, family, or fools: Entrepreneur experience and its implications for equity distribution and resource mobilization. *Journal of Business Venturing*, 27, 525–543.

Larralde, B. & Schwienbacher, A. (2012). Crowdfunding of entrepreneurial ventures. In D. Cumming (Ed.) *The Oxford handbook of entrepreneurial finance*, pp. 369–391. New York: Oxford University Press.

Leibovitz, T. (2013). Crowdfunding audiovisual productions in Spain: The case of Verkami. *Iluminace Journal: The Journal of Film Theory, History and Aesthetics*, 2, 71–81.

Leibovitz, T., Sánchez-Navarro, J., & Roig Telo, A. (2013). Collaboration and crowdfunding in contemporary audiovisual production: The role of rewards and motivations for collaboration. *Cinergie: Il cinema e le altre arti*, 4, 73–81.

Roig Telo, A. (2010). La participación como bien de consumo: una aproximación conceptual a las formas de implicación de los usuarios en proyectos audiovisuales colaborativos. *Anàlisi: quaderns de comunicació I cultura*, 40, 101–114.

Schäfer, T. (2008). *Bastard culture! User participation and the extension of cultural industries*. Amsterdam: Amsterdam University Press.

Ward, C. & Ramachandran, V. (2010). *Crowdfunding the next hit: Microfunding online experience goods*. Paper presented at Computational Social Science and the Wisdom of Crowds (NIPS 2010). Retrieved March 1, 2011, from http://people.cs.umass.edu/~wallach/workshops/nips2010css/papers/ward.pdf

Wojciechowski, A. (2009). Models of charity donations and project funding in social networks. *Lecture Notes in Computer Science*, 5872, 454–463.

2. *Crowdfunding the Narrative, or the High Cost of "Fan-ancing"*[1]

Tanya R. Cochran

Introduction

The landscape of fan cultures has changed in significant ways in recent de-cades. Specifically, the invention of the Internet has provided fans greater access to each other. As a result, fan communities are emerging quickly, living long and prospering much. Digital spaces also afford fans and media creators, producers and distributors more and more immediate interaction with each other than ever before. This ability to communicate easily and instantly has al-lowed for the expanded use of crowdsourcing in general and crowdfunding in particular. The term *crowdsourcing*, coined in 2005 by *Wired*'s Jeff Howe and Mark Robinson, refers to the use of "crowds" as voluntary or unpaid sources of labour, whether that labour is physical (e.g., word-of-mouth marketing) or intellectual (i.e., ideas). According to *Investopedia*, crowdfunding, a type of crowdsourcing, is "the use of small amounts of capital from a large number of individuals to finance a new business venture" (n.d.). To spread the word about this venture, crowdfunding capitalises on the networks of family mem-bers, friends, and colleagues a person has already established through social media platforms such as Facebook, Twitter, LinkedIn, and others.

Crowdfunding has quickly become woven into the fabric of media fan-dom, the example of writer-director Rob Thomas's *Veronica Mars* (2004–7; 2014) Kickstarter campaign one of the most remarkable. As a result, this practice has prompted exigent questions about morals and ethics[2] in a highly participatory and convergent era. Yet the majority of the questions raised by media scholars and critics regarding the *Veronica Mars* campaign have remained focused on media fans, creators, producers, distributors, and their interaction with each other as well as the platforms used to engage crowds.

This essay flirts with that focus, but the goal is to shift attention to (the) narrative. To achieve that goal, narrative impact or how stories affect us humans is addressed first. Next narrative impact is explored as it relates to being a fan and then being a fan in a community, a space in which narratives, individual morals and collective values converge and sometimes clash. Finally, what can happen when fans financially back a narrative they love is considered. Ultimately, I argue that crowdfunding can disrupt the ability of art at its best to do what art does best: provide us with "ethical visions," "particular configuration[s] of rights and wrongs [...put] in motion within a represented human context" (Gregory, 2009: 37), visions that drive our actions and sometimes inspire our activism.

Narrative Impact

In *Shaped by Stories: The Ethical Power of Narrative*, Marshall Gregory (2009) explores the human necessity for stories. As he and other scholars of narrative elucidate, stories provide us with imagined experiences, virtual spaces within which to try on emotions, choices and consequences of various actions; narratives fill in the gaps of our limited lives and are especially adept at developing our empathy (Djikic, Oatley, Zoeterman, & Peterson, 2009), one reason fandom sometimes transmutes into socio-political activism. These experiences are mostly if not entirely the reason we feel compelled to pursue narrative (and why it is worthwhile to pursue the question of how crowdfunding might alter narrative impact). As a result of their experiential nature, all stories—whether fiction or nonfiction, typed or televised, aesthetically pleasing or displeasing, moral or immoral[3]—possess "ethical visions" (2009: 37). If we begin and then continue to read a book, listen to a musical album, play a video game, watch a television show or view a film, we have assented to participate in that ethical vision, to borrow that "view" for a time, to try on that perspective about life. Every story, then, has some degree of influence on us. However, the stories that become beloved are the ones we have given, usually over and over again, more than simply our assent; to those tales we have given our undivided attention and devotion. Thus, those narratives have a more significant impact on us than other ones do. Both in ways we recognise and ways we do not, *those* stories shape us in powerful ways; they become a part of who we are. As Gregory says, we consume them, and they consume us (90). In other words, narrative impact involves, at the very least, a reciprocal relationship between text and reader or fan. Again, as we repeatedly partake of our favoured narratives, those narratives transubstantiate or change substances; they become "more than" and "something other." Stories become

us, and we become stories—in the flesh—through our actions and activism (Cochran, 2014). Hence, narrative impact must be considered in relation to how one becomes a fan and what being a fan means.

Narrative Impact and the Fan

Like many people, I have been a fan since childhood. Even without the term in my vocabulary, as a little girl I strongly sensed what it meant to me to be one. It meant begging for a personal copy of a beloved library book, requesting the latest My Little Pony for my birthday, hanging posters of Michael Jackson and Harrison Ford (as Indiana Jones) on my bedroom walls, subscribing to *Soap Opera Digest* and *Tiger Beat* and composing fan letters to Olivia Newton John, John Travolta, and Sylvester Stallone. In contrast to these very tangible aspects of fandom, the greater part of being a fan meant certain feelings. The feeling of being transported (Green, Strange, & Brock, 2002) and of being inside of other peoples' skins, experiencing in my mind what they were experiencing on the page or screen (Mar & Oatley, 2008; Oatley, 2002; Oatley, 2012). Of course, my grasp of narrative impact matured as I did. When after college I reread for the third time C. S. Lewis's *Chronicles of Narnia*, I became conscious of the influence *The Last Battle* has had on my theological understanding and my daily practice of grace. In graduate school, a newspaper article about an X-Phile, a fan of Chris Carter's *The X-Files* (1993–2002), decided the direction both of my master's degree research and my current scholarship in fandom studies. The article featured a young woman who was about to begin university, and she unashamedly declared FBI Agent Dana Scully as her inspiration for choosing a degree in forensics. For me and perhaps for others, being a fan begins on the outside with a desired object, develops on the inside through emotional investment and works its way out again through behaviours or actions—and sometimes activism. There are, of course, other definitions that overlap with and extend my own, many of them derived from studying fan communities.

As Cornel Sandvoss observes, most fandom research is sociological in nature because exploring interior lives risks pathologising fans (2005: 67). Yet these community-based approaches cannot fully account for what being a fan means, especially in relation to narrative impact (and crowdfunding, as I posit later). We must also "understand the psychological foundations of the self"(68; see also Duffett, 2014: 30). Thus, Sandvoss draws on the basic principles of Freudian psychoanalytic theory to explain the pleasure fans derive from their beloved objects – in most cases, from narratives. Put simply,

the self is split among the id, ego, and super-ego, layers that are constantly in tension with one another. Thus, we experience ourselves as lacking wholeness. To achieve a state of wholeness, we attempt to mend ourselves "through fantasies and action" (70). In our highly mediated lives, we can access those "fantasies" – or "ethical visions" (Gregory, 2009) – easily and indulge in them regularly. For various reasons and in different ways, the books we read, the concerts we attend, the video games we play and the television series and movies we watch give us great pleasure; we enjoy them over and over again. If we accept Sandvoss's definition of fandom "as the regular, emotionally involved consumption of a given popular narrative or text" (2005: 8), nearly every human being experiences this affective relationship with the objects that represent our fantasies or imaginings. Therefore, being a fan is not just what one does but who one is; it is "an existential choice" (Dobel, 2012).

Daniel Cavicchi agrees, asserting that "fandom is not some particular thing one has or does. Fandom is a process of being; it is the way one is" (1998: 59). Because of its existential nature, fandom can feel like religion, which is not to say that it *is* religion. Rather, it can be compared to religion because fandom "represents a search for values" (187). Put another way, fandom is a form of spirituality, a "source of values, identity, and belonging" (188). Mark Duffett concedes that "to become a fan is to find yourself with an emotional conviction about a specific object" (2014: 30). However, he disagrees with Cavicchi that being a fan is existential in nature, insisting that "existential categories usually have a notion of inevitably or destiny attached to them. Cavicchi's notion cannot quite explain how people find this particular category of existence or why they might find themselves leaving it. Perhaps it even implies that we are all – or are *potentially* all – born as fans and just need to realize it" (30–1, original emphasis). Though he rejects Cavicchi's central claim, Duffett concedes that fandom "can heighten our sense of excitement, prompt our self-reflexivity, encourage us to discuss shared values and ethics, and supply us with a significant source of meaning that extends into our daily lives" (18). Curiously, the very reason fandom can accomplish these meaningful outcomes is often left out of discussions: the beloved text, the narrative. Excitement, self-reflexivity, values, ethics, meaning – all of these are examples of narrative transubstantiated, narrative become "something other". Is one born a fan in the same way one is born with particular sex organs? No. However, it might be said, to extend the religion metaphor, that one can certainly be "born again" as a fan. In essence, being a fan has everything to do with an "individual's unique position as a self-determining agent responsible for the authenticity of his or her choices," the very definition of existentialism (Dictionary.com, 2014). Of course, it is only the rare media fan who solitarily

admires a text or narrative; thus, choices are often made in the presence of and in negotiation or conflict with others – with the *crowd* in *crowdfunding*.

Narrative Impact and the Fan Community

Certainly, some self-identified fans do not seek community, but many do, no matter how large or small, virtual or local that community may be, and membership assumes a reciprocal relationship. One fan's ethos or character affects the fandom's ethos, and the fandom's ethos affects the individual's. Ethos is developed through the choices a person or a group makes, decisions that shape the community. In a fan community, members' choices can also indirectly as well as directly impact the object of fandom, the (meta) narrative itself. J. Patrick Dobel (2012) insists that being a sports fan "involves a moral stance. It means acting in ways that impact others and the [object of one's fandom]." Touching on the "Fake Geek Girl" phenomena provides greater understanding of what Dobel means within the framework of media rather than sports fandom.

Comic book artist Tony Harris, who successfully crowdfunded his graphic novel *Roundeye: For Love* in 2011, did not start the "Fake Geek Girl" fire, but he certainly stoked it with his 13 November 2012 Facebook post in which he verbally berates women he considers "fake" because of their limited or lacking knowledge about the comic book characters they cosplay at conventions. Although the issue of how little in Harris's estimation these women know about comics seems to be his central concern, he does not stop there. Harris (2012) further comments on the women's bodies, making multiple statements about their "glossy open lips," revealing costumes, sizeable yet inept breasts and not-so-thin figures. Moreover, he assumes to know their motivations for cosplaying and attending cons, judging those motivations to be entirely self-centred and disingenuous:

> After many years of watching this shit go down every 3 seconds around or in front of my booth or table at ANY given Con in the country, I put this [post] together. Well not just me. We are LEGION. And here it is, THE REASON WHY ALL THAT, sickens us: BECAUSE YOU DONT KNOW SHIT ABOUT COMICS, BEYOND WHATEVER GOOGLE IMAGE SEARCH YOU DID TO GET REF ON THE MOST MAINSTREAM CHARACTER WITH THE MOST REVEALING COSTUME EVER. (n.p)

Harris then accuses these particular female cosplayers of preying on men whom they would never speak to outside of the convention setting. In the end, he says the women are not "authentic" because they do not truly love comics. Rather, they are just the spectacular con-goers (i.e., spectacles) the

press likes to talk to and take pictures of. The "real reason" for the convention, concludes Harris, and the real reason for "the damned costumes yer [sic] parading around in...[is] Comic Book Artists, and Comic Book Writers who make all that shit up." Here, Harris lionises artists and writers and refers to the comic book tales themselves as "all that shit," a move that suggests short-sightedness regarding the power of narrative, no matter the creator. Within moments, Harris's invective blazed a trail across the Internet, lighting more fires and burning bridges as it went. (One wonders how or if his remarks would have affected his Kickstarter campaign to fund *Roundeye: For Love* – a campaign that reached its $10 thousand US goal with only 103, mostly male backers – had they been made before rather than after the fan-funded project launched.) Whereas he is his own person and, therefore, solely responsible for his choices and choice of words, it is impossible to disentangle his diatribe, one conveyed in a decidedly social and communal setting, from comic fandom and the comics industry and, thus, comic books or narratives, many of which have been long criticised for their sexist content. Of course, Harris's post is a microscopic look at a macroscopic problem. As Alex Hern (2012) points out, "the views Harris expresses aren't just held by virulent misogynists – instead, they are depressingly common in 'geek culture.'" An equally virulent backlash from "girl geeks" is not the answer. Instead, insists Susan Polo (2012) of *The Mary Sue*, the "proper response" to someone who has only read one comic series is to offer more recommendations, and "the proper response to someone who appears to want to be a part of your community is to welcome them in. End of story." Of course, Polo could replace the word *response* with *choice*. To create, maintain, grow, or destroy community, members must make (im)moral and (un)ethical choices. A community's ethic is a major part of its metanarrative, a tale collaboratively spun and told (i.e., lived out) by member-authors. In essence, the "Fake Geek Girl" phenomena and Harris's contribution to it have unravelled the metanarrative that casts geek culture in general and comic fandom in particular as safe, welcoming, and accepting spaces.

Clearly, it is important for a fan community to discuss and critique the ways in which its members treat each other and, in turn, impact a fandom's cherished narrative and metanarrative. Despite mindsets such as Tony Harris's, comics and, as a result, comic fandom have in the last decade or so come a long way toward representing the spectrum of human diversity in regard to gender, race, class, sexual orientation, age, religion, and more. These more diverse stories give fans – as the best art does – more of what they need: "ethical visions," "particular configuration[s] of rights and wrongs [...put] in motion within a represented human context" (Gregory, 2009: 37). Also important

to discuss and critique are the ways in which members of a fandom spend money in relation to a beloved text and how monetary decisions affect the community and the object of fandom. However, analyses of spending tend to elicit more ire than those of social behaviour. Nevertheless, emotion-driven investments should be analysed because they have the potential to, like Harris's Facebook outburst, impact a fan community's preferred (meta) narrative. Again, the *Veronica Mars* Kickstarter campaign provides an ideal case study for elaborating on that claim.

Narrative Impact, Fandom, and Crowdfunding

The cult, noir, teen detective series *Veronica Mars* was unexpectedly cancelled in 2007 in its third season, and like many cancelled television shows, the narrative left viewers hanging, desperately wanting to know what would come of their favourite characters. Fans lobbied for the series' return with no success. Six years later, creator Rob Thomas and owner Warner Bros. had devised a possible way to resurrect Veronica and her pals on the silver screen: crowdfunding via Kickstarter or what Suzanne Scott (2013) refers to as an occasion of "fan-ancing." The campaign launched on 13 March 2013 with a goal of $2 million US. Across the World Wide Web, media scholars, bloggers, critics, journalists, and fans themselves immediately went to work to figure out what the campaign meant and would continue to mean for the industry, for fan-producer relationships, and for the text itself (Abbott, 2013; Chin, 2013; Jenkins, 2013a; Jenkins, 2013b; Jenkins, 2013c; Jones, 2013; Lawson, 2013; McCracken, 2013; McMillan, 2013; McNutt, 2013; Mittell, 2013; Paskin, 2013; Pebler, 2013; Poniewozik, 2013; Scott, 2013; Sepinwall, 2013; Stanfill, 2013; VanAirsdale, 2013). Would this campaign change how Hollywood films are funded? Would the campaign augment or diminish the relationship between producers and fans of media narratives? Were fans being exploited? Would "fan-ancing" create pressure for Thomas to write the film's script in a particular way? Before some of these questions could even be broached, the campaign had reached its goal – that is, within ten hours of launch. Over the next thirty days, $5.7 million US was raised. The film was shot, produced, and released within one year of the campaign's start date. Because of the swiftness of the entire event, interested parties are still trying to figure out what the phenomenon meant and might continue to mean. Of course, there is no *one* answer as the implications are multifaceted, still unclear in some respects and, for both of those reasons, beyond the scope of this essay. Also, it is impossible to prove causal relationships without a way to test the campaign again or compare it to another campaign with sufficiently similar characteristics. Yet

from a qualitative perspective, it remains worthwhile to hypothesise what the campaign means and, most importantly, what the film, the narrative itself, means in the context of the best art doing what art does best.

Citing the work of Thomas Elsaesser, Jonathan Gray observes that "buying a movie ticket is an 'act of faith,' in which we pay for 'not the product itself and not even for the commodified experience that it represents, but simply for the possibility that such a transubstantiation of experience into commodity might "take place"'" (2010: 24). Theatres rarely if ever give refunds—and cable companies never do—because, as Gray argues, we are not paying for an actual product; we are paying for a possibility. Nevertheless, we viewers keep investing our time. Especially in regard to television, we willingly and regularly participate in "speculative consumption," evidence that stories have moved us before. At the same time, we cling to "the hope, the possibility, of transubstantiation. Or, as Roger Silverstone notes, 'We are drawn to [...] texts and performances by a transcendent hope, a hope and desire that something will touch us'" (Gray, 2010: 24–5). As mentioned above, this hope is one reason fandom feels like religion or spiritual at times. By noting our desire to have a story "touch us," Silverstone also alludes to what narrative means in our lives, providing us with what we need: imagined experiences that foster greater understanding of the world and deepen our empathy for others. Buying the possibility of these experiences—at the theatre counter, from the cable or streaming company, at the gaming store, in iTunes or from a local bookseller—does not alter the text in direct ways. Allowing that every creator responds to an imagined or real audience of critics, consumers, and other invested parties, a fan's purchase rarely if ever results in a narrative's revision. One can, of course, read (into) a story as one determines, or decide to produce fan fiction to take the narrative further or in a different direction, but a fan's influence is typically limited to creating paratexts.

Initially, it may seem that introducing crowdfunding into this scenario would not necessarily change anything. As Bethan Jones (2013) asks, is there a difference between paying for a film at the theatre counter and paying for it before it is even produced? Both are forms of buying a "possibility" as Elsaesser argues (as cited in Gray, 2010: 24). Yes and no. Bertha Chin articulates one significant difference when she notes that by participating in the Kickstarter *Veronica Mars* fans were not just funding a production studio or pre-paying for a film; they were "funding the creative vision" of Rob Thomas, the artist who gave them their adored narrative universe and its inhabitants. This kind of investment raises questions about fan expectations. Would fan campaign backers "feel entitled to the project now that they've invested money in it? Would Rob Thomas—or any other filmmaker who received his funding via

Kickstarter for that matter—now be obligated to create a piece of work that they think fans want, and would that affect forms of artistic integrity?" (Chin, Jones, McNutt, and Pebler, 2014: par. 2.4). Fan-backers' comments answer such questions:

- I'm very glad I made a pledge. I will always feel like *Veronica Mars* is my movie. (Borsuk, 2014)
- The movie was superb and everything I was hoping it would be. Our money was certainly well-spent. (Greenwaldt, 2014)
- I loved the movie. I can't even describe my feelings – past just saying that I was crying through the whole thing. I do, however, feel upset that some of the questions I was promised would be answered in the film were not. (Lazowski, 2014)
- Loved the movie and am so happy I donated. […] I did have an idea for another movie where you could get in some characters that you were not able to get into this movie. The concept should be around Jake Kane being shot; you could have Duncan return as well as Veronica's mother (Jake is not a married man anymore) you can bring up Lily and we can find out that ever happened to Duncan and his child. Thank you so much. (McDonald, 2014)

Scholars' questions and fan-backers' answers suggest that, in fact, there *are* differences between paying now by backing an artist through Kickstarter and paying later in the more formal setting of a theatre. One significant difference is emotional proximity, the nature of the relationship between audience and author, the art patron and the patronised artist. Traditionally, the filmmaker has a business relationship with a production company; there is a contract. The agreement, even if those involved know each other and consider themselves friends, is business. When a filmmaker enters a relationship with fans using a fundraising platform such as Kickstarter, when that filmmaker sends backers regular updates as if they are intimate investor-friends, when some of those backers "buy in" at levels that entitle them to perks such as roles in the film or private parties with the cast members, and when the rhetoric shifts from business agreement to social contract—that is when something substantively different than paying for a possibility or a product simply at different stages of the story-making process emerges. Of course, there are countless instances of media companies and content regulators dictating—sometimes legally—what creators can and cannot do with their narratives. Fan motivations, though, are distinct. As Jones (2013) states, "The investment is in the text, not the studio. […] the primary objective for me as a fan is to get the [*Veronica Mars*] film made." Yes, to get the film made, but to do so without

any expectations regarding the writing, casting, filming, editing, marketing, or distribution of the text? Tellingly, when fan-backers eligible for a digital download of *Veronica Mars* could not access the film on the day of its release via Flixster, it become even clearer that audience expectations regarding the project were distinct from usual fan-producer-text relationships. Not only did Marshmallows, as devotees call themselves, expect the storyline to "deliver," but also some understood themselves to have purchased a decision-making voice: "we need to show [Warner Bros.] that fans simply won't tolerate [not having a say]. If we help fund it, we get a seat at the table when it comes to basic things like how we want to watch the movie" (Riechers, 2014).

One wonders what less "basic" aspects fan-backers might believe they have a right to influence.

As I complete this essay, the *Veronica Mars* movie has been available for five months. Film critics and movie-goers alike have had a chance to share their reviews. *Rotten Tomatoes* reports that 66% of top critics, 78% of all critics, and 84% of the movie audience think Thomas's film has merit. Still, reviewers—both fan and non-fan—often qualify their comments by noting that it is a film for Marshmallows. *Nerdist.com* staff writer and fan-backer Rachel Heine (2014) asks if it is "really such a bad thing" that the movie is fan-centric. Some critics think so, contending that the film is not what we need from art, though it certainly might be what we want. Writing for *Vanity Fair*, James Wolcott (2014) discusses how television narratives have changed over the last two decades, namely moving from self-contained or episodic storytelling to narrative arcs. With that change, viewership and fandom has also metamorphosed, becoming more active, more emotionally invested and, therefore, more demanding. Wolcott uses an aggressive metaphor to express what he thinks about that shift: "Sometimes a series needs to yank the fans by the back of the hair to show them who's boss." Although he uses distasteful imagery to assert his point, it is a valuable one: for art to do what art does best, it cannot pander to or "fan service" its audience. As Wolcott insists, "If you let fandom dictate the terms of the relationship, the result can be a warm milk bath such as the recent *Veronica Mars* feature […] Everyone involved with the project was so conscientious about giving the fans what they wanted that they neglected to factor in that sometimes giving the fans what they don't know they want is the best revitalizer." Wolcott's contention echoes that of many artists, ancient and contemporary, including Joss Whedon, self-identified Marshmallow and creator of *Buffy the Vampire Slayer* (1997–2003), who has famously stated, "Don't give people what they want, give them what they need" (as cited in Robinson, 2011: 31). Coming from any author, this statement sounds condescending. Yet it can also be read within the framework of what narratology and cognitive psychology have to tell us about how stories operate on

and within the human mind and heart. Stories cast ethical visions; we catch those visions and recast them through our individual morals and collective ethics. This process is exactly what crowdfunding has the potential to disrupt.

Narrative Impact at Its Best

We humans cannot afford many such disruptions because we need narratives that have sound ethical visions. As Sherryl Vint (2014) has argued, Whedon's *Buffy* has "extraordinary value" because "what we need [as audience members…] is a hybrid of myth and metaphor with real-world problems, a potent combination that allows us to both take pleasure from [his] series and also take seriously [their] themes." Vint's argument can also be made about the television series *Veronica Mars* (Wilcox and Turnbull, 2011; Dunn, 2014). Unlike *Buffy*'s Sunnydale, Veronica's Neptune is not set on a hellmouth, so there are no vampires-who-symbolise-real-world-issues to slay. However, very much like Buffy and the Scooby Gang, Veronica and her frenemies deal with some of the same fictionalised yet real demons: being raped, being poor, being abandoned, being profiled, being ostracised. Because they represent real life, the "fantasies" of Sunnydale and Neptune are moving; they touch us. That is what the best art does at its best. It gives us what we need.

Cognitive psychologists Melanie C. Green and Timothy C. Brock (2002) postulate that the aesthetic quality of a text affects its ability to "transport" readers, to make them feel as if they are *in* the text. As a parallel, I posit that the quality of a text's ethical vision also affects both its ability to transubstantiate and the value of the new substance it becomes. To put it bluntly, perhaps some books, some films, some television shows are more likely than others to contribute to the development of a critical consciousness that transmutes into, for example, socio-political activism. The science fiction television series *Star Trek* (1966–1996) and its enthusiasts immediately come to mind. Many fans who at the time of the original broadcast were hoping and even working for racial equality in the United States were drawn to *Star Trek* because of its interracial cast and the adventures that saw the crew of the starship *Enterprise* grapple with social issues such as homelessness, discrimination, religious intolerance, and war. As fans began to find each other through friendships, local clubs, conventions, and fanzines, a community or fandom developed. With that fandom, an ethic also emerged, one that promoted a diverse, free, peaceful society and continues to infuse the ethos of fandom today. There are plenty of recent examples as well. *Buffy* fans have been inspired to seek education regarding feminism, to educate others about feminism, and to advocate for the human rights of girls and women (Cochran, 2012). Many fans of the

Harry Potter books and films have allied themselves to promote and realise voter registration, marriage equality laws, fair labour practices, and the end of local and global hunger. In these cases and many others, narratives themselves rather than a certain author, auteur, or actor have incited activism.

In this essay, I have claimed that the potency of the *Veronica Mars* narrative, the heart of the fandom and one praised for raising critical consciousness, was weakened by "fan-ancing" the series' resurrection as a film. I stand by that assertion. That said, it is also true that the campaign was about more than just the story; it was about the whole crowdfunding experience. Moreover, the film was not attempting to (and arguably could not) do what the series did; it had other purposes, including providing fans with some narrative resolution. Lastly, not every text has to be the best art doing what art does best to be meaningful or enjoyable. This is not an argument about high-brow versus low-brow art. Nonetheless, it is essential to note that whereas fans who are engaged by and in a text and respond, whether through fan fiction or crowdfunding, are absolutely *active* audience members, they are not necessarily *activists*. Activism implies action toward achieving socio-political goals, goals informed by individual morals and collective ethics, many of which we humans derive from the stories we daily and repeatedly engage in.

We cannot ignore the power of narrative and, by extension, fandom. My own experiences as well as my observation of others' experiences have persuaded me that being a fan is indeed, as Dobel claims, an existential choice, a choice that should be made more consciously, more critically. As Paulo Freire and other critical pedagogues have argued, in the banking model of education, pupils receive, memorise, and parrot information; they do not challenge, wrestle with, or render the teacher's communiques. Of course, passive, inept pupils grow up to be passive, inept citizens. In fact, they are not citizens at all; rather, they are the easily controlled and, thus, oppressed. A superior model of education encourages and requires students to develop their ability to complicate, problematise, and decipher the complexity of life as socio-political beings. This model is superior because true education—the act of becoming a person who can reason as well as act reasonably— liberates, empowers, and engenders participatory citizens. In more ways than we often want to or do admit to ourselves as media students, creators, and producers, stories are the most prevalent form of education we engage in, and they demand an analytical eye precisely because they cast ethical visions that we recast with our choices, our very lives. The cases through which we test our ability to respond in moral and ethical ways have changed in recent decades, but the essential questions about existence and existing together have not. Fans crowdfunding a narrative may have a high cost: the dilution of art at its best to do what art

does best, that is, to give us humans—and fans—what we need rather than what we want. Narrative cannot be extricated from money in our convergent media landscape. Therefore, we must obligate ourselves to interrogate both the narratives we engage with and our own desires regarding them and to then critically and responsibly act accordingly.

Notes

1. I express my gratitude to the editors of this volume for their astute and patient work and to the many colleagues who contributed to my articulation of these thoughts, including Rasha Diab, Thomas Ferrel, Beth Godbee, Aphelandra Messer, Jill Morstad, Mark Robison, Meghan Winchell, and Kristopher Karl Woofter.
2. Whereas the words morals and ethics are often used interchangeably or morals are associated with religion and ethics with philosophy, throughout this essay I recognise the two as interrelated yet distinct, defining morals as those codes of conduct that are internally and individually derived and ethics as externally and communally derived.
3. Gregory makes a persuasive case against the amorality of stories.

References

Abbott, S. (2013, April 12). A long time ago we used to be friends, but…. *CST Online.* Retrieved May 19, 2014, from http://cstonline.tv/long-time-ago

Borsuk, C. (2014, April 13). Comment. *The* Veronica Mars *movie project by Rob Thomas.* Retrieved August 1, 2014, from https://www.kickstarter.com/projects/559914737/the-veronica-mars-movie-project/comments

Cavicchi, D. (1998). *Tramps like us: Music and meaning among Springsteen fans.* New York: Oxford University Press.

Chang, C. (2014, March 15). Comment. *The* Veronica Mars *movie project by Rob Thomas.* Retrieved August 1, 2014, from https://www.kickstarter.com/projects/559914737/the-veronica-mars-movie-project/comments

Chin, B. (2013, March 13). The *Veronica Mars* movie: Crowdfunding – or fan-funding – at its best? *On/Off Screen: A Communal Academic Blog on International Screen Media.* Retrieved May 19, 2014, from http://onoffscreen.wordpress.com/2013/03/13/the-veronica-mars-movie-crowdfunding-or-fan-funding-at-its-best/

Chin, B., Jones, B., McNutt, M., & Pebler, L. (2014). *Veronica Mars* Kickstarter and crowd funding. In M. Stanfill & M. Condis (Eds.), Fandom and/as Labor, special issue, *Transformative Works and Cultures,* 15. Retrieved May 20, 2014, from http://dx.doi.org/10.3983/twc.2014.0519

Cochran, T. R. (2012). "Past the brink of tacit support": Fan activism and the Whedonverses. *Transformative Works and Cultures,* 10. Retrieved July 18, 2014, from http://journal.transformativeworks.org/index.php/twc/article/view/331/295

——— (2014). By beholding, we become changed: Narrative transubstantiation and the Whedonverses. *Slayage: The Journal of the Whedon Studies Association,* 11 (2)/12 (1), 20 pars.

Dictionary.com (2014). Existentialism. *Dictionary.com Unabridged.* Retrieved May 22, 2014, from http://dictionary.reference.com/browse/existentialism

Djikic, M., Oatley, K., Zoeterman, S., & Peterson, J. B. (2009). On being moved by art: How reading fiction transforms the self. *Creativity Research Journal, 21* (1), pp. 24–29.

Dobel, J. P. (2012, November 12). Sports fan ethics. *Point of the Game: Conversations on Sports, Ethics and Culture.* Retrieved May 14, 2014, from http://pointofthegame. blogspot.com/2012/11/sports-fan-ethics.html

Duffett, M. (2013). *Understanding fandom: An introduction to the study of media fan culture.* New York: Bloomsbury.

Dunn, G. A. (2014). Veronica Mars *and philosophy: Investigating the mysteries of life.* Malden, MA: John Wiley and Sons, Inc.

Gray, J. (2010). *Show Sold Separately: Promos, Spoilers, and Other Media Paratexts.* New York: New York University Press.

Green, M. C., & Brock, T. C. (2002). In the mind's eye: Transportation-imagery model of narrative persuasion. In M. C. Green, J. J. Strange, & T. C. Brock (Eds.), *Narrative impact: Social and cognitive Foundations*, pp. 315–41. Mahwah, NJ: Lawrence Erlbaum.

Green, M. C., Strange, J. J., & Green, T. C. (Eds.) (2002). *Narrative impact: Social and cognitive foundations.* Mahwah, NJ: Lawrence Erlbaum.

Greenwaldt, M. (2014, March 30). Comment. *The* Veronica Mars *movie project by Rob Thomas.* Retrieved August 1, 2014, from https://www.kickstarter.com/projects/559914737/ the-veronica-mars-movie-project/comments

Gregory, M. (2009). *Shaped by stories: The ethical power of narratives.* Notre Dame: University of Notre Dame Press.

Harris, T. (2012). I can't remember if I've said this before. *Facebook.* Retrieved November 13, 2012, from https://www.facebook.com/tony.harris.313/posts/4441714834591

Heine, R. (2014, March 15). A Marshmallow's take on *Veronica Mars. Nerdist.* Retrieved August 1, 2014, from <http://www.nerdist.com/2014/03/a-marshmallows-take-on-veronica-mars/

Hern, A. Nerds: Stop hating women, please. *NewStatesman.* Retrieved May 22, 2014, from http://www.newstatesman.com/culture/2012/11/nerds-stop-hating-women-please

Investopedia. (n.d.) Crowdfunding. *Investopedia.* Retrieved May 14, 2014, from http://www. investopedia.com/terms/c/crowdfunding.asp

Jenkins, H. (1992). *Textual poachers: Television fans and participatory culture.* New York: Routledge.

—— (2013a, March 27). Kickstarting *Veronica Mars:* A conversation on the future of television (part two). *Confessions of an Aca-Fan: The Official Weblog of Henry Jenkins.* Retrieved May 20, 2014, from http://henryjenkins.org/2013/03/kickstarting-veronica-mars-a-conversation-on-the-future-of-television-part-two.html#sthash. MKBDGIqG.dpuf

—— (2013b, March 28). Kickstarting *Veronica Mars:* A conversation on the future of television (part three). *Confessions of an Aca-Fan: The Official Weblog of Henry Jenkins.* http://henryjenkins.org/2013/03/kickstarting-veronica-mars-a-conversation-about-the-future-of-television-part-three.html#sthash.bCoNCrrs.dpuf

—— (2013c, March 29). Kickstarting *Veronica Mars:* A conversation on the future of television (final installment). *Confessions of an Aca-Fan: The Official Weblog of Henry Jenkins.*

Retrieved May 20, 2014, from http://henryjenkins.org/2013/03/kickstarting-veronica-mars-a-conversation-about-the-future-of-television-final-installment.html

Jones, B. (2013, March 15). Fan exploitation, Kickstarter, and Veronica Mars. *Fan. Academic. Blogger.* Retrieved May 19, 2014, from http://bethanvjones.wordpress. com/2013/03/15/fan-exploitation-kickstarter-and-veronica-mars/

Lawson, R. (2013, March 13). Anyone know of a better charity than the "Veronica Mars" movie? *The Wire: What Matters Now.* Retrieved May 19, 2014, from http://www. thewire.com/entertainment/2013/03/kickstarter-kind-of-annoying-isnt-it/63060/

Lazowski, E. (2014, March 21). Comment. *The* Veronica Mars *movie project by Rob Thomas.* Retrieved August 1, 2014, from https://www.kickstarter.com/projects/559914737/the-veronica-mars-movie-project/comments

Mar, R. A., & Oatley, K. (2008, May). The function of fiction is the abstraction and simulation of social experience. *Perspectives on Psychological Science*, 3 (3), 173–92.

McCracken, C. (2013, April 3). The future of media production? *Antenna: Responses to Media & Culture.* Retrieved May 19, 2014, from http://blog.commarts.wisc. edu/2013/04/03/the-future-of-media-production/

McDonald, E. (2014, March 16). Comment. *The* Veronica Mars *movie project by Rob Thomas.* Retrieved August 1, 2104, from https://www.kickstarter.com/projects/559914737/the-veronica-mars-movie-project/comments

McMillan, G. (2013, March 22). Why the *Veronica Mars* Kickstarter may be a sign of bad things to come. *Time.* Retrieved May 20, 2014, from http://entertainment.time. com/2013/03/22/why-veronica-mars-kickstarter-may-be-a-sign-of-bad-things-to-come/#ixzz2OYH4RUMO

McNutt, M. (2013, March 15). Kickstarting *Veronica Mars:* A moment in a movement. *Antenna: Responses to Media & Culture.* From May 19, 2014, from http://blog.com marts.wisc.edu/2013/03/15/kickstarting-veronica-mars-a-moment-in-a-movement/

Mittell, J. (2013, March 15). *Veronica Mars* and exchanges of value revisited. *Just TV.* Retrieved May 19, 2014, from http://justtv.wordpress.com/2013/03/15/veronica-mars-and-exchanges-of-value-revisited/

Oatley, K. (2002). Emotions and the story worlds of fiction. In M. C. Green, J. J. Strange, & T. C. Brock (Eds.), *Narrative impact: Social and cognitive foundations*, pp. 39–70. Mahwah, NJ: Lawrence Erlbaum.

—— (2012). *Such stuff as dreams: The psychology of fiction.* Malden, MA: Wiley-Blackwell.

Paskin, W. (2013, March 13). "Veronica Mars" Kickstarts a movie project. Salon. Retrieved May 20, 2014, from http://www.salon.com/2013/03/13/the_captialist_veronica_ mars_movie/

Pebler, L. (2013, March 15). Guest post: My gigantic issue with the *Veronica Mars* Kickstarter. *Revenge of the Fans.* Retrieved May 19, 2014, from <http://www.suzanne-scott. com/2013/03/15/guest-post-my-gigantic-issue-with-the-veronica-mars-kickstarter/

Polo, S. (2012, March 27). On the "Fake" Geek Girl. *The Mary Sue.* Retrieved May 22, 2014, from http://www.themarysue.com/on-the-fake-geek-girl/

Poniewozik, J. (2013, March 13). Why the world needs a Kickstarter *Veronica Mars* movie. *Time.* Retrieved May 19, 2014, from http://entertainment.time.com/2013/03/13/why-the-world-needs-a-kickstarter-veronica-mars-movie/

Riechers, M. (2014, March 16). Comment. *The* Veronica Mars *movie project by Rob Thomas.* Retrieved August 1, 2014, from https://www.kickstarter.com/projects/559914737/the-veronica-mars-movie-project/comments

Robinson T. (2011). *The Onion A.V. Club* interview with Joss Whedon. In D. Lavery & C. Burkhead (Eds.), *Joss Whedon: Conversations*, pp. 23–33. Jackson: University Press of Mississippi.

Sandvoss, C. (2005). *Fans: The mirror of consumption*. Malden, MA: Polity Press.

Scott, S. (2013, March 15). Guest post: My gigantic issue with the *Veronica Mars* Kickstarter. *Revenge of the Fans*. Retrieved May 19, 2014, from http://www.suzanne-scott.com/2013/03/15/guest-post-my-gigantic-issue-with-the-veronica-mars-kickstarter/

Sepinwall, A. (2013, March 15). Exclusive: "Veronica Mars" creator Rob Thomas on the wildly successful Kickstarter movie campaign. *HitFix*. http://www.hitfix.com/whats-alan-watching/exclusive-veronica-mars-creator-rob-thomas-on-the-wildly-successful-kickstarter-movie-campaign#YcJ0zVGB5mCVurA3.99

Stanfill, M. (2013, March 25). The *Veronica Mars* Kickstarter, fan-ancing, and austerity logics. Mel Stanfill: Bringing Foucault to Fandom Since 2006. Retrieved May 19, 2014, from http://www.melstanfill.com/the-veronica-mars-kickstarter-fan-ancing-and-austerity-logics/

VanAirsdale, S. T. (2013, March 14). The *Veronica Mars* Kickstarter problem, and ours. *S. T. VanAirsdale*. Retrieved May 20, 2014, from http://www.stvanairsdale.com/2013/03/14/veronica-mars-kickstarter-problem-and-ours/

Vint, S. (2014, June 20). Difficult men, powerful women: *Buffy the Vampire Slayer* and quality television. Keynote Address. Sixth Biennial *Slayage* Conference on the Whedonverses, Sacramento, California.

Wilcox, R. V., & Turnbull, S. (2011). *Investigating* Veronica Mars*: Essays on the teen detective series*. Jefferson, NC: McFarland and Company.

Wolcott, J. (2014, May 9). Hollywood and divine. *Vanity Fair*. Retrieved July 16, 2014, from http://www.vanityfair.com/vf-hollywood/television-fan-obsession-emotional-investment

3. Exploiting Surplus Labours of Love: Narrating Ownership and Theft in Crowdfunding Controversies

Anne Kustritz

Introduction

Imagine someone who enjoys cooking and throwing dinner parties for friends. Unbeknownst to the host, someone else sets up a ticket booth outside the door to charge guests an entrance fee. In this scenario, everyone remains happy: the host enjoys cooking and socialising with friends, while the guests feel they have received good value and want to contribute to the event. The person charging for tickets is obviously delighted. Yet, as something has clearly gone wrong, under what circumstance would the label "exploitation" still apply despite their general acceptance of the arrangement? In this case, awareness of the ticket-seller at the door would bring the whole situation to a screeching halt with cries of indignation from nearly all parties involved. However, after nearly a decade of efforts to raise public awareness about internet business practices, increasingly the issue is not lack of knowledge, but shifting expectations regarding ownership, investment, and rights in relationships between participants and corporations. Through ideological campaigns aimed at changing the social consensus about ownership and the consumer-producer relationship, companies increasingly seek to turn their customers into co-producers who take all the risks of financing, and spend all the time and energy of creative labour and marketing, then take their rewards in symbolic rather than financial form.

In crowdfunding this split becomes particularly stark as fan investors and corporate investors remain in two separate rhetorical-legal worlds. Moments when audience beliefs and corporate policy radically diverge, creating ruptures of discontent within an otherwise hegemonic system of mutual consent,

provide insight into growing attempts by corporations to sell the public a new story about ownership and investment that would allow them unrestricted rights to profit from fans' monetary, social, and creative investments in popular culture. Thus the narrative context of users and producers' discussions of online property often become just as formative as the actual law in shaping contemporary digital economies, while also offering audiences an opportunity to co-narrate new expectations for emerging systems of exchange. Controversies about the ethics and meaning of the Oculus Rift and *Veronica Mars* crowdfunding projects thus reflect contestation between rival financial storytelling practices, providing a window into the ongoing struggle to create a social consensus on the future of digital exchange. This chapter thereby unpacks the layers of motivations, meanings, and strategies each rhetorically and legally poised to define crowdfunding alternately as a champion of digital capitalism, an innovative collectivist economy, or a niche project irrelevant to the larger system of exchange. As a result, this chapter argues for the importance of embedding economic actions within individual and collective narrative frameworks, and beginning any project of systemic economic change with a public process of radical storytelling that makes individuals' fiscal and ideological investments visible.

The Drama of Financing: Corporate and Collective Economic World Making

Involvement with crowdfunding entails participating in specific narratives about economics and exchange, while also investing in a story about the future. Is crowdfunding a tragedy of exploitation, a heroic feat of radical economics, or black humour about the inevitability of business as usual? Yet, this phenomena is not limited to crowdfunding. Whenever people engage with intellectual property and other digital experiments in ownership and (re)distribution they become part of a collectively authored story, one constantly renegotiated among government, corporations, platforms, publishers, creators, and readers (Alessandrini, 2011; McNally, 2012). Despite the seemingly dry subject matter, these explanations become what Michael Warner would call poetic world making, or a performative project of bringing something into being through narrative (2002). As with many economic stories, it demonstrates the complex, dialectical relationship of semi-autonomous dependency between base and superstructure, or material economic conditions, cultural forms, and the stories that explain and allow people to continue enduring life within both. As a result, disagreements about the meaning, value, potential, and consequences of crowdfunding often ventriloquize deeper disagreements

over the system of capitalism itself, and the dangers and opportunities presented by emerging models of digital capital.

The story told through crowdfunding often thematises rebellious triumph. Popularised in the United States by sites like Kickstarter and Indiegogo, but known globally by many names and platforms like Ulule and KissKissBankBank, crowdfunding allows individual inventors, artists, and entrepreneurs to pitch businesses, products, inventions, and projects, with a funding goal needed to launch their idea. Like collective intelligence, collective web funding works from the principle that although no one can fund everything, everyone can fund a little piece of something. While individuals pledge according to their limited resources and interests anywhere from a dollar to thousands of dollars each, crowdfunding can raise enormous capital because it taps collective resources that become much more powerful when combined. This model promises to redirect some of the clout previously reserved for industry insiders to the masses by allowing collective intelligence to decide which projects have merit in an open, public process, instead of industry moguls in a closed system of backroom deals. Crowdfunding thereby appears to promise an expanded and enriched form of choice, by allowing average people to participate at the front end of production, before options have been narrowed to only a few consumer-end products. Suddenly it takes neither the wealth of the Medicis or Rockefellers to become a patron of the arts, nor the financial clout of an investment bank to dabble in venture capital. Sound the trumpets! Yet before getting too swept away by this revolutionary siren song, those two opposing utopian narratives of crowdfunding as populist patronage versus populist venture capital also sketch the inherent tensions and erasures within crowdfunding rhetoric, exposing its underlying vulnerability to appropriation as evidence affirming many different stories about emerging digital economic systems.

One of the major points of debate surrounding crowdfunding is how to form a narrative arc connecting the motives and consequences of individual participants' decisions to pledge money; the patrons versus investors dichotomy begins to open up the stakes of how vastly different the overall cultural value of crowdfunding can seem depending on whether participants take on the guise of unlikely heroes, shrewd financiers, or something else entirely, like exploited dupes. The most obvious context within which such narratives may be framed are the implicit and explicit incentives offered through crowdfunding platforms themselves. Incentives generally come in three forms: equity, rewards or prizes, and symbolic compensation. In the United States and several other jurisdictions the equity form of crowdfunding remains illegal, as crowdfunding participants do not qualify as "accredited investors" (Securities

and Exchange Commission, 2014a). In an equity arrangement, each partici-
pant to pledge money at the front-end development stage of a crowdfunded
project would retain some kind of financial stake in the company and/or the
eventual profits derived from that particular project. This stake may take many
forms, particularly since many crowdfunding pledges are quite small; yet, in
principle, an equity model for crowdfunding would maintain that all initial
investors would be owed some portion of the eventual economic rewards, in
proportion to their financial risk, whether that financial stake takes the form
of stock, options, dividends, or collective minority control of the company
itself. Although the Jumpstart Our Business Startups or JOBS Act was signed
into American law on April 5, 2012 by President Barack Obama, and one of
its provisions included legalising equity-based crowdfunding platforms, that
portion of the bill has been stuck in the data- and opinion-gathering phase
(Securities and Exchange Commission 2014b). Until the law comes into ef-
fect, crowdfunding pledges in the USA must legally remain separate from
other investments, and this strongly affects the kind of economic systems
and stories made possible through crowdfunding. Crowdfunders cannot (yet)
usurp and disrupt the power of large scale venture capital.

Thus, in the United States and many other jurisdictions, rewards and
symbolic forms of compensation provide the main impetus for the initial
development of crowdfunding platforms; yet these two forms of incentive,
along with the spectral promise of equity, often rhetorically overlap and com-
plicate attempts to discern the overall significance of the activity and factors
that motivate individual involvement. In the rewards model, financial backers
receive tokens of increasing value as their contribution increases. Many of
these rewards are material goods, like a copy of the completed album that
backers help fund. However, many other types of rewards derive their value
from connection with forms of symbolic compensation and hint toward the
implicit patronage system that ideologically underpins many crowdfunding
transactions. Often crowdfunding projects reward their backers with increas-
ing levels of access, which can take the form of access to the development
process, as in early versions of computer programming code, access to pro-
duction, as in the ability to visit the studio, access to the artist or developer's
time, as in Q&A sessions, or access to extra aspects of the project unavailable
on the regular commercial market, like collectors' editions or extra bonus
levels to a game. On the one hand, material rewards and access-based rewards
can seem to fade back into the regular functioning of capitalism, because they
can be figured as simple purchases. In other words, thinking of crowdfunding
primarily through the incentive of material and access-based rewards sounds
a lot like the direct and uncontentious exchange of money for goods and

services, and precipitously deflates any emancipatory potential from the practice. It could still be argued that by moving purchasing to the front end of the production process crowdfunding participants exert greater control over which products will enter the capitalist marketplace, but the actual structures of production, profit, and exchange remain undisturbed. This model rhetorically turns crowdfunders back into customers.

On the other hand, the excess symbolic value of access rewards, and the many other purely symbolic forms of crowdfunding compensation point toward the need to create alternate social and economic imaginaries to fully explain the phenomena at play. While the prestige involved in purchasing access can be constructed as a simple matter of consumerism, it may also return to the model of patronage; unlike a fan or consumer who is often socially diminished by their desire for culturally devalued access to a pop property or celebrity, the story of patronage contextualises increased access as a status-building reinforcement of those financial backers without whom artists and creators would cease to function. As in many analyses of fans, the distinction hinges partly upon the perceived value of the cultural object in question, as those who like high-value objects distinguish themselves by association and often evade the "fan" label (Jenkins, 1992). Yet, with these questions of taste culture set momentarily aside, many of the rewards available to crowdfunding backers consist of entirely symbolic gestures with no material or access components. Frequently this takes the form of credit, which can be thought of both as status-building and community-building. Becoming publicly acknowledged and known as a crowdfunding backer, whether by having their names listed on the platform website, printed in an album liner, or spoken during a performance, can serve as a boast of financial clout, but also makes a public claim to a potential form of identity and community, either through association with that specific crowdfunded project, or in general through association with crowdfunding itself.

Focusing on crowdfunding's purely symbolic, non-access-related rewards clarifies not only the common patronage narrative, but also other alternate economic stories that rise to the surface within crowdfunding activities. As demonstrated in the Oculus Rift and *Veronica Mars* examples detailed below, without rewards or equity, without purchasing goods or services, and without any promise of fiscal return or profit, many participants still put money into crowdfunded projects. They often do so based on the premise that their money helps to create a fundamentally new or different, alternative financial system (English, 2014). As with pre-purchasing, this alternative economic story may remain limited to greater influence over industry decisions; by funding projects early in the development phase, they seek to ensure that

these projects are selected for formal production within the existing industry structure. Within the framework of patronage, these may also remain limited to a few vanity projects that crowdfunding backers simply want to feel a part of, with few additional ideological goals. However, others seek to tell a more profoundly disruptive economic story, in which crowdsourced venture capital might completely bypass the existing industry structures and enable the proliferation of more independent and collective production and distribution models. By socialising investment and financial risk, the most radical ideological contextualisation of crowdfunding seeks to free creators and inventors from standard industry contracts, and enable the establishment of collective forms of ownership, production, and reciprocity.

However, unlike (semi-)contractual rewards and equity, symbolic forms of compensation often remain invisible and implicit, apparent only when dramatic moments of controversy require their overt articulation, often when expectations of symbolic investment and compensation have been violated. Pronouncements about the ethics, meaning, and value of crowdfunding frequently draw upon disjuncture in various actors' economic storytelling to make their claims. If, for example, the backer expects payment in the symbolic capital of association with an independent project, but the creator intends to bring his or her work to market in the profit economy, the question of whether exploitation has occurred largely depends on how one judges the merits of normative capitalism and individual ownership, as well as whether any breach of trust or contract may have occurred. Thus examining major crowdfunding controversies allows these implicit economic narratives to surface, and demonstrates how deeply beliefs about what crowdfunding does and can do reflect larger beliefs about the fate of capitalism, consumers, and owners, especially within emerging digital markets.

Cunning, Collectivity, Wealth, and Betrayal: Crowdfunding Stories from Oculus to Veronica Mars

Because the economic story that crowdfunding backers each author often remains internal, and the social norms governing the use of crowdfunding have not fully settled, the web of intersecting expectations and promises between backers and project initiators often becomes visible only when these expectations are violated. As argued by Judith Butler in *Antigone's Claim*, the precise line between acceptable and unacceptable behaviour is only apparent after it is breached, through the spectacle of punishment (2002). Particularly in hybrid social-economic digital forums like crowdfunding platforms, whose newness precludes a shared history and the regulations that collective memory can

produce, controversies over participants' actions reveal the vastly disparate assumptions underlying individuals' participation, and are themselves the very moments that produce the community's future rules and norms. Therefore, investigating two major crowdfunding controversies, over the Oculus Rift virtual reality system and the *Veronica Mars* film, reflects upon the challenges of carving out space for truly radical micro-economies within the larger field of global (digital) capital. The success of the Oculus Rift and *Veronica Mars* film, as well as the looming legalisation of equity-based crowdfunding, all seem poised to remake understandings of what crowdfunding and the entertainment industry can be; yet, they also remain locked in hegemonic struggle with a more collectivist buried script, which these controversies ironically made much more visible. Thus while the Oculus Rift and *Veronica Mars* cases may sound warning bells for the corporate takeover of crowdfunding's populist potential, they may also become the impetus needed to consolidate and amplify a different story about the need to collectively author a digital economic narrative that prioritises creativity, innovation, reciprocity, and community.

When the Oculus Rift Kickstarter project premiered on August 1, 2012, its immediate success foreshadowed the unprecedented financial windfall to come; yet few predicted the pending financial manoeuvres that would also draw unprecedented scrutiny to crowdfunding's ethics and implicit promises. A virtual reality (or VR) headset initially designed for a more immersive video and computer gaming experience, developing the Oculus required its designers to make many important software and hardware innovations toward improving the quality and reducing the cost of VR systems. The Kickstarter pitch aimed itself toward a community of VR enthusiasts, stating proudly "designed for gamers, by gamers," and utilising the rhetoric of "openness," in terms of open platform, open development, and open source (Oculus, 2012). As a system unaffiliated with any of the major corporate game companies, the Oculus also appeared to be an open-platform device that had little to gain from locking out compatibility with competing game systems and software. Completely separate from Oculus' crowdfunding, the project also relied on open source innovation to develop, test, and disseminate its code. Stating, "A key part of the Oculus culture is a drive for openness," Oculus' overt involvement with the open source code movement thus also became part of how the project was perceived by backers (Oculus, 2014). This "openness" became an important form of symbolic compensation and incentive; yet although the rhetoric of "openness" wove itself through much of Oculus' promotional materials, actions, and development, the exact nature and duration of that commitment remained an unspoken, non-contractual,

implicit promise. Therefore, while most of the funding levels for the Oculus came with material rewards, the nature of those rewards and the language used to describe them repeatedly return to the underlying symbolic value of supporting an independent, innovative, and "open" participatory project.

In the most transparent instance, the lowest funding threshold, $10–15, comes with no material reward and only a "sincere thank you" for helping to "take gaming to the next level," as well as regular project updates. 1,009 people pledged at this level by the end of the funding period, and clearly agreed to donate their money, not for goods or services, but for various forms of symbolic capital; each would imagine the exact content of that symbolic capital differently, from a sense of belonging within the interpolated gamer community, to a feeling of accomplishment that their money helped spur on innovation outside the industry. Particularly the promise to send consistent updates to $10 backers indicates an ongoing relationship in which these participants continue their involvement and symbolic investment in the project and crowdfunding community long after the moment that money changes hands. Slightly higher levels of funding, from $15–274, reinforce the non-financial, non-material stakes of the project, because even though they come with material rewards, these items have extremely low intrinsic value. The only thing that could possibly make these funding levels' posters and T-shirts worth the comparatively high cost is their ability to socially signify association with the project, and belonging to a community of other project supporters. This principle becomes especially stark as a T-shirt and poster pack incentivise those who pledge $35, but a signed T-shirt and poster pack require a $75 pledge. As the developers of the Oculus are not celebrities, even on a subcultural scale, the intrinsic value of their signatures cannot explain this $40 jump. Rather, the $75 pledge does not purchase the signature, but rather the signature publicly attests to the $75 pledge and the wearer's proportionately higher investment in the project's success, the "future of gaming," and the Oculus crowdfunding community; thinking of the pledge as buying a T-shirt tells this economic story backwards.

Higher levels starting from $275 all come with a much larger reward: a prototype of the Oculus system and "developer's pack"; however, even this type of funding reduces poorly to the notion of a purchase due to the symbolic excesses and rhetorical framing of these rewards. As indicated in the decision to call this reward a "developer's kit," backers did not simply pre-purchase an early version of a consumer-end product, but were invited to participate in important parts of that product's invention and fine tuning, namely by troubleshooting, and developing the content that would make the technology useful: that is, 3D games specifically intended to be played with a VR headset.

Just like the collaborative open source ethos that created the Oculus' software and hardware, and rhetorically connected it to the anti-intellectual property movement, the developer's packs implicitly acknowledge that much of the Oculus' value will come from interconnection with the gaming community, and the collaborative process whereby openness allows everyone to add value to the technology, and build upon each other's innovations (Oculus, 2012). To this end, the Oculus team sponsored many festivals, competitions, and forums for the design and discussion of new VR-oriented games, including a $50,000 prize at the VR Jam for best new game, and the "Oculus Share," "a new platform that lets you self-publish, discover, download, and play the best VR games and experiences out there" (Oculus 2013a; Oculus 2013b). Notably, while the VR Jam uses money as an overt motivation for participation, the online forum has no such incentives, and therefore offers only the symbolic compensation of contributing to a ground-breaking project and taking part in a community and gift economy; even the title serves as a clear acknowledgement that this is a place to "share."

However, this implicitly promised narrative of openness, independence, and collectivity quickly became complicated by Oculus' increasing overlap with the normative workings of capital, wherein it transformed into a hybrid project in which crowdfunding backers and legal investors' stories about Oculus' meaning and future sharply clashed. The first, less controversial alteration in the initial script occurred when, in 2013, Oculus received investments from private venture capital firms totalling $91 million (Murphy, 2013). The venture capital investment was due in no small part to the spectacular success of their Kickstarter, which raised $2,437,429 from 9,522 crowdfunding backers in only a month, well surpassing their $250,000 goal. Yet while the crowdfunding backers would be compensated largely in symbolic capital, the venture capital firms did not make donations, but expected equity and a monetary rather than symbolic stake in Oculus' future. Thus, to a large extent, as in many critiques of free labour, cognitive capitalism, and overlaps between the open source or gift culture and formal economies, Oculus leveraged money and labour from those who believed in a version of the company's open, collective future, to secure private investment that would drive private ownership and profits (Gill and Pratt, 2008; Terranova, 2000; Zwick, Bonsu, & Darmody, 2008).

Yet, in this case, Oculus couldn't give crowdfunding backers equity, even if they wanted to, because of many countries' laws against equity crowdfunding, as part of restrictions on what "non-accredited investors" can buy. In the U.S. these limit investment in the theoretically riskiest,[1] least regulated financial products to those who can "afford" to lose their principle, which in the

U.S. is defined as individuals with a net worth of at least $1 million, excluding the value of their primary residence (Securities and Exchange Commission, 2014a). However, it also limits the enormous financial rewards associated with high-risk investing to the already wealthy, formally locking the middle and lower classes out of the most rapid and dramatic forms of financialised capital accumulation. Perhaps because the law required that crowdfunding backers and venture capitalists be relegated to parallel economic dimensions, and because these firms overtly claimed no creative control over the Oculus' future development as an open platform, open development, open source system, this initial capitalisation raised relatively minor protest compared to the storm to come.

The far greater threat to Oculus crowdfunding backers' ability to control the technology's economic narrative unfolded on March 25, 2014 when Facebook agreed to buy Oculus for $2 billion. The venture capital stakes received a twenty-fold return, and Oculus' overnight financial success seemed to solidify Kickstarter's clout as a major player in start-ups and the business of early investment (Tate, 2014a). However, at the same time as many financial analysts proclaimed the dawn of the era of crowdfunding, many other commentators declared its precipitous demise, as a torrent of protest by Oculus' initial backers followed the Facebook announcement. While some backers still supported Oculus, in news interviews, editorials, and on Kickstarter's forum, many others expressed anger and betrayal (Johnson, 2014; Luckerson, 2014; Schwartz, 2013). Several news pieces framed this anger as the result of unfairness or sour grapes, because of the immense disparity in fortunes between accredited investors and crowdfunding investors, arguing that such conflicts will be resolved when equity crowdfunding is legalised (Tate, 2014b). Some backers frame their protests in this manner, as a question of equity, profit sharing, and the institutionalised inequality between rich and poor investors. Yet, these form only a small portion of the overall protests against the Facebook sale, and do not explain why crowdfunding backers, who after all were never implicitly or explicitly promised equity or future profit, became so very incensed.

While the crowdfunding backers had already parted with their contributions and did not actually lose money, they did lose their deferred social and cultural capital, as well as the symbolic value of many of their material rewards, because the Facebook sale directly contradicted their economic storytelling about Oculus' open, collaborative, independent future. Unlike the venture capital firms, the Facebook transaction was not an investment but a sale, which made Oculus part of the Facebook corporation. Therefore, backers disapproved of the perceived loss of operational autonomy, the deprioritisation

of the gaming community, and the redirection of their contribution from an independent to a corporate entity. Some backers also referred directly to their material rewards' loss of value, as in one commenter who posted "Please forward me an address so I can return my T-Shirt" (Hannibal, 2014). Such remarks highlight crowdfunding rewards' hybrid material-symbolic position. If the shirt had been purely a purchase with no implicit promise of belonging to a specific narrative financial future, the Facebook sale would not have such a precipitous effect on its perceived value. Many thereby protested not loss of revenue or equity, but loss of the non-contractual but deeply felt promise underlying Oculus' rhetoric of openness and collectivity, and the alternative economic narrative that backers co-constructed through their pledge and labour as (co)developers.

While the Oculus Rift case exposes the layers of often contradictory economic storytelling at play when initially independent Kickstarter projects are overtaken by corporations, the *Veronica Mars* crowdfunding campaign highlights how crowdfunding backers throw the regular functioning of capitalism into stark relief, and the impoverished ability to publicly narrate intelligible alternatives, because this project asked for non-equity contributions even though, from the beginning, it was transparently corporate-owned. On March 13, 2013 a crowdfunding campaign posted by writer and producer Rob Thomas requested funding to make a film sequel to the cancelled *Veronica Mars* television series. Although he had pitched a sequel before, Warner Brothers, who owns the intellectual property rights, refused to greenlight the project. Therefore, Thomas' Kickstarter pitch letter described the crowdfunding campaign not only as the financing needed to make the film, but also as incentive for the series' owners, whom he describes as "very cool" for their willingness to accept these zero-equity pledges and allow the film to be made for their own profit, should the campaign reach its historic $2 million goal (2013). Thomas thus characterises the Kickstarter as a bid to "show there's enough fan interest to warrant a movie" (2013, n.p.). Yet, his framing of crowdfunding as a measure of fans' interest also points toward the silences and contradictions in the many stories told by producers, fans, and commentators about the meaning and significance of the *Veronica Mars* project for the future of crowdfunding, the future of the entertainment industry, and the future of digital capitalism. While the Kickstarter's resounding success, meeting the $2 million goal in just 11 hours and reaching $5,702,153 from 91,585 backers by the campaign's close a month later, did indeed attest to enough "interest" to persuade Warner Brothers to greenlight the feature film, framing the project in those terms simultaneously erases the influence of money and conflates the willingness to spend with the feeling of passionate attachment.

Fans' interest in a *Veronica Mars* feature film could, of course, have been assessed in many ways that did not require fans' expenditure of money, from polls and petitions to letter writing campaigns. As opposed to these methods, the Kickstarter did not so much gauge fans' interest in the film, as demonstrate the cheapest possible measure of their willingness to part with money in the name of the franchise.[2] The Kickstarter thus partially substitutes for the market research that corporations used to have to pay for, and in fact makes these formerly costly parts of the business into sources of profit. The same might be said for many forms of "free labour" that turn jobs the industry used to have to pay often unionised wages for people to work, including script writing and the background acting of "extras," into sources of profit that fans not only do for free, but pay the industry to perform (CBS Corporation, 2006). Arguably, this again levels the playing field between average movie-goers and wealthy industry insiders by providing access, perks, and influence for anyone who wants to enter a pledge, which used to be restricted only to those who could invest on a much larger scale, and who already had access to the industry's notoriously status-conscious, closed system (Ortner, 2010). However, this investor-class rarely accepts payment only in the form of influence, access, and perks, and most often also demands that their financial risk be rewarded with a proportional stake in the company or project's future earnings. Thus arguments that Kickstarter projects like the *Veronica Mars* film offer a fair exchange of populist influence over the once closed process of greenlighting projects in exchange for crowdfunders' cash overlooks the deep inequality that still persists between industry insiders and investors who take on front-end financial risk for the hybrid benefits of influence, access, and equity, and crowdfunding backers who receive only proportionately smaller collective influence and prizes. It also silences a rival financial storytelling practice not about merely levelling the capitalist playing field so that customers gain a few of the perks of industry insiders, but of radically remaking the entire system of ownership, production, and control.

In this mode, many commentators resist narrating the *Veronica Mars* project as a form of exploitation and frame crowdfunding contributions as a completely normative form of purchasing, once again rhetorically making backers into consumers and re-enfolding crowdfunding into the existing logic of capitalism. However, by doing so, they repress the exploitation that is always inherently a part of all labour and purchasing within capitalism. Arguing that crowdfunding is a regular purchase does not preserve it from the forces of exploitation, but rather pits it directly at the centre of profit extraction and its production of material and social inequality. Thus, for example, media scholar Jason Mittell's oft quoted and recirculated Tweet "As for fans and

funders, we're basically just pre-buying merch, DVDs, or experiences. How is that unethical?" only makes sense as part of a story wherein capitalism itself is always already ethical (2013, n.p.). If capitalism is inherently exploitative, then crowdfunding cannot be recuperated by narrating it into the regular unfolding of the system.

Part of the history underlying this line of argumentation is that the *Veronica Mars* project deals with popular culture, an often denigrated form of cultural expression, and directly interpolates fans, a social group often scapegoated for capitalism's excesses. Fans routinely represent an extreme in critiques of mindless consumerism, feminised consumption, and the false consciousness whereby capitalism produces desire then provides the otherwise worthless products that only temporarily satisfy the very emptiness the system feeds upon (Lewis, 1992). In response, several academic commentators in a recent dialogue on "*Veronica Mars* Kickstarter and Crowd Funding" emphasise that "fans aren't ignorant," framing them instead as savvy consumers who deeply understand the industry and leverage their collective dollars and influence to get the most out of their limited power (Chin, Jones, McNutt, & Pebler, 2014). As a result, they do not "feel exploited," but instead become representative of the ultimate rational actors who assess the market and make logical decisions based on their needs and resources (ibid 2.8). These comments highlight both the fans' clout in revitalising a project the industry would not otherwise have produced, and in their pre-purchase of the rewards associated with various pledge levels, from (im)material goods like t-shirts and a digital copy of the film, to forms of access, like a day on the set.

Yet both the figuration of fans as an outgroup of excessive consumers and the hyper-rationalisation of fan consumption activities feed the persistent fantasy that there are any rational actors within capitalism who maximise the material utility and value of their purchases while minimising their contribution to surplus, profit, and symbolic forms of value. By inflating the notion that some consumers make illogical, excessive, or heavily symbolic purchases, while others rationally base their purchasing on logic and material value, these narratives of capitalism seek to construct a story of an economic system that can still be fair and reasonable for those rhetorically purified few with appropriate financial virtues and willpower. These explanations also overlook the long tradition of scholarship on how systems of what might be termed hegemony, ideology, power/knowledge, and financial storytelling function as a means by which most of the exploitation and inequality inherent to the normal functioning of capitalism becomes rhetorically transformed into pleasure, virtue, and the very fabric of everyday existence, meaning that exploitation only very rarely results in feeling exploited (Berlant, 2011; DeCerteau,

1984; Foucault, 1978). The process of seeing and feeling exploitation are themselves an enormous political struggle and necessary precursors to narrating something like a revolution or what Lauren Berlant calls an endless state of emergency (or emergence) that, through the process of abdicating a self-defeating narrative frame, suddenly gains the potential to become an event (2011, 1997).

Conclusion: Fitting Crowdfunding Into a Financial Narrative, and the Exercise of Economic Imagination

Thus, the problem with many crowdfunding discussions is not merely that they often elide the exploitation intrinsic to leveraging backers' donations to feed private profit, but their smothering of the problematic way in which all capitalist exchange leverages the desire, labour, and symbolic value of the many to produce profit for the few. Doing so enables a problematic re-encapsulation of crowdfunding's potential within the normative functioning of capitalism, while making other claims and other financial stories unintelligible. They thereby ridicule and undermine the dream of what crowdfunding could be, and of what economies could be, within the emerging economic systems of digital sociality and circulation. Yet, partly, the controversy that followed these projects also unearthed and facilitated the overt articulation of implicit assumptions and promises that drive a significant portion of crowdfunding activity. Making these investments in openness, independence, and an alternative to existing business models legible marks an important step toward more audaciously formalising and centring these goals in future crowdfunding projects. In this sense, even the dawning of equity crowdfunding will not mark a solution to all of the economic questions raised by such controversies. Levelling the obvious inequalities of access to opportunity between accredited and non-accredited investors addresses only one layer of hierarchy. It may also function as a form of appeasement that seeks to quell critique and new financial narratives with the veneer of a fair playing field.

Thus one could, for example, imagine a crowdfunding system more like Community Sponsored Agriculture or CSAs, in which the process of ethical production and profit distribution is overtly and contractually part of the exchange. Like crowdfunding, CSAs are a form of collective front-end financing that covers start-up costs and cushions risk. With an explicitly ideological bent aimed to make small, organic farms more sustainable, and invest communities in how their food is produced and how collective resources like land and nutrients are cared for, CSAs allow members to buy shares of a farm's harvest at the beginning of the season and thus to subsidise those farming practices they

find most ethical, while protecting such farms from risk by pre-purchasing a stake in the harvest, regardless of how weather and other market fluctuations may impact the yield. As noted by anthropologist Laura De Lind, who not only did fieldwork with CSAs but also founded a CSA, members of these organisations rarely completely share the same ideological goals, nor identical commitments of time, but the CSA project still functions as a forum to assemble a collectivity interested in co-narrating alternatives for how food could be more equitably produced and distributed (DeLind, 1999, 2002; McIlvaine-Newsad, Merrett, Maakestad, & McLaughlin, 2008). In the case of the Oculus and *Veronica Mars*, this is a conversation that could fruitfully be extended to intellectual property, mobilising crowdfunding as a locus for producing alternative narratives of how collective ownership and openness might be preserved when for-profit economies often seem to not only overlap with, but devour sharing economies. Thus while the Oculus and *Veronica Mars* projects sparked controversy as examples of the industry's ability to profit from and reincorporate crowdfunding initiatives, the public forms of protest they inspired also set the stage for a newly explicit practice of collective, alternate economic storytelling, in which the future of digital economics will be as open and radical as participants can imagine.

Notes

1. Risk here is highly ironic, as the government does not intercede to prevent those with a net worth below $1 million from undertaking so many other, arguably riskier things, from other investment risks like the elimination of pensions, to deflated mortgages, to individual margin trading, to other forms of risky gambling with the future like casinos, lotteries, dangerous working conditions, and lack of access to preventative health care. That the only financial risk worth saving people from should be hedge funds and start-up investments seems comparatively bizarre.
2. Kickstarter charges nothing to start a project, and nothing to projects that fail to meet their funding goal, but does take 5% when a funding goal is met. However, that 5% comes out of the donated money, not the project designer's pocket (Kickstarter, 2014).

References

Alessandrini, D. (2011). Regulating financial derivatives? Risks, contested values, and uncertain futures. *Social & Legal Studies,* 20 (4), 441–462.
Berlant, L. (2011). *Cruel optimism.* Durham: Duke University Press.
—— (1997). *The Queen of America goes to Washington City.* Durham: Duke University Press.
Butler, J. (2002). *Antigone's claim.* New York: Columbia University Press.

CBS Corporation. (2006). Calling all fans of *The L Word*. *CBS*, February 1. Retrieved May 25, 2014, from http://www.cbscorporation.com/news-article.php?id=240

Chin, B., Jones, B., McNutt, M., & Pebler, L. (2014). Veronica Mars Kickstarter and crowd funding. *Transformative Works and Cultures*, 15, 2.3, 2.8.

DeCerteau, M. (1984). *The practice of everyday life*. Berkeley: University of California Press.

DeLind, L. (1999). Close encounters with a CSA. *Agriculture and Human Values*, 16, 3–9.

—— (2002). Place, work, and civic agriculture. *Agriculture and Human Values*, 19, 217–224.

English, R. (2014). Rent-a-crowd? Crowdfunding academic research. *First Monday*, 19 (1).

Foucault, M. (1990 {1978}). *The history of sexuality Vol 1*. New York: Vintage Books.

Gill, R. & Pratt, A. (2008). In the social factory? *Theory Culture & Society*, 25 (7–8), 1–30.

Hannibal, B. (2014). Comments. Kickstarter, March 26. Retrieved May 20, 2014, from https://www.kickstarter.com/projects/1523379957/oculus-rift-step-into-the-game/comments?cursor=6303854#comment-6303853

Jenkins, H. (1992). *Textual poachers*. New York: Routledge.

Johnson, J. (2014). Oculus grift. ValleyWag, March 26. Retrieved May 15, 2014, from http://valleywag.gawker.com/oculus-grift-kickstarter-as-charity-for-venture-capita-1551921517

Kickstarter. (2014). Start your project. Kickstarter. Retrieved May 25, 2014, from https://www.kickstarter.com/learn

Lewis, L. (Ed.). (1992). *The adoring audience*. London: Routledge.

Luckerson, V. (2014). When crowdfunding goes corporate. *TimeBusiness*, March 26. Retrieved May 15, 2014, from http://time.com/39271/oculus-facebook-kickstarter-backlash

McIlvaine-Newsad, H., Merrett, C., Maakestad, W., & McLaughlin, P. (2008). Slow food lessons in the fast food Midwest. *Southern Rural Sociology*, 23 (1), 72–93.

McNally, D. (2012). *Monsters of the Market*. Chicago: Haymarket Books.

Mittell, J. (2013). Twitter, March 13. Retrieved May 28, 2014, from https://twitter.com/jmittell/status/311895125431304192

Murphy, D. (2013). Oculus raises $75M in funding to help "Rift" headset go retail. PCMagazine, December 15. Retrieved May 20, 2014, from http://www.pcmag.com/article2/0,2817,2428382,00.asp

Oculus. (2012). Oculus Rift: Step into the game. Kickstarter, August 1. Retrieved May 15, 2014, from https://www.kickstarter.com/projects/1523379957/oculus-rift-step-into-the-game

Oculus. (2013a). Update #42 announcing Oculus share (Beta). Kickstarter, September 9, August 19. Retrieved May 20, 2014, from https://www.kickstarter.com/projects/1523379957/oculus-rift-step-into-the-game/posts?page=3

Oculus. (2013b). Update #43 VR jam 2013 winners announced! Kickstarter, September 9, August 19. Retrieved May 20, 2014, from https://www.kickstarter.com/projects/1523379957/oculus-rift-step-into-the-game/posts?page=3

Oculus. (2014). Update #49 open sourcing the latency tester. Kickstarter, February 5. Retrieved May 15, 2014, from https://www.kickstarter.com/projects/1523379957/oculus-rift-step-into-the-game/post

Ortner, S. (2010). Access: Reflections on studying up in Hollywood. *Ethnography,* 11 (2), 211–333.

Schwartz, A. (2013). Crowdfunding securities. *Notre Dame Law Review,* 88(3), 1457–1490.

Securities and Exchange Commission. (2014a). Accredited investors. US Securities and Exchange Commission. Retrieved May 15, 2014, from https://www.sec.gov/answersaccred.htm

Securities and Exchange Commission. (2014b). Jumpstart our business startups act. US Securities and Exchange Commission. Retrieved May 15, 2014, from http://www.sec.gov/spotlight/jobs-act.shtml

Tate, R. (2014a). Kickstarter rockets into the mainstream after Facebook's $2B Oculus buy. Wired, March 27. Retrieved May 15, 2014, from http://www.wired.com/2014/03/oculus-a-boon-to-kickstarter/

Tate, R. (2014b). How you'll fund—and wildly profit from—the next Oculus Rift. Wired, April 4. Retrieved May 20, 2014, from http://www.wired.com/2014/04/how-to-profit-from-crowdfunding

Terranova, T. (2000). Free labor. *Social Text,* 63(18.2), 33–58.

Thomas, R. (2013). The *Veronica Mars* movie project. Kickstarter, March 13. Retrieved May 25, 2014, from https://www.kickstarter.com/projects/559914737/the-veronica-mars-movie-project

Warner, M. (2002). *Publics and counterpublics.* New York: Zone Books.

Zwick, D., Bonsu, S., & Darmody, A. (2008). Putting consumers to work. *Journal of Consumer Culture,* 8(2), 163–196.

4. On the Sale of Community in Crowdfunding: Questions of Power, Inclusion, and Value

DAVID GEHRING AND D. E. WITTKOWER

Introduction

In 2007 the crowdfunding website Kickstarter was launched. In April 2014 Kickstarter (2014a) reported having received $1 billion USD in donations toward projects started through the site. Kickstarter isn't alone. In recent years, numerous crowdfunding websites have popped up: Indiegogo, Pledge Music, GoFundMe, etc. Despite differences between each website, their general functions are similar: a person builds a campaign or project, promoting an idea that cannot be accomplished due to lack of funding with hopes of attracting willing donors. In exchange for donations, these donors are promised particular rewards or perks that are expected to be delivered if a pre-set financial goal is met.

Ideally, this model provides an opportunity for an aspiring creator to pursue a personal goal unhindered by constraints associated with third party players. It also gives the creator full autonomy and ownership of her product. For the consumer, or donor, it offers the experience of "getting in on the ground floor" – but in a strictly subjective manner. These donations are not investments, nor do they lead to partial ownership. While the donors do receive something for their money, (e.g. the product itself, public recognition of their involvement, personalised material objects, official titles associated with the process), perhaps the primary appeal in donating to these projects lies not the promise of any particular material return for their donation, but the feeling of participation in the creative process.

Indeed, in the "What Is Kickstarter" section of the website, the exchange is characterised by ideals of community, ownership, and democracy (Kickstarter, 2014b). These rhetorics, however, are not connected to any particular policies on structure or outcome, but depend instead on what is at best a "family resemblance" (Wittgenstein, 1953/2009) relation with the ideals rhetorically invoked, leaving artists free to choose whether and to what extent to back up the rhetoric with concrete forms of fan-funder[1] involvement.

A recent study (Mitra & Gilbert, 2014) suggests that rhetoric plays an integral goal in the success or failure of a project. Campaigns that exploit the idea of social identity, participation, and exclusivity have been found to be more successful than those that do not, and consultants are available (Gamerman, 2013) to help build a successful campaign. The choice to become a funder is sold as a relationship, and the relationship is sold as a symbiotic one in which the dreams of the artist are not possible without the financial assistance of the donor, and through which both parties are said to benefit. This symbiosis based on mutual perceived benefit has always been true of the producer-consumer relationship, and so to offer this basic element of the very idea of production under capitalism as a "selling point" seems little else but a new form of advertising unless the process of making interdependence of producers and consumers explicit in the pitch to the potential funder corresponds to some alteration in either product or process.

We can easily imagine fan-based funding structures that implement these ideals of inclusion in clear and robust ways. It is worth making them explicit, briefly, in order to emphasise Kickstarter's significant departures from these possible alternative structures. In what we might call "collective funding" rather than "crowdfunding," fan-funders could exercise creative control over the product, either by acting in the role of a producer, or by negotiating conditions for funding – promising a donation conditional on contractual obligation to, e.g., release an album at a certain price point, to produce software in an open source manner, to grant rights to remix or reuse either to funders or to the entire public, or to produce hardware in a manner wherein funders or the general public are granted rights to develop compatible software. Collective funding could be extended into collective creation, allowing funders to specify design parameters or objectives, or even to collaborate in creating content. A more stripped-down and purely economic version of collective funding could treat fan-funders either as investors, entitled to dividends on profits, or as shareholders, forming a board that would have to approve sale of the funded company or the intellectual property rights (IPR) to its product to corporations, and that would be able to require sharing in revenue generated by the sale of the funded company or IPR.

Given how distant crowdfunding is from these robustly inclusive models of collective funding, it seems a pressing question to ask in what, if any, meaningful sense crowdfunding reflects any kind of shift in power, control, voice, or dependence in favour of fan-funder communities. As things stand, given the structures in place, even the well-intentioned artist who upholds values of inclusion and creative fan-funder communities, and who has perhaps even been motivated to pursue crowdfunding for broadly political reasons, has a tough job ahead in working out how to implement these values within the new model. What now becomes of these ideals in an environment that is in the middle of a paradigm shift? What are artists who seek a robust relationship with a fan-funder base – not merely one of interdependence, which has always been the case, but one of involvement as well – obligated to offer to the fan in an environment of hyper-access? How do we conceptualise this community to which the fan-funder elects herself into by means of a financial donation via PayPal? How is value understood in relation to these terms?

On the Value of Crowdfunded Products

The most obvious alteration in process represented by crowdfunding relative to traditional capitalist production is that one exchanges money for the promise of a product not yet available for sale. In the place of an already existing product that the consumer can evaluate, the crowdfunding campaign puts forward nothing more than a singular idea or desire held by an individual to whom the consumer bears no relation except as mediated by the projected product. The primary effect of the time-shifting of manufacturing to be posterior rather than prior to the economic exchange from consumer to producer is then little more than the transfer of economic risk to the consumer – on the face of it, a rather poor deal for the consumer as compared to traditionally funded capitalist retail purchasing. Why then are fan-funders motivated to participate in the crowdfunding model, what role do rhetorics of inclusion play in fan-funder choice, and what is the nature and the extent of an actual "community" created in crowdfunding?

In many cases, fan-funders may be motivated only by a belief that the project or product will simply not be completed in the absence of crowdfunding. Here, typical forms of use and exchange values can account for the fan-funder motivation without any perception of "community" on the part of the fan-funder whatsoever: where the product will not reach the market in the absence of microdonations, the "funding for perks" model amounts to product presales. Rather than the publisher paying the creator on spec, or the creator simply creating the product on spec, the fan-funder buys the product

on spec in a time-shifted purchase. Inclusion and community in this case is irrelevant, and the risk and delay of purchasing a product yet to be made under the rubric of a perk for a donation is counterbalanced by the perceived inability of the consumer to purchase the product otherwise.

Community seems to play a more fundamental role in fan-funder choices to donate in cases where traditional funding is perceived to be available to the creator, cases where donations continue past the full funding of a project, cases where the monetary value of the donation significantly outstrips the use or exchange value of the perks on offer at that donation level, or cases where funding choices are based in perks having a primarily emotional or ideational value, such as souvenir artefacts or "behind the scenes" updates.

These cases must be accounted for in terms of symbolic value rather than use or exchange value – but symbolic of what? The cultural cachet of early adoption or insider access is well established outside of the crowdfunding model, as in the backstage pass or in having been a fan of something "before it was cool." No reference to democracy or symbiosis is necessary to create these symbolic values, although they may intensify these values through the creation of perceived intimacy and stronger connection with creators and products.

Even in the absence of not only actual but even symbolic kinds of inclusion and democracy in product design and development, there is still a robust at least symbolic community among consumers merely qua consumers. It is well established (e.g. Bourdieu, 1984/2010) that consumers often use communities of taste as marks of social distinction and difference, using products to perform significant identity-constructive roles both in self-identity and in our relations to others. This sort of "branded identity" (Castells, 2009) represents symbolic value for the fan even when purchasing mass-produced and mass-marketed goods, as we see clearly by the stock put in many by the essentially meaningless distinction between being a "Ford man" or a "Chevy man." In an age of narrowcasting and the long-tail, the distinction afforded by consumer choice is extended and diversified – again, even within the realm of the mere uninvolved consumption of goods produced through traditionally funded capitalist models. Crowdfunding offers a clear extension of distinction through branded identity, in at least two ways: (1) increased intimacy of involvement, and (2) increased consumer choice.

In the former case, the mere structure of crowdfunding produces several intimacies supporting the formation and performance of branded identity. Crowdfunding produces a more direct connection between fans and creators through the mere directness of economic exchange in the absence of a retailer. Crowdfunded projects also may lack a corporate intermediary, or may

often at least take place through smaller companies or startups, further creating a felt intimacy. The direct, virtually face-to-face appeal to fan-funders extends this further, as do rhetorics of symbiosis and the frequent provision of project e-mail updates as a perk at various funding levels. A last clear factor in creating felt intimacy is the pitch of products, both by crowdfunding sites and by individual products, in terms of creators' dreams and ideas, projecting the idea that funding is not an exchange for goods and services but a striving together toward a vision based in the creator's identity – an idea much more easily connected to fan-funder identity.

Since these perceived intimacies create community as a symbolic value available for purchase through broadcasting structures – videos, e-mail lists, talk of dreams and the creator's vision, which are basically non-interactive and one-directional – crowdfunding allows for the sale of perceived intimacy in a manner seamlessly scalable beyond any material basis of interdependence. In other words, the perception of initial funders that they are "playing a crucial role in helping an artist realise her vision on her own terms" contains little more symbolic value for the consumer than that provided to funders who contribute long after the project has been fully funded: broadcasted markers of intimacy create symbolic values supporting branded identity whether the project's funding goal has not yet been reached or was long ago exceeded.

In the latter case, crowdfunding extends consumer choice beyond the set of actually existing products into the realm of projected projects, which has the direct effect of increasing the number, range, diversity, and niche-focusing of available products for consumption. Forms of branded-identity that seek not popularity but uniqueness and exclusivity are well served by crowdfunding's ability to bring products to market that are merely profitable enough to be worth producers' while, and crowdfunding, like the rise of cottage industry through outlets like Etsy, offers mass distribution and one-stop shopping options for those who seek scarce and little-known products as such – a paradoxical mass production of the small-batch and obscure.

These symbolic values of community and participation may strike us as very insubstantial indeed. Consider Marcuse's discussion of (deceptive) liberty as domination from *One-Dimensional Man*:

> The range of choice open to the individual is not the decisive factor in determining the degree of human freedom, but *what* can be chosen and what *is* chosen by the individual…. Free election of masters does not abolish the masters or the slaves. Free choice among a wide variety of goods and series does not signify freedom if these goods and services sustain social controls over a life of toil and fear – that is if they sustain alienation. (1964/1968: 7–8)

While "a life of toil and fear" may sound a bit dire, the general point stands clearly enough: our ability to buy a range of not-yet-existent products in addition to the existent ones, and availability of increasingly niche products with increasingly more narrow-casted and intimate sales pitches in no way alters our status as consumers giving mere assent to one rather than some other product in which we have no creative role, design involvement, or active participation. Henry Ford (1922/2005) wrote that "[a]ny customer can have a car painted any colour that he wants so long as it is black." Consumer choice offers deceptive liberty in the claim that you may have any brand of car you like so long as you participate in middle-class ideals bound up with single-occupancy-vehicle – a (false) freedom to choose how to participate standing in for the (real) choice of *whether* to participate, which choice is *a priori* foreclosed upon. Crowdfunding extends the false choice further: you may fund any project you like, so long as you remain a mere consumer and undifferentiated member of a passive audience. The real choice of whether to be satisfied with being an object rather than an agent of production is still not on offer.

The symbolic value of identity provided here seems similarly insubstantial. Here, we might turn instead to Horkheimer and Adorno's claim that

> Sharp distinctions like those between A and B films, or between short stories published in magazines in different price segments, do not so much reflect real differences as assist in the classification, organization, and identification of consumers. Something is provided for everyone so that no one can escape; differences are hammered home and propagated. (2007: 96–97)

As the range and specificity of types increase in keeping with the movement from mass to niche production, it may well be said to still be the case that "something is provided for all so that none may escape." Crowdfunding offers a safety measure to the copyright industries, a pressure release valve whereby fan frustration at e.g. the cancellation of a beloved show may be released. Rather than becoming producers or owners in order to produce in accordance with their own vision and creative desires, the fan-funder becomes the content industry's sharecropper, contributing value in support of a resource over which she gains no control or ownership, supporting profits to which she gains no entitlement. Even if we take quite seriously the importance and meaning fans find in symbolic values of community and identity – something of which Adorno is entirely dismissive – it is still of significant note that crowdfunding seems more to extend than to challenge the dominance of the culture industry.

On the Value of Crowdfunding as Such

Having begun by differentiating crowdfunding from communal funding, and then having outlined an assessment of symbolic values presented to fan-funders by crowdfunded products, we can now turn to symbolic values presented to fan-funders by the process of crowdfunding itself. The fundamental claim we wish to make here is that, while consumable symbolic values presented by crowdfunded products are in continuity with previous forms of branded identity and distinction in taste communities, crowdfunding presents novel forms of symbolic value through its very form. What we consume as fan-funders is, in part, crowdfunding itself.

The "What Is Kickstarter" section of the Kickstarter page, a reductive bullet point list meant to capture the nuts and bolts of the model, emphasises the subjective qualities of this exchange, one that is described as "democratic" and "magical," and an inclusive process in which both the backer and creator are involved in creative ownership. Backing a project, it is claimed, is "more than just giving someone money…it's supporting their dream," and donations allow access into the "club of art supporting fanatics" (Kickstarter 2014b). In accordance with the guidelines of the model, these donations are not to be understood as investments, and the framing of this exchange makes no mention of surplus value, the recognition of which would undermine the ideological force of the model.

A primary symbolic value created by this rhetoric may be the sense of participation in the process, the appeal of being a part of something made more real or authentic by its location in such a free space of direct exchange, scalable consumer pricing, and airy ideals of artists' dreams and fan community. Horning (2011) offers insight on this process of value creation in his suggestion that a by-product of social media is the way in which it can alter the motivation of the consumer:

> They enhance the compensations of consumerism by making it seem more self-revelatory, less passively conformist, conserving the signifying power of our lifestyle gestures by broadcasting them to a larger audience and making them seem less ephemeral. They temper the anonymity and anomie that consumerism's mass markets tend to impose by concretely attaching our identity to what we consume. (n.p.)

As we noted above, a donation to any particular campaign serves as a way for an individual to perform identity through consumption and taste, bolstered by the active selection of a product characterised in terms of an idea or dream, heightening the feeling of self-expression in consumptive practices. Now, though, as we turn from considering the symbolic value of the product

itself to the user experience of participation in the campaign as such, we see additional forms of identification that extend beyond and do not have obvious parallels in identity functions of niche consumerism. The rhetoric of any particular campaign calls forth a sentiment that is a unique component of the model itself: the solicitation of the creator's personal ambition or ideal goal is made successful through a subjective identification with a consumer who is invited into, and included in, the process of creation, framed through the concept of mutual participation through an expression of crucial reliance upon the backers if the project is to "come to life."

The appeal for the backer is thus positioned in an ideational sphere in which consumption is veiled by the subjective aspects of the exchange. By nature of its subjectivity, the consumption of idealised symbolic value remains insulated and intact despite the otherwise crude and objective characteristic of simply sending money to the creator. Thus, the ideology of crowdfunding obscures its economic basis with a spectacle of involvement by deploying a culture of the arts in which money translates into self-expression.

The anti-corporate and even broadly anti-establishment ethos of a decentralised productive model also draws from an ethical framework intimately associated with the arts – in particular, this framework is closely related to the underground movements in music through the '80s and into the '90s. The ethic of 'D.I.Y.' creation emphasises independence and authentic creative expressions, contextualised by the domineering monolith of corporate sponsorship and major record labels. Today, such entities are waning in the face of the increased prevalence of digital technologies and new media, but this has not diminished the symbolic force of outsider and grassroots status, and crowdfunding allows for the consumption of this ethos as a symbolic good, even when it is attached to corporatist production, as in the emblematic case of *Veronica Mars*. The image of the "garage band" draws upon deep cultural commitments, and the threat to the consumer's construction of identity through expressions of taste continues to be threatened by the "selling out" and "going mainstream" of consumer-valorised artists. The rhetoric employed on the Kickstarter website reflects the same mores that have been central to underground movements through its discussion of ownership and control (Kickstarter, 2014b). Indiegogo similarly encourages donors to "fund what matters to you" (Indiegogo, 2014), reflecting the sense of empowerment the consumer receives through contributing.

These cultural commitments were evident in the existence of functioning social networks consisting of and dependent upon both fans and artists, which operated within their own framework of unwritten rules. These networks, initially consisting only of regional pockets of marginalised and

determined teenagers, evolved from small communities into a substantial creative and marketable force, interconnected yet still regionally identified. By the late '90s, these communities, or "scenes," were co-opted by larger corporate entities and major record labels. This was apparent, for example, in the market appropriation of the so-called "grunge" movement. The end result was the commodification of an organic cultural and ethical framework, which was defined and sustained through solidarity between the artists and fans in the spirit of free and purely motivated creative expression unified against the mainstream music and practice.

Adorno (2007: 99) states that "the entire practice of culture industry transfers the profit motive naked onto cultural forms." This succinctly explains a general practice in the monetisation and funding of the arts, but it should be drawn out in relation to our specific interest. By the time Kickstarter emerged in 2007, the music industry was already in the midst of a paradigm shift. Emerging technologies and new media presented new problems of monetisation for longstanding leaders of the industry. The increased access to content through peer-to-peer sharing, and the increased ability to contribute content (YouTube, Logic, Garageband), made it increasingly difficult to charge consumers for products that were only accessible via mainstream retail outlets. In addition, the stigma surrounding these major corporate entities regarding their treatment of art, the artist, and the music fan, was increasing, though it surely was not new. Since the cultural valorisation of artistic creation and consumption had long taken place in the ethereal realm of expression, identity, and genius – to each of which the material conditions of mechanical production, distribution, and sales had always been merely contingent and external necessary conditions – when new channels of access opened up, many fans immediately took advantage of market-unintegrated modes of consumption. Ideally, communication and exchange could now happen directly without the need of mediation by a third party. Following the trend, the artists themselves began appropriating these new technologies and accessing fans directly, leaving the corporate entities to reluctantly follow by attempting to find successful ways to control and monetise content. To be sure, the cultural and ethical framework that developed naturally within regional music scenes throughout the U.S. in the '80s and '90s was appropriated with a degree of success (through clever marketing and acquisition), although it was never completely free of its crude transparency. The accusation of "sell out" was hurled about frequently. This tension that exists among "authentic" artists and so-called "sell outs" is a symptom of the structure identified by Adorno. The industrial production associated with major labels and corporations began to appropriate the artist culture once it recognised its

economic potential. Kickstarter offers a way for the artist to circumvent the major label apparatus and communicate with, and depend on, the fan directly, thus facilitating a new mode of exchange. Still, this exchange is guided by a strong ethical implication that underscores the process. The employment of appeals to community and the inclusion of biographical narration in campaigns reflects an intentional emphasis on the pathos and ethos of creators. If this unwritten code is perceived to be violated in either model, it often breeds resentment, and this resentment indicates that the value the fan-funder receives in participation originates not only with the product, but with the mode of production itself.

This focused analysis of Kickstarter cannot be fully understood in isolation from these material conditions that emerged out of the developments of web 2.0, although elements of consumers' engagement with symbolic value certainly predate these conditions. As Baudrillard argued in *The Consumer Society*,

> The content of the messages, the signifieds of the signs are largely immaterial. We are not engaged in them, and the media do not involve us in the world, but offer for our consumption signs as signs, albeit signs accredited with the guarantee of the real. It is here that we can define *the praxis of consumption*. The consumer's relation to the real world, to politics, to history, to culture, is not a relation of interest, investment or committed responsibility – nor is it one of total indifference: it is a relation of **curiosity**. (1970: 34, original emphasis)

Here Baudrillard identifies the general mechanisms that undergird the crowd-funding process, which reposition consumption in a way that caters more specifically to those who engage in symbolic exchange. Despite the rhetoric employed in campaigns, it often happens that the fan-funder is only engaged to the extent that she or he offers financial backing. Indeed, any discourse between creator and donor regarding the creative process does not occur. In as much as these campaigns seek funds for an idea that has yet to be actualised, all rhetoric employed necessarily refers to the immaterial. Thus, the relationship of the consumer to the creator and the proposed idea is more akin to a curiosity than an interest in that the involvement of the consumer only extends so far as, and is defined by the amount, one is willing to donate. That interest is satisfied according to the will, and at the whim, of the creator. There is no reference against which to evaluate claims made by the donor. The exchange turns on an absence of material value in that the material product does not yet exist. That absence is accounted for with the symbolic value expressed in the rhetoric of the campaign.

The conceptual reduction of fan-funder interest to a relation of curiosity is paralleled by a legal and economic structure that shifts liability and speculation definitively from the producer to the consumer. In the midst of paradigm

shift in content industries brought on by new media, which simultaneously opens up opportunities for new ways of thinking and necessitates adaptation by those individuals and institutions dependent upon funding and monetisation, a space is created in which all prior foundations are now being re-imagined and new ideas are being conceived – and yet even in models like crowdfunding, which seem to be on the side of distributed control and fan empowerment, the new structures in place function in a manner that leaves fan-funders as excluded as ever.

There is much potential for the artist to reclaim control of the ways that her product can be funded and offered up to the public; ways that can avoid any intrusion by a third party that would hinder the process. Indeed, Kickstarter has emerged as a mechanism that offers the artist an increased degree, and new kind, of autonomy over both creative direction and appropriation of garnered funds. The positive value of artistic autonomy – a primary symbolic value offered for sale to the fan-funder by the very model of crowdfunding – not only entails but is actually identical to a lack of control, ownership, agency, and involvement of not only corporate but fan-funders as well. The very disempowerment of the consumer becomes itself an attractive good on offer in crowdfunding, and consumers have been glad to purchase it.

The model functions on the basis of the expression of an ideal that is both liberalist and consumer empowering. The amount of funding any particular project receives is based on the strength of the idea and the ethos and pathos behind it, and the whole process is indeed one characterised by autonomy, both for the creator and for the backer. It is this general front, and its storied successes, which shields the process from any thorough scrutiny. Much of the press coverage garnered by Kickstarter and its peers focuses on the immunity secured as a result of the model's transparency between donor and creator. But what must be emphasised is that fan-funder autonomy consists solely in the choice of whether and how much to pay, within terms set out unilaterally by the creator, with all other aspects of autonomy reserved only for the creator.

Because a predominant character of this model is ideational, any potential breach of this implied ethic or exchange (either in the form of a particular campaign itself, or in the undelivered "awards" promised by the creator) can remain largely overlooked since the economy of the exchange is not framed as the prime motivator for either fan-funder or creator. Indeed, while there have been particularly notorious cases where creators have violated the understood terms of the campaign, legal recourse remains difficult (Gera, 2012). The long-term effects of these transgressions are difficult to evaluate. As of yet, the crowdfunding model remains not only intact, but, in fact, in June 2014, Kickstarter loosened its restrictions for project acceptance (Etherington, 2014).

A key component in the success of the crowdfunding model is that these conflicts between fan-funder empowerment and creator autonomy go unappreciated, but as controversial campaigns and troubling incidents accumulate, the radical disconnect between the symbolic values of community and the actual political-economic power structures in place becomes increasingly clear.

In 2013 Kickstarter was used to raise money for a book that included "offensive" content. The project came under public scrutiny and Kickstarter was compelled to post a response in order to address their role in this project. Despite the actions taken by the website, the individual who started the campaign, which was overfunded by 800%, was able to keep the money raised. Addressing comments questioning why Kickstarter did not pull the campaign down upon hearing about the campaign, Kickstarter (2013) responded, "our processes, and everyday thinking, bias heavily toward creators."

In other problematic cases, the product is simply not delivered, as for example the platformer video game, *Super Action Squad*, on hold two years after being funded at 535% of their goal, due to the team of programmers having found developing a game more difficult than expected (Schreier, 2014). More dramatically, there is John Cambell's decision to burn completed and printed books produced in a 645% funded Kickstarter campaign, explaining in part (quoted in Moss, 2014) that "I will not be responsible for the manufacture of any more unnecessary physical objects," and offering to fan-funders these unilateral terms: "I shipped about 75% of Kickstarter rewards to backers. I will not be shipping any more. I will not be issuing any refunds. For every message I receive about this book through e-mail, social media or any other means, I will burn another book."

In yet other cases, crowdfunding seems to function as a kind of zero-cost research and development resource for corporations, which are able to remain uninvolved as risk and uncertainty is borne by fan-funders and creators, then cherry-picking successful products for integration into traditional capitalist production models by established industry leaders. For example, in the TidyTilt/Logitech case we see the re-injection of a crowdfunded product back into major retail outlets through large distributors, produced by an established major company in the field, which then accrue surplus value on the backs of initial funders (Gara, 2013). Large studios are also using the model, which simply transfers the cost of production onto fans, as in the much-discussed Zach Braff and *Veronica Mars* cases (G.F., 2013; Sherman, 2013).

The case of Oculus Rift provides a robust example of these dynamics, and one that exemplifies with particular clarity the sense in which the crowdfunding model is itself a product for sale in each particular campaign – but a product that is both deceptive and defective. Following a highly successful Kickstarter

campaign, the Oculus Rift company was sold to Facebook for 2 billion USD. As numerous commentators have pointed out (e.g. Leonard, 2014), while many funders were upset that they had contributed value to a large corporation while they were trying to support the dreams of indie developers, a significant additional concern had to do with the fan-funder's eventual user experience of the product, not with political-economic anti-oligopolist ideals or even the symbolic value of supporting DIY culture. Funders imagine how the device will be implemented by Facebook and despair. They imagine it being tied to Facebook's walled gardens, and the software allowed to work with it crippled, monetised, and ridden with advertisements and obligations to be subject to Facebook's massive data collection business model. Here we see a great many values placed on offer through the rhetoric of Kickstarter: (1) the use value of the object itself, constructed through the indie-developer ideals of the project developers, implying which and what kind of software would be available for use through the device; (2) the exchange value of the project, projected to be higher through indie development than through the economies of scale that Facebook will be able to bring, and in the absence of Facebook's interest to sell it with a thin profit margin in order to further integrate users into the Facebook network; (3) and the symbolic value of representing, supporting, and emerging from a grass-roots, user-centred, open-source based and remix/programmer-friendly, anti-corporatist community of common concern. Each of these values is strongly implied by the Oculus Rift campaign as well as innumerable other similar campaigns, each can be expected to be strongly motivating to fan-funders, and all are unsupported by any actually existing structure in crowdfunding.

The ideational force of crowdfunding obscures the problems that can and have taken place and the systematic manner in which its structures range against the very ideals that fuel its success. While crowdfunding's exchange is similar to the more traditional mode (money for material goods with use value, exchange value, or symbolic value), the salient differences reside in the absence of a finished product in the moment of expenditure, the particular mode of solicitation that it necessitates, and the contingencies that frame the model and the dynamic between creator and donor. These three aspects inform the exchange and provide a space of immunity for the creator against which the donor is left with little recourse in the event that the creator takes advantage of the good will of the donors. Crowdfunding, located in the hazy intersection of artist autonomy, economic potential, and the participatory functions of web 2.0, relies upon the offer of symbolic and experiential values that direct scrutiny away from the artist's utilisation of the autonomy provided by the model. If the larger goal of Kickstarter or Indiegogo is to encourage a new standard of both artist-fan relations, and means of funding artistic

projects without disruption from third party financiers, then the artist cannot take advantage of the donors through ideational rhetoric and vague promises.

Note

1. In order to make our case about the inadequacy of the community created through crowdfunding to crowdfunding's own stated ideals, we focus on the paradigm case where the funder is also a fan of either the creator or the project. We seek to focus on this case, since this is the case where the sense of community emergent from the crowdfunding relationship ought to be strongest, and the symbolic value of membership within that community most valuable to the funder. We do not, however, mean to assert that there are not other kinds of cases, including but not limited to funders who are friends and family of those running a campaign, and have no interest in the campaign per se, or funders who may support a campaign that they find simply amusing or silly. Since our purpose here is to assess the value and function of ideational community, we take the backer, supporter, or donor paradigmatically as a "fan-funder," with these other possibilities treated as deviations from this archetype.

References

Adorno, T. (2007). On the fetish character in music and the regression of listening. In J. Bernstein (Ed.), *The culture industry: Selected essays on mass culture*, pp. 26–60. New York: Routledge.

Baudrillard, J. (1970). *The consumer society: Myths and structures*. London: Sage.

Bourdieu, P. (1984/2010). *Distinction: A social critique of the judgment of taste*. New York: Routledge.

Castells, M. (2009). *Communication power*. New York: Oxford University Press.

Etherington, D. (2014). Kickstarter simplifies its rules and lowers the barrier for project acceptance. *Techcrunch.com*, 3 June 2014. Retrieved July 3, 2014, from http://www.polygon.com/gaming/2012/6/27/3099051/backers-rights-what-kickstarter-funders-can-expect-when-they-pledge

Ford, H. (1922/2005). *My life and work*. Project Gutenberg. Retrieved April 9, 2014, from http://www.gutenberg.org/cache/epub/7213/pg7213.html

G.F. (2013). Is it unfair for famous people to use Kickstarter?, *The Economist*, 14 May 2013. Retrieved April 9, 2014, from http://www.economist.com/blogs/economist-explains/2013/05/economist-explains-unfair-fair-famous-people-kickstarter

Gamerman, E. (2013). Here come the crowdfunding consultants. *The Wall Street Journal*, 20 June 2013. Retrieved April 9, 2014, from http://online.wsj.com/news/articles/SB10001424127887324021104578553360922002422

Gara, T. (2013). How a Kickstarter project became a corporate takeover target. *The Wall Street Journal*, 6 June 2013. Retrieved April 9, 2014, from http://blogs.wsj.com/corporate-intelligence/2013/06/06/from-kickstarter-to-takeover-logitech-buys-an-upstart-design-shop/

Gera, E. (2012). Why Kickstarter "can't" and won't protect backers once a projects is funded. *Polygon.com*, 27 June 2012. Retrieved July 3, 2014, from http://www.

polygon.com/gaming/2012/6/27/3099051/backers-rights-what-kickstarter-funders-can-expect-when-they-pledge

Horkheimer, M. & Adorno, T. (1944/2007). *Dialectic of enlightenment*. E. Jephcott (trans.). Stanford, CA: Stanford University Press.

Horning, R. (2011). Social media, social factory. *The New Inquiry*, 29 July 2011. Retrieved April 9, 2014, from http://thenewinquiry.com/essays/social-media-social-factory/

Indiegogo. (2014). Indiegogo. *Indiegogo.com*. Retrieved April 9, 2014, from https://www.indiegogo.com/

Kickstarter. (2013). We were wrong. *Kickstarter.com*. Retrieved April 9, 2014, from https://www.kickstarter.com/blog/we-were-wrong

Kickstarter. (2014a) Kickstarter stats. *Kickstarter.com*. Retrieved April 9, 2014, from https://www.kickstarter.com/help/stats

Kickstarter. (2014b) Seven things to know about Kickstarter. *Kickstarter.com*. Retrieved April 9, 2014, from https://www.kickstarter.com/hello

Leonard, A. (2014). Facebook just crushed the Internet's geekiest dream – and now there's hell to pay. *Salon.com*, 26 March 2014. Retrieved April 9, 2014, from http://www.salon.com/2014/03/26/betrayed_by_oculus_rift/

Marcuse, H. (1964/1968). *One-dimensional man*. Boston: Beacon Press.

Mitra, T. & Gilbert, E. (2014). The language that gets people to give: Phrases that predict success on Kickstarter. *17ᵗʰ ACM Conference on Computer Supported Cooperative Work and Social Computing (CSCW 2014)*. Retrieved April 9, 2014, from http://comp.social.gatech.edu/papers/cscw14.crowdfunding.mitra.pdf

Moss, C. (2014). Man raises over $50,000 on Kickstarter to publish books – Instead burns every copy in a dumpster. *Business Insider*, 9 March 2014. Retrieved April 9, 2014, from <http://www.businessinsider.com/john-campbell-kickstarter-campaign-2014-3

Schreier, J. (2014). "Kickstarter game "on hold" two years after raising $53,000." *Kotaku.com*, 18 March 2014. Retrieved April 11, 2014, from http://kotaku.com/kick starter-game-on-hold-two-years-after-raising-53-1546409876

Sherman, E. (2013). Veronica Mars, or how big business discovered Kickstarter. *Inc.com*, 19 March 2014. Retrieved April 9, 2014, from http://www.inc.com/erik-sherman/veronica-mars-how-big-business-discovered-kickstarter.html

Wittgenstein, L. (1953/2009). *Philosophical investigations*. Boston: Blackwell.

Section Two:
Social and Civic Crowdfunding

5. *Four Civic Roles for Crowdfunding*

RODRIGO DAVIES

Introduction

Crowdfunding, the raising of capital from a large and diverse pool of donors via online platforms, has grown exponentially in the past five years, spurred by the rise of well-known services such as Kickstarter and Indiegogo. While media coverage has focused on its use in creative industries, and legislative attention in the U.S. has turned to the use of crowdfunding as a means of raising capital for companies, less attention has been paid to the use of crowdfunding for civic projects – projects that involve the creation of community assets. A civic crowdfunding project can be defined as one that develops a shared resource that is accessible to the community either as a public asset, a community-owned resource or a public-private partnership, and may or may not involve government.

The nascent field of civic crowdfunding is emerging both on platforms that were designed for more generic uses and on platforms that have been set up specifically with civic projects in mind. Studies of crowdfunding to date, though, reflect a bias toward commercial projects that is not well adapted to civic crowdfunding: existing typologies focus on the identity or role of the individual funder in the process and donors are framed as fans or consumers. Platforms and projects are analysed according to their financial structure, differentiating pledging, lending, and investing models. These models do not account fully for notions of civic identity, complexities of community-government relations, or the historical context of participatory planning and community-led development on which civic crowdfunding builds.

This chapter proposes an alternative typology for civic crowdfunding that considers four "civic roles" that these projects could play: 1. a means of community agency, allowing groups of individuals to create new services and solve local problems; 2. a signaling device to government, demonstrating

need and demand for investment; 3. an expansion of the public-private partnership model to include crowdfunding-enabled groups; and 4. an alternative infrastructure created in response to reductions in public investment. In doing so, it contextualises civic crowdfunding within the history of community fundraising and traces its roots in the United States to Joseph Pulitzer's 1885 Statue of Liberty platform campaign. The research is based on a series of case studies in the U.S. and the UK and draws on interviews with crowdfunding platform owners, project organisers, elected officials, urban planners and individual donors, site visits, donation records, and archival research.

Research Methods

This chapter is based on a dataset of 1,224 crowdfunding projects that were active between 2010 and 2013. The dataset was originally assembled by Davies (2014), using web scraping scripts written in the Python programming language. Projects were collected from the seven largest platforms that either use the term "civic crowdfunding" to describe their activities, or contain a significant number of projects that provide services to communities: Catarse, Citizinvestor, Goteo, ioby, Kickstarter, Neighbor.ly, and Spacehive. Within this dataset, a discourse analysis of 274 projects on ioby, Neighbor.ly, Citizinvestor, and Spacehive was conducted on December 5 and 6, 2013, in which each project was tagged for prominent themes in the texts. The coding process was repeated one day later, for consistency. The four most common themes were used as the basis for the four civic roles proposed in this paper. The case studies chosen to demonstrate each role were the projects in which these themes were most clearly articulated in the discourse itself. Only primary campaign materials, such as campaign pages and social media posts, were considered as part of the analysis, since these texts could be reasonably assumed to have been accessed by the largest number of potential backers.

Twelve interviews with platform owners and campaign promoters were conducted by telephone and in person between June 2013 and April 2014. In person interviews were conducted in London, New York, and Kansas City, Missouri. Additional comments from platform owners were collected from published videos and media appearances, as indicated. Archival study of Pulitzer's campaign with *The World* was conducted at the Columbia University Rare Books Archive and the New York Public Library in March and April 2014, using a combination of microfiche and original documents.

The History and Contemporary Shape of Civic Crowdfunding

Communities have long organised and collaborated to raise funding for public goods and services. This type of activity was especially common in the U.S. and the UK in the eighteenth and nineteenth centuries. The UK Public Parks Movement brought together investments by town councils and corporations with donations from individuals, gathered through "public subscriptions" – open calls to donate funds to buy the land on which the park would be created. Manchester's Peel Park, Phillips Park, and Queen's Park, often cited as being among the oldest public parks in the world, were created in this way and opened on the same day, 22nd August, 1846 (Jordan, 1994). In 1750, Benjamin Franklin created the first public matching fund when he secured an agreement from the Philadelphia legislature to use public funds to match $2,000 donated by individuals for the building of Pennsylvania Hospital (Larson, 1986). The practice has since become common in modern philanthropy and is often used in civic crowdfunding campaigns.

Joseph Pulitzer's 1885 campaign to fund the pedestal on which the Statue of Liberty stands is in many ways a prototype of a quintessential crowdfunding campaign: an initiative that uses a single collection point to raise money from a very large pool of donors pledging amounts from pocket change upwards, to produce a public good (Davies, 2013). If crowdfunding platforms had existed in Pulitzer's time, he would today remain one of their most successful users. In his case, the platform used was the *New York World* newspaper, of which he was proprietor. Pulitzer started the campaign after the so-called "American Committee" that was appointed to manage the statue was unable to raise sufficient funds to pay for the pedestal. The Bartholdi statue, funded and completed in France at the expense of the French government, was marooned in Paris because of the funding gap and faced an uncertain future (Harris, 1985). Pulitzer's campaign was a triumphant rescue effort. Over a period of five months the newspaper raised $100,000 (approximately $2.3 million at today's prices) from more than 160,000 donors, ranging from children to elite businessmen.

The subgenre that we now understand as civic crowdfunding is the "platformisation" of this organised fundraising activity, and for most organisations, the creation of a for-profit business model that supports it. This chapter considers the donation/reward model of crowdfunding, in which campaign donors (backers) receive in-kind rewards, but no financial stake or other form of reward. The platforms in the U.S. and the UK that have supplied the largest number of reward-based civic crowdfunding projects are Kickstarter, Indiegogo, ioby, Spacehive, Neighbor.ly, and Citizinvestor. ioby is the only

non-profit organisation in the group. As in other genres of crowdfunding, the typical organisational model for civic projects is that platforms charge campaigns a fee of between three and five percent in exchange for providing a project page on which creators can publish their own content and facilitate the acceptance of donations via debit authorisations (backers' funds are only debited when the campaign closes). Project owners are charged an additional fee for payment processing (usually levied by a third party such as Amazon Payments, Authorize.net, or PayPal). On Kickstarter, a project must meet 100 % of its funding target in order for funds to be released – a classic "all or nothing" provision-point mechanism – but the other platforms allow partially-successful campaigns to receive the funds committed.

What sets civic crowdfunding apart from its historical precedents is the speed, scale, and portability that this model offers – it has the potential to reduce the cost and time required to build cooperation between governments, the community, and the private sector to produce public goods. Meanwhile, what distinguishes civic crowdfunding from other applications of the method is that interventions in public or quasi-public space necessarily impact incumbent institutions, in a way that a one-off creative project such as a documentary film likely does not. Almost every civic crowdfunding project raises an array of questions around the relationship between individuals and communities and the institutions that seek to serve and represent them. It is for these reasons that it is worth considering the emerging civic roles that civic crowdfunding is playing or seeks to play, and the potential political and social implications of it doing so. I will now discuss the four potential roles outlined above.

Civic Crowdfunding as Community Agency

In cases where crowdfunding campaign organisers are in a position to realise projects without requiring the consent of external institutions – for instance, building a community garden on a land that the organiser owns – crowdfunding can function as a direct expression of community will and agency.[1] This mode of action and type of project is common in contemporary civic crowdfunding and has deep foundations in community-based collective action and resource pooling. In this form, the purpose of the crowdfunding process is therefore to enable a community to accumulate social and economic capital and to direct its collective agency. The agency that civic crowdfunding imparts does have important limitations, as it does not offer collective ownership and is usually a collaboration built on unequal agencies, as will be discussed below. Nevertheless, it can be regarded as one of the dominant modes of action in the field.

The small-scale community garden project, led by a locally-based non-profit organisation, is one of the most common types of civic crowdfunding projects that has emerged in the past three years (Goodspeed & Davies, 2014). A typical example in terms of scale and type of activity is Philadelphia's Mill Creek Urban Farm, a project on ioby that raised $2,039 from 45 donors in March 2012 to fund a farm stand and training programmes in an underserved neighbourhood of the city (ioby, 2012). The group behind the campaign, A Little Taste of Everything, was started in 2005 to supply food to underserved communities in Philadelphia. The project states its locally-oriented social justice goals very clearly in its campaign materials:

> Our neighborhood farm stands provide fresh, organically-grown produce to an under-served community that has otherwise limited access to healthy food. Local residents can buy the food at affordable, below-market prices, and we are also the only stand in the area that accepts Farmers' Market Nutrition coupons and Supplemental Nutrition Assistance Program (SNAP) benefits. (ioby, 2012)

Furthermore, the group says its vision is that "local communities work together to build an environmentally and economically sustainable urban food system." Supporting its aspirations to community cooperation and resource generation, the organisation has a strong record of delivering on its mission to create a community movement: in 2012 the farm sold $6,000 worth of fresh produce to 665 customers, and worked with 600 volunteers who gave a total of 2,000 hours of labour to the organisation. The idea that community agency is produced through a combination of economic and human resources is central to ioby's approach, which invites users to donate their time rather than money. The platform describes itself as a "crowdresourcing" platform in order to emphasise non-monetary contributions, and states: "ioby is more than a funding platform. We call ioby crowd-resourcing because we want you to get all the resources you need for a successful project" (ioby, 2013).

The idea of community resource-pooling to produce public goods, while often underrated, is well established. Ostrom argues that it is important to encourage this type of activity – which she terms "public entrepreneurship" – in order to improve the level and range of public services that are available to communities, since the market often has misaligned incentives and the government lacks adequate resources to produce these services. Moreover, she notes that studies have "repeatedly found communities of individuals in urban and rural areas who have self-organized to provide and co-produce surprisingly good local services given the constraints that they face" (Ostrom, 2005). Jacobs' famous account of community action in the Back of the Yards area of Chicago explains how residents were able to rehabilitate 5,000 houses

in the 1950s using the skills within the community, such as construction and plumbing. The community had previously created its own council to coordinate its interests, and acted to organise in the face of indifference from both government and private-sector lenders. Jacobs argues that "in effect, the Back-of-the-Yards already operates as an administrative district, not formally or theoretically, but in fact…which usually depends wholly on internal cross-use for its foundation" (Jacobs, 1992). If civic crowdfunding project assets are managed by the community, the projects may be seen as analogous to worker-owned co-operatives and credit unions, examples of what Alperovitz terms "wealth-democratizing, institution-building trends" that are shifting the organisation of capital away from corporations and toward individuals and communities (Alperovitz, 2013).

However, in most cases civic crowdfunding produces a type of community agency that is limited by three factors: the presence of differential agencies, the lack of collective asset ownership, and reliance on a third-party platform. While these limitations are to some extent inherent in crowdfunding, they may change over time as new models or adaptations of civic crowdfunding emerge. Firstly differential agencies seem inherent in crowdfunding because it requires that participants have real dollars to "vote" with. The presence of real money introduces the possibility that an individual with more resources is able to increase their influence over the process and undermines the idea that crowdfunding is an egalitarian form of preference expression. Second, it is currently very rare that civic crowdfunding projects produce an asset that is collectively owned and managed. Project owners cannot offer direct ownership or shareholding in the assets being produced to backers of the campaign, since this would constitute "equity crowdfunding" and necessitate compliance with regulations established by a national financial authority.[2] Backers are therefore contributing to projects that produce shared assets from which they benefit but over which they have no specific ownership. Their behaviours could be said to reflect a desire to participate collectively, solve problems, and produce common resources rather than to fund or to own assets. Third, community organisations may operate and collect funds, but they typically do so through a third-party platform, to whom they pay a fee that dilutes the overall amount raised. It is likely that in the future, some communities may seek more comprehensive ownership of the crowdfunding process, to assert their control over outcomes and avoid paying fees to third parties. An early example of this organisational model is ChangeFunder, a donation-based crowdfunding platform created by the Portland, Oregon-based non-profit Springboard Innovation to support local businesses in the state. The platform's first project seeks $58,000 to help restore a seventy-year-old tavern

in the rural town of Lostine (Curry, 2014). Community-operated platforms remain relatively uncommon, however, likely because few local organisations have sufficient excess capacity and resources to manage a crowdfunding platform of their own.

Civic Crowdfunding as a Signaling Device

The notion that civic crowdfunding can act as a signaling device to government is rooted in the idea that crowdfunding is as much an indication of demand as it is a vehicle for substantive action. For a project to be a signal rather than an action in itself likely means that the campaign does not expect to raise the full project cost via crowdfunding and is seeking outside (public or private investment), or requires government approval in order to proceed. In the same way that many crowdfunding projects on platforms such as Kickstarter and Crowdtilt rely on a provision point mechanism to distribute funds – in other words, projects need to reach an agreed target in order to receive the financing pledged by the crowd – from a macro perspective, the raising of a symbolic amount of capital by a civic crowdfunding project could be seen as activating a political provision point.[3] The strength of crowdfunding as a signal is therefore strongest in projects that seem unlikely to have been realised without the presence of crowd-organised demand. These cases support the argument made by Chris Gourlay, founder of Spacehive, that crowdfunding is "creating a way for communities to get projects off the ground that wouldn't have otherwise happened" (Spacehive, 2013a).

The impact of crowdfunding as a producer of otherwise unlikely outcomes is most obvious in civic projects that seek to raise a small portion of the finance required to fund a major new infrastructure project. In Kansas City, Missouri, the non-profit organisation BikeWalkKC used Neighbor.ly in October 2012 to raise $419,298 for a pilot of a bikesharing scheme for the city, enough to fund ten stations and operating costs for approximately three years. The majority of the funding came from a corporate donor, BlueCross Blue Shield, but since the group's long-term goal was to secure public funding for the scheme's expansion and operation, BikeWalkKC saw crowdfunding as a mechanism to demonstrate public support for the idea (Davies, 2014). The city council had already passed a resolution supporting a public-private partnership to deliver the scheme "with little or no cost to the city" and agreed to waive permitting fees, but the future of the scheme was unclear (Marcason et al., 2012). Kansas City has also long been a challenging city for bicycle advocacy groups: the city was placed last out of 50 cities in a study of biking accessibility by the Census Bureau in

2007 (U.S. Census Bureau, 2007). The crowdfunding campaign had mixed results – it attracted 28 backers, 7 of whom where institutions – but it became a high visibility project both for Neighbor.ly and the civic crowdfunding movement. The bikeshare scheme attracted 1,200 riders in its first year. Its visibility was such that BikeWalkKC was able to lobby successfully for federal funding for the expansion of the bikeshare scheme, from the Federal Highways Administration (Bike Share KC, n.d.). In 2014 this funding, alongside donations from the Kaufman Foundation and the Nelson-Atkins Museum, was used as seed funding for a series of crowdfunding campaigns spread across ten zones of the city, this time seeking a total of $1,000,000 – the largest campaign ever launched on a civic crowdfunding platform (Scola, 2014). That campaign is ongoing, and while BikeWalkKC has not yet secured municipal funds for the bikeshare scheme, it continues to lobby elected officials for that investment.

Crowdfunding may also signal the need, and advocate for, non-monetary government cooperation in the process. Early research suggests that around one in ten projects on civic crowdfunding platforms explicitly describe forming a partnership with a government agency for investment, permitting, or development purposes (Davies, 2014). A group of New York–based designers are currently engaged in one of the most audacious campaigns of this kind: to create Plus Pool, a floating swimmable pool in New York's East River. While the ultimate construction project is likely to cost as much as $15 million dollars, the group began the process of advocating for its construction with a $25,000 campaign on Kickstarter in June 2011, the proceeds of which they proposed to spend on tests of the filtration materials necessary to make the water in the pool safe for swimming. The first campaign raised $41,647 from 1,203 backers (Plus Pool, 2011). Two years later the group returned, seeking $250,000 to build a 35'x35' version of the pool to test the engineering technology the group had developed with a team of architects and engineers. The second campaign raised $273,114 from 3,175 backers (Plus Pool, 2013). The Plus Pool team is around six months behind its original schedule, but aims to have the pool completed by 2016. Dong Ping Wong, one of the creators of the project, says their intention is to fund the complete cost of the pool by selling 140,000 ceramic tiles around the pool, each named for a backer, at $199 each. But financing alone is not enough to realise the project: it also requires city approval and permitting that could run into hundreds of thousands of dollars. Wong says the group hoped that the ambitiousness of the scheme would be "huge red light for the city to pay attention" (Wong, 2013). The project does not yet have official public approval, although Wong says the crowdfunding campaign has enabled the group to win the tacit

support of government to continue the process. Their intention is that that cooperation can be formalised later in the development.

> It's a bureaucratic issue rather than a depth of budget issue. It's difficult for any official or the city as a whole to choose a specific project. Doing something risky or new is hard...We'd like to have a combination of crowdfunding and for the city have a bit of skin in the game. That it becomes a city project and it's not purely private. (Wong, 2013)

Civic Crowdfunding as an Extension of Public-Private Partnership Models

The strategy of bringing together public and private funding to provide services to communities long predates crowdfunding, and in this way crowdfunding can be seen as a natural extension of the public-private model – an extension that diversifies the potential range of private partners that can act alongside government. This is shown by the emergence of civic crowdfunding campaigns that build directly on existing public-private partnership structures. These projects do not seek to remake or reform those structures, but rather to add crowdfunding to the toolkit of financing mechanisms that can be used by potential partners to government.

PPP schemes that provide for the temporary use of public space are the most common targets of civic crowdfunding projects. Parklets, a system of allowing individuals and groups to create temporary installations in parking spaces, is one such framework. Twelve parklets have been successfully crowdfunded on Kickstarter since April 2012, in Oakland, Philadelphia, San Francisco, Seattle, and Vancouver, raising a total of $112,979. Five of the parklet campaigns were started by businesses, while the remaining seven were organised either by individuals, development corporations (community and government-created) or a mixture of the above. These campaigns are a particularly strong example of public-private cooperation in crowdfunding since parklet projects on Kickstarter have a ninety-two per cent success rate, around twice that of projects in comparable categories.[4] In August 2013, San Francisco (the creator of the first parklet scheme) created Living Innovation Zones, applying a similar approach to underused public spaces on the city's main thoroughfare, Market Street. It actively encourages potential partners to consider crowdfunding their project. Exploratorium, a local science museum, raised $32,696 on Indiegogo (around half its original target) to help fund its installation of two musical benches, the first LIZ, in November 2013 (Exploratorium, 2013).

It is possible to imagine many other use cases for crowdfunding in existing public-private partnerships. Kansas City's crowdfunding of its bikeshare scheme described above may in the future evolve from a signaling device to a formalised public-private partnership in which the crowd, directed by a non-profit sponsor, continues to be a financial partner. It is also possible that government could see crowdfunding as a way to test demand for new services as well as reducing the amount of capital required to begin a project. Both scenarios may demand new types of civic crowdfunding processes, though, such as those that offer the public ownership or the prospect of financial return. Otherwise citizens and communities may feel that this form of financial co-operation with government amounts to a de facto additional layer of taxation rather than an opportunity for a more meaningful engagement with government. As will be discussed in the following section, civic crowdfunding can be seen both as evidence of governments looking outwards and supporting greater community autonomy, and, on the other hand, as a convenient vehicle to advance austerity measures and a rationale for disinvesting in public goods.

Civic Crowdfunding as a Response to Government Austerity

While civic crowdfunding can build productively on the existing relationship between government, community, and the private sector, its civic role may be seen in less optimistic terms: as a response to government austerity and the weakening of civic institutions. Davies finds that around one in ten civic crowdfunding projects mentions public investment shortfalls in their campaign material (Davies, 2014). These campaigns are commonly framed as projects that deserve funding for which there is no remaining public finance, or existing services that are being cut due to budget constraints. Nevertheless, the rhetoric of these campaigns is rarely oppositional to government and few organisers openly criticise austerity measures in their publicity material. This is perhaps not surprising, since in most cases campaigners still require the cooperation of government to secure the permits necessary to execute their projects.

In some cases weakened institutions themselves are turning to civic crowdfunding. The bankrupt city of Central Falls, Rhode Island, crowdfunded $10,044 on Citizinvestor in November 2013 to pay for recycling facilities in a local park, explicitly citing its financial distress as a motivating factor (Citizinvestor, 2013). In the campaign the city notes that it consistently has the highest unemployment and poverty rates, and the lowest incomes, in Rhode Island. In other cases, crowdfunding campaigns are emerging from communities as a response to the threat of the withdrawal of services or

facilities by government. The Spacehive campaigns "Loop de Loop" and "Light Up Stalybridge This Christmas" both carry a strong air of resignation with respect to the future of public funding. The "Loop de Loop" project, which successfully raised £10,559 to convert a toilet block in Frome, Bristol into an art gallery, notes: "The toilet block was abandoned by the District Council in 2007 and has been a boarded-up eyesore in the centre of town ever since" (Spacehive, 2013b). A campaigner for the Stalybridge group, which raised £2,699 to pay for Christmas lights in the town centre, writes on their fundraising page:

> Lasting memories are made when families watch the spectacle of Santa turning on the lights, distributing sweets to the children, and usually having to be rescued by the local fire service. I am sure every child can remember this wondrous sight, but regrettably, this year will be different due to cost. The absence of Christmas lights will be a constant reminder of better times. In these times of austerity the Council has some hard decisions to make. They will be making a contribution but that leaves a gap to bridge to have the special festive lights. Stalybridge Business Forum is determined…to ensure this is done as quickly and cost effectively as possible. (Spacehive, 2013c)

To what extent do these campaigns reflect the reduction of public investment and to what extent do they support the case for it? Few projects openly criticise austerity measures, or frame themselves in opposition to government policy, while most platforms embrace the idea that civic crowdfunding is a response to austerity and fiscal weakness. Consequently, civic crowdfunding platforms tend to present their activities as a mixture of unfortunate necessity and bold opportunity. Neighbor.ly founder Jase Wilson says starkly that "cities are going broke." He argues that the decline in municipal bond valuations and the ability to ensure those transactions affordably is a key reason why U.S. municipalities and citizens are interested in civic crowdfunding: "The cheap money ride might be over… It's time to take a serious look at the way we fund things" (Wilson, 2013). Meanwhile, Spacehive's Gourlay suggests that the fiscal weakness of municipalities creates previously unavailable opportunities for innovation and problem-solving: "We're trying to open up public space…to make it easier for communities to get stuff done in their local area. We think there's a real opportunity to do that now because of the economic situation" (BBC News, 2012). Civic crowdfunding is too new a phenomenon to enable an analysis of how the emergence of projects in particular localities affects government investment in those areas. However, this argument is being made in other sectors. Noting the fact that Kickstarter raised more for arts projects than the U.S. National Endowment for the Arts in 2013, Brabham claims that the success of crowdfunding encourages public disinvestment.

> Governments may begin to see crowdfunding as a viable alternative to public
> funding for the arts, which has come under scrutiny in the United States and
> abroad in the wake of the Great Recession. If small groups of fans are willing
> to crowdfund these artistic products into being, the political logic may go, then
> why should taxpayers be expected to foot the bill? In weak economies, sites like
> Kickstarter could pose real threats to public funding. (Brabham, 2013)

Civic crowdfunding is yet to be used at scale by municipalities or govern-
ments, which would support a more concrete analysis of the relationship
between civic crowdfunding for public goods and existing spending mecha-
nisms and funding streams.

Conclusion: The Future of Civic Crowdfunding

As civic crowdfunding emerges and grows, it will demand much further in-
quiry to understand how its role as a civic actor is impacting incumbent insti-
tutions. Standards of data collection and transparency on civic crowdfunding
platforms are patchy at best, and it is not yet possible to establish a clear
picture of how crowdfunding resources are being distributed across commu-
nities. Over time, public agencies and community organisations alike will seek
to understand whether civic crowdfunding is creating new opportunities for
previously underserved communities or widening existing inequalities. In the
longer term, it will be possible to track whether the introduction of crowd-
funded projects into neighbourhoods encourages or discourages public invest-
ment, and whether the presence of those projects contributes to greater civic
engagement and community well-being.

Meanwhile, crowdfunding has a transparency and accountability chal-
lenge to face that poses a significant moral hazard to civic projects. Once a
project has completed its fundraising cycle, there are no formal accountability
structures or means for backers to monitor progress toward the promised
outcome. In crowdfunding for creative projects, this disconnect leads to dis-
appointment with a creator and in rare cases, the mobilisation of opinion
against the project through social media. In civic projects, the potential for
loss of faith in public institutions and damage to community cohesion as a
result of a failure to execute a project is a much more pressing concern. Plat-
forms that do not have legal frameworks in place to manage the execution
of projects may find themselves entangled in the consequences of unfulfilled
projects, or will simply find that public agencies are not willing to accept the
liability associated with using their platform.

In the future, civic crowdfunding is likely to become a more contested
and controversial activity as participants' ambitions expand to a wider array of

projects. While to date the projects that civic crowdfunding has produced have remained relatively uncontroversial, this may partly be a function of its newness. The vast majority of civic crowdfunding projects in the U.S. and the UK have been small in scale, requiring relatively small and localised groups of backers to realise. Cross-community coalition building has not, except in a handful of cases, been a necessary condition for success. Parks and gardens, the most common type of civic crowdfunding project to emerge, are natural early points of adoption since organised opposition to public green space is rare and maintenance costs are much lower than a more complex facility, such as a community centre. It seems unlikely that civic crowdfunding will remain in this uncontroversial space forever, though. The typology of four roles proposed in this chapter reflects the tensions inherent in planning processes: the delicate balance between the interests of governments, the private sector, communities and individuals and the constant contesting of public space. It is clear that civic crowdfunding can be used for a wide range of purposes and to suit the ends of any of the above actors, in a collaborative manner or for the benefit of one stakeholder group over another.

Since civic crowdfunding seems at once to support such a wide array of interpretations and possible roles for projects to play in civil society, researchers and practitioners will have a rich and complex set of data to work with as they track its progress. As civic crowdfunding expands to impact a broad range of disciplinary approaches, radiating out from its roots in media studies, management science and political science, it will also begin to offer more substantive responses to not only the descriptive and analytical questions currently being posed, but also to normative questions around what the future shape and role of civil society should be.

Notes

1. For a discussion of cases where institutional support is required, see 'Crowdfunding as Signaling Device'.
2. Equity crowdfunding as established by the JOBS Act (2013) is yet to be implemented in the United States.
3. On Kickstarter, 100 % of the target, or on Crowdtilt, the agreed 'tilt' amount (Crowdtilt, 2014).
4. Parklet projects have been placed in the Public Art, Design and Food categories, which have average success rates of between 38 % and 47 % as of March 21, 2014, according to Kickstarter's public statistics (Kickstarter, 2013). Their success may be partly attributed to the sizes of the projects: six of the twelve projects raised between $5,000 and $10,000, the range within which most successful Kickstarter projects occur. Projects in that range account for close to two-thirds of all successful projects on the site. The remaining six parklet projects raised between $10,000 and $15,000, the second-most common size range for successful projects.

References

Alperovitz, G. (2013). *What then must we do?: Straight talk about the next American revolution*. White River Junction, VT: Chelsea Green Publishing.
BBC News. (2012). London parents crowdfund new playground. Retrieved December 7, 2013, from http://www.youtube.com/watch?v=puJVfHvJf_8
Bike Share KC, n.d. Kansas City B-Cycle (initiative page). Neighbor.ly. Retrieved March 30, 2014, from http://kcbcycle.neighbor.ly/
Brabham, D. C. (2013). *Crowdsourcing*. Cambridge: MIT Press
Citizinvestor. (2013). Clean up CF: New bins in Jenks Park. Citizinvestor. Retrieved December 8, 2013, from http://www.citizinvestor.com/project/clean-up-cf-new-bins-in-jenks-park
Crowdtilt. (2014). What's a tilt amount? And what can tilting do for you? Crowdtilt.com. Retrieved March 30, 2014, from http://help.crowdtilt.com/customer/portal/articles/1483280-what-s-a-tilt-amount-and-what-can-tilting-do-for-you-
Curry, L. (2014). Lostine Tavern: a farm-to-table tavern. ChangeFunder.
Davies, R. (2013). Statue of Liberty and early crowdfunding. *BBC News*. Retrieved March 30, 2014, from http://www.bbc.co.uk/news/magazine-21932675
Davies, R. (2014). *Civic crowdfunding: Participatory communities, entrepreneurs and the political economy of place*. Masters thesis, MIT.
Exploratorium. (2013). Exploratorium Living Innovation Zone. Indiegogo. Retrieved March 30, 2014, from http://www.indiegogo.com/projects/474961/fblk
Goodspeed, R. & Davies, R. (2014). *Civic crowdfunding and the planning process*. Manuscript in Preparation.
Harris, J. (1985). *A statue for America: the first 100 years of the Statue of Liberty*. New York: Four Winds Press.
ioby. (2012). Philadelphia's Mill Creek Urban Farm. ioby. Retrieved from https://ioby.org/project/philadelphias-mill-creek-urban-farm
ioby. (2013). About ioby – By the numbers. Retrieved December 3, 2013, from http://ioby.org/about
Jacobs, J. (1992). *The death and life of great American cities*. New York: Vintage Books.
Jordan, H. (1994). *Public Parks, 1885–1914*. Gard. Hist. 22, pp. 85–113.
Kickstarter. (2013). Kickstarter Stats. Kickstarter.com.
Larson, D. M. (1986). *Benevolent persuasion: The art of Benjamin Franklin's philanthropic papers*. Pa. Mag. Hist. Biogr. 110, 195–217.
Marcason, Johnson, Davis, Brooks, Circo, Curls, et al. (2012). Authorizing and encouraging Blue Cross and Blue Shield of Kansas City (BlueKC) and BikeWalkKC to create BikeShareKC powered by Blue KC.
Ostrom, E. (2005). Unlocking public entrepreneurship and public economies. WIDER Discussion Papers//World Institute for Development Economics (UNU-WIDER).
Plus Pool. (2011). +Pool: A floating pool in the river for everyone. Kickstarter. Retrieved March 30, 2014, from https://www.kickstarter.com/projects/694835844/pool-a-floating-pool-in-the-river-for-everyone
Plus Pool. (2013). + POOL, tile by tile. Kickstarter. Retrieved November 30, 2013, from http://www.kickstarter.com/projects/694835844/pool-tile-by-tile

Scola, N. (2014). Kansas City tries crowdfunding its bike share. Next city. Retrieved March 30, 2014, from http://nextcity.org/daily/entry/kansas-city-tries-crowdfunding-its-bike-share.

Spacehive. (2013a). Meet the UK's crowdfunding superstars. YouTube. Retrieved December 7, 2013, from http://www.youtube.com/watch?v=aQY-CgR6-KQ&feature=youtube_gdata_player

Spacehive. (2013b). Loop de Loop. Retrieved from http://spacehive.com/loopdeloop

Spacehive. (2013c). Light-up Stalybridge this Christmas. Retrieved from http://spacehive.com/light-upstalybridgethischristmas

U.S. Census Bureau (2007). *American Community Survey 2007.* Washington, DC.: U.S. Census Bureau.

Wilson, J. (2013). Keynote by Jase Wilson at CityAge: The New American City – December 3rd & 4th, 2012 – Kauffman Center, Kansas City. Retrieved December 7, 2013, from http://www.youtube.com/watch?v=PUYJy-rLY7g&feature=youtube_gdata_player

Wong, D. P. (2013). Plus Pool interview by Rodrigo Davies. Telephone.

6. *Crowdfunding and Pluralisation: Comparison Between the Coverage of the Participatory Website Spot.Us and the American Press*

Marcelo Träsel and Marcelo Fontoura

Introduction

Spot.Us is one of the best-known crowdfunding projects in journalism. With an innovative and intriguing way of proposing and funding journalistic stories, it materialised a new form of making journalism possible, especially in harsh times for the profession, when we consider the challenges imposed by new media and the financial crisis on newspapers and other media outlets.

We explored the content of news pitches and published stories on Spot. Us, comparing their themes with the average frequency of themes in the usual coverage of daily and weekly American press, using data both from the study of Lynch and Peer (2002) and from the *State of the News Media* report (2008). This analysis was run in order to check for differences between the subjects favoured by traditional newsrooms and those privileged by contributors of the participatory web news site. The hypothesis is that microfinance can be a way to pluralise the news, as proposed by Gans (2003).

As we are going to see more closely, the research shows that the crowdfunding of news stories, as performed by Spot.Us, can be a viable alternative for publishing more different points of view, as well as subjects and themes. From the perspective of a reader, it would not make sense to help fund journalistic stories, had they been the same they would find on the outlets they already read or watch. Moreover, as we discuss, to replicate the traditional coverage

from newspapers and big companies would not make sense, from an operational point of view. Crowdfunding finds its niche on more well-researched topics.

Thus, crowdfunding as seen here becomes a way of diversifying the news digest that readers consume, through stories that complement established media outlets and fill information gaps, in an initiative we can link to the second tier of information, as proposed by Gans (2003).

Since the year 2000, the press has been going through a series of economic crises that affect the quality of news (McChesney, 2013). The transition of advertising budgets from the news media to information technology companies such as Google and Yahoo! generates high competitiveness for financial resources in the press industry. As the Project for Excellence in Journalism (Pew, 2013) reports, in 2012 the audience of all news media shrank in the United States, with the exception of cable TV and the Internet. The trend of audience migration from traditional media to the Internet has remained constant over the past years. On the other hand, advertising budgets have not followed this migration. Newspapers, magazines, radio, and TV are losing revenue, and advertising dollars generated by online newsrooms are not compensating the losses. One of the main consequences of this scenario is a dramatic decrease in newsroom jobs, which results in news stories of poorer quality (McChesney, 2013).

The economic crises add to the long-term structural problems of journalism. Gans (2003), Schudson (2003), and McChesney (2013), for instance, argue that newspapers have not fulfilled their social function properly due to constraints of the productive routines of professional press.

> The problems stem largely from the very nature of commercially supplied news in a big country. News organizations are responsible for supplying an always new product to a large number of people, regularly and on time. As a result, news must be mass produced, virtually requiring an industrial process that takes place on a kind of assembly line. (Gans, 2003: 49)

To meet the need of mass production requires the imposition of certain constraints on journalistic work, such as the requirements of objectivity and impartiality – an arrangement that often leads to the reproduction of the status quo. According to Gans (2003), the role of journalism in a democracy is to contribute for all citizens to be effectively represented by the political class, as expressed in the professional myth that only informed citizens can be represented, and only journalism can inform them. However, the press has fallen into much discredit among the citizenry, and journalists now find themselves powerless to redeem the trust of their audience.

Analysing American journalism, Gans (2003) identifies several factors causing the disempowerment of reporters. Structural factors include cost cutting in newsrooms, shrinking audiences, financial losses forcing companies to rebalance budgets, and the disapproval of the audience, who criticise some methods used by reporters, as well as perceived insufficient attention to their interests. Among the factors that contribute to the discredit of journalism, the main aspect is that news is being produced "top-down," that is, they focus too much in the upper echelons of government and tend to reproduce the views of the elite, not of citizens as a whole. Journalists, then, tend to be seen as "strangers" to the common people, and are considered part of the same elite whose actions they report in their everyday life: "Journalism proceeds on the assumption that if it reports the activities of the high and mighty, citizens have the information they need to perform their democratic roles and responsibilities" (Gans, 2003: 48). While justifying this procedure to protect the interests of citizens, according to Gans most journalists rarely take into account the roles that citizens effectively play in democracy, reducing them in general to a vote at the polls. One of the reasons for this is that high-ranking politicians tend to give greater importance to the vote that elected them and can get them out of power, and reporters tend to focus on issues that their main sources consider important (Schudson, 2003; McChesney, 2013).

A possible solution to these problems would be to "pluralise" the points of view represented in the news, creating a multi-perspectival news ecology:

> Ideally, multiperspectival news encompasses fact and opinion, reflecting all possible perspectives. In practice, it means making a place in the news for presently unrepresented viewpoints, unreported facts, and unrepresented, or rarely reported, parts of the population. (Gans, 2003: 103)

One way to materialise this proposal would be to shift the focus of journalism from the elite to the working class, which makes up the majority of the population. In addition to tracking the changes in the stock market, for example, the press could monitor changes in the labour market and prices of products and services. In addition to reporting the drama of crime victims, one could also try to determine the causes and conditions that lead the perpetrators to commit criminal acts. Another way would be to pluralise the composition of newsrooms, seeking to encourage the candidature and admission of reporters from various ethnic and socioeconomical origins. Diversity might help in reporting the facts from the perspective of different social groups.

Yet another way to achieve this proposal would be to better incorporate audience interaction in the production process of online journalism, taking advantage of the relative ease and low cost of using computer mediated

communication technologies (Träsel, 2008). The online news sites where the public can interact with the published content, whether sending their own journalistic material, or commenting and debating over journalistic material published by an editorial team, professional or not, can be considered participatory journalism spaces. Primo and Träsel (2006: 9) define participatory webjournalism as "practices developed in sections or in the totality of a web periodical, in which the divide between production and consumption cannot be clearly recognized, or does not exist at all."

Gans (2003) fails to explore the implications of this new communications medium in his proposal of multiperspectival news, but here we depart from the premise that the possibility for citizens to cooperate with online news media can achieve such pluralisation of journalism. However, the Internet is the first technology that makes this proposition operationally and economically viable (Bruns, 2005). There would be, in the Gans model, a two-tiered media structure: central media (or primary) could be complemented by a second tier of peripheral media, which would report the news to specific audiences. Indeed, the notion of multiperspectival news is very similar to the current ecology of networked communications, in which amateurs and professionals, local and global news vie and dispute for hegemony in the circulation of information (Anderson, Bell, and Shirky, 2012).

Additionally, Gans (2003: 109) suggests that social groups may offer money in exchange of the journalism they need. His proposal refers mainly to subsidies from governments to keep newsrooms running, especially in small communities. However, the development of web based microfinance tools in recent years allows individuals to make donations to reporters to ensure that facts deemed important are investigated and reported to society.

Crowdfunding is a process through which individuals and organisations donate small amounts of money to a specific cause, enabling its execution. It is amplified by the decentralised architecture of the Internet. Since proponents usually make use of social networking services to promote the raise, it is possible to collect larger quantities of resources at lower financial and operational costs than using traditional methods such as raffles and garage sales. The term has been used to designate the funding, via the Internet, of activities and products such as works of art, news stories, and electronic devices since the early 2000s. A perhaps more accurate term for crowdfunding would be "micropatronage," as Kohn (2001) suggests:

> Micropatronage entails a return to the content creation system of the 15th century, namely art patronage. The downsides are that artists are open to influence from their patrons [...] and that content creators need to be matched up with patrons. The advantage is that with the near-zero cost of information distribution,

finding patrons becomes simpler, as does having one artist supported by numerous patrons. Thus, rather than the Medicis funding Michelangelo's works, an artist such as Aimee Mann with a small, passionate following could probably find 1,000 individuals willing to donate $100 a year or more.

However, the term has been seldomly used and crowdfunding now seems to be the most accepted term to describe the act of making small donations in support of a cause, whether or not a financial return is expected.

The first case of crowdfunded journalism on the Web was the American reporter Christopher Albritton, who in 2002 raised $15,000 among the readers of his weblog Back to Iraq to cover the costs of researching stories during the war. In Brazil, in March 2014, O Sujeito[1] was launched, a channel dedicated solely to projects of crowdfunded journalism. It was conceived as an extension of Catarse, the largest platform of collaborative funding in the country. Among the journalistic projects already funded through Catarse is Cidades para Pessoas,[2] an initiative of multimedia reporting, blogging, and book publishing about urban mobility. The reporter Natalia Garcia proposed it to the users of Catarse, and subsequently most texts were republished by the traditional press. The project involves travelling to twelve different countries and, in the current context, would hardly get the funding inside a Brazilian newsroom, given the time-consuming and expensive reporting involved. Microfinance thus presents itself as an alternative to both journalists and the audience, allowing them to fulfil the public interest and bypass the barriers to investigative reporting.

As Aitamurto (2011) states, the main motivation of citizens who donate money for performing stories is not so much the desire to become informed about the chosen topic, but an identification with the values of a particular community, made possible by participation in the crowdfunding process: "The traditional role of journalism as a storyteller around the campfire has remained, but the shared story is changing: people no longer share merely the actual story, but also the story of participating in a story process" (Aitamurto, 2011: 429). From this point of view, crowdfunding can become a means of expression of the interests of communities in the public sphere and the embodiment of the multiperspectival news model championed by Gans (2003).

As we can see through the analysed material, crowdfunding in Spot.Us stories performs a double concept for the public. It is both a way for citizens to find information they wouldn't have in the traditional media, as well as a way of taking part in the process, strengthening ties with peers.

That said, Spot.Us is the vehicle through which we are analysing the impact of crowdfunding on the news agenda, regarding subjects and themes.

Crowdfunded Journalism in Spot.Us

Spot.Us was created in October 2008 by journalist David Cohn. The initiative also received support from other foundations that foster journalism and research, such as the Knight Foundation. The spirit of the project was open, as its founder stated: "We have some guiding philosophies, I'd say. One is that journalism is a process [...], a series of acts. And another aspect as a philosophy for us is that journalism should be participatory. It is something that the public should be engaged in" (Spot.Us: 2008).

Spot.Us was a news site that proposed a different model. The financing of the stories and the suggestions came directly from individual users. The initiative was defined as "a pioneer project of open-source 'community driven reporting'" (Spot.Us: 2008). "Community," in this case, should be understood not necessarily as a geographically determined social network, but rather as a virtual community, in the sense presented by Rheingold (2000). Also, since Spot.Us was open to collaboration from any locality, it catered potentially to all of the global communities. Ideally, it would become a patchwork of virtual and local communities news. With a free registration, one could suggest any Internet story. At the end of 2013, there were approximately 20,000 registered contributors, according to the site itself.

Recently, the project was sold and belongs to American Public Media, a public radio network. However, Spot.Us has been disabled. The page remains accessible, but out of date. According to a warning on the web site, donations are not accepted anymore, as well as pitches. The project is undergoing redevelopment and was supposed to return in June 2014. It is difficult to state why the website had its development and operation suspended by its new owner, especially because they are not open to contacts regarding this situation. One possible explanation is that its business model was not financially viable for a big company.

Any themes were accepted, and these suggestions were called "tips," the most basic form of idea. In them, the user-author described questions she considered relevant to the investigation and other users could "pledge" money to the proposal, as a way to show interest in the idea. However, if the story was produced, there was no obligation to pay the promised amount.

The suggestions were made available on the website.[3] It was then up to registered reporters to build more complete propositions from these ideas. When this was done, a "pitch" replaced the original tip. This new proposal was already linked to a reporter that would fulfil it if it obtained the necessary funding. The journalist would detail what would be his/her reporting methods, goals, and how the story would help society to move forward on

that issue. On this page there was also a brief description of the qualifications of the reporter and his/her work. At this stage, the contributions made by readers were effectively collected and presented in a bar informing how much money had been raised.

When the necessary amount was completed, the journalist developed the story, in a time varying between two weeks to two months, depending on the complexity of the pitch. The story was then published in Spot.Us in a specific section,[4] under a free license, allowing anyone to republish it, as long as the authors and Spot.Us were credited. Spot.Us also partnered with other news organisations as a way to amplify the impact of the crowdfunded stories. A company could finance 50% of the production value, and in return, had the prerogative to publish it firsthand. In that case, the amount financed by the community was returned to the individuals in the form of credits, which they could redirect to other pitches, if they wished. Among the news organisations that worked with Spot.Us were *The New York Times*, the *Oakland Tribune*, and the station KALW. Reporters were registered freelancers and their qualifications varied greatly. They could be beginners or experienced reporters, but were required to provide proof of competence, such as presenting a portfolio.

The coverage of Spot.Us focused primarily on the state of California, and mainly in the cities of San Francisco, Oakland, and Los Angeles. However, after some months of operation, pitches in other regions, including Africa, were being proposed and funded. Another change introduced toward the final months of operation was the publication of news stories in Spanish. Another feature were the "assignments": when working on a pitch, the reporter could ask, if deemed necessary, for the help of a reader at some point of the process. The reader could help by taking pictures, researching documents, or conducting interviews. Users would apply and the journalist selected the one he/she deemed appropriate.

Methodological Procedures

This study is based on a content analysis of the tips, initial suggestions, and the published stories on Spot.Us. The research was initially undertaken by Fontoura (2010), where the data and methodology are thoroughly detailed. The first category of analysis was the tips, which represented themes that users suggested individually. However, the tips studied here were not carried forward, but remained initial proposals, either because no reporter was interested, or because there was no "promise" of funds from other members. Once a reporter transforms a tip into a pitch, the original tip is extinct. Thus, it was inferred that all of the analysed material from the group had not passed

to the subsequent stage. The published stories represent a conjunction between the skills and interests of the reporters and direct preferences of contributors, expressed in the form of grants for the development of the pitch. We chose not to analyse the pitches, for they were considered inconclusive. It is possible that, at the moment of collection, a certain pitch "X" had a certain amount of funding, but the next day it would be transformed into published news. Thus, we decided to leave them aside. The second category of analysis was the stories effectively published on the Spot.Us website. The *corpus* of the first stage of analysis included all published news stories and tips available in the archives of Spot.Us at the moment of collection – August 21, 2010, for tips, August 21 and 22, 2010, for published articles. A total of 141 suggestions and 81 published articles were collected for analysis, adding up to 222 units.

The origin of the funding pledges was distinguished as coming from the author of a pitch, a company, or Spot.Us itself, since it is possible that, for example, of $100 promised for three people in a tip, $50 are from the author and $25 from an organisation, with only $25 coming from a regular contributor. On the occasions when the founder, David Cohn, promised financing using his personal profile, there was no differentiation. A similar collection was conducted among the published reports. Attention was also given to the financing coming from "groups," nonprofit organisations that can make donations. Six stories lacked information about their financing.[5] According to David Cohn[6], they predate the launch of the current version of the website and the data was lost in the migration. To guarantee a purer sample, this material was not included. Regarding the distinction of financing from the public and organisations, the site was divided as follows: the amount of money of organisational support is included in the overall amount of the story – for a story that needed $700 and there was $200 coming from organisations, the other $500 came from the general public.

The material was organised in spreadsheets.[7] The categories encompass subject and source of funding. The sample was divided by the most important theme in the tip or published story: Crimes/Public Safety, Culture, Economy, Education, Employment, Sports, Infrastructure, Media, Politics/Elections, Health/Science, Sustainability/Environment, Technology, Social Issues, and more. Ten subjects were grouped in pairs (such as Crimes/Public Safety) and treated as separate entries, but were unified by theme, for the sake of affinity and organisation, during the analysis.

Initially, stories were presented without regard for theme in Spot.Us. Thus, the categories used in the content analysis were created by Fontoura

(2010), based on a pre-analysis of the main themes of the stories. During the period of analysis, however, categories for all types of texts (tips, pitches, and stories) were introduced by Spot.Us. It was found, however, that each item could be related to more than one category. We decided, then, to keep the previously developed categories to avoid confusion caused by duplicate categories in the analysis process. Anyway, the categories introduced by Spot.Us are quite similar to those developed during the research.

The results are shown in Table 6.1. In the suggestions group (in which neither had effectively become a story), four themes were found to be predominant: Infrastructure, Environment/Sustainability and Economics, all presenting 23 tips each, and Social Issues, with 19 suggestions for a total of 141 suggestions. The group of effectively crowdfunded and published news stories, on the other hand, show a quite different picture. Of the 81 published reports, 19 belong to the category Sustainability/Environment, and 13 to Social Issues. That is, the former is significantly more frequent. Economics and Infrastructure, which were more frequent as tips, do not follow the same ratio in the group of published news stories.

Table 6.1: Distribution of subjects between suggested and published stories on Spot.Us.

	Suggested	*%*	*Published*	*%*
Crimes/Public Security	6	4,2	9	11,1
Culture	12	8,5	1	1,2
Economics	23	16,3	8	9,8
Education	6	4,2	6	7,4
Employment	6	4,2	2	2,4
Sports	0	0	1	1,2
Infrastructure	23	16,3	7	8,6
Media	2	1,4	1	1,2
Politics	10	7	6	7,4
Social Issues	19	13,4	13	16
Health/Science	7	4,9	3	3,7
Sustainability/ Environment	23	16,3	19	23,4
Technology	3	2,1	2	2,4
Others	1	0,7	3	3,7
Total	141	100	81	100

Source: Authors (2010)

In other words, users of the site predominantly propose stories related to Infrastructure, Economics, Sustainability/Environment and Social Issues, but the last two themes are adopted by reporters and financed more frequently. Indeed, the theme Sustainability/Environment encompasses almost a quarter of the entire news production of Spot.Us during the period of research. Taking into account the criteria of newsworthiness set by Traquina (2005), the most frequent news-value in the materials published on Spot.Us is proximity, or the tendency to attribute more importance to facts that are geographically and culturally closer to the public. Other criteria often found was relevance, according to which an event has greater newsworthiness according to its direct impact on the daily lives of the public (Traquina, 2005). In general, readers of Spot.Us seem to care about community and the impact of local economic activity on the environment.

The stories about sustainability and environment are exemplary of this tendency to value proximity and relevance by Spot.Us supporters. The themes revolve around measures to make the economy more communitarian, the environmental damages that urban people cause every day without realising it, transformation of some city areas to be less harmful to the local environment, and better use of urban natural resources. There is a local and practical appeal in both proposals (tips) and published stories, although this appeal is not present in all of them.

Such news values can also be found in the tips and stories categorised under the theme Social Issues. One of the areas where Spot.Us has more registered users is Oakland, CA, which has high levels of poverty, malnutrition, violence, and poor education. The city is a constant subject of pitches, and its low development rate is cause for investigation and discussion of alternatives. All these subjects were addressed by the tips and stories grouped in the Social Issues category. At the same time, subjects of the Infrastructure group, such as decaying pavement, a bridge that has exceeded the time schedule for construction, and problems in government's call centres are highly determinant in citizens' lives, and were suggested by supporters and investigated by reporters.

Content in the American Press and in Spot.Us

As a way to advance the hypothesis that crowdfunding might be an instrument of multiperspectival news (Gans, 2003) the results of the content analysis in the participatory news website Spot.Us were compared to averages obtained in a content analysis of American daily newspapers, conducted on a national scale by the Readership Institute of Northwestern University (Lynch & Peer,

2002). The study by Lynch and Peer analysed the content of a sample of 100 newspapers titles across the United States market, comprising 74,000 stories, in order to offer comparison data that enables newsrooms to compare their output with other newspapers across the United States. The sample included newspapers of diverse circulation brackets, up from 10,000 copies, and of diverse focuses, from local to international. No other content analysis of the American press of such scale has been published recently, but, although topic proportion may have changed slightly since then, this study remains the best source of data on the content of the average newspaper in the United States. The purpose of the comparison between the two sets of data is to observe the differences between the themes chosen for coverage by Spot.Us collaborators and by professional American journalists. The premise from which the study has parted is that there would be differences between the media agenda and the public agenda.

The reason we compared the results of Spot.Us with data from national newspapers and magazines, instead of local newspapers, is the website did not intend to have an exclusively local focus. Many stories were about local themes because the primary base of collaborators was constituted by residents of the Bay Area. However, Spot.Us also had stories being developed all over the United States and even abroad, so it's not possible to categorise this case of crowdfunding as only local. For example, there was a *New York Times*–funded story on the trash disposed of in the Pacific Ocean. Also, having a bigger amount of stories from San Francisco and around may be due to the fact that the website is from there, and the city is on the cutting edge of technology and media. Thus, we chose to compare the production of Spot.Us only with magazines and newspapers, not using specifically local press, because it seemed a more fair comparison.

The study shows that in the U.S. newspapers, the more frequent theme is sports, representing between 18.8% and 26.2% of the whole universe of published news. The themes related to politics, war, and the government represent between 17% and 20.8% of the news, a lower proportion. The third subject most reported about is crimes and other types of felonies, with 9.2% to 13.2% coverage. Materials on the environment and climate, on the other hand, only comprise between 1% and 2.9% of news coverage. Economic themes represent between 5.4% and 12.1%. Infrastructure issues, such as urban planning and the use of public space, sometimes are not even present, reaching a maximum of 3.7% of editorial space.

The results of the content analysis of American media produced by Lynch and Peer (2002) contrast sharply with the results obtained from the content analysis of the tips and published news in Spot.Us. The dominant topics in

suggested stories were the economy, environment/sustainability and infrastructure, each with a proportion of 16.3% of the total. Crime and public safety were the themes recommended by only 4.2% of collaborators of Spot. Us. Politics was the preferred theme from 7% of collaborators. However, the main discrepancy between the manifested interests of Spot.Us' contributors and U.S. commercial press is the sports theme, about which there has been no coverage of on the participatory news website until August 21, 2010.

However, not all suggestions become published stories on Spot.Us. So while the economy, environment, and infrastructure present the same frequency as tips, that is, 16.3%, infrastructure accounts for only 8.6% of the published news; economy, 9.8%, and the environment, 23.4%. The sports theme appears among the published stories, although it is not present among the suggestions, representing 1.2% of the coverage – a proportion still much smaller than the space occupied by sports in the average American press. Politics-related news is 7.4% of the total, very similar to the tips. But news on crimes and public safety at Spot.Us occupy a proportion within the average of the traditional press, 11.1%.

Graph 6.1 shows a comparison between the proportions of subjects covered in the American press and the ratios obtained through content analysis of the news stories published in Spot.Us. Since the report of Lynch and Peer (2002) offers ranges of averages, it was decided, for comparison, to use the highest numbers in each subject by taking the averages relating to newspapers with circulation above 200,000 daily copies. Among the dailies in this category were outlets such as the *Houston Chronicle, The Baltimore Sun* and the *Chicago Tribune*.[8] Moreover, the categories created for the content analysis of Spot.Us were used as a basis for comparison, which have no parallel with the content analysis conducted by the Readership Institute in some instances: social issues, media, and employment. Chart 1 presents only data that could be compared without much distortion. Moreover, the category Infrastructure was compared to the subcategory City Planning/Land Use, as it was considered the closest.

Table 6.2: Comparison of stories published on Spot.Us and the average American newspapers with circulation over 200,000 copies (%).

	Spot.Us	*Published*
Crimes/Public Security	11,1	13,2
Culture	1,2	11,6
Economics	9,8	12,1
Education	7,4	2,3

	Spot.Us	Published
Sports	1,2	26,2
Infrastructure	8,6	3,7
Politics	7,4	20,8
Health/Science	3,7	2,5
Sustainability/Environment	23,4	2,9
Technology	2,4	3,6
Others	3,7	2

Source: Authors (2010)

One can notice a significant difference between the most frequent themes in U.S. newspapers and on the coverage of Spot.Us, except in the case of crime and public safety, in which the proportions are similar. A specific study would be necessary, however, to rule out the hypothesis of numbers matching by chance. The hypothesis that the news of the participatory news website Spot.Us presents different proportions than the average American press, regarding the addressed topics, seems to be confirmed.

The results for Spot.Us were also compared with the most common subjects proportions of the magazines *Time, Newsweek*, and *U.S. News* in 2008 (Pew, 2009), published in the annual *State of the News Media* report.[9] The reason for this second round of comparison was the possibility that the dynamics of news production in Spot.Us are closest to the production routines of weekly magazines than those of daily newspapers. Different publishing cycles imply different organisational newsroom structures and therefore different possibilities in reporting (Schudson, 2003). The comparison is not perfect, because the categories used in the study of the Project for Excellence in Journalism are quite different from the categories defined in Spot.Us and in the initial research. On the other hand, categories in content analysis always derive from the studied objects and therefore the themes chosen for the report should reflect the organisation of American magazines. However, some of the most important categories of our study, such as Economics, Sports, Politics, and Health, are present, giving margin for realising a fair comparison. It is impossible to find another study with exactly the same categories of subject, hence the need of gathering studies such as this one. Still, the absence of the very category of Sustainability, for instance, already gives a glimpse of a difference in the content between the outlets.

Despite the caveats above, we can state there is great difference in the coverage of topics of Spot.Us and weekly magazines. While Security Crimes and Public, Education, Employment, Infrastructure, Media, Social Issues and

Sustainability and the Environment categories were not themselves represented in the magazines, International-News, Personal Finance, Entertainment/ Celebrity, Travel/Leisure/Sports, Home & Garden, Fashion/Food/Beauty, and Children showed no significant frequency in Spot.Us. There's probably coincidence between some of the issues absent in either set of categories, but we chose to compare only the data that can be clearly contrasted.

Table 6.3: Thematic comparison of stories published on Spot.Us and the aggregated average of *Time, Newsweek,* and *US News* magazines (%).

	Spot.Us	Magazines
Culture	1.2	11.8
Economics	9.8	6.9
Sports	1.2	2.2
Politics	7.4	36.2
Health/Science	3.7	8.1
Technology	2.4	1.2
Others	3.7	4.6

Source: Authors (2014)

The comparison shows a large gap between the coverage of U.S. weekly magazines and the articles chosen by contributors on Spot.Us. While 36.2% of magazines devoted editorial space to National Affairs in 2008, only 7.4% of the stories published by Spot.Us dealt with politics. However, if the categories related to politics, such as criminality, jobs, education, infrastructure, media, and social issues – all arguably related to National Affairs – had their proportions aggregated; they would represent 54.1% of the coverage on Spot.Us. Thus, it appears that, in any case, there is a discrepancy between the most frequent subjects in both groups.

Spot.Us distinguished itself again by the importance given to the subject Sustainability and Environment (23.4%), which was absent as a category of analysis in the weeklies. In contrast, 11.8% of magazines devoted editorial space to Culture, versus only 1.2% of all articles published by Spot.Us. Although weekly outlets devote double the space to Health/Science, they addressed the topic of Technology/Computers with about half the frequency dedicated to the subject by Spot.Us.

The limits of this comparative study are the different scale of samples, differences in the methods of analysis, the temporal discrepancy of the data on the American press, and the fact that the numbers offered by Lynch and Peer (2002) and Pew (2009) are related to newspapers and printed magazines,

not websites – each medium has its own requirements in terms of production routines and audience. It is not possible either to produce generalisations from this study about the trend toward thematic difference in the coverage of traditional media and participatory online news sites. The conclusions are applicable only to the case of Spot.Us. Despite these limitations, however, this study highlights the need for more extensive research, taking into account the largest possible corpus of published articles in participatory online news.

Conclusions

The different results in the three content analyses above can be attributed in large part to the different objectives of newspapers, weekly magazines, and crowdfunded news websites. While the mainstream media outlets should meet the needs of information of public interest of their readers, offering the essential news for the exercise of citizenship and good performance in the everyday of modern and postmodern societies, online participatory news sites usually are created as alternative sources of information, providing news about themes missing from mainstream media or unusual viewpoints. In other words, readers would have no reason to see Spot.Us as a replacement for their sources of daily information. Indeed, the very production routines of this participatory web news site would not be adequate for everyday coverage and general news.

The definition of pitches and stories exclusively from suggestions of readers in a production routine committed to the traditional 24-hour cycle of newspapers, television news, and radio news is impractical. First, due to the randomness in the proportions of subjects, depending on the social and cultural moment, it could result in a flood of suggestions for pitches related to environment in a newsroom unprepared to deal with the peculiarities of the subject, for example, not having specialised reporters. Second, because of the way newsrooms are arranged, newsrooms that work in 24-hour cycles need to set their stories and pitches at the beginning of the day, and weekly newsrooms working under a deadline should plan accurately the content of their magazines. Otherwise, they would cripple their own production routines. On the other hand, collaboration with the public may arrive at any time and need not meet a specific deadline. Third, much of the stories covered by commercial newsrooms are related to pre-booked happenings, such as press conferences, product launches, and anniversaries, whose promoters already have privileged access to journalists. Finally, the press should fulfil the social function of presenting the facts of the public agenda to society, while contributors to participatory online news sites such as Spot.Us act according to private interests – which may be even more committed to the public interest

and well-informed about the criteria than editors and publishers, but lack the supervision of peers as in professional newsrooms.

Moreover, collaborators of Spot.Us are probably daily newspaper readers, or the audience of TV and radio news, with special interests in specific topics. It would not make sense for these contributors to fund pitches that could be read in the newspapers they subscribe to or read online. It can be inferred; therefore, that crowdfunding in Spot.Us stories is a way for citizens to fill information gaps left by mainstream media coverage, as well as means for taking part in the story and establishment of community bonds.

The fact that there is quantitative divergence in the topics covered by the American press and in the coverage of Spot.Us indicates that this participatory web news site is fulfilling the role of media in the second tier, as described in the journalism model of two tiers proposed by Gans (2003). The crowdfunding of journalistic stories thus presents itself as a viable alternative to the pluralisation of the news.

In future research, it might be useful to qualitatively evaluate the materials published via crowdfunding, to assess whether, in addition to differences in agenda, participatory web news sites akin to Spot.Us do feature divergent frames and discourses than those of traditional media, another important aspect in the building of a multiperspectival news environment.

Notes

1. http://osujeito.catarse.me/pt
2. http://cidadesparapessoas.com/
3. http://www.spot.us/stories/suggested
4. http://www.spot.us/stories/published
5. They are: "Ethanol Could be a Weak Link in State's Energy Network," "SF Election Truthiness Campaign," "Bay Area Cement Plants and Global Warming," "Agriculture poisons water for 1.3 million San Joaquin Valley residents," "The Impact of Violence On the Youth in Oakland," and "Sixth and Market – Under the Microscope."
6. Personal e-mail message from 7 October 2010.
7. The complete spreadsheet of the story pitches analysed is available on the following address: http://goo.gl/69kqt. The complete spreadsheet containing the published stories is available on the following address: http://goo.gl/0qUqA
8. The complete list of newspapers studied can be found here: http://www.readership.org/impact/impact_papers_list.asp
9. One reason for using 2008 data instead of more recent numbers is Spot.Us was created in 2008. Another reason is the 2008 dataset includes only American *hard news* magazines, and other years' reports included, for example, *The Economist* and *The New Yorker*.

References

Aitamurto, T. (2011). The impact of crowdfunding on journalism: Case study of Spot. Us, a platform for community-funded reporting. *Journalism Practice*, 5(4), 429–445.

Anderson, C. W., Bell, E, & Shirky, C. (2012). *Post-industrial journalism: adapting to the present*. New York: TOW Center for Digital Journalism.

Bruns, A. (2005). *Gatewatching: collaborative online news production*. New York: Peter Lang.

Cohn, D. (2010). Personal e-mail message from October 7, 2010.

Fontoura, M. C. (2010). Microfinanciamento de notícias: uma análise do website *Spot.Us*. Undergraduate thesis, Pontifícia Universidade Católica do Rio Grande do Sul, Porto Alegre.

Gans, H. (2003). *Democracy and the news*. New York: Oxford University Press.

Kohn, D. (2001). Steal this essay 3: How to finance content creation. *TidBits*. Retrieved August 19, 2014, from http://tidbits.com/article/6629

Lynch, S. & Peer, L. (2002). *Analyzing newspaper content: a how-to guide*. Evanston, IL: Readership Institute.

McChesney, R. (2013). *Digital disconnect: how capitalism is turning the Internet against democracy*. New York: The New Press.

Pew (2013). *State of the news media 2013*. Washington: Project for Excellence in Journalism.

Primo, A. & Träsel, M. (2006). Webjornalismo participativo e a escrita coletiva de notícias. *Contracampo*, 14, 37–56.

Rheingold, H. (2000). *The virtual community*. Cambridge: MIT Press.

Schudson, M. (2003). *The sociology of news*. New York: Norton.

Spot.Us. (2008). What is Spot.Us about?', *Spot.Us*. Retrieved September 10, 2010, from http://spot.us/pages/about

Traquina, N. (2005). *Teorias do jornalismo: a tribo jornalística – uma comunidade interpretativa transnacional*. Florianópolis, Brazil: Insular.

Träsel, M. (2008). Grassroots online journalism: public intervention in Kuro5hin and Wikinews. *Brazilian Journalism Research*, 4(2). Retrieved September 30, 2013, from http://bjr.sbpjor.org.br/bjr/article/view/150

7. *Is It Fair to Monetise Microcelebrity? Mapping Reactions to a Crowdfunded Reporting Project Launched by an Italian Twitter-star*

Giovanni Boccia Artieri and Augusto Valeriani[1]

Introduction: How Claudia aka @tigella Became a "Twitter Celebrity"

In 2010 Claudia Vago (@tigella on Twitter, where she opened her account in August 2008) was an almost unknown young woman in her early thirties living in a small mountain village of Northern Italy. At the time Claudia was working as web editor for the tourist board of the Emilia Romagna region and had neither experiences nor ambitions in journalism. She was in fact a member of some of the communities of Italian early adopters of web 2.0 platforms but she could not be considered a leading figure.

In early 2011 what substantially changed the online status of Claudia was a specific activity on Twitter: she started curating for her followers a stream of messages regarding the Tunisian uprising, continuing with the whole "Arab Spring." Later the same year, she drifted her attention toward Europe and the U.S. to follow the *Indignados* and Occupy movements, thus specialising her Twitter feed on social movements. In curating these stories Claudia adopted an approach highly sympathetic with protesters, frequently writing very emotional Tweets and giving the impression of considering herself in some way involved in the mobilisations.

This hyper-activity substantially increased her popularity within the Italian twitter-sphere, also because it was focused on an issue – social movements – that eventually become one of "the" stories of 2011. During the same months,

the Italian mainstream media "discovered" Twitter and, also as consequence of this hype, the number of users increased dramatically[2]. The media attention around Claudia grew and she became the first authentic "Twitter personality" in Italy. In November 2011 *Wired* magazine (Italian edition) published a list of the "fifty Italian Twitter accounts to follow" and @tigella (Claudia) was the only one – in a list of politicians, well-known bloggers, ICT experts, and academics – included just due to her activity on Twitter.

On February 5, 2012 Claudia launched[3] the "Manda @tigella ad occupare Chicago!" ("Send @tigella to occupy Chicago") initiative: she asked the crowd to fund her to cover from the field a gathering of the U.S. Occupy movement organised to protest against the NATO Summit scheduled for the following May in Chicago. The budget (€ 2.600), which also included a fee for her work (€ 800), was completely crowdfunded in 10 days. This was unusual considering that crowdfunding was still a novelty in Italy and the platforms created for coordinating crowdfunded journalism had experienced many difficulties (e.g. Spot.Us Italy launched in May 2010 was closed at the end of the same year after various problems and a general lack of interest). For the sake of brevity we will refer to the project as TOWS, which is the acronym for Tigella Occupies Wall Street and was also the hashtag adopted by Claudia while in the U.S. to mark the Tweets she published as part of her "correspondence."

Since the very first days after Claudia put the call online, mainstream media paid attention to TOWS. This process resulted in a new legitimacy for Claudia who was raised to the level of "web celebrity" known also to a generalist audience: her online reputation was suddenly transformed to mainstream popularity. Such a transformation culminated when she appeared as special guest in *Volo in diretta*, a popular late night live TV show hosted by the very mainstream actor Fabio Volo, who interviewed her specifically on TOWS.

Contextually to this media hype, a very tense debate erupted on the Italian Internet-sphere: the broadcast media and online representation of Claudia collided and opened up a discursive terrain characterised by the emergence of a conflict, in which the highly polarized positions of supporters and detractors became visible. TOWS was transformed into a discursive field where the dispute around the potential and the value of the project was highly intertwined with the judgment around the construction of a personal path of self-branding by Claudia.

The Study: Journalism, Microcelebrity, and Crowdfunding

Existing literature on crowdfunded journalistic initiatives has focused both on proponents and funders' perspectives. As regarding the proponents' side, in

her seminal research on the Spot.Us community, Aitamurto (2011: 440) argued: "A crowdfunded journalistic process creates new requirements for the journalist's role. To succeed in fundraising and raising awareness about the story project, the journalist has to reach out to the community –for example, through their social networks." Now, if different skills are required to get attention and get funded, this means that subjects having good networking competences – despite their lack of background in newsmaking – might be better positioned to succeed than others having exclusively reporting abilities. This idea is in some way confirmed by Jian and Usher (2014) in their more recent study on Spot.Us funders' preferences, where the two researchers found that most donors did not consider relevant, in their donating choices, proponents' previous journalistic experience. As a consequence, crowdfunding might represent a great opportunity for newcomers to the news market to "jump-start their career" (Jian & Usher, 2014, p. 165), a pattern that could be applied also to the case we present here.

Discussing the potential of crowdfunding as a new opportunity for public interest journalism, Carvajal et al. (2012) stressed the active role assumed within the process by donors, defining them as gatekeepers of this new ecosystem. This idea echoes Aitamurtu's interpretation (2011) of crowdfunded journalism as the very realisation of the idea of "collective intelligence" by Pierre Lévy: by funding a story, donors express a collective judgment about the topics that need to be reported. These interpretations of journalistic crowdfunded initiatives imply a loss of control on the newsmaking process from the perspective of the journalist and a consequent empowerment of the audience. However the actual range of this "redistribution" of power still needs to be more precisely assessed.

In investigating how funders exercise the power acquired, while Burtch et al. (2013) and Aitamurto's (2011) studies found that altruistic motivations – i.e. contributing to common good and social change – were the main drivers behind donors' choices, Jian and Usher's findings (2014) suggest that donors favour stories that provide practical guidance for their daily life. Finally, Jian and Shin (2014), considering behavioural data on Spot.Us users' donation records, found that personal connections with the proponent represent a significant predictor of actual donation levels. These competing findings call for further research on funders' motivation in journalism related projects, especially when developed outside of dedicated platforms like Spot.Us and by very peculiar subjects like Claudia.

The present chapter thus aims at enriching the debate around crowdfunded journalism by introducing the dimension of microcelebrity (Senft, 2008, 2013) developed within online environments and by adopting – albeit

through a qualitative study – a holistic approach that considers the reactions to Claudia's pitch not only by those who funded TOWS but by the broad online ecosystem. In this way we argue that a crowdfunding initiative might generate also conflicts, resistances, and tensions within specific milieus. Indeed, by analyzing the different readings of TOWS and Claudia by the crowdfunders, the media coverage of the initiative and by various communities "inhabiting" the Italian web, we will show that the case of Claudia demonstrates how new figures are emerging within journalism ecosystems, staying at the intersection between different fields without being accepted as a full member within any of them. We will argue that the success of Claudia's journalistic crowdfunding – as well as the strong criticisms it received – prove that authority developed by these newcomers can be capitalised and spent on different territories, apparently without disorienting their fan/supporters but at the same time generating tense conflicts within the broad system.

More specifically, we will show how all the subjects and communities (activists, web professionals and simple social media users) who discussed TOWS online were also debating whether monetising the popularity developed within a pro-am (a hybrid between professional and amateur, see Boccia Artieri, 2012) media environment through crowdfunding practices should be considered as the very realisation of a web "gift based" economy or a betrayal of it. A gift economy is a logic based on transactions involving more social relations rather than monetary profits or personal gains (Pearson, 2007). Financing a crowdfunding initiative launched by an online "friend" can assume the value of a symbolic reward that emphasises more the bond of affection with the proponent, rather than representing an economic material investment. At the same time, the whole campaign could be seen as an attempt, by the proponent, to unfairly monetise such capitals of trust.

If we consider these opposite readings in term of moral economy (Thompson, 1993), i.e. the interplay between economic activities and cultural norms accepted within a community, we could see the emergence of what could be defined a "multiple" or at least a "double" moral economy at work behind the reactions to Claudia's initiative. Indeed the competing interpretations of the meaning to be attributed to TOWS show how the development – and the mainstreamisation – of crowdfunding practices could also generate conflicts surrounding the "real" nature of new economies characterising digital societies.

In order to investigate these issues we considered, through a qualitative frame analysis, the content of a corpus of news articles (N=17) and blog posts (N=15) referring to TOWS written between the launch of the project and two weeks after Claudia's return to Italy (5 February–6 June 2012). Texts

have been retrieved from the web by searching very specific keywords related to the project.[4] As regarding articles we considered all pieces published in online versions of national newspapers (such as *La Repubblica*, *La Stampa*, *L'Unità*, *Europa*, *Il Fatto Quotidiano*), in online-only national newspapers (such as *Il Post*, *Linkiesta*, *Fanpage*, *Affari Italiani*), in other online news platforms (such as *Ustation*, *Intervistato*, *Dailybest*, *Tuttogratis*) and in online publications specialising in issues related to journalism (such as *LSDI* and *European Journalism Observatory*). As regarding blog posts, in order to have the full picture of the debate emerging in the blogosphere around TOWS, we included in the analysis all the pieces retrieved, regardless of the popularity of the blog; comments to posts and articles were analysed too. Moreover, a sample of extended public conversations[5] (N=8) happened during the same time span on Friendfeed and Identi.ca social networking websites was included in the analysis. As for TOWS funders, we delivered an online survey to the 130 people who bought the 260 shares to pay TOWS. The survey (26 multiple choice questions and 2 open) was in the field between 1 July and 31 August 2012 and was completed by 79 funders. Finally we had one e-mail interview with the anonymous creator of a fake Twitter profile mocking Claudia's activity.[6]

In Claudia We Trust! The Community of Crowdfunders

Claudia's case shows the emergence of a new kind of authority within contemporary information and journalistic ecosystems, one acquired through practices of microcelebrity within online communities (Senft, 2008, 2013). The relationship developed between her and the community of people who eventually funded TOWS is thus the first crucial aspect to be considered.

By analyzing through a survey the motivations and expectations of the community who funded TOWS, we tried to investigate the basis of such relationships. One hundred thirty donors bought the 260 shares (€ 10 each) of the € 2,600 asked for by Claudia through produzionidalbasso.org, a small Italian generalist crowdfunding platform that, unlike other more famous sites such as Kickstarter, does not take any percentage of the funds raised. Each funder had the opportunity to buy as many shares as they wanted and, despite the fact that the platform allows proponents to do so, Claudia did not offer any specific rewards for funders. This choice could already be interpreted as the result of Claudia's self-confidence in the existence of a community developed around her presence online that needed just to be activated.

Our research indicated that 97% of TOWS donors who answered the survey had a Twitter account and 72% described themselves as frequent users

of the social network. Such a high percentage of avid users among our respondents shows how Claudia's activity on Twitter could have been crucial in developing the relationship between her and the people who crowdfunded TOWS: 96% of the donors were already in touch with Claudia when they funded the project and 89% had developed this relationship via Twitter.

We might also speculate that, at least judging from funders' motivations, the affordances of the platform as a highly personalised relational and communicative milieu (Marwick, 2010) contributed in defining the strong focus on Claudia instead of on the project. Indeed, almost half of the respondents (48%) defined their donation as a consequence of estimation and trust for Claudia and her activity on Twitter and roughly one of three (34%) was moved by curiosity for a different approach in news reporting. On the contrary, just 13% were moved by interest for exploring a new funding model for journalism and only 5% framed their choice in relation to the topic proposed. It should also be noted that 81% of respondents stated that they would have funded Claudia regardless of the story chosen.

The strong personalisation of TOWS around Claudia and her online reputation is thus confirmed, and the same trend emerges analyzing the expectations respondents declared to have when they read the call and decided to fund. In answering our survey's open question, several funders focused the description of their expectations exclusively on Claudia, e.g.:

> I expected to have at my disposal the vivid, heretical, original and correct work of someone I trust and, at the same time, to support her work.

> For me it was more a 'prize' for her, for all the initiatives she has undertaken.

Some of the donors explicated that they expected something like a "participant observation" or "ethnography": it is thus clear that they wanted her personality to strongly emerge from the "coverage." Moreover, despite the fact that this was Claudia's first reporting experience, just 1% of the funders identified the project as amateur, while 53% of them considered TOWS as professional, and 46% a pro-am hybrid. This finding is even more interesting considering that roughly a half of our respondents were either journalists (9%) or web professionals (29%), e.g. social media editors, social media strategists, and web PRs. Judgments over professionalism and personal trust were thus highly blurred in funders' interpretations.

As already described in section two, the latest research by Jian and Shin (2014) showed that personal connections might play an important role in determining behaviours of funders of journalistic initiatives. Their finding is coherent with literature on funders of a broader spectrum of crowdfunding

initiatives – especially culture and art projects (e.g. Gerber, Hui, & Kuo, 2012). Thus, personalisation around the proponent is not at all exceptional in crowdfunding initiatives, and might have been underestimated in previous studies on crowdfunded journalism (Burtch et al., 2013; Aitamurto, 2011; Jian & Usher, 2014). Our research indeed confirmed that journalistic campaigns do not necessarily differ from other crowdfunding initiatives with regards to the importance assumed by personal connections in motivating funders to donate. However our study showed that personal connections could also be the result, as in the case of Claudia, of a relationship developed entirely via social media with the proponent, assuming the status of "online friend" or even of microcelebrity, while funders acting as a fan community. Our findings demonstrate that the way Claudia and her funders developed their relationship has substantially affected the expectations funders have for her new "work" and the reason behind their choice to donate. This connection that was developed almost exclusively on Twitter seems indeed to have assumed a very personal nature that reminds us of the celebrity-fan relationship (Marwick and boyd, 2011).

Crowdfunding, Microcelebrity and Mainstream Media Attention

According to the interpretation proposed above, the success of TOWS crowdfunding should be therefore understood mainly in terms of microcelebrity practices on social media. However, such popularity has to be considered also in relation to the attention that mainstream media eventually gave to Claudia and her journalistic project.

As we argued, through her content curation activity on Twitter, Claudia not only developed niche popularity, but also established a networked community that, by amplifying her actions, made her more visible over time, creating the basis for the development of her status as a microcelebrity. In this regard we can think of microcelebrity as a technique that "involves people 'amping up' their popularity over the Web using techniques like video, blogs, and social networking sites" (Senft, 2008: 25). In microcelebrity practices on social media therefore, we face a code-switching between fans and friends, audiences and communities (Senft, 2013).

It should be noted that the goal of microcelebrity practices is not necessarily to transform such authority in mainstream popularity; rather it might just be to keep or develop a status within a specific community. However, especially within current hybrid information ecosystems (i.e. systems where legacy, web and social media spheres are highly intertwined and characterised by a continuing mutual reference, see Chadwick, 2013) it is not unlikely that

the online microcelebrity eventually attracts the attention of the mainstream media. Such mainstreamisation has two effects for the microcelebrity: the first one is obviously the amplification of celebrity, while the second is a partial loss of control, both in the representation of the self and in the relationship with fans/friends, and more generally with the communities inhabiting the milieu where the celebrity was originally developed.

When Twitter became newsworthy for the mainstream, the Italian media "exploited" Claudia and TOWS to tell the public about the emergence of new personalities and new funding models within social media economies. In this way Claudia was transformed into a public figure and was brought out of the Twittersphere to become the object – not just the subject – of a narrative that spread across different media and arenas.

As described in section two, we analysed the content of all articles addressing TOWS written on online news outlets between February and April 2012 and found a general highly supportive attitude toward the project. For example, on 11 February Riccardo Luna, the former editor in chief of the Italian edition of *Wired,* wrote a strong endorsement for TOWS in the evening edition of *La Repubblica*[7] arguing that Claudia's activity on Twitter, as well as her crowdfunding campaign, was anticipating the future of journalistic practice in digital environments. Journalistic recounts of TOWS frequently described the project as an opportunity to revive journalistic practice, while the absence of any professional reporting experience in Claudia's background was never mentioned as something negative. Moreover, in presenting Claudia, journalists mainly adopted professional definitions: she was called a "correspondent," a "freelance journalist," a "reporter."

What emerged from our analysis is a sort of "cooptation" where an amateur project and a new business model, instead of being demonised as potentially destabilising the status quo, were re-conducted under the umbrella of journalism. Such a cooptation however should be interpreted as strategic, since by uncritically accepting Claudia within their "family," journalists partially de-problematised the impact, for their own profession, of the emergence of crowdfunding practices. This strategy could be recognised also in the fact that, despite the reference to journalism, the main focus of the articles was frequently the quick and positive answer of the crowd and the trust showed for Claudia. This frame transformed TOWS into a tale: the story of a previously unknown young woman who became a celebrity on Twitter, getting money from her community of fans. On the website of *L'Unità* newspaper, Buquicco and Loy (2012) wrote:

> It is easy to get attention social media if your name is Jovanotti [Italian pop star active on Twitter]. It is much more difficult and challenging if you are tweeting

from your cottage in Busana, a small village on Reggio Emilia mountains. But @tigella managed it, becoming a personality with more than 10 thousands followers, with tweets much more influential than columns on newspapers and hashtags more followed than press releases from the government.

In conclusion, the mainstream celebrification of Claudia was more helpful for the media in transforming her and the project into everyday news than in opening up a real debate on the future of newsmaking and the role crowdfunding could have in it. The "fairytale" of Claudia produced by mainstream media was not at all in contradiction with the high personalisation that we found in analyzing funders' motivations. On the contrary, it contributed to frame Claudia's activity and status online in terms of stardom. However, the fact that this vision of Claudia was not just shared within the inner circle of her friends/followers/fans autonomously, but instead projected outside for the consumption of the mainstream public fostered a tense and highly polarized debate online.

We can say that the online popularity of Claudia, associated with the recognition given by the mainstream media, built a particular context of expectation and tension around the project. TOWS becomes an area of negotiation and conflict in relation to microcelebrity practices of Claudia's visibility and also to the idea of a monetisation of her popularity with the connivance of the mainstream media. In the next section we will present and try to interpret such debate.

Who Deserves Celebrity Online? And When Is It Fair to Monetise It?

When Claudia launched the campaign and especially after TOWS received the attention of the media, a multitude of different opinions and judgments emerged online, reflecting different visions of celebrity, professionalism, and also of the appropriateness for her to launch the crowdfunding appeal. We believe that mapping these reactions – through the qualitative approach presented in section two – is fundamental to track the impact TOWS had on the Italian information ecosystem. In this regard we have identified three main frames within which different subjects and communities discussed online Claudia and TOWS' success: activism, professionalism, and celebrity.

Activism frame

Many among those who discussed TOWS online argued that it was inappropriate to use the popularity acquired with non-profit activities, and by

adopting an activist attitude (that we briefly described in the introduction), to develop it into a for-profit project. As emerged from comments to the TOWS launch post, many considered the budget of TOWS not to be coherent with what they viewed as an alleged activism project:

> Weren't you supposed to occupy? Sleeping in a hotel?! Is this the new generation of activists? Poor us![8]

For the majority of those who adopted the "activism" frame to interpret the project, the choice of the story to be covered – the Occupy Wall Street movement – was also controversial, with many questioning the real "alternativeness" of the project. Commenting on an article criticising TOWS written by Bernardo Parrella (the coordinator of *Global Voices* online-Italy) on LSDI, Carlo Gubitosa, a well-known media activist, wrote:

> If Claudia had proposed a reportage on the US homeless, instead of proposing something on the movement currently most covered by media, would the reaction/interest/support of the public have been the same?[9]

What is argued here is that TOWS (and possibly journalistic crowdfunding in general when not supported by a preliminary grassroots discussion) reproduced *de facto* the mainstream media logic, i.e. establishing an obsessive focus on a single big story that receives the attention of all media outlets and forgetting all the rest. Thus, the issue of collaboration appeared to be very relevant for those focusing their attention on the "social and civic dimension" of TOWS. One of the promoters of Youcapital, a short-lived platform for crowdfunded reporting, commented on the same post:

> Experiments in community funded reporting like Spot.us in the USA aren't built over the extemporaneous decision of an individual to develop a personal project. On Spot.us local communities of citizens are involved, together with reporters, in the definition of projects to fund and discuss opportunities and the collective interest of a story.[10]

Claudia's alleged exploitation of a manufactured self-representation as an activist was highly criticised, especially by those arguing instead to be authentic activists on the basis of their documented backgrounds in political activism. On identi.ca, a niche open source social networking platform used especially by activists, the user *Detta_Lalla*, started a heated discussion by writing:

> I organized and took part in 7 internationalists camps, in 4 IIRE international seminars, in 3 Social Forums, I was in Genoa during the G8, send me to #occupychicago[11]

With this provocation the user was questioning the "curriculum" of Claudia, implicitly arguing that her militant approach on Twitter was instrumental and that she was lacking an authentic background in activism, essential for a proponent to be funded for a media-activism project.

To conclude, the majority of those who interpreted TOWS' crowdfunding within a frame of activism criticised the fact that a real collaborative process was completely missing. They considered TOWS to be an individualistic project disguised as a "civic" or "activist" initiative.

Professionalism frame

Among those who, in their online interventions and comments, adopted professionalism as a main frame for interpreting TOWS' relevance, the reference to the quality of the project and to the lack of competence of Claudia have been frequently mixed. It should be preliminarily noted that, according to our study, a large majority of those who chose such a specific frame to discuss TOWS were professionals active in the online environments.

Bratiakaramazovy – which is the nickname of a digital strategic planner and web content specialist – questioning the identification of Claudia's activity as a professional activity, wrote on her blog:

> A smartphone, some social media curation experience and the right tweet at the right time don't transform a netizen into a reporter.[12]

Another web professional, blogging as *Annie*, stressed the distinction between different competences within online skills spectrum, and the difference between a professional know-how and a naive, presumptuous enthusiasm:

> A girl, experienced in tweets selection and retweeting has decided to make it big and personally produce contents on current affairs. (...) Whether or not the girl in question is also experienced in video-making, news-writing or other is impossible to know. For what I understand she has never even live-blogged a small town festival.[13]

The vague description of the project and of the coverage plan presented on the TOWS campaign launch post was criticised by many, in particular by those claiming a professional experience in developing projects online.

To summarise, the majority of those who framed TOWS in terms of professionalism recognised how crowdfunding should be considered as an important mean to innovate business models related to information and knowledge projects, especially within web or hybrid environments. However almost all of them stressed the belief that projects should be developed over a

strong professionalism and not just by simply capitalising and monetising on extemporaneous popularity.

Celebrity frame

Tech-savvies as well as early adopters of Twitter and more "geeky" social media platforms like Friendfeed reacted to the process of sudden mainstream-isation – also via Claudia – of what for them was a familiar environment with annoyance and sarcasm. In their discussion of TOWS these subjects often showed intolerance to mainstream media simplification and exaggerations and wanted to mark a distance between their understandings of the Inter-net and the "ignorance" of mainstream media. Moreover, many considered Claudia to be "conniving" with media representation of her work as part of a calculated strategy of self-celebrification to be monetised. This was accom-panied by dynamics typical of online communities, where the emergence of personalities or opinion leaders frequently generate into hostile and satirical reactions manifested through specific practices, such as flaming, trolling, or the creations of fake profiles (Bergstrom, 2011).

For example, the anonymous person who created a fake Twitter account named "tirella" (which could be translated as "puffed up girl") to mock Clau-dia, when asked about TOWS argued:

> Tigella works in overselling mode, pushing as important irrelevant things (...) She spreads compulsively initiatives more useful to her popularity and self-esteem than to real causes.[14]

Claudia was thus accused of employing tactics of microcelebrity to transform herself into a brand by flirting with the mainstream media. Some Friendfeed users ironically argued, in more than one discussion thread, that Claudia had chosen to travel to New York for tourism or for shopping reasons, while an-other user mocked her, posting an improbable request for funds "to have a sex meeting with an escort paid by the crowd."

To conclude, media attention and the consequent scaling up of Claudia's popularity unleashed simultaneously a process of mainstream legitimation and a process of de-legitimisation within the niche community where Claudia cultivated her initial capital of popularity. Such a community became clearly polarized in its reaction to TOWS: while a part of it supported Claudia and assumed the nature of a fan community (as we have described in the section on the crowdfunders), another disowned her.

For those who critically focused their discussions around TOWS on Clau-dia's "puffed up" celebrity, the issue was not the quality of her crowdfunding

per se but the fact that she was exploiting crowdfunding as a way to monetise and increase further a popularity she did not deserve.

Conclusions: Is Monetising Social Media Microcelebrity a Sin?

Claudia was in the U.S. from April 30 to May 23, 2012. She used almost exclusively Twitter to report and curate stories regarding Occupy Wall Street movement's activities and protests, however she also created a blog where all the pictures, videos, and notes collected were stored. After TOWS, Claudia established a professional activity as social media manager (mainly related to non-governmental and civic initiatives) and consolidated the status of "personality" within the national Twittersphere. For example when, in January 2013, Mario Monti – at the time serving as Prime Minister – organised a Twitter chat to launch his newborn political party and replied almost exclusively to journalists and opinion leaders, Claudia had the "privilege" to be the first to get answered.

In this article we have focused on a very specific moment of Claudia's path to transform her amateur passion for curating stories on Twitter into a professional activity. As we have described, the convergence between the explosion of Claudia's microcelebrity in mainstream popularity and the "passing" from amateur non-profit activities to a for-profit "professional flavour" project, generated a discursive context that polarized the communities in which she had originally built her reputation as well as those potentially "invaded" by the project. Different visions of what a good or even fair crowdfunding campaign for a journalism project is about have emerged, as a result of competing interpretations of Claudia's path to celebrity and of the real nature of the project.

A first implication of our research has to do specifically with the dimension of funders' relationships with the proponent in reporting-based crowdfunded initiatives. We have described how Claudia's funders assumed the nature of a fan community, expressing a very limited interest for the story she proposed and having almost no concern for her lack of experience in newsmaking. This finding calls for reconsidering the idea that, with the development of a pro-am information environment and the emergence of crowfunding practices, the position of journalist as a "hero" is necessarily fading away (Flew and Wilson, 2010), being replaced by a less personalistic and more collaborative model.

At the same time, by considering also the perspective of subjects that, while paying attention to Claudia's activity, did not fund the project, we saw the emergence of a highly critical debate around TOWS. This finding represents what we believe is a second and possibly more important implication of our study: crowdfunding initiatives, under certain circumstances, might

generate symbolic conflicts that represent important occasions to better understand how a broader system reacts to transformations. The case of Claudia shows how a crowdfunding campaign launched by a web microcelebrity – especially when developed around an activist or at least a civic interest initiative – could easily become an occasion for a deep symbolic conflict since it can be alternatively interpreted as the monetisation process of a relationship previously based on gratuity or as the highest expression of reciprocity. Indeed, according to our interpretation one of the main questions TOWS ultimately posed was: when and under what circumstances is it fair to monetise popularity gained online? In this regard TOWS generated such a conflictive reaction because it was developed within a double "moral economy" (Thompson, 1993) environment, a concept that could indeed be perfectly applied to the relationship between social media reputation and use of this reputation to get funds from the crowd. On the one hand – as emerged by analyzing funders' motivations – it can be seen as part of a moral "gift economy" based exchange: Claudia had undertaken for free her activity of curation on Twitter, she has donated her time and expertise to an online community, and was funded by the same community as part of a logic of reciprocity (see Pearson, 2007). On the other hand –as emerged by considering the perspective of those criticising it – TOWS can also be read as a moral "entrepreneurial economy" based initiative: Claudia took advantage of her reputation by asking to be funded for a project she did not have specific expertise to carry out, exploiting her position as a microcelebrity.

We are aware that TOWS represents a very specific case; for this reason we are very cautious in generalising our findings. However we believe that our attempt to adopt a broad systemic approach – albeit through a qualitative research – unveiled a very nuanced reality potentially emerging around crowdfunded journalistic initiatives that still has to be fully addressed by research. In particular, future studies could either consider similar cases in different national systems or adopt a comparative approach in order to understand to what extent contextual patterns (such as journalistic culture, nature of media market, diffusion of crowdfunding practices) affect the way individuals and communities react to project like TOWS and to personal/professional paths like the one of Claudia Vago.

Notes

1. This chapter is the result of a collaborative research, however in accordance with Italian academic conventions we specify that Augusto Valeriani wrote the sections 3, 5.1, and 5.2, while Giovanni Boccia Artieri wrote the sections 4 and 5.3. The two authors collaborated in writing sections 1, 2, and 5.

2. Vincenzo Cosenza (http://vincos.it/2011/12/01/twitter-in-italia-analisi-dei-segnali-di-crescita/) using Audiweb/Nielsen data, stressed a significant increasing in the number of Twitter users per month in Italy between December 2010 (1.3 million) and October 2011 (2.4 million).

3. http://tigella.altervista.org/manda-tigella-a-occupare-chicago/

4. The combinations of keywords adopted to retrieve the articles were: "Claudia Vago" AND "tigella," "Claudia Vago" AND "Occupy Wall Street," "Claudia Vago" AND "crowdfunding," "Tigella" AND "Occupy Wall Street," "Tigella" AND "crowdfunding."

5. We chose Friendfeed and Identi.ca since, albeit niche services in Italy, they are used mainly by tech savvies (Friendfeed) and activists (identi.ca). Conversations were retrieved by querying internal search engines and by adopting the keywords "tigella" and "Claudia Vago." All the relevant conversations having more than 20 single messages were included in the analysis (N=8).

6. Coherently with the described methodology, we specify that (excluding for those taken from open answers to our survey and from the e-mail interview with the anonymous person behind Claudia's fake profile) all the quotes presented within the chapter are taken from public online pages.

7. The article was also republished online by *Il Post* newspaper at http://www.ilpost.it/riccardoluna/2012/02/11/il-futuro-del-giornalismo-lo-scopriremo-forse-seguendo-tigella-che-va-a-chicago/

8. See note 3.

9. http://www.lsdi.it/2012/perche-non-e-il-caso-di-mandare-qualcuno-a-chicago/

10. See note 9.

11. http://identi.ca/conversation/90400890

12. http://ifratellikaramazov.wordpress.com/2012/02/16/il-giornalismo-e-morto-viva-il-giornaliso-1-or-occupychicago/

13. http://danzasullacqua.wordpress.com/2012/02/13/disinformazione-reintermediata-e-supercazzole-2-0/

14. E-mail interview June 2012.

References

Aitamurto, T. (2011). The impact of crowdfunding on journalism. *Journalism Practice*, 5(4), 429–445.

Anonymous, Interview via e-mail, June 2012.

Bergstrom, K. (2011). "Don't feed the troll": Shutting down the debate about community expectations on Reddit.com. *First Monday*, 16(8).

Boccia Artieri, G. (2012). Productive publics and transmedia participation. *Participations: Journal of Audience and Reception Studies*, 9(2), 448–468.

Buquicchio, C. & Loy, M. (2012). Addio giornali, inviata a Chicago ci vado con i follower di Twitter. *L'Unità* (website), 15 February 2012. Retrieved from http://www.unita.it/tecnologia/addio-giornali-inviata-a-chicago-br-ci-vado-con-i-follower-di-twitter-1.382085

Burtch, G., Ghose, A., & Wattal, S. (2013). An empirical examination of the antecedents and consequences of contribution patterns in crowd-funded markets. *Information Systems Research*, 24(3), 499–519.

Carvajal, M., Garcia-Aviles, J. A., & Gonzalez, J. L. (2012) Crowdfunding and non-profit media: The emergence of new models for public interest journalism. *Journalism Practice*, *6*(5–6), 638–647.

Chadwick, A. (2013). *The hybrid media system: Politics and power*. Oxford: Oxford University Press.

Flew, T. & Wilson, J. (2010). Journalism as social networking: The Australian *youdecide* project and the 2007 federal election. *Journalism*, *11*(2), 131–147.

Gerber, E. M., Hui, J. S., & Kuo, P. Y. (2012). Crowdfunding: Why people are motivated to post and fund projects on crowdfunding platforms. In CSCW Workshop.

Jenkins, H. (2006). *Convergence culture: Where old and new media collide*. New York: New York University Press.

Jian, L., & Shin, J. (2014). Motivations behind donors' contributions to crowdfunded journalism. *Mass Communication and Society*, DOI: 10.1080/15205436.2014.911328

Jian, L. & Usher, N. (2014). Crowd funded journalism. *Journal of Computer Mediated Communication*, *19*(2), 155–170.

Marwick, A. E. (2010). Status update: Celebrity, publicity and self-branding in Web 2.0. PhD dissertation, New York University.

Marwick, A. & boyd, D. (2011). To see and be seen: Celebrity practice on Twitter. *Convergence*, *17*(2), 139–158.

Pearson, E. (2007). Digital gifts: Participation and gift exchange in Livejournal communities. *First Monday*, *12*(5).

Senft, T. (2008). *Camgirls: Celebrity and authenticity in the age of social networks*. New York: Peter Lang.

Senft, T. (2013). Microcelebrity and the branded self. In J. Hartley, J. Burgess, and A. Bruns (Eds.), *A companion to new media dynamics*, pp. 346–354. Hoboken, NJ: Wiley-Blackwell.

Thompson, E. P. (1993). *Customs in common: Studies in traditional popular culture*. New York: New Press.

8. Because It Takes a Village to Fund the Answers: Crowdfunding University Research

DEB VERHOEVEN AND STUART PALMER

"The first point to emphasise is that the crowd never feels saturated".
ELIAS CANETTI, CROWDS AND POWER, 1978: 22

Introduction

Whichever way you look at it, online crowdfunding is ramifying. From its foundations supporting creative industry initiatives, crowdfunding has branched into almost every aspect of public and private enterprise. Niche crowdfunding platforms and models are burgeoning across the globe faster than you can trill "kerching". Early adopters have been quick to discover that in addition to money, they also get free market information and an opportunity to develop a relationship with their market base.

Despite these evident benefits, universities have been cautious entrants in the crowdfunding space and more generally in the emerging "collaborative economy" (Owyang, 2013). There are many cultural and institutional legacies that might explain this reluctance. For example, to date universities have achieved social (and economic) distinction through refining a set of exclusionary practices including, but not limited to, versions of gatekeeping, ranking, and credentialing. These practices are reproduced in the expected behaviours of individual academics who garner social currency and status as experts, legislators, and interpreters (Osborne, 2014: 435). Digitalization and the emergent knowledge and collaboration economies have the potential

to disrupt the academy's traditional appeals to distinction and to re-engage universities and academics with their public stakeholders. This chapter will examine some of the challenges and benefits arising from public micro-funding of university-based research initiatives during a period of industrial transition in the university sector.

Broadly, then, this chapter asks: what does scholarship mean in a digital ecosystem where sociality (rather than traditional systems for assessing academic merit) affords research opportunity and success? How might university re-search be rethought in a networked world where personal and professional identities are blurred? What happens when scholars adopt the same pathways as non-scholars for knowledge discovery, development, and dissemination through use of emerging practices such as crowdfunding? These issues will be discussed through detailed exploration of a successful pilot project to crowdfund univer-sity research, *Research My World*. This project, a collaboration between Deakin University and the crowdfunding platform pozible.com, set out to secure new sources of funding for the "long-tail" of academic research. More generally, it aimed to improve the digital capacity of the participating researchers and create new opportunities for public engagement for the researchers themselves as well as the university. We will examine how crowdfunding and social media platforms alter academic effort (the dis-intermediation or re-intermediation of research funding, reduction of the compliance burden, opportunities for market vali-dation, and so on), as well as the particular workflows of scholarly researchers themselves (improvements in "digital presence-building," provision of cheap alternative funding, opportunities to crowdsource non-academic knowledge).

In addressing these questions, this chapter will explore the influence that crowdfunding campaigns have for transforming contemporary academic practices across a range of disciplinary instances, providing the basis for a new form of engagement-led research. To support our analysis we will provide an overview of the initiative through quantitative analysis of a dataset generated by the first iteration of *Research My World* projects.

Crowdfunding University Research

Traditionally, the main source of funding for university research comes from either private (both philanthropic and commercial) or government grants. Typically the application process for these grants is labour intensive and car-ries a high compliance burden. This in turn inflates the cost of the research grant to both the university and the research team. Grant schemes are usually highly competitive with low success rates (in Australia government research grants are given to less than 20% of the applicants), favour experienced or

senior researchers, and take considerable time to be processed thereby delaying potential discoveries. The barriers are particularly high for early career scholars who are nevertheless under significant pressure to produce a successful research profile in order to secure employment.

In December 2012 pozible.com (currently the world's third largest crowdfunding platform) and Deakin University agreed to create an opportunity for the community funding of university research. Adopting an "all or nothing" strategy for crowdfunding, *Research My World* launched to the public in May 2013 with eight projects spanning a range of discipline areas and project types. Subsequent campaign rounds occurred in September 2013 and April 2014 and the programme was expanded to include research bids from other universities and research centres.

Although it is very early days, the crowdfunding engagements that have arisen within the university sector itself are typically based on one of three models:

1. Student Incubators. These initiatives typically focus on graduates in business-related disciplines and are intended to drive the development of entrepreneurial opportunities for students. Typically these efforts have been generated by the university's enterprise division. Examples of this foray into crowdfunding can be found at Trinity College, Dublin, at the University of Vermont's Start programme and at Georgia Tech's Starter initiative.

2. University-level Fundraising Programmes. In this model universities use existing philanthropic networks (particularly those derived from alumni projects) to channel donations through an internally administered crowdfunding platform. To date this activity is typically driven by a university's advancement division. Notable early adopters deploying this strategy to specifically support research include the Georgia Institute of Technology, University of California (San Francisco) and the University of Virginia's USEED initiative. In the UK, Hubbub offers a purpose built social funding service to universities, colleges, schools, and their students and staff. Hubbub works principally through the existing mechanisms within universities designed to bolster philanthropic activity ("advancement") or entrepreneurship ("enterprise").

3. Disaggregated Crowdfunding Effort. This is by far the most common form of university crowdfunding in which students and staff seek crowdfunding opportunities using external platforms. Within this model, several different options for crowdfunding research have emerged. Platforms such as Microryza, RocketHub, Experiment.com, and Petridish have recently emerged to specifically support STEM

research. Another early site devoted to science fundraising, Geek-Funder, has already closed. Generally these sites are also limited to dealing with research at the project level rather than forming institutional or sectoral partnerships. As a result the net benefits of these sites are correspondingly reduced.

In this context, Deakin University's foray into crowdfunding was unique on several counts. First, it emerged from the university's research portfolio rather than its advancement or enterprise divisions, although these were active participants throughout. Second, the university chose not to develop its own platform or host one on its own website but to "follow the crowd" by forging a formal relationship with an existing and successful crowdfunding platform: pozible.com.

Deakin's partnership with Pozible was explicitly intended to provide a funding avenue for early career researchers and/or for projects requiring only modest investment. Project size ranged between $5,000 and $20,000 and the participants were supported by the university's marketing, public relations, and social media divisions. Participants were, however, expected to manage their campaigns on their own terms and to develop and use their own networks and communities of interest.

Campaigns operated on an "all or nothing" basis and for the most part adopted a hybrid donation and reward model. This enabled the university to offer supporters a deductible tax receipt. In the first round, more than 700 supporters, ranging from individuals through SMEs to large companies, financially backed the projects and the programme achieved a 75% success rate. Above and beyond the evident financial rewards, *Research My World* held a wide range of ambitions, most notably to:

- Encourage community agency in university research
- Use crowdfunding as an opportunity to promote individual agency on the part of the researcher
- Identify crowdfunding as a sign of institutional ambition and/or capacity
- Promote academic research in terms of its meaning to communities and not just other academics
- Shift the way universities promote research in an increasingly networked environment
- Provide a "discipline-neutral" opportunity; both science and humanities-creative arts were able to generate funds if community relevance was demonstrated.

As academic researchers ourselves, we were keen to emphasise the way that crowdfunding provided the public an opportunity to go beyond just supporting the project at hand by also signaling their support for an idea or approach. In fact in our experience, projects that were able to connect with abstracted or ambitious ideals (conservation, sustainability, social equitability and so on) were more likely to succeed. Scholars benefited from being able to demonstrate that their projects were extending the available "marketplace" of ideas, values, and opportunities. More surreptitiously we also sought to influence the behaviour of the different actors in the crowdfunding exchange by creating closer links between researchers and the communities that would benefit from their work. Our intention was to leverage from these altered behaviours and thereby also influence the way both academics and members of the public engage with existing institutional structures. What we hadn't intended but that did emerge during the course of the campaigns, was an active discourse around the idea that crowdfunding was an indicator of sectoral limitation; that *Research My World* was either a harbinger or worse, a possible cause of diminishing funding opportunities for academic research.

Research My World

The first iteration of *Research My World* has been highly influential for establishing the workflows of university crowdfunding in Australia and the specific experiences of these first eight projects is the basis for the detailed analyses in this chapter. After the university's research division gave the green light, a small team of six staff members (including senior, mid-career, and early career academics as well as diverse registers of non-academic staff) was formed via the university's Yammer account (an enterprise social network for staff and a smattering of students). This team, in consultation with staff from Pozible, established the *Research My World* methodology and undertook to provide formative and summative project evaluation to the university and the wider sector (Verhoeven et al., 2013).

A university-wide call for proposals prompted twenty-one applications which were assessed by the project team and representatives from Pozible. These were measured for their suitability for a crowdfunding campaign (rather than their merits as research projects per se) and a final list of eight projects from a wide array of research disciplines was selected to proceed. Applications took the form of a short online survey in which prospective participants answered questions about their project, the scale of their social media use and networks, their understanding of project stakeholders, and so

on. Selected project leaders were then invited to attend a short workshop to enhance their social media skills, establish their project materials (videos, images, websites, and so on) and otherwise prepare them for the demands of campaigning. The eight projects that proceeded in this first iteration of *Research My World* (and that form the basis for the analyses in this chapter) were:

Table 8.1: Research My World projects.

Project title	Project URL	Research Discipline
Mighty Medical Maggots to fight the Bairnsdale Ulcer	http://pozible.com/mightymaggots	Health and Medical Sciences
Products of Play: Caching in on Australian Gamers	http://pozible.com/playcache	New Media and Creative Industries
Voyages of Discovery	http://pozible.com/voyagesofdiscovery	Remote Sensing and Aquatic Biology
How salty is your seafood?	http://pozible.com/saltyseafood	Environmental Science
Would you like seaweed with that?	http://pozible.com/seaweed	Marine Biology
Retake Melbourne	http://pozible.com/retakemelbourne	Creative Arts and History
Discovering Papua New Guinea's Mountain Mammals	http://pozible.com/tenkile	Applied Ecology and Conservation
Healthy Gigglers	http://pozible.com/infantprogram	Nutrition and Population Health

Surprisingly, immediate interest in the programme was expressed, almost exclusively, by very senior researchers although this quickly waned when the project parameters were explained to them (small financial gains for a large social media effort). This curiosity from senior academics indicates the perceived value of some of the less tangible benefits of the crowdfunding process, such as the easier and more efficient application process than typically required by traditional research programmes.

From the outset, in conceptualising their crowdfunding projects, the participating researchers were challenged to alter their customary approach to research applications, particularly in the following areas:

- Radically shorter application and approval timeframe (projects needed to be ready to go in weeks rather than months or years)
- No long written scholarly documents but a requirement for digital and social media skills
- Emphasis on plain language communication rather than the specialised language necessitated by peer review
- A "flipped funding model". Researchers were required to identify minimal funding targets rather than the aspirational (and even amplified) budgets suggested by traditional grants, which are then renegotiated when they aren't fully funded. Once research-by-crowdfunding targets are reached the money is fully funded (less credit-card and platform fees) and targets can in fact be exceeded.
- The use of incentives to encourage donations required our researchers to begin to think beyond the parameters of project PR and more like marketers.
- Treat crowdfunding as a first rather than the final step in the financing process; as an opportunity to "pre-sell" the research itself and trigger later investment interest.

A clear expectation of *Research My World* was that campaigns would be driven by and focus on, individual researchers rather than the university. This placed significant pressure on the participants to "own" their campaigns at all levels. Post-project questionnaires indicated that researchers were underprepared for the amount of time and work their campaigns involved (Verhoeven et al., 2013: 6). For other researchers, the requirement to adopt an iterative approach to their campaigns and to adapt their campaign parameters and expectations continuously proved especially challenging and reflected broader changes in the space-time organisation of traditional academic research praxis than they anticipated. For example, placing the researcher at the centre of the campaign made familiar binary distinctions such as academic/non-academic almost untenable. The effort of linking a previously "private" Facebook account to their funding campaign proved a bridge too far for some. Other researchers based at regional campuses found they had become overnight celebrities through their promotional efforts and the comforts of academic anonymity were rudely replaced with public accountability to a much wider set of stakeholders. The heady mix of ideas and affects that contribute to the incomputable X-factor of crowdfunding success constituted unfamiliar terrain for many of the participants. Science-based researchers were particularly tasked to move away from the logic of closed systems and predictable populations when it came to the conduct of their crowdfunding campaigns.

There were also challenges for the other participants in *Research My World*, most notably the university and the crowdfunding platform itself. Whilst crowdfunding can be absorbed into some existing narratives of university enterprise, such as the language of the "pilot study," of experimentation and innovation, for the most part the "light weight" and networked principles of crowdfunding project management challenge the cumbersome organizational, technical, and social infrastructures of universities. Even apparently simple tasks such as creating a university PayPal account became almost insurmountable hurdles. As an "all of university" initiative, involving staff across campuses, disciplines, departments and administrative units, there is an enormous amount of silent, almost invisible work and resourcing, that goes on in the background of a successful research campaign. University actors (researchers, managers, administrative staff) alternately adopted tactical and strategic moves to ensure projects succeeded. The key challenge for universities then, especially those that are looking for the full range of benefits offered by research crowdfunding, is to make the shift from a historical inclination to impose "control" across a full range of institutional behaviours to embracing a disposition of "setting parameters" instead.

Finally, there were also unexpected challenges for the Pozible platform, itself a critical actor in the exercise. *Research My World* began as a Pozible "collection," an aggregation of projects within a sequestered section of the Pozible website. After the success of the first round of projects, Pozible elevated research initiatives to a core category within their site architecture, improving discoverability and opening up research crowdfunding opportunities to other universities, research centres, and individuals. At every level of software and interface design, of "back-end" technology and user experience (by both researchers and donors) there were complexities presented by university research that required creative workarounds. Questions as to how much intermediation was required by the platform and how much needed to be pre-empted by the university were constant. For example, what of the expectation that university researchers have pre-approved ethics checks against their planned activities? How to deal with non-online transactions such as checks or money-orders, which were preferred by many project donors? So whilst academics grappled with the demand for improved digital capacity, the crowdfunding platform dealt with the sometimes resolutely pre-digital preferences of university and public stakeholders. This suggests that in practice, rather than creating opportunities for the disintermediation of university research, crowdfunding is actually a matter of creative re-intermediation in which the crowdfunding platform rearranges the terms of engagement between the university, the researcher, and the public.

Friends with Community Benefits: Digital Capacity Building

To better understand the reorganisation of effort and capacity involved in crowdfunding university research, the *Research My World* team collected a wide range of quantitative project-related data. Unlike the guarded nature of peer-based decision-making in traditional research funding systems, we were inundated with data for measuring the project campaigns as they developed and assessing the paths to project success.

Given that it is a relatively recent phenomenon, research identifying the characteristics of, and factors that contribute to, a successful crowdfunding campaign, has only recently emerged. Studies can be broadly divided into those using qualitative methods based on interviewing campaign principals (Hui, Gerber, & Greenberg, 2012; Klaebe & Laycock, 2012) and quantitative methods seeking associations between measurable project dimensions and success status (Hekman & Brussee, 2013; Lu, Xie, Kong, & Yu, 2014; Mollick, 2014; Saxton & Wang, online early).

For *Research My World*, a data set of more than fifty variables for each of the eight projects was collected, covering project characteristics including:

- amount of funding requested/pledged;
- project success status;
- project interactions via the Pozible project website;
- Twitter data;
- Facebook data;
- YouTube data; and
- traditional media reporting.

Using quantitative analysis of the available project-related data we can make some preliminary observations of the critical factors for project success. As with any large data set, one way to identify the significant variables of interest is to individually assess their association with campaign success status (Hekman & Brussee, 2013; Lu et al., 2014; Mollick, 2014). Two useful measures of association – Spearman's rank correlation coefficient (ρ) and Kendall's rank correlation coefficient (τ) (Sheskin, 2007) – were calculated in order to ascertain the association between project success status and all the other variables we collected. A strong association with project success status as a dependent variable required both ρ and τ to have a value greater than 0.6, and for the correlation to be significant ($p \leq 0.05$). There were eight dependent variables in our data that met these criteria. However, some of these variables are almost certainly inter-correlated with each other and we used Principal Component Analysis (PCA) to re-map the input variables into a new

set of variables. PCA reduces the eight variables above to three that have the following factor structure:

1. the diameter of the Twitter network, the average directed path length of the Twitter network, the average undirected path length of the Twitter network, and the average Twitter network Erdős number for project principal – explaining approximately 48% of the variation in the original data (i.e., factors relating to the reach of the project's Twitter network);
2. the number of social media shares from the Pozible project website, the total page view count for the Pozible project website and the total unique page view count for the Pozible project website – explaining approximately 37% of the variation in the original data (i.e., factors relating to the ability of the project to attract eyes to its Pozible website and then get the website on-shared); and
3. the average pledge amount – explaining approximately 14% of the variation in the original data.

If these three transformed variables are computed for each project and the associations of these new variables with project success status are tested, then significant associations can be shown between transformed variables one and two, and project success status. On the other hand, variable three relating to average pledge amount did not have a significant association.

Limitations of the Research

The number of research crowdfunding projects included in this analysis is only small – just the first round of eight *Research My World* projects. Within those eight projects, there are significant variations in their characteristics, i.e., amount of funding sought, duration of campaign, research topic area, and so on. Given these limitations it is possible to say that the observed measures of correlation indicate a potential association between variables, but do not definitively represent a causal link between them, and they do not provide a total basis for predicting project success.

Acknowledging the limitations of the analysis above, from the first transformed variable, it seems clear that social media can play an important part in contributing to the success of a crowdfunding campaign. Anecdotally, those describing their research crowdfunding experiences identify social media communication as significantly improving their prospects of project success (Perlstein, 2013). Notably, while crowdfunding per se is not new,

the harnessing of social media for viral marketing and mobilisation of online communities is a new development (Hemer, 2011). Social network effects take precedence over traditional economic explanations of participation and investment (Saxton & Wang, online early). Those seeking crowdfunding who have a higher "social capital" are likely to have a higher probability of success (Wu, Sun, & Tan, 2013). In this sense it can be argued that online crowdfunding is the quantification (monetisation) of one's (online) social capital (Hui et al., 2012).

Be Sweet and Retweet

In analyzing the *Research My World* projects, transformed variable one suggests that characteristics of the project principal's Twitter network are a significant factor in determining project success – indeed others have also made this observation (Lu et al., 2014). The NCapture programme is able to capture all publicly available data (Tweets and Retweets) originating directly from a specific Twitter account, as well as data arising from a search for Tweets containing specific keywords. Twitter project-related data was captured during the period of the crowdfunding initiative. The NVIVO programme was then used to convert the captured Twitter data into Microsoft Excel spreadsheets. In all, 3668 *Research My World*–related Tweets were recorded, representing 982 unique Twitter account handles and 7758 separate Twitter messages.

For each of the projects, the spreadsheet Twitter data were exported in comma separated values (CSV) format, and then imported into the Gephi programme to analyse the Twitter communication network embodied in the data for each project. Gephi can evaluate a range of standard network parameters that characterise the structure and topology of a network (Hekman & Brussee, 2013). The network path length between any two nodes (in this case, Twitter accounts) in a network is the shortest number of edges (links/hops between nodes) that must be traversed to get from one node to the other. If we consider the "direction" of a Tweet as being "from" the Tweeter and "to" the recipient of the Tweet, then we can assign a direction to network edges, and the directed path length between two nodes is the shortest number of edges in the same direction that must be traversed to get from one node to the other. If we consider one node in the network to be a reference point, then the Erdős number for any other specific node is the undirected path length between that specific node and the reference node. The four Twitter network parameters noted above as being significant are:

1. the diameter of the Twitter network – defined as the largest undirected path length between any two nodes in the network;
2. the average directed path length of the Twitter network – the sum of the lengths of all unique directed paths in the network divided by the number of such paths;
3. the average undirected path length of the Twitter network – the sum of the lengths of all unique undirected paths in the network divided by the number of such paths; and
4. the average Twitter network Erdó´s number for project principal – the sum of all Erdó´s numbers for all network nodes other than the project principal divided by the number of network nodes minus one.

All of the four network parameters found to be significantly associated with project success status (and components of transformed variable one) relate to the topological width of the project Twitter network – the more extensive the "reach" of the network, the more likely a project was to be successful. The number of project backers (and hence cumulative funding) was observed to increase with the number of network edges (communication links) and the overall diameter of the Twitter network (Lu et al., 2014). Further, Lu et al. (2014) propose that it is not just the size of the social media network that is important, but also how information is propagated within the network. By accessing the separate personal networks of those individuals in their direct social network, a crowdfunder can reach prospective donors who would otherwise be beyond their direct contact (Saxton & Wang, online early).

From transformed variable one and the wider literature, we are able to conclude that a crowdfunding principal or project should leverage the reach of their social network. They need to maximise the path length of their social media communications related to the project. This is not about sending lots of Tweets per se, but extending the sequence of Retweets and other rebroadcasts about the project to new/unique potential pledgers.

Show Me the Data!

The Gephi programme can also be used to visualise a Twitter communication network by presenting Twitter user accounts as "nodes," and the communication path (representing one or more Tweets) between two nodes as an "edge." In the network diagrams given here, edges are presented as curved lines and the direction of Tweets is clockwise around the edge. The width of an edge is proportional to the total number of Tweets recorded between the two nodes

in that direction, and the size of a node is proportional to the total number of edges (inward and outward) connected to that node.

Importantly, we were able to use these visualisations during the campaign period to advise participants on how to improve their social media performance.

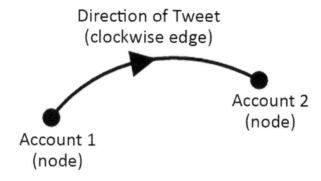

Figure 8.1: Twitter network visualisation schema.

While there is a single topological arrangement of the data for a given network, it can be visualised in many ways. Figure 8.2 shows all the *Research My World*–related Twitter network data arranged using the Yifan Hu layout algorithm (Hu, 2005) provided by the Gephi programme, based on the schema given in Figure 8.1, and with the nodes of the seven project principals that used Twitter as part of the campaign communication strategy indicated by large circles.

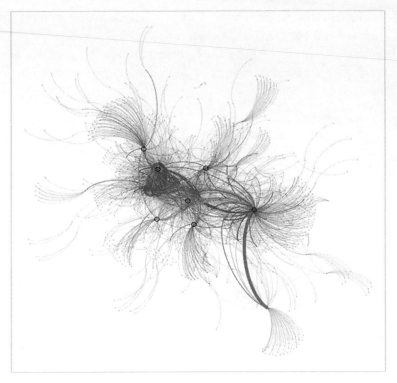

Figure 8.2: Combined Twitter network for all *Research My World* projects.

All of the projects were significantly interconnected in the Twitter communication space. The project principals were known to each other, and there was a wider team supporting the *Research My World* initiative, and together both of these groups provided significant promotion for all of the projects via social media. For comparison, Figure 8.3 and Figure 8.4 provide the visualisations for the separate Twitter networks for a successful project and unsuccessful project respectively. Figures 8.3 and 8.4 are presented using the same scale for node size and edge width. The network of the successful project in Figure 8.3 is clearly larger and more complex than that of the unsuccessful project in Figure 8.4.

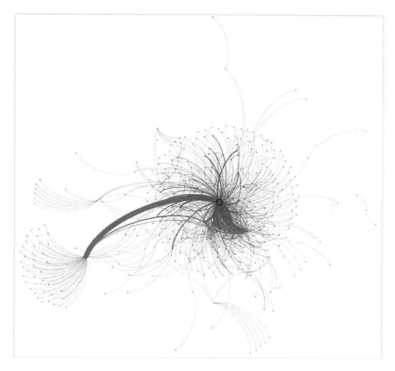

Figure 8.3: Twitter network for a successful *Research My World* project.

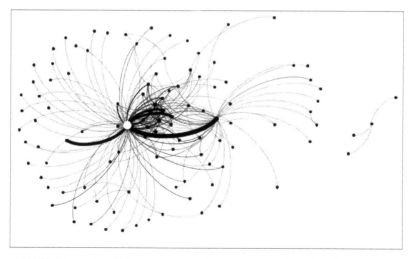

Figure 8.4: Twitter network for an unsuccessful *Research My World* project.

Again, acknowledging the limitations of the analysis above, from the second transformed variable, it seems clear that the amount of eyeball/click traffic into and out of the project website on the Pozible crowdfunding platform can also play an important part in contributing to the success of a crowdfunding campaign. This would seem to support the university's decision to partner with a major crowdfunding platform with vast amounts of website traffic. While not all page views may convert to a funding pledge, a certain percentage will, and an absence of page views represents potential pledges forgone. Some web traffic source information (limited to the high-level domain name) was available for the *Research My World* Pozible project websites. Figure 8.5 is a visualisation of the available traffic source information.

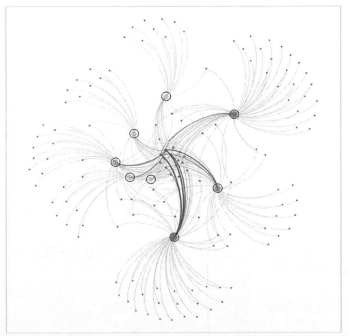

Figure 8.5: All inbound web traffic for the *Research My World* projects.

Inward traffic links to all eight *Research My World* projects are shown as clockwise edges into the project nodes indicated by large circles. Nodes are sized proportionally to the total number of edges connecting to them, and edge widths are sized proportionally to the total number of inward web connections along that path. The overall network diagram shows three principal regions. First, there is a central cluster of inbound traffic sources common to most of the eight *Research My World* project websites.

Second, there is a ring around the central cluster containing the eight *Research My World* project websites, as well as a group of inbound traffic sources common to two or more of the *Research My World* project websites. Finally, there is an outer halo of inbound traffic sources unique to the *Research My World* project website node that they are located adjacent to. This diagram visualises the inbound website traffic information, but does not imply a rate of conversion of this traffic to pledge dollars. Examining the central region of Figure 8.5 more closely, five of these web traffic sources appear in the top six sources for all eight projects, in approximately the following rank:

1. (direct) – representing inbound traffic arising from users entering the Pozible URL directly into their web browser, from links bookmarked in users' browsers, from internal links within the Pozible website, and other sources not 'jumping off' from another web page;
2. t.co – the URL shortening service provided by Twitter, so inbound traffic from project URL links embedded in Tweets;
3. google – inbound traffic from this source is presumably from URLs returned via Google web searches;
4. facebook.com – inbound traffic from this source is from URL links embedded in Facebook posts; and
5. deakin.edu.au – the web domain of the university from which all the *Research My World* research projects originate, so presumably inbound traffic from links to projects in news articles on the Deakin University website.

From transformed variable 2 and the wider literature, we can conclude that a crowdfunding campaign should drive eyeballs to the project website AND encourage those viewers to share the project website with others. Every opportunity should be taken to include a direct, and if possible live clickable link to the project website in any third party references to the project. The general description of the project on the project website, and the message of thanks displayed to pledgers, should ask the reader to hit the appropriate social media share buttons. These simple techniques can have significant influence on a campaign's success.

For the successful projects, data were available describing the time sequence of pledges made. Figure 8.6 is the combined pledge timeline for all *Research My World* projects together. The columns give the daily totals of pledges, with the dollar amount scale given on the left vertical axis. The line gives the cumulative total pledges as a percentage of the total funding

requested by all projects with the cumulative percentage scale given on the right vertical axis.

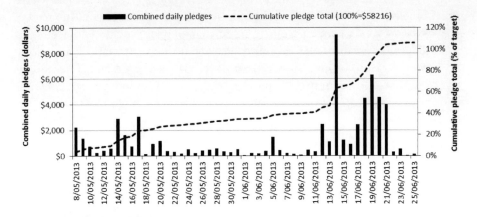

Figure 8.6: Combined pledge timeline for all *Research My World* projects.

While there is some variation in the individual project pledge timelines, they typically show the form apparent in Figure 8.6 – some initial activity, followed by some degree of lower activity producing a rate of pledges that, if continued, would not lead to a successful campaign. However, all of the successful campaigns experienced one or more relatively large pledges late in the day that carried them across the line. It's not clear whether the "crisis" of the impending project close-and-fail brings latent donors out of the woodwork, whether the same circumstance galvanises the project leaders in a surge of promotional activity, or whether some other factor is at play that dramatically increases the pledges at the end of the project. Understanding the characteristics of these late-appearing significant benefactors would be advantageous for future projects.

It is possible to examine the relationship between the time sequence of pledges and the time sequence of other project-related activity, for evidence of correlation. A useful measure is the cross-correlation coefficient (CCF). Time sequence data were available for Twitter and Facebook activity. The power of cross-correlation analysis is increased with the length and richness of the time sequence data, so the project with the richest pledge sequence combined with high levels of project-related social media activity was chosen for detailed analysis. Cross correlation analysis revealed that the strongest and most significant temporal relationship for total dollars pledged per day was with total Twitter activity per day (Tweets plus Retweets plus Mentions). This relationship is visualised in Figure 8.7.

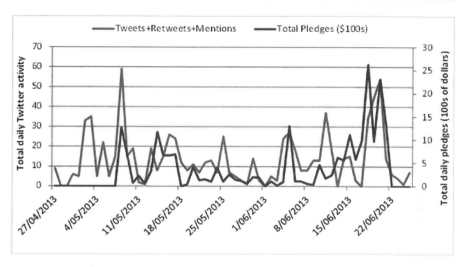

Figure 8.7: Timeline of pledges and total Twitter activity for one *Research My World* project.

Interestingly, the total Twitter activity per day had a stronger cross correlation with total dollars pledged per day than number of Tweets per day. This hints again at the importance of reaching, cultivating, and leveraging off a social media community for project success.

Conclusion

Following the successful first iteration of *Research My World*, Deakin University and Pozible continue to explore and expand their association. As this chapter is written they are in the thick of a third round of crowdfunding campaigns. Despite the evident challenges experienced by researchers there seems to be no shortage of eligible projects at Deakin and some academics have returned to the fray for a second effort. But the broader uptake from other universities has been slow.

As a new socio-technical infrastructure (what Nigel Thrift might call an "expressive infrastructure") crowdfunding vigorously exercises social media, mobile technologies, cloud computing, and post-modern financing behaviours (Thrift, 2012). And although it can be accommodated within familiar discursive frameworks, crowdfunding in practice remains a challenging activity for universities and university researchers to participate in. Without doubt, universities are in an important position to influence the evolution of research crowdfunding in the near future. The benefits are far reaching, providing opportunities for both universities and the public to engage with research

crowdfunding in order to realise wider social outcomes far beyond the specific campaign at hand. But as much as the perceived benefits (to universities in general and to researchers in particular) are aspirational, the practice of university crowdfunding is pragmatic and prosaic, a more or less constant process of micro-problem solving.

Successfully crowdfunding research requires unassuming champions in all corners of an organisation; an unlikely alignment of academics, administrators, entrepreneurs, and senior management. It also relies on encouraging researchers to extend their reach well beyond the horizon usually beheld from the university tower. In particular scholars are required to demonstrate a style of digital mobility and resourceful social impact that defies typical university systems for measuring merit. And so although the relationship between wide social media influence and crowdfunding success would seem to be supported by the project data, the career (or even workload) benefits for individual researchers are not yet evident.

How sustainable are university crowdfunding efforts? Ultimately, will the crowdfunding of scholarly research deter traditional investment or encourage it? Without more data, and more time, we can't yet answer this question. More evidence-based comparative research on different approaches and models, beyond the *Research My World* case study, is also urgently required. Perhaps we need to launch our own research campaign…

References

Canetti, E. (1978). *Crowds and power.* New York: Seabury Press.
Hekman, E. & Brussee, R. (2013, 4–6 November). Crowdfunding and online social networks. *Proceedings of the 2013 Consortium on Applied Research and Professional Education,* Manchester, 1–22.
Hemer, J. (2011). *A snapshot on crowdfunding.* Karlsruhe, Germany: Fraunhofer ISI.
Hu, Y. (2005). Efficient, high-quality force-directed graph drawing. *Mathematica Journal, 10*(1), 37–71.
Hui, J., Gerber, E. & Greenberg, M. (2012). *Easy money? The demands of crowdfunding work.* Report prepared for Segal Technical Report: 12–04, Chicago.
Klaebe, H. G. & Laycock, R. (2012). *Motivations and barriers to crowdfunding.* Report prepared for Australia Council for the Arts (Artsupport Australia), Sydney, NSW.
Lu, C.-T., Xie, S., Kong, X. & Yu, P. S. (2014, 24–28 February). Inferring the Impacts of Social Media on Crowdfunding. *Proceedings of the Seventh ACM WSDM Conference,* New York, 1–10.
Mollick, E. (2014). The dynamics of crowdfunding: An exploratory study. *Journal of Business Venturing, 29*(1), 1–16.
Osborne, T. (2004). On mediators: intellectuals and the ideas trade in the knowledge society. *Economy and Society,* (33), 430–47.

Owyang, J., Tran, C. & Silva, C. (2013) *The Collaborative Economy. A Market Definition Report*, Altimeter Group. Retrieved from www.altimetergroup.com

Perlstein, E. (2013). Anatomy of the Crowd4Discovery crowdfunding campaign. *SpringerPlus, 2*(1), 1–3.

Saxton, G. D. & Wang, L. (online early). The Social Network Effect: The Determinants of Giving Through Social Media. *Nonprofit and Voluntary Sector Quarterly.*

Sheskin, D. (2007). *Handbook of parametric and nonparametric statistical procedures* (4th ed.). Boca Raton; London: Chapman & Hall/CRC.

Thrift, N. (2012). The Insubstantial Pageant: Producing an Untoward Land, *Cultural Geographies, 19*(2), 141–168.

Verhoeven, D., Palmer, S., Seitzinger, J., & Randall, M. (2013). Crowdfunding Research Pilot Project Evaluation., Deakin University: Melbourne. Retrieved from http://www.deakin.edu.au/research/documents/research-my-world.pdf

Wu, J., Sun, H. & Tan, Y. (2013). Social media research: A review. *Journal of Systems Science and Systems Engineering, 22*(3), 257–282.

Section Three:
Fandom and the Media Industries

9. *Fixing Television by Funding a Movie: The Crowdfunding of Veronica Mars*

Ethan Tussey

Introduction

The film noir detective series *Veronica Mars* (UPN/CW, 2004–2007) uses the *The Dandy Warhols* song "We Used to Be Friends" as its theme song to establish the show's message of adolescent angst. The song also happens to describe the frustration of fans of the series toward the television network that aired the episodes. *Veronica Mars* fans, or "Marshmallows" as they call themselves, "used to be friends" with the network, even working to improve the network's ratings and revenue but quickly felt alienated from the television business model that valued them less than a more desirable mass audience.

These fans coalesced on websites like MarsInvestigations.com and TelevisionWithoutPity.com to discuss the show in great detail and sophistication while also teaching one another about the television industry in an effort to save the show from cancellation. The ad-hoc media industries education that these fans collectively cobbled together distinguishes them from other viewers. By learning about the relationship between ratings, television networks, studios, and affiliates, Marshmallows became aware of the business complexities and power structures that shape their cultural products and their own value as an audience. The fact that these fans understood their relationship to show business makes their participation in the crowdfunding of the *Veronica Mars* movie an informed political decision and not an example of exploitation as some critics fear.[1]

Crowdfunding campaigns are the latest topic in an old debate over audience agency and the power of the culture industries to exploit consumers. Partisans on either side of the debate have argued the merits of audience

resistance and negotiation of Hollywood's ideological influence. Media industries studies scholars have called for efforts to bridge this divide by examining specific interactions between audiences and the culture industries (Holt & Perren, 2009). The debate has only intensified with the rise of online communication. Convergence Culture scholars have argued that the Internet offers an opportunity for audiences to participate in the culture they consume (Jenkins, 2006). The Kickstarter campaign for *Veronica Mars* is an ideal example of this debate as it brings together an active audience of fans and a powerful film studio. On one side of the debate, scholars such as Mark Andrejevic argue that media companies take advantage of online communities by offering them the appearance of participation in an effort to exploit their free labour, or in the case of crowdfunding, their bank account (2007). Key to these debates is whether the participatory experience that fans are offered through activities like crowdfunding is radical enough to change the status quo and improve the quality and equality of the culture industries. Secondarily, these critiques argue that interactive opportunities merely trap fans into a false sense of empowerment, what Andrejevic calls "digital enclosure," that makes consumers even more manipulated by the culture industries by encouraging fans to understand culture in terms that best suit the business needs of media companies (2007: 2).

I argue in this chapter that the crowdfunding of *Veronica Mars* did not exploit the fans because it was the final step of a long history of fan activism against the television ratings system and network executives. The lesson to be learned from *Veronica Mars* fans is that scholars must understand the history and reasoning of a fan community to evaluate crowdfunding campaigns. A group of fans financing a studio film seems like an example of a "digital enclosure," until one considers how crowdfunding enabled fans to reject the status quo of broadcast television. These arguments are supported by the research I did on the crowdfunding campaign, included interviews in 2013 with representatives of both the *Veronica Mars* production team (Associate Producer Ivan Askwith) and the fan community (MarsInvestigations.com founder Wai Yin). Through these interviews, as well as analysis of trade publications, including Variety, Fast Company, The Wrap, and online discussion forums, including TelevisionWithoutPity.com, NeptuneRising.com, and MarsInvestigations.com, I learned that the Marshmallows attempted to save the show by engaging with the realities of the media industries and by embracing strategies that made their fandom visible and highlighted the deficiencies and injustices of the television industry's business model. Beyond the primary goal of getting a *Veronica Mars* movie, the crowdfunding campaign allowed fans to demonstrate their

value and passion in a way that the ratings system ignored. These efforts are essential to understanding how the crowdfunding of *Veronica Mars* meant more than simply financing a movie; it represented an indictment of the television industry.

Veronica Mars fans understood that this alternative mode does not allow them to profit but does allow them to participate in the creative process (via exclusive status updates from the production) and voice their desires (via the Kickstarter comment board). The understanding of the arrangement is best articulated by Robert Brian Taylor a fan and contributor to the campaign, "Fans who donated (including myself) don't want profits and are fully aware that we're not entitled to any. We just want the damn movie. That's the transaction, and everyone understands it" (2013). These fans have learned from their efforts to save the show when it was on the network and have eagerly chosen an alternative model that offers direct access to the producers of the series. Television scholar and *Veronica Mars* fan Jason Mittell, describes this alternative model as a "down payment" for a cultural product not unlike paying in advance for a DVD (2013). The execution of the Kickstarter campaign made it much more than a down payment as it encouraged fans to participate in the production process. Throughout the campaign and production of the movie, *Veronica Mars* showrunner Rob Thomas and star Kristen Bell refer to the fans as "their bosses," not just their audience. While this can be dismissed as shrewd public relations, the campaign offered a level of participation that made it successful and different from previous efforts to include fans in the production and distribution of cultural products.

Prior to crowdfunding options like Kickstarter, television fans attempted to affect the fortunes of their favourite shows via "Save Our Show" campaigns. Research on Save Our Show campaigns outlines how fans gathered to present their value to television network executives.[2] Fans of the series *Star Trek* (CBS), *Jericho* (CBS), *Friday Night Lights* (NBC), and *Chuck* (NBC) famously petitioned studio executives with mailing campaigns and publicity stunts (Savage, 2014: 3.1). The more industry-savvy fans attempted to appeal directly to sponsors by purchasing the advertised products during the airtimes of their favourite show. Fans of the show *Chuck* coordinated efforts to patronise Subway, a sandwich restaurant that sponsored the show, during *Chuck*'s airtimes to demonstrate their support. Their efforts resulted in Subway financing an additional season of the show (Poniewozik, 2009). The fans' success was directly attributable to the way they demonstrated their understanding of the economic requirements of the television industry.

Veronica Mars fans eagerly embraced crowdfunding because the current value system and business model of the television industry mostly ignores their viewership and passion for television. The television industry in the United States is a business designed to sell audiences to advertisers. Production studios such as Warner Bros produce television shows that are sold to television networks such as the CW that believe these shows will appeal to the network's group of affiliates, regional broadcast networks that air the national network's nightly programming. The Nielsen audience research company selects a sample of the American television audience and gives shows ratings based on the number of viewers of each programme. As Eileen Meehan has written, the Nielsen ratings system is charged with determining the ability of shows to gather a large enough consumer audience to justify the investment of advertisers (1990). Essentially, Nielsen establishes the value of certain shows so that networks and their affiliates can sell a "commodity audience" to sponsors. The ratings system's selective sample size ignores passionate constituencies in favour of mass audiences. According to fan scholar Christina Savage, the *Chuck* audience transformed their fan labour into economic value to make their voices heard and affect the success of their beloved show (2014). While Savage argues that this is a step forward for fan activism, "Save our Show" campaigns still reinforce the television industry's business model by appealing to advertisers instead of financing the shows directly. Crowdfunding differs from these efforts because it replaces the economic system that finances television shows by offering a more direct form of financial exchange that values fan labour in the creative process.

Veronica Mars fans chose crowdfunding as a way of protesting the television industry after growing frustrated with Save Our Show campaigns throughout the three season run of the series. The evolution of the *Veronica Mars* fans' disappointment with the television industry is apparent on the MarsInvestigations.com website. The website, led by Wai Yin (screen name wyk), was established by a group of *Veronica Mars* fans who first came together to form a community on the website TelevisionWithoutPity.com. Like most fan-made websites the content is a mix of effusive praise for the show and deep analysis including attention to the show's anti-establishment, anti-exploitive capitalism, and pro-feminism themes. Comparing the website entries to coverage of the show in the popular press and industry publications, such as *Time* magazine and TheWrap.com, provides an understanding of the fan culture and its motivations. Taken together, these sources provide context for the claims about the social dynamics and meaning making of the community in regards to the political decisions they made in their fan activities and their reasons for participating in the Kickstarter campaign.

Neptune Rising: The Origins of the Veronica Mars *Fan Community*

Fan activity on the level that sparks Save Our Show and crowdfunding campaigns is rarely organised without a political purpose. Matt Hills characterises fans as "commodity-completest [that also express] anti-commercial beliefs or 'ideologies'" (2001: 40). This is not surprising given the fact that fans often use the mythologies and themes of their favourite texts as a lens for engaging the world, whether through activism or simply by connecting with others.[3] In the case of *Veronica Mars* fandom, the community celebrated the show's feminism, its examination of class-consciousness, and defence of the disenfranchised. The fans' own feelings of being marginalised by the television industry can be observed in their discussions of the UPN/CW network executives and their celebration of the culture of outsiders.

As quickly as the community had formed, they began to organise in opposition to obvious commercial efforts of the network. Discussion of the second episode "Credit Where Credit's Due" (Original Airdate September 28, 2004) on TelevisionWithoutPity.com blames the network for violating the unwritten rules of the community. In an effort to garner attention for the new show, stunt casting was attempted as hotel heiress Paris Hilton guest starred. Hilton was given the role of Caitlin Ford, who is investigated by Veronica and revealed to be a manipulative villain. The fans on TelevisionWithoutPity.com did not take kindly to the presence of Hilton as they felt she represented the complete opposite of the community's values. Comments like, "Why was Paris Hilton on my television? Go away!" (Twistedsoul7), and "the worst part of the episode by far was 'special guest star' Paris Hilton. Special? Come on" (Nit), represent the community's anti-commercialism. Not only did fans reject the stunt casting but they blamed the network, not the show's producers, for ignoring the values of the community, "Do they not realize their target audience is not going to respond well to Paris Hilton? Oh wait I am assuming a television network has any knowledge of their target audience whatsoever" (Kieyra). The overwhelming negative reaction to the casting of Paris Hilton is one of the earliest examples of the fans distinguishing themselves from the commercial interests of the television network. The sentiment that the show was accomplishing something special despite the meddling of the network would evolve to distrust of the entire industry as the community increasingly attempted to have their devotion acknowledged by the television network.

Trying to Save a Show for a Network That Ignores You

Cindy Au, the Head of Community for Kickstarter, summed up the feeling of hopelessness that television fans often have when it comes to the television industry: that "nothing that great ever gets to last on television" (2013). The feeling that the television industry is broken begins with the idea that television networks do not care about their most devoted fans because they are more dedicated to serving the sponsors. A discussion on the public fan website MarsInvestigations.com makes this feeling apparent as two members of the community discuss the difference between the "previously on" recaps produced by the show's producers and the promotional advertisements produced by the network:

wyk: It makes me happy when I hear, "Previously on *Veronica Mars.*"

Inigo: I get a warm glow. Sometimes they don't use the same shots as they used in the previous episodes, which can be a bit confusing, but that happens later in the season.

wyk: I wonder who cuts together the previously. They are usually pretty well done. They should hire that person to do the promos.

Inigo: Yes, god, the promotions. Why can't the makers be responsible for the promotions, rather than the networks? They at least have an ideas of what the show is about, what would and wouldn't spoil.

wyk: Networks use promotions to attract new fans, so they have to make the promos as interesting as possible, even if it means telling us how the episode ends.

Inigo: Are you saying that Rob couldn't make a decent promotion, one that wouldn't be interesting?

wyk: Rob is already in charge of running the show, polishing the scripts, picking all the music and fawning over Greta. Let the poor man get some sleep.

Inigo: Sleep is for the weak. Anyway, maybe the industry would be better served if at least the program-makers worked with the networks. In Australia, the promos for this episode were almost exclusively the Skank, from what I've read.

The fans' frustration with the network's lack of understanding of the core audience escalated in the third season as the network worked with the producers of the show to change the narrative format to make it easier for casual viewers to follow the detailed plots. Instead of having a variety of ongoing season-long mysteries combined with cases of the week, the third season reduces the number of running plots and ends them within 7–8 episodes.[4] According to fans, the show's long running plots gave "each plot its due attention"

(misskiwi) and demonstrated that TV could have "complex storylines" where "important events come together nicely week after week." (Topanga & Alliterator, 2005). Prior to the launch of the third season UPN merged with rival network WB and rebranded as the CW network. The CW was focused on establishing itself as a competitor to other broadcast networks such as CBS, NBC, ABC, and Fox and was looking for ways to expand the audience including changing the narrative structure of the series.

Despite the fans' distrust of the network, many of the most dedicated Marshmallows were willing to participate in a variety of campaigns to keep *Veronica Mars* on the air even if that meant helping the network succeed in their attempt to broaden the show's audience and win the ratings race. Organising the fan community to keep the show on the air required an understanding of the television industry. The Marshmallows quickly realised that none of their members were Nielsen families, the select sample of U.S. households whose viewing habits are monitored and tabulated to determine the television ratings. Unable to be counted by the Nielsen system, the fans were concerned their value as an audience was not being recognised.[5] wyk described the problem to the community by explaining, "our site can't do much about the ratings system but we can do something to make TPTB aware of non-Nielsen fandom" (wyk). In an effort to address their disenfranchisement, they decided to write their demographic information on printouts of $2 bills and send them to the network executives to educate them on their "very diverse audience" so that they could find appropriate sponsors to make the show financially viable.[6] The idea to use replicas of fake $2 bills was inspired by the episode "Clash of the Tritons" (original airdate January 11, 2005) in which a suspect that Veronica has outwitted finds an incriminating message on a dollar bill: "Veronica Mars is smarter than me." The campaign was particularly amusing as the suggestion was that fans believed the network executives were not smart enough for the show. The fans sent these bills to the network and the network's affiliates as they came to understand the seats of power in the television industry. Targeting network affiliates was particularly astute as these regional broadcasters pay franchise fees to the national television network for shows, like *Veronica Mars*, that are meant to attract regional audiences. Making Veronica Mars fandom visible to the affiliates proved that the show was popular in their region even if the Nielsen numbers showed low ratings. *Veronica Mars* fan groups, beyond MarsInvestigations.com, would attempt similar mailing campaigns, including shipping Mars Bars candy bars or an entire pallet of marshmallows to executives to get their attention and indicate the passion of the ignored audience (Hercules, 2007). These campaigns were even endorsed by those working for Warner Bros Television, the studio that

produced the show, as they helped the fans target the appropriate executives at the network.[7] These acts were deliberate protests against the measurement of the audience and the way they perceived the television industry as ignoring the value of certain consumers.

In addition to reaching out to affiliates, fans of the show also tried to get the attention of the home entertainment executives by boosting DVD sales. The "Look to the Skies" campaign was designed to boost DVD sales, as this was a more direct path to demonstrating the fans' economic value.[8] Shows such as *Futurama* and *Family Guy* had been saved by DVD sales so *Veronica Mars* fans realised that there might be a path to proving the value of the audience through purchasing DVDs. Additionally, they purchased DVD box sets and donated them to libraries so that they could simultaneously improve sales while growing the audience for the third season by giving new fans the ability to catch up on past episodes. The fans donated over 400 sets of the DVDs to libraries (West, 2006). They also continued to bombard network executives with displays of their fandom, including sending care packages and organising a sky writer to fly over the network headquarters.[9]

Through their interactions with producers and the networks, the fans learned about the television industry and its pitfalls. They learned about the ratings system, the importance of DVD sales, the influence of advertisers and affiliates. However, every attempt to engage the industry and demonstrate their economic power was rebuffed, and the show was eventually cancelled. Through it all, they maintained a relationship with the show's cast and crew, particular the show's creator Rob Thomas. The fans and Thomas established what Henry Jenkins and Joshua Green frame as a "moral economy" in which producers and consumers develop a shared understanding of the values that made the show unique and work together to maintain this social contract with the fans (2009). The fans established this rapport by starting a dialog with Thomas, first on TelevisionWithoutPity.com and later on his own personal website and via correspondence with MarsInvestigations.com, where he would discuss the inner workings of the television industry and the behind-the-scenes of the creative process. This relationship would be a key to the success of the crowdfunding campaign that launched the *Veronica Mars* movie.

Kickstarter: Finally a Way to Have Their Fandom Counted

Following the show's cancellation in 2007, the cast and crew went on to work on other projects but the fan community continued to carry the torch for *Veronica Mars*. Bell explained that at every press event she did someone

would ask about the future of *Veronica Mars* (Radloff, 2014). As Thomas and Bell looked for a way to make the movie, the show continued to find new fans through syndication, DVD sales, and streaming platforms. Over a year before the crowdfunding campaign was launched, Thomas' friend Robert Harrison, lead singer of the band Cotton Mather, suggested Thomas try Kickstarter, an online crowdsourcing platform where many musicians had been finding funding (Sepinwall, 2013). Warner Bros Digital, the team behind the popular *Mortal Kombat* web series, was the division of the studio that managed the *Veronica Mars* crowdsourcing experiment. According to Associate Producer Ivan Askwith, "the success of the campaign did not lie in an innovative approach to social media or new technological platforms, but in a focused understanding of what fans care about, and why" (Askwith, 2005). In the end, the campaign adopted a strategy of acknowledging the value of fans and including them in the creative process in a way that the television industry could never accommodate.

Those who criticise the *Veronica Mars* Kickstarter campaign for duping fans into financing a movie for a major film studio should consider that the fans understood crowdfunding as a welcome alternative to the television industry.[10] As Thomas explained in interviews, the Kickstarter campaign was not a charity but a direct transaction with the fans (Sepinwall, 2013). Appealing to the fans directly gave the audience the opportunity to express their fandom without having to make it palatable to the television industry's business models. No longer did the fans have to organise to make themselves attractive to sponsors, affiliates, or the Nielsen ratings system. Instead, fans could use the things they learned in Save-Our-Show campaigns to spread the message that Kickstarter was finally allowing their fandom to count. Thomas, Bell, and Askwith understood the importance of giving fans the feeling of being direct contributors to the campaign because they had been interacting with them since the show premiered on UPN and understood the fans' frustration with the television industry. Askwith provided a unique perspective, as he was a fan of the show before he worked with the team. In addition to being a fan, he was an academic interested in understanding how passionate audiences could be better engaged by the media industries.[11] In a 2005 article for *Slate* magazine, Askwith had explained that the arrival of digital distribution was less about new mobile forms of engagement or on-demand access than the ability of fans to invest in their favourite content through purchasing a "season pass" of a television show. Askwith says that fans' support of the television show *Chuck* by purchasing sandwiches from the show's sponsor Subway was "a break through moment that demonstrated that people were willing to underwrite the costs of their favourite television shows." He understood that

the Kickstarter campaign offered the *Veronica Mars* fans an alternative to the television ratings system that allowed them to directly support the show.

Kickstarter allows those seeking funding to set a financial goal that must be met within a certain timeframe. In the case of *Veronica Mars*, the goal was $2 million in 30 days. "Backers," as contributors are known on Kickstarter, pledge money to support creative projects. In most Kickstarter campaigns, backers can give amounts in a variety of tiers in exchange for rewards. For example, a pledge of $35 receives a free digital copy of the film, a PDF of the script and a T-shirt. Beyond these rewards, the backers also received regular updates and behind-the-scenes exclusives about the production of the film offered solely to the fans participating in the campaign. Fans were so eager to make a direct contribution to the production of *Veronica Mars* that the campaign made its goal in less than 12 hours. In the end, more than 91,000 fans contributed and over $5.7 million was raised, making it the most successful Kickstarter campaign for a film in the history of the website to that point.

The campaign did not end with the pledge drive but continued throughout the entire production of the film. As Askwith explains, "the biggest mistakes people make [with crowdfunding] is what they do after they get funded." The team wanted to avoid these mistakes so they provided backers with regular updates on the production of the film. These updates attempted to include the fans in the creative process instead of simply being a promotional tool. One example of this inclusive engagement included bringing the fans in on an editing sequence for the film so that they could see how decisions are made. Askwith oversaw these updates, explaining that he tried to coordinate updates that detailed "what the project meant to Rob [Thomas] and why Kristen [Bell] wanted to be involved."[12] Following this strategy, the team produced over 100 updates that focused on the passion and dedication of the cast and crew instead of simple dispatches about the progress of the movie.[13] Key to this strategy was participating in the fandom with the fans and adopting their taste culture through the use of references that are meaningful to the community. This level of fan engagement was a big change from the days of Paris Hilton, as the cast and crew of *Veronica Mars* tried to respect their backer "bosses" instead of simply placating their fans.

The belief that the film should be made for the fans that paid for the film, rather than the studio that was distributing it, extended to the plot and tone. Thomas explains that "[t]he six months before Kickstarter, I was thinking of a plotline that revolved around Veronica as a young FBI agent, but when it became a fan-financed movie, I couldn't figure out a way that an FBI case could roll in Wallace and Mac [and everyone else]. So I sort of abandoned

that FBI idea and tried to find a plot to get back to all the characters we know and love. Because if the fans are going to pay for a movie, I want them to see the characters they love" (Atkinson, 2014). If anything, the cast and crew may have been too devoted to ensuring their fans received return on their investment, as the consistent refrain in reviews of the movie was that it was too dedicated to the desires of the original television fans. Criticism of the film lamented the overly complicated plot and the inclusion of characters that served no purpose other than to serve fans (McMillan, 2014). Throughout the film, there are references to past episodes, storylines, behind-the-scenes gossip, and references to the actor's real lives. As fan studies scholars have noted in the past, these kinds of references are the currency that maintains the community (Klinger, 2006).

Given the lengths that the Kickstarter campaign and the production took to engage the fans in the creative process it is hard to argue that the backers were duped by a film studio. Backers were involved as extras in several scenes, one was rewarded with a one-line speaking part, and several names of the backers were incorporated into the movie. The involvement of fans in the film does not mean that the Internet is leading to an era of egalitarian participatory engagement. Warner Bros is using the success of the campaign to launch a web series that the audience will presumably be less included in (McMillan, 2014). Warner Bros Digital also used the campaign to introduce these fans to their digital cloud service Ultraviolet (Shaw, 2014). Even Thomas is returning to more traditional forms of production, as he has launched a *Veronica Mars* book tie-in and is eager to work with Netflix or Amazon as a way of rebooting the series (Nededog, 2014). Clearly, the financial potential of the series remains in the hands of Warner Bros but the fans' ability to participate in the creative process and influence the narrative and stylistic aspects of the film set crowdfunding platforms like Kickstarter apart as unique tools for engaging the inequalities of the media industries.

Conclusion

Connecting the success of the *Veronica Mars* Kickstarter campaign to the history of the fans' anti-television industry activism demonstrates the politics behind the Kickstarter campaign. Certainly, some of the success of the campaign can be explained by the enthusiasm for participating in a "cultural happening" and the fact that donations for *Veronica Mars* was among the first crowdfunded projects to get mainstream attention. In fact, new media scholar Ian Bogost has argued that a major factor in the success of crowdfunding is the excitement of participating in a grassroots movement (2012). Kickstarter

encourages this feeling as it frames its service as a place for community and inspiration.[14] In this way, Kickstarter sees itself as a place for establishing alternate cultural industries where people use the barrier breaking potentials of network communication to eschew the traditional culture industries and instead create what Yochai Benkler has called a "networked public sphere" (2006).

Critics of crowdfunding may see Kickstarter's branding as clever marketing that obscures the fact that a film studio is capitalising on fans' labour and donations. Focusing on Warner Bros' profits ignores the victory of a vocal minority of fans that contributed to the Kickstarter as part of their long crusade to change the way they are counted and monetised by the television industry. From their successful Kickstarter campaign, *Veronica Mars* fans have revealed the financial potential of financial transparency and direct engagement. The fact that *Veronica Mars* fans enter into this arrangement as investors, rather than as viewers, is a testament to the way the Internet can make the creative industries more participatory. Further research on this topic should consider how an audience's direct investment through crowdfunding versus the indirect advertising and ratings system changes the relationship between producers and consumers. In the case of *Veronica Mars*, direct investment resulted in a movie built for the tastes and enjoyment of fans. It remains to be seen if this is a sustainable model or if storytellers will feel hindered by the expectations of their fans in the same way they feel constrained by the directives of television executives.

Acknowledgements

I would like to thank my graduate research assistant Hemrani Vyas for her meticulous work on this project.

Notes

1. Concerns about crowdfunding typically focus on the way multimillion dollar media corporations convince their audiences to finance their projects. Often this is described as exploitation. A good example comes from Richard Lawson's piece for the Atlantic Wire. "Anyone Know a Better Charity Than the 'Veronica Mars' Movie?" Atlantic Wire. March 13, 2013. http://www.thewire.com/entertainment/2013/03/kickstarter-kind-of-annoying-isnt-it/63060/. For more examples of the range of concerns see the excellent summary of reactions compiled by Bethan Jones on her blogpost, "Fan Exploitation, Kickstarter and Veronica Mars." Bethanvjones.wordpress.com. March 15, 2013. http://bethanvjones.wordpress.com/2013/03/15/fan-exploitation-kickstarter-and-veronica-mars/
2. For a good overview of the history of these campaigns and their implications see Christina Savage, "Chuck Versus the Ratings: Savvy Fans and 'Save Our Show' Campaigns," ed. Mel Stanfill and Megan Condis, *Transformative Works and Cultures*.

Vol 15 (2014). http://journal.transformativeworks.org/index.php/twc/article/view/497/427

3. Among the many examples of this phenomenon, consider Henry Jenkins' description of the Harry Potter Alliance. Henry Jenkins, How "Dumbledore's Army" is Transforming Our World: An Interview with the HP Alliance's Andrew Slack, *Confessions of an ACA-Fan The Official Weblog of Henry Jenkins,* July 23, 2009 http://henryjenkins.org/2009/07/how_dumbledores_army_is_transf.html

4. Rob Thomas discussed the logic of this strategy in interviews prior to the third season. For example, Eric Goldman, "Veronica Mars Season 3: Kristen Bell and Rob Thomas Talk," IGN.com, July 18, 2006. http://www.ign.com/articles/2006/07/18/veronica-mars-season-3-kristen-bell-and-rob-thomas-talk

5. For a more detailed description of the ratings system read Eileen Meehan, "Why We Don't Count: The Commodity Audience," in *Logics of Television*, ed. P. Mellencamp (Bloomington: Indiana University Press, 1990), 117–137.

6. Wyk, "Two Dollars for a Second Season Campaign," MarsInvestigations.com, http://marsinvestigations.net/campaigns/twodollars.php

7. Wyk explains that a Warner Bros publicist reached out to help the fan community, Wyk, "Two Dollars for a Second Season Campaign," MarsInvestigations.com, http://www.marsinvestigations.net/campaigns/twodollars.php

8. Wyk, "Look to the Skies" MarsInvestigations.com, http://www.marsinvestigations.net/look_to_the_skies.php

9. ibid.

10. For an example of the debate concerning the merits of crowdfunding consider this piece, Bertha Chin, "The Veronica Mars Movie: Crowdfunding – or fan-funding- at its Best?" On/Off Screen. March 13, 2013. http://onoffscreen.wordpress.com/2013/03/13/the-veronica-mars-movie-crowdfunding-or-fan-funding-at-its-best/

11. Askwith was a student of Henry Jenkins at MIT's Convergence Cultures Consortium and wrote his thesis on fan engagement and the future of television metrics. The title of the thesis is Television 2.0: Reconceptualizing TV as an Engagement Medium.

12. Askwith interview with author April 1, 2014.

13. Kristin Thompson discussed a similar strategy in her analysis of fan interactions with the production of *Lord of the Rings* see Kristin Thompson, Frodo *Franchise: The Lord of the Rings and Modern Hollywood.* (Berkeley: University of California Press, 2007).

14. "Seven Things to Know About Kickstarter," Kickstarter.com https://www.kickstarter.com/hello?ref=footer

References

Abele, R. (2004). Eyes on Veronica Mars. *LA Weekly*, November 4.

Adalian, J. (2003). Dramatic developments driving UPN's 2004 slate. *Daily Variety*, October 28.

Andrejevic, M. (2007). *iSpy: Surveillance and power in the interactive era.* Lawrence: University Press of Kansas.

Askwith, I. (2005). TV you'll want to pay for. *Slate,* November 1. Retrieved from http://www.slate.com/articles/technology/webhead/2005/11/tv_youll_want_to_pay_for.html

—— (2014). Interview with author on April 1st.

Atkinson, K. (2014). "Veronica Mars" at PaleyFest: Logan and Veronica weren't always meant to be, and 5 more revelations. *Entertainment Weekly*, March 14. Retrieved from http://popwatch.ew.com/2014/03/14/veronica-mars-paleyfest-panel/

Au, Cindy. (2013) "It's On, Kids" A fan history of *Veronica Mars*. Kickstarter. Retrieved from https://www.kickstarter.com/stories/veronica

Benkler, Y. (2006). *The wealth of networks: How social production transforms markets and freedom*. New Haven: Yale University Press.

Bogost, I. (2012). Kickstarter: Crowdfunding platform or reality show? *Fast Company*, July 18. Retrieved from http://www.fastcompany.com/1843007/kickstarter-crowd funding-platform-or-reality-show

Chin, B. (2013). The Veronica Mars Movie: crowdfunding-or fan-funding- at its best. March 13. *On/Off Screen*. Retrieved from http://onoffscreen.wordpress.com/2013/03/13/the-veronica-mars-movie-crowdfunding-or-fan-funding-at-its-best/

Green, J. & Jenkins, H. (2009). The moral economy of Web 2.0: Audience research and convergence culture. In J. Holt & A. Perren (Eds.), *Media industries: History, theory, method*, pp. 213–227. Malden, MA: Wiley-Blackwell.

Hercules. (2007). Help flows in to save Veronica Mars!! *Aint It Cool News*, June 7. Retrieved from http://www.aintitcool.com/node/32906

Hills, M. (2001). *Fan cultures*. New York: Routledge.

Holt, J. & Perren A. (2009). *Media industries: History, theory, and method*. Malden. MA: Wiley-Blackwell.

Jenkins, H. (2006). *Convergence culture: Where old and new media collide*. New York: New York University Press.

—— (2009). How "Dumbledore's Army" is transforming our world: An interview with the HP Alliance's Andrew Slack. *Confessions of an ACA-Fan The Official Weblog of Henry Jenkins*, July 23. Retrieved from http://henryjenkins.org/2009/07/how_dumbledores_army_is_transf.html

Kieyra. (2006). Veronica Mars episode 2 "Credit Where Credit Is Due." Retrieved March 6, 2006, from TelevisionWithoutPity.com

Klinger, B. (2006). Once is not enough: The functions and pleasures of repeat viewings. In *Beyond the multiplex: Cinema, new technologies, and the home*. Berkeley: University of California Press, pp. 135–191.

Lawson, R. (2013). Anyone know of a better charity than the "Veronica Mars" Movie? *The Wire*. March 13. Retrieved from http://www.thewire.com/entertainment/2013/03/kickstarter-kind-of-annoying-isnt-it/63060/

McMillan, G. (2014). After movie's Kickstarter success, Veronica Mars to get spinoff web series. *Wired*, January 15. Retrieved from http://www.wired.com/2014/01/veronica-mars-web-series/

—— (2014). How "Veronica Mars" fans ruined the movie reboot for everyone else. *Wired*, March 19. Retrieved from http://www.wired.com/2014/03/veronica-mars-fans/

Meehan, E. (1990). Why we don't count: The commodity audience. In P. Mellencamp (Ed.) *Logics of television*, Bloomington: Indiana University Press.

Misskiwi. (2005). "Blast from the past" roundtable reviews. MarsInvestigations.com. Retrieved from http://www.marsinvestigations.net/episodes.php?id=205&title=blast_from_the_past

Mittell, J. (2013). Veronica Mars and exchanges of values revisited. *Just TV.* March 15. Retrieved from http://justtv.wordpress.com/2013/03/15/veronica-mars-and-exchanges-of-value-revisited/

Nededog, J. (2014). Veronica Mars' creator talks movie sequel, possible Netflix or Amazon series reboot. *The Wrap,* March 13. Retrieved from http://www.thewrap.com/paleyfest-veronica-mars-movie-panel-rob-thomas-kristen-bell

Nit. (2006). Veronica Mars episode 2 "Credit Where Credit Is Due." Retrieved March 6, 2006, from TelevisionWithoutPity.com

Poniewozik, J. (2009). Saving *Chuck:* Don't applaud, throw money. *Entertainment,* April 23. Retrieved from http://entertainment.time.com/2009/04/23/saving-chuck-dont-applaud-throw-money/

Radloff, J. (2014). Kristen Bell reveals what happened behind the scenes on the new Veronica Mars movie. *Glamour.* March 11. Retrieved from http://www.glamour.com/entertainment/blogs/obsessed/2014/03/kisten-bell-reveals-what-happe.html

Savage, C. (2014). Chuck versus the ratings: Savvy fans and "save our show" campaigns. *Transformative Works and Cultures.* 15. Retrieved from http://journal.transformativeworks.org/index.php/twc/article/view/497/427

Sepinwall, A. (2013). Exclusive: "Veronica Mars" creator Rob Thomas on the wildly successful Kickstarter movie campaign. *HitFix.* March 15. Retrieved from http://www.hitfix.com/whats-alan-watching/exclusive-veronica-mars-creator-rob-thomas-on-the-wildly-successful-kickstarter-movie-campaign/2

Shaw, L. (2014). Warner Bros. to refund angry "Veronica Mars" contributors. *The Wrap.* March 14. Retrieved from http://www.thewrap.com/warner-bros-refund-veronica-mars-contributors-download-flixster-ultraviolet-problems

Taylor, R. B. (2013). In defense of the Veronica Mars movie Kickstarter project. *Cult Spark.* March 14. Retrieved from http://cultspark.com/2013/03/14/in-defense-of-the-veronica-mars-movie-kickstarter-project/

Thompson, K. (2007).*The Frodo franchise: the Lord of the Rings and modern Hollywood.* Berkeley: University of California Press.

Topanga and Alliterator. (2005). "Rat saw God" roundtable reviews. MarsInvestigations.com. Retrieved from http://www.marsinvestigations.net/episodes.php?id=206&title=rat_saw_god&type=roundtable

TwistedSoul7. (2006). Veronica Mars episode 2 "Credit Where Credit Is Due." Retrieved March 6, 2006, from TelevisionWithoutPity.com

West, K. (2006). Veronica Mars fans donate DVDs to promote the show. *Cinemablend.* August 22. Retrieved from http://www.cinemablend.com/television/Veronica-Mars-Fans-Donate-DVDs-To-Promote-The-Show-853.html

Whedon, J. (2005). Joss luvs Veronica. *Whedonesque.com,* August 12. Retrieved from http://whedonesque.com/comments/7502

Wyk. $4,000 shower season 3 campaign. MarsInvestigations.com. Retrieved from http://marsinvestigations.net/campaigns/postcardintro.php

Wyk & Inigo. (2004). "Credit where credit's due" roundtable reviews. MarsInvestigations.com. Retrieved from http://www.marsinvestigations.net/episodes.php?id=102&type=roundtable

Zemler, E. (2013). Kristen Bell: "Veronica Mars" could be my whole life. *CNN.* July 20. Retrieved from http://www.cnn.com/2013/07/20/showbiz/comic-con-kristen-bell/

10. Public Service Announcements With Guitars: Rock 'n Roll as Crowdfunding Cause for Amanda Palmer and IAMX

Larissa Wodtke

Introduction

Due to development in digital technology and its impact in the form of immaterial labour (Lazzarato, 1996), cognitive capitalism (Peters & Bulut, 2011), and "the commons" (Hardt & Negri, 2009), many musicians are turning to crowdfunding platforms such as Kickstarter and PledgeMusic to support their artistic labour financially. Crowdfunding, a method of raising public funds from a large group of individuals via online third parties, is an "emerging and growing form of non-state funding for the arts" (Harvie, 2013: 168). These online platforms, which reflect the biopolitical power of what Hardt and Negri conceive of as the "multitude," allow musicians to manufacture scarcity in a post-scarcity economy through "value-added" items and services beyond digital music itself, which by its very medium is no longer perceived as valuable in a postindustrial capitalist economy (Wodtke, 2014). In examining the successful crowdfunding campaigns, and more specifically the pitch videos, of Amanda Palmer and IAMX, run via Kickstarter and PledgeMusic, respectively, I argue these methods for raising capital utilise a rhetorical strategy similar to those of charities and fundraising drives for public service broadcasting. In doing so, they use emotional appeals and affective labour to persuade their fans to mobilise as activists for a moral cause, invoking language of temporality, including the "future of music" and "creating history together," not unlike previous musician-endorsed

causes like the charity albums and mega-events of the 1980s (Lahusen, 1996). Representing their ethos as an authentic counter-force to the corporate music industry, these musicians call a specific public into being, a public who is permitted intimate access to the artist and whose affection is seemingly reciprocated. Moreover, these artists complicate their capitalistic framework by performing the role of a public artist, or busker, which has connotations of begging. I would like to explore the implications of perceiving musical labour as a public service and a cause alongside the patronage relationship within crowdfunding. In this relationship, the artist and fans perform a multitude of roles, with differing, often contradictory and alternating, power dynamics.

I chose to explore the crowdfunding videos of Amanda Palmer and Chris Corner, who performs under the name IAMX, because their videos employ similar rhetorical strategies, and they achieved success well beyond their goals (in Palmer's case, $1.2 million rather than $100,000, and in IAMX's case, 817% of his goal, raising 100% only one hour into the campaign). Many similarities already exist between these artists: they both used to be in bands with record label contracts; they are multimodal artists, engaging in visual art, film, and fashion; they write highly personal songs about their vulnerabilities; they adopt theatrical personas reminiscent of cabaret and burlesque entertainment, erotically using their bodies to imply intimacy and transparency in their relationships with their fanbases; and they are vocal about love for their fans, hailing a familial, cultish public. As "independent" artists who have eschewed the ostensible security, and perhaps unwanted control, of record label support, and as performers who foster seemingly intimate, affective relationships with their fans, the logic of their decision to use crowdfunding becomes apparent.

Do It With a Rockstar: Crowdfunding Platforms

Crowdfunding can be defined as using the Internet to raise funds from many individuals, or "crowds," for a particular project, such as the development of a video game, the production of an album, or a charitable cause. Unlike crowdsourcing, crowdfunding seeks financial support rather than expertise and feedback (Harvie, 2013: 170), thus crowdfunding has often been discussed in the context of business and venture capital investment (Belleflamme et al., 2013; Mollick, 2014; Tomczak & Brem, 2013). However, despite discussions of the implications of crowdfunding for journalism (Aitamurto, 2011), theatre (Harvie, 2013), and documentary production (Sørensen, 2012), critical examination is only beginning for crowdfunding in

relation to its cultural meaning for musicians and their fans. Whilst physical crowds, which assemble in public, often urban, spaces, are considered a feature of the modern, industrialised world, virtual crowds that connect in the online environment are seen as a product of the postindustrial, information age (Schnapp & Tiews, 2006). With this shift in the concept of the crowd itself, it is necessary to interrogate the uses to which these kinds of crowds are put.

Though crowdfunding started gaining popularity and media attention in 2010, shortly after the founding of online platforms such as Kickstarter, PledgeMusic, and Indiegogo, there are earlier cases of online fan communities using the Internet to raise funds for bands/artists. One such case was that of the band Marillion, whose fans raised money to allow them to tour the United States in 1997 (Golemis, 1997). Also, in 1999, Momus, aka Nick Currie, produced his album *Stars Forever* by using the Internet to ask fans, and even companies, to pay $1,000 each to have a song custom-written about them. The emergence of third party platforms has simplified and legitimised the process of crowdfunding, and taken the customization aspect of a project like *Stars Forever* to extreme levels, encouraging those who seek funding to provide a plethora of exclusive offerings to funders. These platforms have arguably become a new intermediary between performers and their audiences, taking a percentage of the funds raised in exchange for the use of their platform, payment and communication systems, and professional advice. By formalising the crowdfunding system, these platforms have created a business model that places performers/artists in an entrepreneurial role, necessitating the use of attention-grabbing, persuasive promotional tools to "pitch" their projects to potential donors/patrons/investors. One of these tools is the pitch video, a common feature in crowdfunding campaigns. Despite the fact campaign webpages contain a textual description of the proposal along with a reward menu, the video functions as a more immediate, and often more aesthetically creative, way to describe and promote the project. These videos are considered significant contributors to the success of the fundraising; for example, Slava Rubin, co-founder of Indiegogo, claims that "crowdfunding pitches with video content raise 112% more than pitches without videos" (Huff, 2012).

Palmer and Corner's videos reveal a multi-layered rhetorical appeal based upon addressing collective crowds, including demands to be activists and donors for a worthy cause, but they, too, call upon these crowds as individuals with the capacity for intimacy and affective relationships, including those of patronage. These demands are not mutually exclusive, and interact

in numerous, sometimes conflicting, ways, including the nature of fans' collaboration with the artists within these crowdfunding structures.

"This Is the Future of Music": Amanda Palmer's Kickstarter Campaign

Amanda Palmer rose to prominence in 2000 in the musical duo The Dresden Dolls, a self-described "Brechtian punk cabaret" act. After releasing two major label studio albums, and one compilation album, The Dresden Dolls went on hiatus whilst Palmer pursued solo projects and collaborations with artists such as Ben Folds and Jason Webley. In 2012 Palmer used Kickstarter to fund her *Theatre Is Evil* album, art book, and tour, raising nearly $1.2 million after setting a goal of $100,000. At the time of writing, her campaign remains the most highly funded for a music album. Her campaign included rewards ranging from limited edition vinyl records to art opening/ backer parties in various cities, to dinner with Palmer herself, the latter valued at $10,000.

In her pitch video, Palmer stands barefoot on a Melbourne street wearing a kimono, holding up a series of handwritten title cards as music from *Theatre Is Evil* plays in the background. The production quality appears deliberately do-it-yourself, only cutting away from the series of shots of Palmer to photographs and graphics, and once panning to the cameraman's feet and to her scattered cards. The style, along with Palmer's persona, is informal, accessible, and playful. She specifically contrasts her current campaign for $100,000 with the budget of a major record label: "WHEN I WAS ON A MAJOR LABEL,/ THEY FOOTED THE BILL FOR ALL THAT STUFF./IF I HADN'T LEFT THE LABEL THE RECORDING BUDGET ALONE/FOR THIS RECORD WAS SCHEDULED TO BE OVER/$200,000.00/AND THE PROMO/DISTRO BUDGET AROUND ANOTHER/$300,000.00." She reinforces the positive difference between crowdfunding and being under contract to a record label: "I'D MUCH RATHER STAND HERE/ WITH JIM/HOLDING UP SIGNS TO ASK/YOU/FOR THE MONEY TO RUN MY BUSINESS./AND THIS WAY/I WILL ACTUALLY SEE A PROFIT FROM MY MUSIC." Her last cards state: "I HOPE YOU WILL JOIN/ OUR ROCK N ROLL CAUSE...THIS IS THE FUTURE OF MUSIC/THIS IS HOW WE FUCKING DO IT/WE ARE THE MEDIA/I LOVE YOU." She throws her last cards onto the street and runs out of shot. The final frame is an appeal to preorder her album and contribute to the campaign.

"We're Creating History Together": IAMX's PledgeMusic Campaign

Like Palmer, Chris Corner began his career in a band signed to a record label; in his case, the band was trip-hop outfit Sneaker Pimps. Since 2004 Corner has been working in Berlin on a solo project under the name IAMX, and his ethos has been grounded equally in fierce independence from record labels and a purported intimacy with his cult following. Like Palmer, he often communicates with his fanbase via a blog, as well as by video diaries on YouTube, and more recently, by Twitter. After releasing five albums, Corner used PledgeMusic in 2012 to help fund his next album, *The Unified Field*, its promotion and distribution, a behind-the-scenes documentary, and a North American tour. In return for funding support, fans could receive rewards such as signed set lists (€25), an e-mail exchange with Corner (€50), and a dinner party with Corner and his friends (€2,000).

The video has a higher production value than Palmer's, featuring quick cuts, soft focus, fades, extreme close-ups, loops, and flickering effects. Corner delivers his pitch primarily as a voiceover backed by acoustic guitar and electronic noises. As with much of his work as IAMX, this video has an erotic element, featuring shots of his keyboard player, Janine Gezang, performing brief sadomasochistic gestures, such as snapping a belt like a riding crop and slapping her thigh, on which "Pledge" has been written, and scenes of Corner being sprayed with water and opening his shirt.

He opens with the greeting, "Welcome glamourous friends and beloved ones," and stares directly and steadily into the camera, as he continues to do intermittently for the rest of the video. He mobilises the hyperbolic language that he often uses in his lyrics and blog:

> We need you hand in hand, mouth to mouth, intertwined for this survival of art and for the future of meaningful music. We're creating history together. I am already deep in the ocean of the next IAMX record...and it must become as explosive as my imagination imagines it and as touching as you need it to be. I want it to move you. I want it to fuck you. I want it to dictate the psychology of your offspring. Many of you have been asking how you can get involved supporting IAMX. That's why I'm here at PledgeMusic. You can give, I can create.

He then explains that he needs financial support to allow him to work more collaboratively, referring to himself as "the solitary studio soldier," who has been "going around in circles, repeating [himself] and eating [himself] up from the inside." This admission leads him to the more business-oriented portion of his video in which he discusses the professionals with whom he intends

to work, including producer Jim Abbiss and filmmaker Danny Drysdale. Corner ends his video by calling his campaign an "untested process" that could fail, but once again performs a romanticised, erotic intimacy by saying he and his fans could be "left in debt, naked, with nothing but our eternal love for each other."

Saving Music: Activism and Public Good

Though Amanda Palmer's video is playful and Chris Corner's is more intense, they are comparable. Both are handmade by the artists (with assistance from collaborators) and feature direct appeals, the gaze constantly addressing the viewer. They offer aural samples of what you are being persuaded to support, hopefully convincing you that the musicians have begun or nearly completed their labour. By invoking other well-known names – whether the artists working for Palmer, or Corner's use of Jim Abbiss and Danny Drysdale – they associate themselves with quality whilst demonstrating their collaborative spirit and justification for money spent on additional labour. Their rhetoric assumes that they, as artists, have converging needs and goals with their fans, and characterises fans as people of distinction and taste, who will become activists by influencing the future of music and making history. Replace "music" with "starving children," or "poverty," and the message seems more familiar. Palmer reinforces the implication of activism and agitation by using the public space of the street and title cards reminiscent of protest placards and the 60s counterculture of Bob Dylan's "Subterranean Homesick Blues." In these videos, there is a focus on futurity, but aware of the demands in the speedy digital world, the artists balance this investment with immediacy in the form of exclusive updates. Palmer and Corner perform identities that are bound up with authenticity and autonomy, projecting the same qualities and values onto their fans who will presumably agree that their causes are meaningful and worth supporting. Matt Stahl argues that within the world of popular music, "aesthetic and personal autonomy...are now often bundled together under the heading of authenticity," and existing as such, connote "modern utopian practices and values" (2013: 18).

Palmer and Corner's campaigns and rhetorical strategies speak to notions of access, transparency, and participation; these popular topics in relation to the digital economy also overlap with techno-utopian ideals, which appeal to the anti-authoritarian politics embedded in rock 'n roll culture. Amanda Palmer states: "I hope you will join our rock 'n roll cause... . We are the media." Chris Corner declares: "We need you hand in hand, mouth to mouth, intertwined for this survival of art." The implication is that fans are powerful

in large numbers and that they are participating in and fighting for these art-ists' urgent causes. These causes, which are essentially Palmer and Corner's art, in turn, contribute to their fans' identities and sense of empowerment. Lawrence Grossberg observes the relationship between fandom and political action:

> The fan's relation to culture in fact opens up a range of political possibilities and it is often on the field of affective relations that political struggles intersect with popular concerns. In fact, the affective is a crucial dimension of the organization of political struggle. No democratic political struggle can be effectively organized without the power of the popular. It is in this sense that I want to say that the re-lationship of fandom is a potentially enabling or empowering one…. (1992: 64)

Palmer and Corner employ an emotional, revolutionary rhetoric to mobilise their fans in the name of music, implying that they will work together to alter the state of artistic creation and consumption.

In a *Guardian* article, Yancey Strickler, co-founder of Kickstarter, said, "When I'm supporting some band [through the site] I love, I'm not 'shop-ping' in the record store, I'm creating alongside them. I get to see the thing happen and be part of the process and know that I made a contribution. I think the emotional resonance that comes with that is huge" (Saner, 2012). Though crowdfunding platforms imply that fans are creating in collaboration with their favourite artists, there are differing degrees of actual engagement and reciprocity. Amanda Palmer often crowdsources onstage musical support, as controversial as it may be (see Wakin, 2012), and provides multiple venues for feedback and dialogue (Potts, 2012), activities that align with Hardt and Negri's ideas of the biopolitical power of the commons (2009) and multi-tudes (2004). In the case of IAMX, distance between artist and fan exists despite the repeated invocation of "we." Corner says in his video, "You can give. I can create," quite clearly delineating the artist and fan roles. In his campaign, a fan may pay for engagement, via e-mail or in person at a dinner party, but contact is otherwise limited. However, Corner's campaign is not unique in this respect—many crowdfunding campaigns for musicians offer similar constraints on participation—and Palmer herself is not asking fans to collaborate in the actual artistic process of making the album. The supposed voice and participation permitted for fans is wrapped up in communicative capitalism (Dean, 2009) and its pretence of a democracy that it does not actually create. Despite the rhetoric of participation, collaboration, and ac-cess, these campaigns remain fundraisers looking for donations, and rely on rhetoric associated with charitable causes, including campaigns for services deemed to be for the public good.

In fact, Palmer and Corner's campaign videos and their reward menus are reminiscent of the fund drives for public service broadcasting (PBS), where the more one pledges, the more "gifts" s/he receives, and where viewers are repeatedly told that they are responsible for the range and quality of the programming through their monetary generosity. Corner stresses that "the number of North American cities included in the tour will depend on the amount of money you raise, so you will have to put more in to get more out"; similarly, Palmer states: "THE MORE WE RAISE IN THIS KICKSTARTER/ THE MORE ASTOUNDING OUR/ TOUR,/VIDEOS,/ALBUM PACKAGING,/AND BOOK/WILL BE." Even as fans are individually thanked through their rewards, they are ostensibly contributing to a greater good for a larger number of fellow fans. Additionally, PBS emphasises the service they are providing: cultural, educational, and independent of commercial interests and advertising. Palmer and IAMX echo these intimations of a public good that subverts the corporate establishment, charging their campaigns with a morality similar to that of charitable causes, many of which have used the "symbolic power of music to motivate action as well as emotion" (Westley, 1991: 1012). Despite the perception of charity as an agent for addressing social problems (Livingstone, 2013: 348), it is also a "cultural concept; it is consumed and reproduced as a commodity, part of the spectacle, a social event" (Livingstone, 2013: 350). This capitalist, neoliberal sense of charity is a feature of previous musician-endorsed campaigns, such as Live Aid, portraying consumption as a subversive, moral act of agency that challenges authority (Davis, 2010: 103; Lahusen, 1996: 84; Westley, 1991); nevertheless, these music-based charitable texts are "some of the few appropriate venues within which ordinary members of society can overtly express compassion and enact protest within the compassionate conservative cultures in the West" (Davis, 2013: 212). H. Louise Davis argues that Live Aid "ushered in a new culture of consumer activism centred around the highly visible and undeniably profitable mega-event" and "hailed every concert-goer, every television viewer, as a consumer-donor, as an active subject capable of effecting change on a global scale" (2013: 211–12). The fan is only a countercultural activist in so much as s/he is a capitalist consumer. This contradictory position is already present in the tension of fandom itself, in what Matt Hills calls the "curious co-existence within fan cultures of both *anti-commercial ideologies and commodity-completist practices*" (2002: 28).

Another term for this version of charity is philanthrocapitalism, popularised by Matthew Bishop and Michael Green in their 2008 book. They define the term as "the capitalist mobilization of a society's productive capacity [which] can also be made to serve ecological goals, the struggle against

poverty, and other worthy ends" (34). Uday Khemka, director of the SUN Group investment company, predicts that "philanthropy will increasingly come to resemble the capitalist economy," turning causes into "social entrepreneurs" seeking investments from philanthropists who consider how they will maximise their "social return" (*The Economist*, 2006). Furthermore, this neoliberalization of charity has connections to Slavoj Žižek's term "cultural capitalism," in which consumers believe they are acting morally and more meaningfully by consuming commodities that are deemed goods for the public good (i.e., "fair," "sustainable," etc.). Žižek argues that "we primarily buy commodities neither on account of their utility nor as status symbols; we buy them to get the experience provided by them in order to render our lives pleasurable and meaningful" (2009: 52). Crowdfunding makes this same slippage between philanthropist and consumer.

Though Palmer and Corner utilise many of the same rhetorical strategies as public arts fundraising, they are ultimately selling commodities, and in Palmer's case, naming profit as one of her goals. Palmer even states in her video that she would be willing to accept an interest-free loan from the "insanely rich." This blurring of charity and venture capitalism is complicated by the fact that a crowdfunding platform like Kickstarter specifies that it cannot be used for "charity, cause, or 'fund my life' projects" (Kickstarter.com), but some platforms, like PledgeMusic, feature a charitable component, allowing artists to donate some of their raised funds to another cause (PledgeMusic). In fact, Chris Corner pledged a portion of his excess funds to the Richard Dawkins Foundation for Reason and Science.

Jen Harvie argues that "though crowdfunding enables individuals to act with self-determining agency in deciding what arts to choose to fund, it destabilizes mutual social responsibility" (2013: 173); in other words, crowdfunding does not necessarily create a socially coherent and collective group of supporters. Using a case study of the theatre group Punchdrunk, she explains that mixed modes of art funding, including crowdfunding, often "risk monetizing social relationships and intimacies, reinforcing elitist market hierarchies and reifying the understanding of the supremacy of the individual over the group that is so crucial to the neoliberal ideology" (2013: 177). These concerns are reflected in crowdfunding for music, in which elitism is implicit in the hierarchy of the rewards menu. For example, one of the more expensive rewards in the IAMX campaign was a golden ticket that allowed the funder to enter a concert earlier than others, thereby potentially obtaining an ideal position next to the stage. The more a fan is willing and able to pay, the more privileged her/his claimed position is in the fan hierarchy. These elite fans could also appear to be purchasing more intimacy, including increased access,

attention, and reciprocity, from performers. The fan purchasing a dinner party with Chris Corner gains a sense of more authentic intimacy and power than the fan who only purchases a record, and in doing so, perhaps "proves" her/his dedication and love. This hierarchical, monetised structure could lead to a cycle of more extravagant gestures on the parts of both artist and fan, detracting from any sense of crowd collectivity and common cause. Moreover, monetising social relationships with fans through crowdfunding and fetishizing intimacy (Harvie, 2013: 181) can exploit this perceived closeness in the name of capitalism.

Nevertheless, there is a practical reality to be addressed within the business of selling music, apart from the crowdfunding model. The capitalist ideology embedded in the twentieth-century music industry exists in perpetual denial, especially in arguments about authenticity, "selling out," and anti-establishment art-making practices. In defense of his prescient *Stars Forever* project, Momus exposes the "ridiculous paradoxes built into pop music and its guilty co-existence with capitalism," and anticipates the spread of crowdfunding, comparing it with earlier patronage systems:

> The only difference is that now, you don't have to be an aristocrat to get a piece of the action... . Which is more honest, the subscription publishing system of the 18th century, when poets would gather enough subscribers to pay for printing a batch of poems and then write them, or the romantic posturing of the nineteenth century, when poets would claim to be indifferent to their audience and totally separate from the systems of publishing, promotion and marketing? (1999)

Momus interrogates the logic of sublimating the capitalistic, commercial aspect of selling music, thereby recommending the potentially more transparent system in patronage. However, this type of music business appears to shift the uneasy relationship between art and commerce to the relationship between artists and fans.

The Labour Pains of Relationships: Busking, Patronage, Affect

Perhaps Palmer and Corner's focus on the moral good in their crowdfunding campaigns is a strategy to mitigate the connotations of busking, or what one journalist called "the art of 'persuading strangers to fork out money for free music'" (Kastner, 1992). In the current digital economy, where musicians are increasingly viewed as asking people to pay for music that is often already made free through the Internet, the analogy of busking is even more apt. Crowdfunding videos place the artists in a public forum, performing and displaying their music alongside a direct appeal for money, which can carry a stigma

associated with begging and vagrancy. In an Indiegogo blog post about making successful pitch videos, John Trigonis advises, "Don't solicit, elicit," and expands on this point by stating that there is a "huge difference between pitching and panhandling — with the latter, you're asking for a handout while the former is all about the finesse of eliciting a response from a potential funder by offering them a chance to become part of something great" (2013). The implication here is that artists must foster a sense of collaboration with their fans, even if this collaboration is not wholly authentic, to invoke a sense of profitable capitalistic investment rather than undeserved charity. Marillion, the band whose fans funded their 1997 tour, were initially skeptical of their grassroots campaign, worrying that they would be "perceived by the media as beggars" (Golemis, 1997), and in his pitch video, Chris Corner says, "To make this possible in an indie universe, I wouldn't say I beg, but I...I ask for your help." Amanda Palmer addresses this tension in her 2013 TED Talk, entitled "The Art of Asking," in which she attempts to deconstruct the shame in asking strangers and her public for help and justifying artistic work that does not easily fit the capitalist market.

As a result of these tensions, crowdfunding has led to debates about which causes constitute a "proper" use of this particular method of fundraising and/or raising of capital. The discourses that circulate about who deserves to ask for funding reveal popular assumptions about independence, accountability, charity, and worthy causes. Amanda Palmer was the focus of this kind of criticism, with one of the more visible critiques coming from producer Steve Albini, who denounced Palmer as an inefficient, exploitative businessperson, especially in regards to her crowdsourcing of backing musicians (Denney, 2013). Though Palmer was accustomed to crowdsourcing for most of her career, seeing it as a DIY alternative to corporatised practices, her $1.2 million raised via Kickstarter changed the context and power dynamics; as a privileged millionaire, she was now scrutinised for her business management, and as the beneficiary of numerous public donations/investments, she was now accountable to her public/stakeholders.

Furthermore, these crowdfunding campaigns allude to the similarly fraught relationship of patronage. Crowdfunding is often referred to as "micro-patronage," which allows a large number of people to give smaller contributions, rather than the traditional patronage system in which a few people donate large amounts of funding (Harvie, 2013: 170). Marjorie Garber presents "the paradox of 'patronizing' as both endorsement and condescension" and discusses it in tandem with "the paradox of 'public taste' as both blockage and goal" (2008: 124). Though the post-Enlightenment idea of the artist is one in which the artist becomes part of the capitalistic market rather than

the patronage system (Hobsbawm, 1977), crowdfunding campaigns, such as Palmer's and IAMX's, reestablish a version of patronage, along with its conflicting demands and considerations of the so-called public. Garber asserts that the artist can occupy a liminal space as guest or servant within their patronage relationship (2008: 5), often leading to resentment, restrictions, or expectations that go beyond a mere professional business exchange, including what Garber calls the "fantasy of...immediacy" (2008: 121). This last point especially exposes the challenges of affective labour, or labour that creates and maintains social relationships (Hardt & Negri, 2004: 110–111). Garber compares patronage to a romantic relationship (2008: 120), and in doing so, points to the trepidation involved in accepting monetary payment for what amounts to affective labour. She writes: "the idea that art is related to love, and thus, in an etymological as well as a pragmatic sense, to the *amateur*, has had some negative effects upon the idea of art-making as a *profession*" (2008: xii). In other words, how can we value affective labour?

According to Hardt and Negri, we cannot effectively value it: "[b]iopolitical products...tend to *exceed* all quantitative measurement and take *common* forms, which are easily shared and difficult to control as private property" (2009: 135–136). This immeasurability, which affects the ability to sell immaterial, deterritorialised music in a capitalist market, is equally applicable to the artists' affective labour, a facet of their already precarious work. With the affordances offered by the digital economy, including social media and music production/distribution tools, musicians are increasingly expected to be "cultural entrepreneurs" (Morris, 2013) and engage in roles beyond creating and performing music (Thomson, 2013). Palmer and Corner engage in emotional labour surplus to their artistic work, possibly recognising that what fans are asking of musicians is what fans already ask of themselves: affective labour. The controversy around Palmer's use of fans for unpaid labour as live musicians highlights the often invisible affective labour and porous boundaries already inherent in the fan experience. Activities such as fan-created zines, blogs, and record labels, along with participation in street teams or sharing links through online social networks, are generally unpaid, emotional labours (Baym & Burnett, 2009; Morris, 2013), and in many ways, similar to types of paid affective labour, such as PR or marketing.

Music is, like many other arts, highly affective; in fact, much of its value to fans is bound to meaningful feelings, including "[a]uthenticity, identity formation and other traces of traditional identity politics...especially as imagined in music-oriented discourses about 'belonging,' affiliation, attachment and musical value" (Thompson & Biddle, 2013: 16). This definition of authenticity is less about autonomy and anti-establishment

values, and more about "the affective processes of…feeling at home, feeling invested" (Thompson & Biddle, 2013: 17), which are at play in Palmer and Corner's crowdfunding campaigns. Emotional investment is transfigured into financial investment. The fact that funders are figured as part of a crowd also allows for an analogy to crowds experiencing live music together. Attending a music performance is intensely and innately affective; fans are often physically acted upon and physically act upon others, in a moshpit for example, as the music itself acts emotionally on the entire crowd. Both Palmer and Corner's live performances are physically and emotionally intimate; in fact, Corner uses the more pathological term of psychosis to refer to the state of a crowd passionately engaged in collective listening (*You Can Be Happy*, 2013). This extreme state of shared realities challenges the contrasting notions of intimacy and anonymity that are often associated with crowds (Egginton, 2006: 99). The implicit hope in campaigns such as those for Palmer and Corner is for transference of this kind of crowd affect into crowdfunding affect.

From the perspective of the artists who perform surplus affective labour, especially in order to remain outside the music industry's control, this "free labour" (2004), in Tiziana Terranova's terms, can lead to exhaustion and frustration. As Morris notes in his study of musician Imogen Heap, who decided to use innovative crowdsourcing for her album *Ellipse* whilst taking on much of her own promotion and administrative duties, she became overwhelmed and disappointed in her decreasing time commitment to making music itself (2013: 12). Chris Corner struggles with his own affective labour, revealing that although fans, with their energy and love, take IAMX to another level at live shows, their engagement can also become emotionally overwhelming: "It almost makes you shut down because it's just a bit too much love in one amount in one evening.… I wouldn't say I don't like it, but I think it's something you have to control and come to terms with at some point" (*You Can Be Happy*, 2013).

Conclusion

Even as a flawed, ambiguous system, does crowdfunding "work" more fairly than the machinations of the music industry? Within the parameters of record contracts, artists are paradoxically both "autonomous and the target of control" (Stahl, 2013: 3), whilst, arguably, within the crowdfunding apparatus, the employer's control is diminished or eliminated, and artists are thus less vulnerable to what Stahl terms "contractual alienation." However, as evident from Palmer and Corner's additional affective labour to produce multiple

unique rewards, and to create and maintain networks with fans, greater responsibilities come with this power, flexibility, and autonomy, and artists enter into a more complicated relationship with their fans. In crowdfunding, both artist and fan are labourers; they are also simultaneously lovers *and* beloved. Even as they share these roles, they also occupy positions of difference, including artist as cause and fan as activist/donor; artist as entrepreneur and fan as investor; artist as idol and fan as idoliser; artist as creator and fan as patron; artist as public service and fan as public; artist as unique individual and fan as part of common crowd. These shifting dynamics disrupt potentially alienating power relations, yet are continually influenced by late capitalism; public good becomes conflated with private goods.

At the beginning of the 21st century, the political economy of music is a visible case study for affective labour in the context of new digital materialities, and crowdfunding, with its demonstration of philanthrocapitalism and rhetoric of fan activism, continues to evolve as a major contender for a business model. In 2012 the majority of funded projects through Kickstarter were those for music (Kickstarter.com, 2012); at the same time, Kickstarter hosted the campaign for CASH Music, a free online resource for musicians that aims to challenge third-party crowdfunding sites. Crowdfunding is becoming a common feature in the music-making economy, encouraging further analysis of the implications, ethics, and realities of its appeals, including the actualities of fan empowerment and collectivity, or conversely, the neoliberal individualism and exploitation in the enterprise. The success of these appeals ostensibly depends on the personalities/personas of artists, including their capacity for affective labour, and the publics that they are able to hail, raising questions about how affective labour might be one of the responses to music becoming the cause.

References

Aitamurto, T. (2011). The impact of crowdfunding on journalism: Case study of Spot. Us, a platform for community-funded reporting. *Journalism Practice, 5*(4), 429–445.

Baym, N. & Burnett, R. (2009). Amateur experts: International fan labor in Swedish independent music. *International Journal of Cultural Studies, 12*(5), 433–49.

Belleflamme, P., Lambert, T. & Schwienbacher, A. (2013). Crowdfunding: Tapping the right crowd. *Social Science Research Network*. Retrieved October 31, 2013, from http://papers.ssrn.com/sol3/papers.cfm?abstract_id=1578175

Bishop, M. & Green, M. (2008). *Philanthrocapitalism: How the rich can save the world*. New York: Bloomsbury.

Davis, H. L. (2010). Feeding the world a line?: Celebrity activism and ethical consumer practices from live aid to product red. *Nordic Journal of English Studies, 9*(3), 89–118.

Davis, H. L. (2013). Concerts for a cause (or "cause we can"). In J. C. Friedman (Ed.), *The Routledge history of social protest in popular music*, pp. 211–226. London: Routledge.

Dean, J. (2009). *Democracy and other neoliberal fantasies: Communicative capitalism and left politics*. Durham, NC: Duke University Press.

Denney, A. (2013). Interview: Steve Albini. *The Stool Pigeon*. Retrieved March 24, 2014, from http://www.thestoolpigeon.co.uk/features/interview-steve-albini.html

The Economist. The birth of philanthrocapitalism. February 23, 2006. Retrieved February 23, 2014, from http://www.economist.com/node/5517656

Egginton, W. (2006). Intimacy and anonymity, or how the audience became a crowd. In J. T. Schnapp & M. Tiews (Eds.), *Crowds*, pp. 97–110. Stanford: Stanford University Press.

Garber, M. (2008). *Patronizing the Arts*. Princeton, NJ: Princeton UP.

Golemis, D. (1997). British band's U.S. tour is computer-generated. *Chicago Tribune*. Retrieved February 19, 2014, from http://articles.chicagotribune.com/1997-09-23/features/9709230071_1_music-fans-newsgroup-marillion

Grossberg, L. (1992). Is there a fan in the house?: The affective sensibility of fandom. In L. A. Lewis (Ed.), *The adoring audience: Fan culture and popular media*, pp. 50–65. London and New York: Routledge.

Hardt, M. & Negri, A. (2004). *Multitude: War and democracy in the age of empire*. New York: Penguin.

Hardt, M. & Negri, A. (2009). *Commonwealth*. Cambridge: Harvard University Press.

Harvie, J. (2013). *Fair play: Art, performance and neoliberalism*. Basingtoke, UK: Palgrave.

Hills, M. (2002). *Fan cultures*. New York: Routledge.

Hobsbawm, E. J. (1977). *The age of revolution: 1789–1848*. London: Abacus.

Huff, C. (2011). The crowdfunding guide for artists: Part 2. *The Abundant Artist*. Retrieved February 23, 2014, from http://theabundantartist.com/the-crowdfunding-guide-for-artists-part-2/

Kastner, J. (1992). Toronto busker's life is no easy street. *Toronto Star*, 15 August, p. A2.

Kickstarter.com. (2012). Best of Kickstarter 2012. Retrieved April 1, 2013, from https://www.kickstarter.com/year/2012

Kickstarter.com. Kickstarter Basics >> Frequently Asked Questions (FAQ) — Kickstarter. Retrieved March 24, 2014, from https://www.kickstarter.com/help/faq/kickstarter%20basics

Lahusen, C. (1996). *The rhetoric of moral protest: Public campaigns, celebrity endorsement, and political mobilization*. Berlin: De Gruyter.

Lazzarato, M. Immaterial labour. *Generation Online*. Retrieved October 10, 2012, from http://www.generation-online.org/c/fcimmateriallabour3.htm

Livingstone, N. (2013). Capital's charity. *Capital & Class*, 37, 347–53.

Mollick, E. (2014). The dynamics of crowdfunding: An exploratory study. *Journal of Business Venturing*, 29(1), 1–16.

Momus. (1999). On patronage. *iMomus*. Retrieved March 21, 2014, from http://imomus.com/onpatronage.html

Morris, J. W. (2013). Artists as entrepreneurs, fans as workers. *Popular Music and Society*, 37(3), 1–18.

Palmer, A. The art of asking. *Ted.com*, 2013. Retrieved March 4, 2014, from http://www.ted.com/talks/amanda_palmer_the_art_of_asking

Peters, M. A. & Bulut, E. (2011). Introduction: Cognitive capitalism, education and the question of immaterial labor. In M. A. Peters & E. Bulut (Eds.), *Cognitive capitalism, education, and digital labor*, pp. xxv–xl. New York: Peter Lang.

PledgeMusic. PledgeMusic. Retrieved March 24, 2014, from http://www.pledgemusic.com/learn/artists

Potts, L. (2012). Amanda Palmer and the #LOFNOTC: How online fan participation is rewriting music labels. *Participants: Journal of Audience & Reception Studies, 9*(2), 360–382.

Saner, E. (2012). Kickstarter: the crowdfunding site that wants to spark a creative revolution in the UK. *Guardian*. Retrieved November 20, 2012, from http://www.theguardian.com/technology/2012/nov/14/kickstarter-crowdfunding-creative-revolution-uk

Schnapp, J. T. & Tiews, M. (2006). Introduction: A book of crowds. In J. T. Schnapp & M. Tiews (Eds.), *Crowds*, pp. ix–xvi. Stanford: Stanford University Press.

Sørensen, I. E. (2012). Crowdsourcing and outsourcing: the impact of online funding and distribution on the documentary film industry in the UK. *Media, Culture & Society, 34*(6), 726–743.

Stahl, M. (2013). *Unfree masters: Recording artists and the politics of work.* Durham and London: Duke University Press.

Terranova, T. (2004). *Network culture: Politics for the information age.* London: Pluto.

Thompson, M. & Biddle, I. (Eds.). (2013). *Sound music affect: Theorizing sonic experience.* New York: Bloomsbury.

Thomson, K. (2013). Roles, revenue, and responsibilities: The changing nature of being a Working Musician. *Work and Occupations, 40*(4), 514–525.

Tomczak, A. & Brem, A. (2013). A conceptualized investment model of crowdfunding. *Venture capital: An International Journal of Entrepreneurial Finance, 15*(4), 335–359.

Trigonis, J. (2013). 5 ways to power-up your crowdfunding pitch video. *Indiegogo Blog.* Retrieved from February 23, 2014, from http://go.indiegogo.com/blog/2013/02/five-ways-to-power-up-your-crowdfunding-pitch-video.html

Wakin, D. J. (2012). Rockers playing for beer: Fair play? *The New York Times.* Retrieved March 24, 2014, from http://artsbeat.blogs.nytimes.com/2012/09/12/rockers-playing-for-beer-fair-play/?_php=true&_type=blogs&_r=0

Westley, F. (1991). Bob Geldof and Live Aid: The affective side of global social innovation. *Human Relations, 44*(10), 1011–1036.

Wodtke, L. (2014). MP3 as contentious message: When infinite repetition fuses with the acoustic sphere. In M. Reimer, N. Ali, D. England, & M. Dennis Unrau (Eds.). *Seriality and texts for young people: The compulsion to repeat*, pp. 237–257. Basingstoke, UK: Palgrave Macmillan.

You can be happy (Berlin, 2013). Directed by Danny Drysdale.

Žižek, S. (2009). *First as tragedy, then as farce.* London: Verso.

11. The Role of Crowdfunding as a Business Model in Journalism: A Five-layered Model of Value Creation

Tanja Aitamurto

The Rise of Crowdfunding in Journalism

The traditional business models in journalism are in transformation; as subscription revenues are falling in print, online revenues from paywalls can't match the deficit, and online advertising is not as profitable as in the print era (Downie & Schudson, 2011; McChesney & Pickard, 2011). Audiences are also scattered online, and the value of online journalism is declining when measured monetarily. Due to the large number of layoffs in media, the newsrooms have shrunk to one third of what they used to be. Consequently, the number of freelance journalists is growing, and there's a constant, feverish search for new revenue sources.

One new potential revenue source for journalism is crowdfunding – a distributed funding model in which stories are funded by small donations or payments from a large crowd of people. Crowdfunding is a type of crowdsourcing; in crowdfunding, the crowdsourced task is to gather money for a certain purpose, and in crowdfunding in journalism, the task is to gather funding for a story pitched by a journalist. Freelance journalists pitch their story ideas on crowdfunding platforms, like Kickstarter, and community members – that is, anybody who goes to the website – can fund the pitches they like.

Crowdfunding in journalism has become increasingly common in recent years. Crowdfunding platforms such as Kickstarter, Indiegogo, Beacon, and Spot.Us have enabled crowdfunding for journalistic stories, which cover a large array of topics and geographic locations. As a more recent trend, combinations of crowdfunding and crowdsourcing information for journalistic

stories have started to appear, such as *The Guardian*-backed Contributoria – a platform for crowdsourcing, co-creation, and crowdfunding in journalism. Moreover, crowdfunding has been increasingly used to fund entirely new journalistic platforms and publications, like *Krautreporter* in Germany and *de Correspondent* in the Netherlands.

While crowdfunding in journalism has become increasingly common, there is a growing need to examine the role of crowdfunding as a business model in journalism. Therefore, the focus of inquiry here lies in the following two questions: What is the role of crowdfunding in the business model ecosystem in journalism? What are the possibilities and constraints of crowdfunding as a business model in journalism?

This chapter introduces a typology that enables the analysis of crowdfunding in journalism by placing it into four categories. Furthermore, this chapter also introduces a model for analysing the value of crowdfunding in journalism. The chapter is structured as follows. I will first establish definitions and categories of crowdfunding. Then a new typology for crowdfunding in journalism is introduced and instantiated in the context of journalism. The functions of crowdfunding in each model are then examined and analysed, and a model for analysing the value of crowdfunding is introduced. Finally, the role of crowdfunding as a business model for journalism is then discussed on a more holistic level as a part of the novel emerging business model system for digital journalism.

The Essence of Crowdfunding: Small Amounts From a Large Crowd

Crowdfunding basically means soliciting funding from a large crowd of people online. The amount of individual donations, payments, or investments is typically small, starting at $1. The power in crowdfunding lies in the quantity of funders, and crowdfunding initiatives typically aim for large numbers of funders. Through this method, an individual, group of people, or organisation can raise funding for their cultural project, such as music and literature, or for developing new products, like technological gadgets or newly designed coffeemakers. The method is also used to raise funding for start-up companies. Belleflamme et al. (2010) define crowdfunding as the collective co-operation of online individuals who pool their money for a project or product.

By pooling their money through crowdfunding, funders often enable a realisation of a process and a product that might not have come true otherwise. For instance, in crowdfunding music, funders can support a musician who is in the beginning of his or her career and doesn't have a recording contract yet. Or,

in new product development, a designer might want to design and manufacture a board game as a side project. Finding ways for funding for an individual project is challenging, but crowdfunding provides a viable option.

Crowdfunding can happen anywhere online, including on one's own blog or website, but the practice often takes places on dedicated online platforms due to the large audiences the platforms are able to gather and the technical affordances they provide. The number of crowdfunding platforms is increasing, and there are platforms that are specific to pitches from a certain area and those that accept pitches from several contexts. For instance, musicians seek funding on SellaBand, while Fundable and Startup Crowdfunding are dedicated to funding entrepreneurs. Spot.Us, Beacon, and TugBoat accept only journalistic projects, whereas Kickstarter, RocketHub, and Indiegogo are flexible about the context of the project and accept pitches from artists of all kinds, entrepreneurs, and philanthropists.

Crowdfunding platforms typically take a slice of the revenue the pitch gathers. That slice is growing: in 2012 alone, the crowdfunding industry raised \$2.7 billion in support of over a million projects, and the market was estimated to double in size in the following year (Massolution Research, 2013). The payments are often facilitated through Amazon Payments or PayPal integrations, which make the payment process seamless. Products that are pushed forward by crowdfunding are making it more often to the public awareness. To cite a few examples, virtual reality system Oculus VR, which was funded on Kickstarter, was acquired in 2014 by Facebook for \$2 billion. Smartwatch-maker Pebble sold more than 400,000 of its crowdfunded smartwatches in 2013.

Four basic models of crowdfunding can be distinguished, those being donation-based, reward-based, lending-based, and equity-based (c.f. Agrawal et al., 2011, 2013; Kuppuswamy and Bayus, 2013; Massolution, 2012; Mollick, 2013). In donation-based crowdfunding, funders donate to a project without tangible compensation in return. An instance of this model is when a funder donates on Spot.Us or Kickstarter to a journalistic story, which doesn't provide tangible rewards, or the donation is so small that it doesn't reach the tiers that provide rewards. In reward-based crowdfunding, funders are offered rewards such as T-shirts, stickers, or the product for which the money is raised. Rewards are often structured in tiers: the more funding the supporter gives, the higher the value of the reward. For instance, if the goal of a project on Kickstarter is to produce a children's book, rewards are related to the book, and on a certain tier, the funder receives the book in return for the money.

The rewards have also been called "patronage perks" (c.f. Kappel, 2008), in that the rewards are given to supporters, i.e., patrons, and the rewards often

provide more exclusive access to the making of the process of a music record, for instance, or interactions with an artist. Artistic patronage in crowdfunding creates a direct relationship between the supporter and the creator (Beer & Badura, 2012). In the traditional artistic patronage a handful of supporters donate big sums, but in crowdfunding the support comes from a large crowd in small amounts. The distributed patronage model follows the notion of 1,000 true fans by Kevin Kelly (2008): it'd be enough support if each fan pays $100 a year to support the creator's art. Crowdfunded patronage for cultural productions is becoming more common, as specific platforms and models for cultural crowdfunding are in rise. Patreon, a San Francisco–based start-up, which was founded in 2013, raised $15 million in venture capital to extend its operations in June 2014. On Patreon the supporters – who are called Patrons – contribute to YouTube videos, music, science, comics, and dance productions, among other things. Patrons pledge as little or as much as they want to their favourite productions. On subscription-based pledges, the Patron contributes a given amount every month.

The type of crowdfunding in which rewards include the actual end-product of the crowdfunded production process has also been called crowdfunding for pre-orders. The crowdfunders thus pre-purchase the product and will receive it (Belleflamme, Lambert, & Schwienbacher, 2013).

In lending-based crowdfunding, funders expect to receive back the funding they contribute to a project, perhaps with interest. Kiva.org is one of the best known micro-lending sites. In equity-based crowdfunding, the funders receive equity and/or shared revenue in return for their investment. That is a typical arrangement in crowdfunding for start-ups, but it is also used in other realms of crowdfunding. SellaBand, for example, enables artists to offer funders a share in their revenue (Bannerman, 2013; Massolution, 2012).

Crowdfunding for rewards can be defined as an umbrella term for crowdfunding in which supporters receive a tangible reward for their money. To this end then, crowdfunding for preordering and crowdfunding for equity are both categorised as reward-based crowdfunding. Rewards basically mean a return for the money invested or given, or, in other words "bang for the buck". However, it is necessary to note that in donation-based crowdfunding, there can also be, and most likely are, rewards for the donors. This means that the donors must have an incentive to donate, even though they wouldn't get a tangible return, or an object, for their donation. The incentive can be, for instance, a feeling of belonging to a community, as noted in studies about crowdfunding in journalism (Aitamurto, 2011).

Another way to categorise crowdfunding is by distinguishing the funding activity between *ex ante*[1] and *ex post facto* crowdfunding (Kappel, 2008).

In *ex ante* crowdfunding, the funds are raised to support a future action, event or process to achieve a certain outcome. In *ex post facto* crowdfunding, instead, the funds are raised for a completed product. *Ex ante* crowdfunding is the more common crowdfunding model. *Ex post facto* crowdfunding is more of a digital tip jar (Kappel, 2008: 377) in that money is raised for a product that would be often available for free anyway. For instance, in 2007, the band Radiohead allowed its fans to determine what price to pay for its release *In Rainbows*, including an option to download it for free (Lipsman, 2007). In other words, paying for the record was voluntary, and the price was based on a "pay what you like" model.[2] Another instance of *ex post facto* crowdfunding is social payments or micro-donations, such as on Flattr. On Flattr, the user makes voluntary payments; in other words, users make donations to the sites they like or for pictures they want to support using browser extensions or an embedded button or widget on a website. Crowdfunded artistic patronage on platforms like Patreon is a mix of *ex ante* and *ex post facto* crowdfunding. The supporters contribute to productions before they are ready, and they might keep supporting the creator after the first project is ready, thus using the digital tip jar model in patronage.

Crowdfunding in Journalism: Evolving Models

Crowdfunding in journalism has become more common since the 2008 launch of Spot.Us, the pioneering large-scale platform for crowdfunding in journalism. On Spot.Us[3], journalists would pitch stories and gather funding, initially, as a donation-based crowdfunding without rewards, and later as the platform evolved with a tiered reward-model, thus moving to reward-based crowdfunding model. Typically, crowdfunding in journalism is *ex ante* crowdfunding, meaning that the funding is gathered before the story process begins. Thus, the funding is often essential for the story to be realised.

Crowdfunding platforms for journalism have a pre-screening process for the pitches: the pitches have to be accepted by editors. Depending on the model used, the platform may or may not restrict the amount that a single funder can donate to a story. For instance, on Spot.Us, a single donor can donate 20% of the total fundraising goal. This is to prevent the disproportionate influence of a single donor in a story process. However, by creating several profiles, a donor could bypass the rule, if he or she so wanted, and donate multiple times under several profiles. Donations in journalism are not a new phenomenon, though. In the United States, NPR, formerly National Public Radio, drives yearly campaigns for donation-based funding. However, what is

new in crowdfunding models is that the funders are supporting one story or author with their contributions, rather than an organisation.

Typically, crowdfunding works like a campaign. The pitches have a defined length, and the journalist spreads the word on social networking sites about the ongoing pitch. It is like a fund-raising event, which is distributed across the crowds, lengthened temporally and doesn't require the attendees to gather in same physical space. Depending on the crowdfunding platform used for the campaign, the journalist gets to keep the money only if the fundraising goal is reached, which is the case on Kickstarter, for instance. On other platforms, such as RocketHub and Spot.Us, the fundraiser keeps the money that he or she managed to gather, whether the goal is reached or not. Crowdfunding is favoured by freelance journalists. For them crowdfunding is often one revenue source among others, and it has become a more appealing funding mechanism as the traditional newspaper industry is falling, and a decreasing number of journalists get paid by the legacy media. The crowd-funded stories are published in the mainstream or independent media publications or on the crowdfunding platform, or on both.

Crowdfunding disrupts some of the traditional structures in journalism. First, in the traditional journalistic process, the value proposition of a journalist's pitch has to appeal first and foremost to the editors, who then decide whether a story topic is accepted to the publications' agenda and if a story is published or not. The editor also decides about the pay for the story. In crowdfunding, on the contrary, the journalist is pitching directly to the public – to the potential readers. That direct connection to the end-users requires new skills and approaches from journalists. It is challenging for journalists to adjust to their new role, which requires undertaking marketing efforts on social media and selling their work directly to the audience, rather than to editors (Aitamurto, 2011).

Second, crowdfunding in journalism alters the power structures in the journalistic process. In the traditional model, the journalist and the publishers act as the gatekeepers for story topics, thus setting the journalistic agenda. But in crowdfunded journalism, the power is shared between the journalistic institution, which here refers to journalists, and funders. The donors are the decision makers in crowdfunding; they "vote" with their donations. Thus, in crowdfunded journalism, the readers' agenda manifests in crowdfunding as an aggregated judgment about the stories that are worthwhile in covering. By donating to a pitch, the donor expresses which topics need to be reported. Donors' judgments are aggregated and accumulated into funding for a story, and with the appropriate funding, stories will be delivered. These aggregated judgments are a manifestation of collective intelligence in crowdfunded

journalism. Collective intelligence refers to the distributed talent and knowledge of large crowds (Lévy, 1997; Landemore, 2013).

Typology for Crowdfunding in Journalism

While it is important to understand the types of crowdfunding in general as discussed in the previous section, in order to analyse the impact of crowdfunding, it is also necessary to view the role that crowdfunding serves in journalism. Therefore I introduce here a novel framework with which crowdfunding in journalism can be analysed. The typology has four categories, and the categories indicate the role of crowdfunding in journalism. The categories are as follows:

i) Fundraising for a single story
ii) Fundraising for continuous coverage/beat
iii) Fundraising for a new platform/publication
iv) Fundraising for a service that supports journalism

In the following section, I will examine these categories further by instantiating them in examples.

Fundraising for a Single Story

Crowdfunding for a single journalistic story is perhaps the oldest model of crowdfunding. In this model, the journalist pitches a story online for potential funders. The pitching often happens on a specific platform, like Kickstarter, Spot.Us, or Contributoria. Journalists have raised funding for their stories ranging from local coverage to explorations overseas. Some of these well-known stories include the coverage of the Pacific Garbage Patch by Lindsay Hoshaw in 2009. She wanted to investigate the floating island of plastic particles in the North Pacific Ocean, known as the Great Garbage Patch or as the Pacific Trash Vortex. Hoshaw raised $10,000, which was her fundraising goal, to cover the costs of joining a boat trip to the Garbage Patch, and one of the stories she wrote was published in *The New York Times*. To mention another well-known fund-raising effort, Ted Rall, a columnist and cartoonist, funded a trip to Afghanistan in 2010 to cover the war and write a book. He raised $25,999, while his goal was $25,000. While these spectacle-like campaigns and coverages are some of the best-known instances about crowdfunded journalism, there are hundreds of crowdfunded stories that haven't received such a large amount of attention as the more high-profile articles.

Another novel crowdfunding model is Contributoria. Contributoria is a collaborative platform on which journalists pitch stories, and supporters can contribute by funding. The support is shown by distributing points to the pitches. The supporter gets points when she or he joins Contributoria, and the more she or he pays as subscriptions, the more points the supporter has. Contributoria takes a step beyond the basic donation- or equity-based crowdfunding model by offering three subscriber levels. The levels include a free "Starter-level" and a "Supporter-level," which costs about $3 a month. The third level is called "Patron," and it costs about $10 month. Patron-level subscription is needed for a user to be able to write and publish on Contributoria. The user gets points when she or he joins Contributoria, and the more the user pays, the more points she or he gets. The user can then use those points to back writers' proposals. Writers' payments are provided by the community membership pool and other sources of funding, such as sponsorship. Contributoria received initial backing from the Google-sponsored International Press Institute News Innovation Contest, and the platform is currently funded by the Guardian Media Group.

Contributoria also enhances collaboration between the supporters and journalists to advance the story process. The readers are asked to comment on the stories that are still in making and share information related to the story on the Contributoria platform. Furthermore, Contributoria encourages participant co-creation, a method in which readers and journalists collaborate using a systematic online dialogue, which can lead to commitment to follow the author and the publication, and even subscribe for the content (Aitamurto, 2013). Thus, pitching on Contributoria is not only about funding, but the process also supports the journalist's knowledge search.

In this *ex ante* type of crowdfunding, the funds raised from the crowd are essential in funding the journalistic examination, whether this is gathering revenue to pay the journalist or for covering the costs accrued from reporting. In addition, crowdfunding enables sensing the audience's interest for a story and its topic. This means that the more monetary support from a larger number of donors, the more interest there is in the story. Furthermore, journalistic crowdfunding requires opening up the story process to the public. This means that in order to pitch to the public, the pitch has to be publicly visible. That requires a certain degree of transparency for the pitch, which is atypical in the traditional journalistic story process. As a benefit of this transparency, journalists might attract sources, which may prove useful in the story process. This is particularly visible in the Contributoria model, in which the supporters are invited to co-create with the journalists. By pitching in public, journalists

are also attracting readers not only to this particular story at work, but they are also building their brand and thus attracting readers to their future work.

Fundraising for Continuous Coverage/Beat

In this model, crowdfunding is used to gather funding for a more permanent support of a journalistic initiative than just a single story. This model is used, for instance, to fund continuous beats covered by journalists. Beat reporting means specialised reporting, in which a journalist builds her or his knowledge about a particular topic or area. That is how journalists become experts in certain topic areas, like in covering the nation's economy or local food production. While Kickstarter, Indiegogo, and Spot.Us fund beats too, a media start-up called Beacon uses crowdfunding particularly for continuous coverage of beats. On Beacon, potential supporters browse through different authors and their projects, and if they find one that they like, they can pay for a subscription. There are different subscription levels, with the basic price being $5 per month. The subscription gives the subscriber access to the full array of Beacon content. Once logged in and subscribed, the reader gets suggestions for stories from Beacon. Beacon emphasises the journalists' brands, and in that, combined with the continuous subscription-based pledging, its model resembles crowdfunded artistic patronage on platforms like Patreon. The support often builds on fandom, and fandom translates to online following, and following to audience, and in the context of crowdfunding, funders.

The majority of the money (70%) a donor, or, rather, a subscriber, pays goes to the specific project that they support on Beacon. Beacon calls the subscriptions "monthly dues." One third of the subscription revenue is split between Beacon and the "bonus pool." The bonus pool is an aggregate pool of funds that is distributed to the most popular journalists on the platform in the given month, where popularity is based on the number of recommendations, which, on Beacon, are called "Worth-Its," similar to Facebook's "Likes." Popularity is measured by the amount of readers who click the "Recommend" button after they finish an article, showing that they actually thought it was worth their time. Beacon experimented with gathering funding for a breaking news event in August 2014, when it raised money for coverage about the police shooting of an unarmed African American teenager in Ferguson, Missouri. The funds (about $4,000) were raised in about a week, and with that Beacon was able to secure funding for continuous coverage for about a week. Reporting was done by several journalists.

The monthly payments from subscribers are similar to several other subscription models. One parallel model is the membership models of museums,

charities, and public parks, for instance. The membership model has also become more common in journalism in recent years. Several non-profit publications gain revenue by using membership models, but the difference from the crowdfunded model is that often the membership is paid on a yearly basis, and the membership also offers other benefits than access to the publication, which might be free of charge anyway. Those perks can include access to members-only events and experiences, live chats with journalists, and so on. Non-profit publications like the *MinnPost* in Minnesota and the *Voice of San Diego* in California provide memberships for their supporters. The *Voice of San Diego* members belong to an "inner circle" that is invited to events and discussions with the publication. The benefits also include newsletters, a quarterly magazine, and promotions.

To use another parallel, in a digital context, monthly, or yearly subscriptions are used by movie and video streaming companies, such as Netflix and Hulu. By paying a monthly fee, subscribers receive access to the providers' video content. To use one more parallel, several other cloud-based services, like Dropbox, Google Drive, and Flickr provide monthly or yearly subscriptions that extend storage space and the coverage of the provided services.

Journalism, however, differs from the other aforementioned services. Journalism has a shorter shelf-life than many other cultural productions, like music, movies, or books. What is a topical story today, this week, this month, or this year is most likely not timely, accurate, or interesting soon afterwards. Journalism also includes a substantial amount of unpredictability. The pitches journalists initially present to funders might take new directions as the journalist digs deeper into the story and finds information that changes the direction of the story. Also, even though a reader liked one story about environmental issues by a certain writer, the next one by the same author but with a different topic, or vice versa, might not be of interest to the funder. Therefore, funding a single story for $10 might be more appealing to the backer than committing to a continuous coverage of a topic that the reader is not that passionate about, or to a continuous coverage by a journalist that the reader is not that attached to follow. The threshold to actually commit for a beat might prove to be a challenge for beat-funding crowdfunding platform, particularly in this age of "content-snacking" – the readers are used to reading a story from one source, another one from somewhere else, rather than committing to one publication to satisfy their information needs.

Furthermore, journalism is not a commodity either, unlike cloud-storage services, for instance. It doesn't provide such continuous usefulness as Dropbox or other services, so a customer's willingness to pay for journalism in a similar monthly or yearly subscription model might be lower.

Fundraising for a New Platform or Publication

Crowdfunding is used also to fund new platforms or publications for journalism. In this model, an individual, a group or an organisation crowdfunds a new publication initiative. Journalist Andrea Seabrook, a former NPR Congressional Correspondent, crowdfunded her new publication, *DeCode DC*, on Kickstarter in 2012. With a goal of $75,000, she raised over $100,000 from about 1,600 backers for her publication, which covers Washington DC, particularly politics, focusing on "Washington's dysfunction, corruption, and negligence of the issues that affect American citizens every day" (as described by Ellen Weiss, chief of the Scripps Washington bureau, in Romanesko, 2013) by producing podcasts. The funding raised on Kickstarter functioned as seed money to the operation. *DeCode DC* was later acquired by the American media conglomerate E. W. Scripps Company.

Another instance of crowdfunding to kickstart a publication is that of *Matter*. A science publication, *Matter* raised over $140,000 on Kickstarter in 2012 from about 2,500 backers. The campaign almost tripled its goal of $50,000. *Matter* provides long-form, in-depth science and technology journalism. *Matter* was acquired in 2013 by a Twitter co-founder Evan Williams' new publication *Medium*, a curated publication for thoughtful blogging. *Matter* now publishes its stories as a part of *Medium*, which is a venture-backed journalistic initiative based in San Francisco.

In Germany a digital news magazine site *Krautreporter* raised $1.38 million in 2014 for developing and launching the journalistic operation. The magazine aims to do long-form journalism, allow access to it for free, and find sustainable support by voluntary membership payments. A Dutch record-braking initiative, *de Correspondent*, with a funding goal of about $1.14 million, raised $1.30 million to launch their operation in 2013. The funds were raised in $80 subscriptions for a year-long membership and by additional extra donations. The content is controlled by a paywall – only a certain amount of articles can be read without charge – and fully accessible to members only. In a year, *de Correspondent* has got over 20,000 subscribers and hires a full-time staff over 10 (Nieman Journalism Lab, 2014).

In these instances, crowdfunding brings in the essential seed funding to the journalistic operation. A substantial amount of funding can also carry over to the operations so that with the crowd's contributions, the news operations can be run for a while. As the European examples *Krautreporter* and *de Correspondent* show, crowdfunding enables the publication to test its traction and gather attention, which is important when launching a new publication. Crowdfunding is thus a way to start building audiences, and, in many cases,

appeal to future subscribers or payers. Hence, the method functions as a way to build an audience and brand for the new publication.

Crowdfunding to Fund Operations Supportive to Journalism

Crowdfunding is also used as a method to fund operations that support journalism. These can be delivery mechanisms and marketing. An example of this function is PedalPowered News, a campaign run on Kickstarter by the *Public Press*, which is a print paper in San Francisco focused on in-depth and investigative reporting. The Public Press had a goal of $10,000 for a new delivery method for the newspaper: newspapers delivered by bicycle to the subscriber's door. The campaign raised about $21,000 from 1,016 backers. By reaching the threshold of 1,000 backers, the Public Press unlocked a matching grant of $10,000 from the John S. and James L. Knight Foundation.

The funding enabled the delivery mechanism. Crowdfunding functioned also as a marketing campaign for the *Public Press*, which enabled it to reach out to new audiences and raised the profile of the publication.

The Value of Crowdfunding in Journalism

Crowdfunding serves several purposes in journalism, as the examples in the previous section show. Crowdfunding is not only about raising money, but it also creates value in other ways: through crowdfunding, a journalist or publication can test the potential traction of a story topic or the appeal of an author or a publication. Crowdfunding also serves as a branding mechanism, whether it is about branding a journalist, a beat, or a publication. By so doing, it also helps in building audiences and a following for a journalist or a publication.

Figure 11.1 illustrates these four dimensions of value, or rather, value tiles, that crowdfunding creates in journalism. The dimensions are illustrated as tiles because the points for value creation build on each other; they are partially overlapping and are not mutually exclusive but are mutually beneficial. In some crowdfunding initiatives, all the value dimensions are realised equally, and in others, some dimensions appear more strongly than others. For instance, even if a crowdfunding effort does not reach its fundraising goal, the attention gathered during the campaign can prove to be helpful in branding the effort and taking it forward. As Figure 11.1 illustrates, the value creation process in crowdfunding is cyclical: the more attention a pitch gains, the more likely it will raise more funding, develop a stronger following and reach out to larger audiences, which increases the possibility that the journalist will also find relevant knowledge and sources for reporting. The power, scalability,

and sustainability of crowdfunding is restricted by several constraints. First, successful crowdfunding requires attention and reaching out to large crowds of potential donors. Marketing a pitch requires human resources and, often, money when producing marketing materials, such as videos for the pitches. Hence, marketing the pitch is a cost-point in crowdfunding. Depending on the amount of time the journalist is willing to put into the interaction with contributors, interaction costs can also be high, because interactions online – for instance by chats, e-mails or Internet calls – with the contributors require time. In the traditional journalistic process, the journalist is focused on gathering information and writing stories. In this crowdfunding era the journalist still does that, and, in addition, takes care of the marketing. The stages of work that crowdfunding creates can be divided into five stages (Gerber, 2013 Hui et al., 2014): Preparing the campaign material, testing it, publicising the campaign, following through with the project and reciprocating the resources and lessons learned back to the community. Thus, the success of value creation in crowdfunded journalism depends on the time and resources that the journalist invests in the five stages, but at the same time, the investment creates costs. The formula doesn't lead to a guaranteed success because there are so many factors that impact the success of a pitch, like the skill and luck involved in creating a successful marketing effort for the pitch, the quality and amount of competing pitches at the time, and sudden changes in news flow, which impact the urgency of the topic.

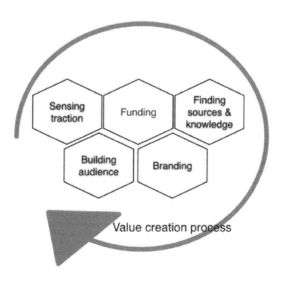

Figure 11.1: Value creation process in crowdfunded journalism.

An important factor for the success of a pitch is the size of the crowd that the pitch is able to reach and convince to contribute. As seen in the given examples in which crowdfunding has been used for journalism, the amount of money can sound large, reaching over $100,000, but the number of backers is still typically in thousands rather than in tens or hundreds of thousands. The contributing crowds are still small and are far from the tens or hundreds of thousands, or millions, of readers that news outlets have.

The constraints of crowdfunding also lie in the drivers of the crowd to fund journalism. There are strong assumptions about the incentives to donate to journalism. Often, motivations for funding are assumed to be those of contributing to high-quality journalism – the rationale being that journalism is so good that the readers want to pay for it. Another often heard rationale is that of the greatness of the authors and people's willingness to support talented authors with money. Yet research findings (Aitamurto, 2011) indicate that rather than the quality of the work or the qualities of the author, it is the role of journalism that funders want to support. The act of donating is more about altruism rather than about supporting a particular pitch or author. Furthermore, in their study about drivers for contributing to crowdfunded journalism Jian and Shin (2014) find that fun and being among the friends or family of the journalist who is pitching are the factors that can predict higher contribution levels. This can mean that other motivation factors, such as altruism and feeling of belonging to community can motivate for one-time contributions, but less likely continuous support. Jian and Shin interpret that the fun factor in crowdfunding derives from novelty value in the act of contributing and from empowerment that the funders feel when contributing. To this end, if the drivers for higher levels of donations are restricted by kinship and novelty, then that restricts the scalability of crowdfunding. Assuming that altruism and empowerment don't create long-term commitment to contribute to journalism, these motivation factors are not particularly encouraging for a scenario in which crowdfunding would be largely the only revenue source for journalism.

As most of the crowdfunded stories are typically available to be read online for free, regardless of whether the reader has paid for the process or not, it might be that the majority of readers will not pay for journalism, whereas a small portion actually ends up paying for everyone. Yet the latest models for crowdfunding, like Beacon and de Correspondent, employ subscription models in that they are moving away from donation-based crowdfunding toward a more traditional subscription model for content. In these models, the content is not necessarily available for free, so it can't be accessed without a subscription. The difference, though, is that unlike subscribing for a

full newspaper, the supporter initially funds a certain beat or author, and by so doing, they get access to a whole pool of content on the website. While this model of crowdfunding appears more sustainable for the journalist and the crowdfunding platform, yet, the findings from studies about motivation factors for contributing in crowdfunding indicate that scaling such models in a viable way beyond a journalist's networks – basically, family and friends – can be challenging. On the other hand, if the funder gets information, that she or he finds useful, maybe a new habit can be formed: a habit of reading crowdfunded journalism. Another constraint in subscription-based models is the loss of attention for the stories, which occurs when the content is behind a paywall. Getting a story shared and linked online by masses of readers and other publications might be more appealing for a journalist than writing for a small audience behind a controlled access.

In order to realise the potential of crowdfunding and utilise the benefits of the funding mechanism, it has to be understood that crowdfunding doesn't replace the legacy business models for journalism. It is not, and it won't be, a similar revenue model that used to be the mainstream model journalism: either paid staff or freelancers paid by the story so that a salary or a payment from the news organisation was the primary source for revenue for the journalist. Crowdfunding can typically provide partial support to a journalist. It provides support for some stories, or for some beats, and for most journalists it is, and will be, one revenue source among others. Gaining continuous revenue by crowdfunding is particularly challenging for journalists, who do lower-profile coverage, rather than for reporters, who engage in spectacle-like reporting trips overseas or exciting investigations and who have built their brand already.

At the same time, while providing only partial financial support for journalists, crowdfunding creates value in several other ways, such as branding, testing the traction, finding new audiences and discovering knowledge and sources. Thus, crowdfunding plays an important role in the emerging new business model ecosystem in journalism in which revenue sources are becoming ever more distributed, irregular, and insecure.

Notes

1. *Ex ante* is Latin and means "before the event." *Ex post facto* is Latin and is translated to "after the fact" or "from after the action."
2. As a result, two out of five downloaders were willing to pay for the *In Rainbows* album, and the average was $6, according to comScore (Lipsman, 2007).
3. Spot.Us was initially funded by the Knight News Challenge award grant. Spot.Us was acquired by American Public Media in 2011, and in December 2013 operations were

paused for evaluation. By then, a total of 264 stories were funded by 6,915 donors, with an average donation of $23.

References

Agrawal, A., Catalini, C., & Goldfarb, A. (2011). The geography of crowdfunding. NBER Working Paper, No. 16820. Retrieved from http://www.nber.org/papers/w16820
—— (2013). Some simple economics of crowdfunding. NBER Working Paper, No. 19133. Retrieved from http://www.nber.org/papers/w19133
Aitamurto, T. (2011). The impact of crowdfunding on journalism: Case study of Spot. Us, a platform for community-funded reporting. *Journalism Practice, 5*(4), 429–445.
—— (2013). Balancing between open and closed: Co-creation in magazine journalism. *Digital Journalism, 1*(2), 229–251.
Bannerman, S. (2013). Crowdfunding culture. *Wi Journal of Mobile Media, 7*(1) Retrieved July 15, 2014, from http://wi.mobilities.ca/crowdfunding-culture
Beer, S. & Badura, K. (2012). The new Renaissance: A break-through time for artists. *Berkeley Journal of Entertainment and Law, 1*(1) 66–74.
Belleflamme, P., Lambert, T., & Schwienbacher, A. (2010). Crowdfunding: An industrial organisation perspective. Paper presented at Digital Business Models: Understanding Strategies conference held in Paris on June 25–26, 2010. Retrieved July 15, 2014, from http://economix.u-paris10.fr/pdf/workshops/2010_dbm/Belleflamme_al.pdf
—— (2013). Crowdfunding: Tapping the right crowd. *Journal of Business Venturing, 29*(5), 585–609; CORE Discussion Paper No. 2011/32) SSRN. Retrieved July 15, 2014, from http://ssrn.com/abstract=1578175 or http://dx.doi.org/10.2139/ssrn.1578175.
Carvajal, M., García-Avilés, J. A., & González, J. L. (2012). Crowdfunding and non-profit media. *Journalism Practice, 6*(5–6), 638–647.
Downie Jr., L. & Schudson, M. (2011). The reconstruction of American journalism. In: McChesney, R. & Pickard, V. (Eds.), *Will the last reporter please turn out the lights: The collapse of journalism and what can be done to fix it.* New York: New Press, 55–90.
Gerber, E. & Hui, J. (2013). Crowdfunding: Motivations and deterrents for participation. *ACM Transactions on Computer-Human Interaction, 20*, 6, Article 34 (December 2013), 32 pages.
Hui, J. S., Greenberg, M. D., & Gerber, E. M. (2014). Understanding the role of community in crowdfunding work. *Proceedings of the 17th ACM conference on computer supported cooperative work & social computing.* Pp. 62–74. February 2014, Baltimore, Maryland, USA.
Jian, L. & Shin, J. (2014). Motivations behind donors' contributions to crowdfunded journalism. *Mass Communication and Society,* DOI: 10.1080/15205436.2014.911328
Kappel, T. (2008–2009). Ex ante crowdfunding and the recording industry: A model for the U.S.? *Loyola of Los Angeles Entertainment Law Journal, 29*, 375–385.
Kelly, K. (2008). 1,000 true fans. *Technium*, March 4, 2008. Retrieved August 18, 2014, from http://www.kk.org/thetechnium/archives/2008/03/1000_true_fans.php

Kuppuswamy, V. & Bayus, B. L. Crowdfunding creative ideas: The dynamics of project backers in Kickstarter (January 29, 2014). UNC Kenan-Flagler Research Paper No. 2013–15. Available at SSRN:http://ssrn.com/abstract=2234765 or http://dx.doi.org/10.2139/ssrn.2234765

Landemore, H. (2013). *Democratic reason: Politics, collective intelligence, and the rule of the many.* Princeton, NJ: Princeton University Press.

Lévy, P. (1997). *Collective intelligence: Mankind's emerging world in cyberspace.* Cambridge, MA: Perseus Books.

Lipsman, A. (2007). For Radiohead fans, does "Free" + "Download" = "Freeload?" *comScore*, November 5. Retrieved July 15, 2014, from http://www.comscore.com/Insights/Press-Releases/2007/11/Radiohead-Downloads

Massolution Research. (2012). 'Crowdfunding industry report: Abridged version. Retrieved July 15, 2014, from http://www.scribd.com/doc/92871793/Crowd-Funding-Industry-Report-2011

Massolution Research. (2013). The crowdfunding industry report. Retrieved from http://research.crowdsourcing.org/2013cf-crowdfunding-industry-report

Mollick, E., 2013. The dynamics of crowdfunding: Determinants of success and failures. *Journal of Business Venturing 29*(1), January 2014, 1–16.

Nieman Journalism Lab. (2014). The newsonomics of European crowds, funding new news. June 26, 2014. Retrieved from http://www.niemanlab.org/2014/06/the-newsonomics-of-european-crowds-funding-new-news/

Romanesko, J. (2013) E.W. Scripps restructures its Washington bureau, acquires DecodeDC. November 12, 2013. Retrieved August 18, 2014, from http://jimromenesko.com/2013/11/12/e-w-scripps-restructures-its-washington-bureau/

12. Crowdfunding and Transmedia Storytelling: A Tale of Two Spanish Projects

Carlos A. Scolari and Antoni Roig Telo

Introduction

The aim of this chapter is to introduce and analyse two Spanish transmedia projects that have included crowdfunding in their financial strategies: *The Cosmonaut* and *Panzer Chocolate*. Both projects are considered examples of transmedia storytelling initiatives relying on crowdfunding to different degrees. Many different strategies can be found under the name of crowdfunding, from platforms that treat funds as microdonations like Verkami (http://www.verkami.com/) or Goteo (http://goteo.org) – also known as *micropatronage* – to entrepreneurs who consider crowdfunding as a good way of securing investments. The two initiatives discussed here have explored the different dimensions of crowdfunding, even changing their approach during the development of the respective projects. As we'll see through this chapter, creators involved in the development of crowdfunding strategies for both projects show an ambivalent perspective: they all acknowledge favourable aspects particularly in terms of public impact and community building, but they also stress different hurdles, like the huge efforts that must be undertaken in order to manage the processes along time (with generally small teams) and, for audiovisual productions, the limitations in strict budgeting terms.

Before continuing, it is necessary to define what transmedia storytelling is. According to Jenkins (2003, 2006a, 2006b, 2009) many contemporary works are characterised by expanding their narrative through different media (film, TV, comics, books, etc.) and platforms (blogs, forums, wikis, social networks, etc.). For example, the Fox series *24* began as a TV show but ended up including

short episodes for the web (webisodes) or mobile devices (mobisodes), video-games for consoles, mobile games, comics, novels, board games, and a plethora of official and fan websites. We can add a second feature to this cross-media dimension of storytelling evidenced by Jenkins: the creation of user-generated contents. Transmedia narratives may begin in a Hollywood studio or in the comic book editor's office in Manhattan but they continue, for example, in a blog written by a Finnish girl or in a parody video uploaded onto You Tube by a group of Brazilian fans (Ibrus & Scolari, 2012; Scolari, 2009, 2013a, 2013b).

Transmedia narrative worlds are a real challenge for media researchers. Communication and media studies have always proposed monomediatic approaches. For example, there are many specific semiotics (semiotics of radio, semiotics of television, semiotics of cinema, semiotics of theatre, etc.) but we don't have a semiotics of transmedia experiences (Scolari, 2012, 2013b). The same may be said about the political economy of crowdfunding: there are a lot of studies about traditional broadcasting financing strategies but crowdfunding practices are so new that researchers are still coming to terms with them. This chapter is situated at the crossroads between transmedia storytelling and crowdfunding.

As already indicated, the reflection on transmedia and crowdfunding will be based on two productions: *The Cosmonaut* and *Panzer Chocolate*. *The Cosmonaut* is a science fiction feature movie (premiered on May 2013) that included more than 30 web videos, a mockumentary, a book, and a series of products for the expansion of the narrative universe. Considered as the first high-level audiovisual production in the Spanish crowdfunding movement, *The Cosmonaut* received more than € 400,000 from almost 5,000 partners around the world. *Panzer Chocolate* is a horror production, also released in 2013, and situated at the junction between transmedia storytelling and crowdfunding. The project includes a movie, motion comics, videogames, mobile apps, and an alternate reality game.

As we'll see later, the two projects analysed in this chapter share certain features, mostly timing (both projects took shape around 2008–2009 and were completed in 2013), an innovative discourse on film production, the fact of being the first feature film for the young teams involved, and a commitment to the independence of the creative vision. These features are of great importance in terms of the connection of these transmedia projects with a wider social and cultural phenomenon like crowdfunding. Following authors like Kappel (2009), Belleflamme et al. (2010), and De Buysere et al. (2012), we understand crowdfunding as a complex phenomenon that goes beyond dedicated platforms or specific rewards; it can be broadly considered as a more or less flexible economic agreement based on trust and affective

engagement with the creative vision of project promoters in a peer-based economy. This collective building of trust and affective engagement is essential for generating interest in new disruptive projects that otherwise would not be picked up by the radar of mainstream.

This chapter describes the main similarities and differences between the two initiatives. We will also compare many aspects of *The Cosmonaut* and *Panzer Chocolate,* from the narrative structures to the relationships between textual components and crowdfunding strategies, and the role of fan communities. The analysis is based on a compilation of the official transmedia textual pieces – that is, the canon – strategic documents regarding both projects and a series of unstructured interviews with their directors (Nicolás Alcalá from *The Cosmonaut* and Robert Figueras and Gemma Dunjó for *Panzer Chocolate*). The interviews were held in Barcelona in early 2014 (January/February). In both cases the main objective of the interviews was to identify advantages and limits of the crowdfunding strategies. We were especially interested in issues like the articulation of crowdfunding with other financing strategies, the effort (in time and human resources) required by crowdfunding or the equilibrium between audiovisual creation and funding-oriented activities.

The Cosmonaut

The Cosmonaut was born in 2009 as a mono-media project but the dynamics of the production process opened it to new spaces and practices. According to Nicolás Alcalá (one of the creators of *The Cosmonaut*)

> (...) in the early months (the project) was conceived only as a movie. However I have notes in my notebook when I was writing the script, even though it was a short movie, where I wrote things like 'Fragmenting?', 'How do viewers watch today?', or 'transform it into a series?'. The change occurred when we visited Power To The Pixel (the second edition, I guess) and I heard Lance Weiler, Ted Hope and especially Mike Monello talk about that. I returned from this trip convinced that the project should be transmedia though I still didn't have any idea what this meant (and would not understand it until many months later, during the editing process, when today's transmedia project finally took shape).[1]

As *The Cosmonaut* transformed itself into a transmedia project, new contents and pieces emerged. Many of them were never produced, for example an alternate reality game, or a series of mobisodes linked with mini-video-games. The team created 15 specific episodes and during the editing process left about 30% of the images out of the final cut to transform them into new episodes. In this case the transmedia contents did not only expand the narrative universe, the merchandising played an important role in the diffusion and

financing of the project. According to the producers of *The Cosmonaut* – a work licensed under Creative Commons – consumers have the right to decide when, how, and where they watch the movie, to pay for it (or not), to share it, and to modify it. The producers have also proposed a Partnership Program for the exhibition of the film and the creation of a whole media experience around the story. We will now examine this project in detail and analyse the evolution of the crowdfunding campaign in the following section.

The Transmedia Narrative World

The Cosmonaut tells the story of two Soviet cosmonauts – Stan and Andrei – in the context of the space race between the USSR and the U.S. in the 1960s. Yulia, a young communications technician, completes the basic character group that is surrounded by historical events that take place over 15 years: successes, failures, accidents, conspiracies, favouritisms, and secret missions.

In October 1975 Stan departs to the Moon. Two days after the launch, the ship loses all communication with Earth. For half a year Andrei and Yulia look for him relentlessly. One day Stan's spaceship returns to Earth. There is no trace of *The Cosmonaut* in it but a series of radio transmissions starts. *The Cosmonaut* shows many narrative and aesthetic influences, from Andrei Tarkovky's obsessions on memory, lost love and reality, to Joan Fontcuberta's reflections on the truthfulness of photography.

The story was told across multiple media and platforms. As published in the document entitled *The Plan 3*

> (...) during the editing of *The Cosmonaut*, we not only did *The Cosmonaut*, but we also made 32 pieces of between 2 and 15 minutes which expand the universe of the film and which, at this point, are as important as the movie itself. They are not satellites. Of course, the film can be watched alone and be understood, but our story-world includes the transmedia pieces, which are crucial to understanding the universe where our story is set. The same thing works for the book and the narration created to be told through Facebook (Riot Cinema, 2012, pp. 3–9).

The Cosmonaut generated a huge textual galaxy around it. Many of these pieces – like the feature film or the book – are clearly part of the transmedia narrative universe; other textual pieces should be considered paratexts (like the film trailer or *The Hummingbird*, a mockumentary) and, from our perspective, also part of the transmedia storytelling experience. Finally, any description of *The Cosmonaut*'s textual world should also include the metatexts that reflect on the audiovisual production process (i.e., blog posts). The following tables represent the entire official textual galaxy of *The Cosmonaut* (by "official" we refer to all the texts produced by the team and not by the

users). The first table includes the transmedia narrative contents that constitute the canon of *The Cosmonaut*, from the feature movie to the webisodes. The second table focuses on the paratexts (i.e., trailers, mockumentaries, social networks, etc.). Finally, the third table includes a couple of educational materials – never published nor distributed – based on the experience.

Table 12.1: The Cosmonaut – Official transmedia narrative universe.

Content	Characteristics	Type	Distribution
The Cosmonaut	Feature movie – 93' Note: The team also produced a linear version of the movie, which is still waiting for the final edition.	Free in the official web and P2P platforms. Paid content in VOD platforms and USB drive	Official web DVD USB drive Cine TV (Canal + and others)
Moonfiles	15' short film	Free: online Paid content: USB drive	Official web USB drive
The Voyage of the Cosmonaut	Diary-poem book that contains scrap notes, fragments, and photographs.	K Program (subscription)	Official web Printed book distributed with the Premium edition of the DVD
Poetry for Cosmonauts	Book	Free: online Paid content: printed book and USB	Official web USB drive Book
Webisodes	35 webisodes 2'-15' – USB drive	Free: online Paid content: USB and DVD	Official web USB drive About half of the mobisodes are distributed in VOD platforms (Yomvi, Nubeox) and may be found in the DVD.
Facebook	13 different profiles with 7 main characters and 6 secondary ones	Free	In real-time before the launching of the movie

As it can be seen, most of the transmedia content was released for free and as a paid content in specific supports (DVD and USB drive).

Table 12.2: The Cosmonaut – Official paratexts.

Content	Characteristics	Type	Distribution
Trailers	Production of 4 teasers in 2009. One more teaser in 2010 and a final trailer with FX.	Free	Vimeo
The Hum-mingbird	Mockumentary (fictionalised documentary)	First paid content, now for free	Vimeo / USB
Fighting of	This documentary is a portrait of the (difficult) production process in Latvia and Moscow during 8 weeks. It has never been completely edited and the team decided not to distribute it.	—	—
Soundtrack (I)	Official soundtrack by Joan Valent	Never published because of copy-right limits.	—
Soundtrack (II)	Alternate soundtrack (webisodes, trailers) by Tryad, Cumie, Little Toys, Edward Artemyev, Pavel Chesnokov, and Remate.	Never published because of tim-ing limits. It was incorporated as an OST of the webisodes and in the credits of the feature movie.	—
I hear voices from Space	Music inspired by *The Cosmonaut* by Kai Ochsen	Never published because of timing limits. It was incorporated as a OST of the webisodes and in the credits of the feature movie.	—
Facebook (project)	https://www.facebook.com/cosmonaut.movie	Free	Web
Twitter (project)	https://twitter.com/cosmonaut_movie	Free	Web

Even if this table only includes official contents, the users created 78 different versions of the trailer during the Teaser Remix Experience.

Table 12.3: The Cosmonaut – Metatexts

Type	Characteristics	Content
Never published because of timing and production limits.	The DVD for schools and students to be distributed at a reduced price. It contains the movie, the linear cut, all the musical scores, an audio commentary from each of the departments of the film and access to download all the contents of the movie. The DVD also includes contract models, budgets, dossiers, storyboards, and all the script versions, including the technical one.	Pack for students and film schools
Never published because of timing and production limits.	This "small indie film manual" collects in about 100 phrases and small footnotes all the experience accumulated in over three and a half years producing *The Cosmonaut*.	*Riot Cinema Workbook*

All of this content was licensed under Creative Commons licenses, which allowed it to be distributed, copied, remastered, and modified, thus generating new textual components that expanded the narrative universe. Finally, the transmedia strategy also included experiences like *The Cosmonaut*s concert – a two-day indie groups music festival in June 2009 – and a flashmob on 29 January, 2010 to simulate a Moon landing in Madrid.

Evolution of the Project

The following are the main events in the evolution of *The Cosmonaut*. In May 2009 the project started with the launch of the website and the crowdfunding campaign in a Spanish platform: Lánzamos (<http://www.lanzanos.com>). In January 2010 the team released the first teaser of the feature movie, made up of images not included in the film. Two more trailers and a mobile teaser followed this.

In February 2010 the team made an open call to any audiovisual creator interested in remixing and recruiting the three trailers of the feature film; this initiative was called the Teaser Remix Experience. The team released 41 scenes under CC license and invited people to use the cuts and sound files to play with them. They encouraged users "to do remixes in as many formats as possible, from music videos to complete narrative cut-ups for mobile broadcast." They could use "any technique, taking the trailer from simple

re-working through to pure abstraction." The proposal was successful as they received 78 new trailers. At that time *The Cosmonaut* was already a very well-known project and many media professionals were talking about "the first Spanish movie based on a crowdfunding strategy."

In May 2011, after having raised € 120,000 in two years, the team decided to start shooting the film with the support of a Russian co-producer who provided an additional € 120,000 to the project. One week before shooting the co-producer had to withdraw. A desperate campaign – *Save The Cosmonaut* – was then launched requesting the community to help save the movie. In only three days more than 600 people contributed a total of € 131,000, allowing the film to be shot. The investors who "saved *The Cosmonaut*" – the minimum contribution was € 100 – and the rest of the project followers could watch the shooting they had made possible in a streaming window included in the interface of the official website[2].

In October 2011, once shooting was finished, the team released an update of the business model (*Plan 2*). One year later *Plan 3* was released, which was the final update of the project. *Plan 3* includes a more complete description of the transmedia strategy and the textual universe around the feature film (Table 1). In accordance with the general philosophy of the project – based on a radical transparency of the procedures – both versions of the Plan were publicly accessible.

As *The Cosmonaut* transformed itself into a transmedia storytelling experience the distribution model also changed and adopted new features. Originally designed to be premiered at different moments, the team finally opted for an almost simultaneous premiere in all release windows (cinema, web, television, and DVD/USB) so that the user can choose the format they want to watch the movie in (Riot Cinema, 2012, p. 27). On the web the movie was released for free in HD on May 18, 2013. On the same day and at the same time the movie was shown in Madrid and programmed by Canal+. In the cinema the exhibition was supported by *The Cosmonaut Experience* tour, a proposal that merged performance elements with audience interaction (individuals and institutions could organise their premiere anywhere in the world through a partnership programme). For technical reasons the DVD and the USB drive were distributed a couple of weeks after the premiere; the USB was specifically designed for *The Cosmonaut* and is shaped like a Soviet spaceship. Finally, on television, the movie was distributed on Canal+ and in the YOMVI Platform under a VOD system. This version offered an alternate ending and 16 transmedia pieces.

Forty-five days after the premiere the balance was as follows:

- 80,000 reproductions of the movie on different online channels
- About 2,000 people went to the premiere in Madrid and Barcelona
- More than 70 screenings all over the world
- 10,000 reproductions on Canal+
- Over 400 DVDs sold
- 80,000 reproductions of the transmedia episodes (34 short movies) (Previously on *The Cosmonaut*, 2013)

But *The Cosmonaut*, like any transmedia project, did not finish with the feature film premiere. Inspired by projects like *Memento in Chronological Order* or *Star Wars: Episode III.5: The Editor Strikes Back*, in June 2012 the team invited users to re-edit *The Cosmonaut*. They released the raw videos and sound files online so that users could edit their own version of the movie, transform it into a short film, remix it, make a parody, or include the images in a brand new production (Re-edit *The Cosmonaut*, 2013).

The same movement was reproduced with the website: the team invited users to re-edit the contents. The philosophy of the entire project was summarised by the creators of *The Cosmonaut* (Carola Rodríguez, Bruno Teixidor, Nicolás Alcalá, and Javier Cañada) in their blog:

> *The Cosmonaut* has not only been a movie, but also a 'laboratory', with over a hundred people working on it in its four years of development, leaving their personal mark and helping it grow. Now we open its doors so you can touch it all and get into the kitchen. (Kolibri Tools, 2013)

Crowdfunding in Deep Space

As already indicated *The Cosmonaut* was considered the first Spanish feature film based on a crowdfunding financing system. The crowdfunding process went through different phases. In the first phase the funding was raised through crowdfunding and private investment; in the second phase the producers decided to create *The Plan*, a programme in three stages that diversified the financing of the project to include private financing, sponsorship, crowdfunding, and distribution pre-sales. In this second phase crowdfunding carried less weight than in the first draft of the project. However, crowdfunding was fundamental for creating a strong community of fans around *The Cosmonaut*.

The Cosmonaut's crowdfunding proposal included two figures: the regular producer and the movie investor.

Table 12.4: The Cosmonaut – Regular producers and movie investors.

Regular Producer	Movie investor
Contribution from € 2	Contribution from € 100
Producer	Owns a percentage of the film's profits
Welcome pack	Private newsletter
Ticket for the raffle of one of *The Cosmonaut*s' suits that would be used in the film	Member of *Program K* (social community around the film)
Further investments could be made to buy merchandising items	Ticket for the raffle of one of *The Cosmonaut*s' suits that would be used in the film
Member of *Program K* (social community around the film)	—
4145 producers	**598 investors**

The final cost of the project was € 860,000. In November 2012 – six months before the release of the feature movie – the team had achieved € 399,000 via crowdfunding. The contribution of crowdfunding also included merchandising (€ 138,000) and private investors (€ 260,000).

What was the experience like for the team? For Nicolás Alcalá *The Cosmonaut* represented a "creative, wonderful and unique" production experience but which was also "extremely exhausting." From an economic perspective it was "very difficult to reconcile with other works" and "not profitable enough to fully compensate" the effort.

> This project has been wonderful, I would not change a single second, but I don't want to spend four years trying to finance another film. We'll have to take everything we've learned and look at how we can do this in a way that is more sustainable, where people can collect their salary, and we can work in parallel with other projects so that we can pay the rent. I believe that crowdfunding, to a greater or lesser extent, will continue to operate but it doesn't fit all projects.[3]

As it can be seen, crowdfunding is not a magic solution to all the financing problems of transmedia production. For little teams the implementation of a funding strategy based on micropayments requires full-time dedication, making it difficult to develop more than one project at a time or to exclusively focus on the audiovisual creation. The next case history – *Panzer Chocolate*

– will expand this analysis of the complexities of crowdfunding when applied to transmedia initiatives.

Panzer Chocolate: *Aittersweet Horror Symphonies*[4]

Panzer Chocolate's approach to crowdfunding was very different to that of *The Cosmonaut* – it could even be considered as the complete opposite in certain aspects. However, both projects share their condition of being the product of a deep reflection on alternative models of film production, creativity, financing and distribution.

In 2006 the creative core behind *Panzer Chocolate*, Robert Figueras and Gemma Dunjó, set up Filmutea, a social network focused on independent film professionals[5]. Acting as Chief Executive Officer and Chief Operating Officer respectively, Figueras and Dunjó aimed to expand the Filmutea business beyond its condition of networking site. The plan was to add crowdfunding and producing services, inspired by the initial success story of music portal Sellaband[6]. The key feature of Sellaband[7] was considering funding not only as donations in exchange of rewards (if there were, indeed, rewards), but as investment. Moreover, in some cases, Sellaband also took on the role of record label, recording and distributing some of their fan-supported artists. This way, the engagement of "believers" (as project funders are known in Sellaband) was tied to the potential economic return of investment in a cultural product sometimes developed "in-house." However, this model of open worldwide cultural investment through the Internet was challenged by lots of complex legal issues and uncertainties. This was even more evident when applied to the film production business, due to the much higher amounts of money and longer production timelines involved. Finally, the original plan for a crowd-investment filmmaking platform was abandoned. As Robert Figueras stated in personal interview[8]:

> We talked with a series of private equities, that is, companies that invest in start-ups, and all of them refused because crowd-investment in movies didn't seem profitable enough. They wanted business with high growth rates, like online games.

This quote is important as it underlines how investors perceive filmmaking as – at the very least – an uncertain activity in terms of return of investment, particularly when compared with cheaper and far less risky and complex entertainment products like casual games. It could be said that Figueras' statement aligns independent filmmaking (at least part of its production processes)

with one of crowdfunding's greatest strengths: the fact of not being defined in terms of profit, but of trust and exchange.

Fortunately, this was not the end of the story. In 2008 Figueras and Dunjó had new ideas for a transmedia horror movie and, after getting a private grant from the Digitalent Foundation[9]; they started working on what was to become *Panzer Chocolate*, developing a transmedia screenplay in 2009 with horror-specialist screenwriter Pep Garrido. A first teaser and a website emphasising *Panzer Chocolate*'s transmedia elements drew some attention. But even with the publicity presenting it as the first transmedia movie in Spain, getting together the budgeted € 1,500,000 proved to be very difficult.

In 2010 and 2011 an alternate reality game and a series of webisodes were developed as a test ground. However, it was not until 2012, when production company Silencio Rodamos[10] entered the production that the necessary private investment was achieved, thus greenlighting the production – directed by Figueras himself – together with the development of a companion interactive mobile app. In November 2013 the full interactive *Panzer Chocolate* experience was premiered at the Gijon Film Festival (Spain) and at the American Film Market (California). Plans for regular and special theatrical exhibition, TV, and digital distribution were still in the works for 2014. Paradoxically enough, the innovative transmedia experience built around *Panzer Chocolate* has been forced to adapt to a classical exhibition window system in order to get some returns of investment.

Panzer Chocolate revolves around Julie Levinson, an archaeology student who, together with some friends, discovers a Nazi bunker called "Valhalla" while searching for stolen art pieces. A hideous presence turns their search into a terrifying odyssey, closely tied to dark revelations from the past. Tables 5 and 6 show the official transmedia universe and paratextual texts respectively.

Table 12.5: Panzer Chocolate – Official transmedia narrative universe.

Distribution	Type	Characteristics	Content
Negotiating different deals through an International Sales Agent: Cinema, Paid TV, Free TV, DVD, Blu-Ray, and Streaming.	Paid	Horror feature film – 86'. The story is set in 2013.	*Panzer Chocolate*
Available on Google Play and in the App Store.	Paid	Interactive App – The sound from the movie triggers the App, and this works as a second screen. The interaction happens during the movie, and after the movie. When the movie ends, the audience enjoys 5 more minutes of movie on their devices, in a kind of choose-your-own-adventure game.	Panzer Movie
Included in the Panzer Movie App.	Free	Comic – The story is set in the '40s. Some characters are different than those in the movie. It expands and complements the main story in the feature film.	9mm Puro
Available in Google Play and in the App Store, in its own App.	Freemium	Video Game – Engine: Unity 3D. It is a first-person horror game in which the objective is to escape from a secret laboratory. The story is based in the '70s.	Panzer Lab
Kindle, Google Play and App Store.	Paid	The novel – It includes scenes that did not make the final cut. It also includes scenes that were not shown. Plus 5 alternative endings.	*Panzer Chocolate*

Table 12.6: Panzer Chocolate – Official transmedia paratexts.

Content	Characteristics	Type	Distribution
Website			
Trailer			
Press Kit	www.panzerchocolatemovie.com		
Image Gallery		Free	Web
Newsletter			
Facebook	https://www.facebook.com/panzer chocolate		
Twitter	https://twitter.com/PanzerChocolate		

Panzer Chocolate: *On Donations, Investment and the Crowdfunding That Never Was*

After attending Indiegogo's opening party in 2008 in New York, and taking into account their previous tentative steps toward crowd-investment, Figueras and Dunjó considered their crowdfunding strategy carefully. They were skeptical about crowdfunding *Panzer Chocolate* through a donation model for a variety of reasons, but mainly due to the budget scales:

> When you want to make a short, it's your first project and you need 10,000 €, it makes sense to use a crowdfunding platform. But in the case of a first feature film, even a low budget one like ours, you need to raise a lot of money, and you probably won't get much more than 10 or 20% of your budget. You have to be conscious of these limitations and consider other viable strategies. (Robert Figueras)

At first they were more interested in the strategy of discretionary loans, which were used to fund the environmental documentary *The Age of Stupid* in 2009. However, this model is suitable for a non-profit social-themed documentary, but not for a commercial horror movie; so different alternative options, aimed at reaching distant investors, were explored. In 2011 Figueras and Dunjó planned a couple of ultimately flawed crowdfunding initiatives based on this idea. The first one was what they themselves considered an experiment:

> We were pretty sure that most of the people in crowdfunding processes were acquaintances or people from our close environment. And then we put Panzer in Indiegogo, telling none of our followers about it. We wanted to know what the platform in itself could do for us, if it could catch the attention of strangers, of people previously unaware of it. It did absolutely nothing! (Robert Figueras)

The second one was the *Panzer Fund* campaign, scheduled and even announced for 2011, but never implemented. In this case, they decided to control the funding process directly instead of relying on a third party crowdfunding platform. This way, they could have total access to their followers and their data in order to create a community that could be transferred to subsequent projects. The other key idea behind the *Panzer Fund* was to attract interest from a large number of investors previously unaware of the project and willing to contribute with bigger sums of money, with a minimum amount of € 500. Their argument for avoiding micro-investments was fairly pragmatic: from their point of view, taking into account all the work in managing such small amounts of money, like € 10 or € 20, waiting for a long-term return due to the three or four years needed for producing a movie was, in their own words, simply not worth it. But in the end the *Panzer Fund* initiative was abandoned due to the lack of a clear regulation and excessive risk:

> We wanted to be very careful about the way of approaching a potential crowd of investors. There are lots of legal hurdles. Some similar initiatives end up working as producing companies attracting certified accredited investors towards traditional projects with distribution deals and pre-sells already arranged. (Gemma Dunjó)

One of the most immediate conclusions that can be drawn from their informed yet hesitant crowdfunding approach to financing *Panzer Chocolate* has to do with project typology:

> When you are planning to work on a sort of social or environmental project you have a social base behind you, helping you in the financing. This works. But it does because of all this social and thematic background, not the project. I would also include those kinds of projects that present themselves as disruptive and revolutionary events, aimed at turning the industry upside down, like those licensed under Creative Commons or aimed at creating an engaged community. The community doesn't want to become an investor, they don't think in terms of return but of the statement being made. This can work too, for the same reason. But in the case of commercially-oriented projects like ours, you don't have this social base willing to contribute to your project. (Robert Figueras)

For them, cases like *The Age of Stupid*, *The Day Afterwards*[11] or *The Cosmonaut* are "one of a kind" projects that belong to the aforementioned categories: environmental, social, and disruptive, and that benefit from having engaged, and often pre-existing, communities. That makes sense for crowdfunding, but at the same time shows its limitations in terms of replicability: "you can't be forever selling your project on the sole premise of being unique, of being the first one. You can't be the first one forever."

Beyond the connection to cultural or social "causes" as viable ways to crowdfund a film, and even beyond the supposed duality of profit/non-profit, another interesting point has to do with genre and thematic choices. *Panzer Chocolate* is a first feature film, and a horror movie dealing with topics like drugs and Nazism. This makes generalist television reluctant to buy the rights in advance; and despite a promising career in specialised festival circuits, it is not easy to be given a regular theatrical distribution. Therefore, what remains is the shrinking home video sales or Video On Demand services. This situation affects pre-sales and consequently increases the perception of risk. The question is then; does the transmedia element work in its favour?

> For a first feature film, it hasn't helped us at all. When we first went to Cannes to try to explain what we wanted to do, nobody quite understood us, they looked down on us. It is now, when we can show what we have done that people become enthusiastic about it. "Oh, this is cool!!" But many investors didn't get it at the beginning. Even some of our own producers didn't quite understand what it was all about until they attended the premiere and saw the audience playing and interacting with the movie through their mobile phones. (Gemma Dunjó)

There are three main challenges that a transmedia project like *Panzer Chocolate* is facing in terms of any kind of crowdfunding, be it donations or investment:

- *Panzer Chocolate* is a calling-card film, conceived at the margins of the industry, which closes many doors to traditional grant schemes.
- The main asset of the film is its transmedia condition, which is met with enthusism in some circles, but not in the world of traditional investment: as much as transmedia can be considered a buzzword, it is still seen by industry agents as experimental, over-complex, expensive, and ultimately tied to public funding and support (as in the case of public broadcasters like the Canada Film Board or cultural endeavours like Arte in Europe). Consequently, there is no perception of a viable growth model that would attract private investment.
- Finally, *Panzer Chocolate* is a horror film, which attracts a well-defined and engaged audience in relation to specialised festival circuits, but at the same time provides fewer opportunities in terms of TV pre-sales or theatrical runs.

If we consider all these facts together, it is no wonder that *Panzer Chocolate*'s production process has been so difficult. Not having secured pre-sale deals is an obstacle to providing warranties of investment returns. It has to be a leap of faith, and in this context, a layer of innovation means greater uncertainty and higher perception of risk.

Conclusions

Writing about web series, Ellingsen (2012) described the situation of crowd-funding strategies:

> As the crowdfunding phenomenon continues to grow, it is fast becoming more than just a funding campaign for creative endeavours. At its best, it is an emerging business model that is changing the relationship between creators and consumers, bringing them closer together with a kind of co-op strategy, a development very much along the line of the process described by Henry Jenkins in *Convergence Culture*...Crowdfunding can be a way to spread merchandise, and a way to help merchandise and marketing pay for itself. However, it does demand a savvy promoter and arguably a highly engaged audience to succeed. And, despite its promise and potential, few web series (if any) have so far raised enough money through crowdfunding to pay wages to cast and crew. (Ellingsen 2012, p. 210)

The same promises, potential, tensions, and limits may be found in film-based transmedia projects.

As it has been shown in the previous pages, both *The Cosmonaut* and *Panzer Chocolate* are film-based transmedia projects. But unlike *The Cosmonaut, Panzer Chocolate* was conceived from the very beginning as a transmedia experience. *The Cosmonaut* started as a monomedia project but the dynamics of crowdfunding transformed it into a transmedia experience. This production shows that transmedia is not just a storytelling strategy with the objective of consolidating a narrative-centred audience of fans: it is also a financial strategy. Crowdfunding created the necessity of producing new content for contributors; this first expansion of the narrative universe transformed *The Cosmonaut* into a transmedia storytelling experience. *Panzer Chocolate*, however, is the typical product of a new generation of artists who "think in transmedia terms" and design the narrative experience from scratch to be expanded in different media and platforms. Its "artisan" approach, where a very small but committed team makes up the project's creative core, shows the importance given to having control over the integrity of their product. We must take into account the difficulties involved in persuading investors of the commercial potential of such an innovative approach to filmmaking: thus, being in the first wave of transmedia filmmakers has been more of a hurdle than an advantage.

These two experiences demonstrate the potential and limits of crowdfunding. *The Cosmonaut* was possible because of the engagement of fans during the production (especially during the big crisis that finished with the Save *The Cosmonaut* campaign); however, the dynamics of crowdfunding consumes a lot of time and energy that the creators could be dedicating to their productions. As transmedia production implies the generation of a lot

of content, crowdfunding is barely able to sustain this production activity in different media and platforms (in the end, this is the reason why *Panzer*'s producers discarded trying to build a community). However, as many pieces can be released as premium content, the production of narrative expansions (mobisodes, videogames, books, etc.) can be exploited to increase the revenues. In other words: transmedia storytelling proposes extra content that could be used as a reward for the micro-investors that decide to participate in the crowdfunding project.

In the specific case of *Panzer Chocolate*, the project went through different phases and tentative strategies: in this scheme of things, crowdfunding was always a key pending issue. Moreover, the producers' interest in new alternative funding models preceded the development of *Panzer Chocolate*. However, in the end, the actual plan became too hesitant in terms of crowdfunding. Why? According to the producers, the first problem was being a commercial horror movie that is not tied to pre-existing engaged communities formed around a social/cultural cause, which is key in crowdfunding processes. Secondly, the need to keep the integrity of the creative vision in a small core team; thus, control was privileged over community building. And finally, the interest in building a business model that was replicable (to be repeated in the same way in a new project), sustainable (so you can make a living during the development process), and profitable (allowing for a return of investment). Thus, the genre approach, control, and the business model directed the producers toward an investment-oriented crowdfunding model, which was too complicated to carry out due to the complexity of international regulations still behind tangible new forms of networked global cultural investment.

If we compare the distribution models, *The Cosmonaut* proposed user-centred distribution (for example the premiere of the movie on simultaneous screens) while *Panzer Chocolate* was based on a more traditional theatre-centred distribution model. In the latter case, however, distribution was tied to innovation, connected to the immersive experience. Early experiments with interactive screenings of *Panzer Chocolate* emphasised the interest in collective experience (in a specific sequence, the protagonist repeatedly uses a flashlight in the dark while being chased by a monster; at the same time, the *Panzer Chocolate* app triggers the flashlights of the mobile devices in the theatre, creating a hallucinatory and deeply immersive moment, which is strongly tied to the cinematic experience).

The Cosmonaut was a monomedia project that, on its way to crowdfunding, found the transmedia; *Panzer Chocolate* was a transmedia project that, after going through a crowdfunding experience, opened itself to new

horizons. Both of them demonstrated that the dialogue between transmedia storytelling and crowdfunding is possible but complex. In any case, we are facing a continuous work in progress based on trial and error.

Notes

1. Interview with Carlos A. Scolari (Barcelona, January 2014).
2. More information about the Save *The Cosmonaut* campaign can be found in the post *Reflexiones sobre Save The Cosmonaut* 2011. Accessed 25 January 2014.
3. Interview with Carlos A. Scolari (Barcelona, January 2014).
4. Some of the data included in this section comes from an interview between Antoni Roig Telo and the producers in Barcelona, February 2014.
5. In 2013, according to their own data, they had more than 50,000 members.
6. The future evolution of Sellaband as a business would prove, however, far from placid. See an early cautious account on future projections of Sellaband (http://www. theguardian.com/music/musicblog/2007/mar/15/sellabandsmusicbusinessrevo) and a report on its bankrupcy and relocation in 2010 (http://www.wired.com/busi ness/2010/02/bankrupt-crowd-funded-sellaband-acquired-by-german-investors). Accessed 18 February 2014.
7. https://www.sellaband.com/ accessed 18 February 2014.
8. All direct quotes in this section from an interview with Robert Figueras and Gemma Dunjó, Barcelona, February 2014.
9. A short-lived innovation institution created as a spinoff of a renowned animation company based in Barcelona, Cromosoma.
10. An independent film and entertainment company based in Barcelona.
11. *The day afterwards* (*L'endemà*) is a film project on the independence of Catalonia that raised almost € 350,000 in its crowdfunding campaign in the Catalan-based portal Verkami.

References

Alcalá, N. (2014, January 15). Personal interview.

Belleflamme, P., Lambert, T., & Schwienbacher, A. (2010). Crowdfunding: Tapping the right crowd. *Social Science Research Network (SSRN)*. Retrieved February 4, 2014, from http://ssrn.com/abstract=1578175

De Buysere, K., Gajda, O., Kleverlaan, R., & Marom, D. (2012). *A framework for European crowdfunding* . Retrieved February 4, 2014. www.crowdfundingframework.eu

Ellingsen, S. (2012). Web series, independent media and emerging online markets: Then and now. In I. Ibrus & C. A. Scolari (Eds.), *Crossmedia innovations. Texts, markets, institutions,* pp. 199–216. Frankfurt: Peter Lang.

Ibrus, I., & Scolari, C. A. (Eds.) (2012). *Crossmedia innovations. Texts, markets, institutions.* Frankfurt: Peter Lang.

Jenkins, H. (2003). Transmedia storytelling: Moving characters from books to films to video games can make them stronger and more compelling. *Technology Review,* January 15 . *Retrieved January 25, 2014, from* http://www.technologyreview.com/biotech/13052

—— (2006a). *Fans, bloggers, and gamers: Exploring participatory culture.* New York: New York University Press.

—— (2006b). *Convergence culture: Where old and new media collide.* New York: New York University Press.

—— (2009). The revenge of the origami unicorn: Seven principles of transmedia storytelling. *Confessions of an Aca-Fan.* Retrieved January 25, 2014, from http://henry jenkins.org/2009/12/the_revenge_of_the_origami_uni.html and http://henryjen kins.org/2009/12/revenge_of_the_origami_unicorn.html

Kappel, T. (2009). Ex ante crowdfunding and the recording industry: A model for the U.S.?, *Loyola of Los Angeles Entertainment Law Review*, vol. 29, pp. 375–385.

Kolibri tools: use our code for your web. (2013). Retrieved January 25, 2014, from http://www.thecosmonaut.org/blog/?p=852

Leibovitz, T., Roig, A., & Sánchez-Navarro, J. (2013). 'Collaboration and crowdfunding in contemporary audiovisual production: The role of rewards and motivations for collaboration. *Cinergie:il cinema e le altre arti.* Retrieved August 19, 2014, from http://www.cinergie.it/cinergie-n4.pdf

Previously on The Cosmonaut. (2013). Retrieved February 4, 2014, from http://www. thecosmonaut.org/blog/?p=826>i, http://www.cinergie.it/?p=3214

Re-edit The Cosmonaut. (2013). Retrieved January 25, 2014, from http://www.thecos-monaut.org/blog/?p=820

Reflexiones sobre Save The Cosmonaut. (2011). Retrieved from http://www.elcosmonauta. es/blog/?p=477

Riot Cinema. (2012). *The Plan 3.* Retrieved January 25, 2014, from http://es.cosmonau-texperience.com/web/contents/theplan3_eng.pdf

Roig A., Sánchez-Navarro, J., & Leibovitz, T. (2012). ¡Esta película la hacemos entre todos! Crowdsourcing y crowdfunding como prácticas colaborativas en la producción audiovisual contemporánea. *Revista de Comunicación y Tecnologías emergentes, ICONO14.* Retrieved January 31, 2014, from http://www.icono14.net/ojs/index. php/icono14/article/view/113

Scolari, C. A. (2009). Transmedia storytelling: Implicit consumers, narrative worlds, and branding in contemporary media production. *International Journal of Communication* 3: 586–606.

—— (2012). The Triplets and the incredible shrinking narrative: Playing in the borderland between transmedia storytelling and adaptation. In I. Ibrus and C. A. Scolari (Eds.), *Crossmedia innovations. Texts, markets, institutions,* pp. 45–60, Frankfurt: Peter Lang.

—— (2013a). *Narrativas transmedia. Cuando todos los medios cuentan.* Barcelona: Deusto.

—— (2013b). Lostology: Transmedia storytelling and expansion/compression strategies. *Semiotica*, vol. 195, pp. 45–68. DOI: 10.1515/sem-2013-0038.

13. Kickstarting Big Bang Press, Publishing Original Novels by Fanfic Authors

Gavia Baker-Whitelaw

In November and December 2013, I co-ran a Kickstarter campaign that raised over $50,000 to publish three novels by fanfiction authors.

The plan was to use the money from Kickstarter pre-orders to fund the publishing and publicity costs of those three books, meaning that a core audience from the fanfic community would propel our first three authors into (hopefully) mainstream success. Promisingly, our most popular reward level was to receive early copies of all three novels in e-book format, with the second most popular being a similar reward for illustrated paperbacks. Most of the rest of our backers ordered one individual book or e-book, or chose to buy all three books plus extra rewards like postcards, art prints, and personalised gifts. Basically, people wanted what we were selling.

Like many start-ups, Big Bang Press began with one person having a cool idea and then digging through their contacts list until they'd cobbled together something approaching a company. In our case it was my friend Morgan Leigh Davies, and her idea was to set up a small press dedicated to publishing novels by writers from the fanfic community.

Most people who read or write fanfiction have at some point thought, "This fanfic is better than most published novels." Despite the lingering mainstream prejudice against fanfic writers (they're not talented enough to write their own stories; they're all silly teenage girls; they're pornographers), it's difficult to spend much time in fandom without realising that many of these writers are incredibly talented. Unfortunately, the publishing industry still has some catching up to do when it comes to tracking down those authors. As a

group of longtime fanfic readers and writers, this is a major driving force for everyone working at Big Bang Press.

Plenty of fanfiction writers have gone on to publish novels, often using ideas that they reworked from fanfics by changing the character names. After *Fifty Shades of Grey*, the number of people trying to publish reworked fanfics skyrocketed. Several romance and erotica ebook presses appeared out of seemingly nowhere, catering exclusively to *Twilight* fic writers.

Although we had no particular problem with people filing the serial numbers off a fanfic for publishing purposes, we decided that Big Bang Press would specifically look for original novels. We wanted to find writers from the fanfic community who could already write smart, entertaining, popular stories, but who hadn't been given the opportunity to submit an original work to an agent or publisher. We wanted to find a wider audience for those writers without them having to abandon their existing readership or their background in fandom. And since we didn't have any money, crowdfunding was the obvious way to go.

We spent months working on Big Bang Press before we went public with our plans, mostly to avoid seeming like old news by the time our Kickstarter began. The reason why most Kickstarter campaigns only last about 30 days is because people respond to the urgency of the countdown, with a disproportionate amount of funds being raised in the first and last 48 hours of any campaign. We emerged onto the Internet fully formed, meaning that no potential backers ever had to see us during our awkward adolescent stage of drafting publicity materials and deciding which books to publish.

Of course, this did present one major issue: how to select the novels we wanted to publish. We needed three books in order to launch the Kickstarter, and we couldn't advertise Big Bang Press publicly until after the Kickstarter launched. This meant we couldn't have open submissions, so the first step of our submissions process was to produce a longlist of fanfic writers who we knew to be of publishable quality. We asked them if they wanted to submit the first three chapters of a manuscript, a full plot summary and a cover letter, and then our submissions editor helped them develop those manuscript excerpts. Finally, the other four members of staff read the manuscripts and voted on which three were the best.

The resulting manuscripts ranged in genre from young adult fantasy satire, to queer coming-of-age literary fiction, to a dark urban fantasy novel. Our first book, *A Hero at the End of the World* by Erin Claiborne, will be on sale in November 2014 and is already receiving great feedback from early readers and reviews. After that we'll be publishing *Juniper Lane* by Kady Morrison and *Savage Creatures* by Natalie Wilkinson, released a few months apart.

The appeal of our Kickstarter was split between the books and the concept of Big Bang Press itself. Our three authors all had pre-existing audiences thanks to their fanfic, so while plenty of people backed our Kickstarter based on the chapter excerpts we posted on our site, there were also people who wanted to support the authors themselves. As for BBP's appeal in a more general sense, I suspect that a lot of people from fanfic backgrounds were motivated by the same frustration I felt myself: the familiar sensation of reading a really excellent fanfic and thinking, "This is better than plenty of published fiction."

Our crowdfunding goal was $40,000. Each of the authors was paid a $5,000 fee for her book, and the rest of the money went to publishing and publicity costs, taxes, Kickstarter fees, and payment for our illustrators, graphic designers, website designer, and staff. (As with a lot of new start-ups the staff are working pretty much for free, on the assumption that this could turn into a proper job once we've got a few books out. Also, Kickstarter forbids crowdfunding a business, rather than a single project.)

My official title at Big Bang Press is Managing Editor, a job that began with me co-running the Kickstarter campaign and now seems to consist of sending a million e-mails per day because all of us live in different time zones. For the Kickstarter, Morgan and I did as much research as possible – which isn't much, because Kickstarter has only been around for five years and people are still getting the hang of it. Most of the popular advice amounted to basic common sense such as:

- Find your niche. (In our case, this was easy: We were already in the niche.)
- Make sure your page is clear and easy to read. (I am a journalist; Morgan is a writer and editor. We were fine.)
- Provide a wide range of reward tiers.
- Try to get attention from relevant blogs and media outlets. (Obvious.)
- Exploit all of your social networks both online and off. (VERY obvious.)
- Don't refer to pledges as "donations," because you're not running a charity.

Looking back, there is surprisingly little I'd change about the way we ran the Kickstarter. The main thing I'd do differently was our video, which was unavoidably clunky because none of us is a filmmaker, and two of our authors had to film their statements using webcams. This didn't matter to most of our target audience (fortunately, video quality isn't very relevant to publishing),

but news sites and blogs do tend to embed Kickstarter videos when writing about a campaign.

Most publishing Kickstarters are for self-published books of some kind. Only 31% of them reach their crowdfunding goal, and about 65% of successful publishing projects have a goal between $1,000 and $10,000 (Kickstarter. com). In that context, our goal of $40,000 and three illustrated novels was quite ambitious. The good news was that between the three authors, three illustrators and five publishing staff, we already had a wide network of people who would be interested in buying this kind of book. And, of course, we had the power of Tumblr.

Tumblr is the social hub of online fandom – or at least, the part of fandom that would be interested in our books, which skewed toward new adult audiences, fanfic readers, and people with a vested interest in seeing more diversity in popular literature. All three of our books have queer characters and characters of colour in central roles (partly a coincidence and partly a product of the progressive nature of fanfic culture), and this struck a chord with people who discuss media representation and diversity on Tumblr. Crucially, Tumblr is also the ideal social networking/blogging site to use if you want something to go viral, because it relies entirely on people reposting other people's content.

By the end of our 30-day crowdfunding period our backers had pledged $53,890, and the vast majority of them had come to us via Tumblr. More of them came through Tumblr than from geek culture blogs like io9 or The Geekiary, or from media sites like HelloGiggles and Hypable, or even from Facebook and Twitter combined. Our second most popular source of backers was our own website – which people had primarily been visiting via Tumblr links. In other words, our main strength was the fact that we already knew where our core audience would be found. People were sharing our Kickstarter with their friends on Tumblr, and this turned out to be more effective than coverage from high-traffic news sites and blogs.

When running a crowdfunding project, it's more or less inevitable that you'll encounter someone who thinks you're terrible simply for using crowdfunding in the first place. I've followed a few Kickstarter and Indiegogo ventures in the past, and a common refrain among critics (or, more accurately, disgruntled Internet commenters) is that artists and creators shouldn't be "begging" online. Either that, or they subscribe to the idea that if an artist was *really* any good, they'd be using so-called traditional methods. Obviously this is nonsense on many levels, not least because crowdfunding automatically gauges your audience's interest level. Even if two or three people think that a project is spurious or a sellout, they've basically been proven wrong if enough others decide to pledge money toward your campaign.

In the end all we could really do was to allow our campaign to speak for itself, and hope that any anti-crowdfunding fanatics would change their minds once the books were published. Since our first novel, *A Hero at the End of the World* by Erin Claiborne, has already managed the notoriously rare publishing industry achievement of a starred review from Kirkus Reviews, we seem to be doing all right so far.

Intellectually, I was aware that our Kickstarter would be under a lot of scrutiny, both from people who might doubt its reliability and from people who were excited to learn more about the books. But my experiences with Kickstarter had the unexpected effect of making me both more analytical *and* more forgiving when looking at other crowdfunding campaigns myself.

A lot of campaigns fail because their pages are poorly written or unappealing, but I've begun to realise that this isn't always a relevant criticism of a Kickstarter's professionalism. Obviously if it's a publishing project then writing style is very important, but not everyone is a writer, and most people are *definitely* not publicists. To me, a far more important thing to focus on is your ability to judge how ambitious is Too Ambitious.

Sometimes, Too Ambitious is related to lack of experience or forward planning, and sometimes alarm bells go off due to an inexplicably high crowdfunding goal. But most of the time, it's more nuanced than that. When Amanda Palmer famously asked for $100,000 to record an album, a lot of people thought this number was preposterously high. But when she published an account of what she did with the $1.2 million she eventually received, it was clear that the money had gone toward improving the products her backers were receiving. Meanwhile, plenty of big-budget video game Kickstarters have sunk because they hadn't predicted how much money they'd actually need. A dauntingly high crowdfunding goal is only a problem if its creator doesn't seem to know what they're doing with it. Likewise, I'm now less likely to be turned off by a seemingly "inexperienced" Kickstarter campaign, especially if they have a clear plan in place and a simple goal in mind.

A project like publishing a book, distributing an album, or mass-producing an item of clothing benefits from existing guidelines and frameworks on how to do those things. And of course, the Kickstarter money isn't paying to build a studio or set up a printing press, it's probably just going to pay someone else to cut the record, print the book, or sew the t-shirts.

In that context, the idea of publishing and publicising three books is certainly ambitious for a start-up company, but it's not *overly* ambitious. We are following a relatively typical route for publishing a book: sending advance copies to celebrities and like-minded authors for cover blurbs, drumming up

reviews from respected critics and publishing industry magazines, and paying a printer to print and distribute the actual books.

Compared to many crowdfunding ventures, we were not a high-risk investment for our backers. The most popular reward by far was $25 for all three e-books – a small amount of money for a product that could simply be e-mailed to you once it was available. I didn't think of it like this at the time, but the popularity of this type of reward is very heartening. It's a sign of people being optimistic but sensible, the two best traits to associate with any crowdfunding campaign.

A Hero at the End of the World by Erin Claiborne will be published by Big Bang Press on November 11, 2014.

Reference

Kickstarter.com. *Kickstarter Stats*. Retrieved September 22, 2014, from https://www.kick starter.com/help/stats

14. Building a Better Kickstarter: Crowdfunding My So-Called Secret Identity

Will Brooker

I sometimes put things in writing, in public, to force myself – my future self – to live up to those promises. I made a number of claims in the *Times Higher Education* magazine when I was appointed editor of *Cinema Journal*, in summer 2011, about the broader platform and wider engagement that we'd offer under my tenure, and I've tried to stick to those ideas. A little later, in autumn of that year, I set out a series of aims for a project called *My So-Called Secret Identity*, concluding with the pledge that we were "building a better Batgirl."

It was a rash pledge, considering that all I had at the time was a rough storyline and a selection of sketches and costume designs; and it was complicated by the fact that, while Barbara "Batgirl" Gordon had not been historically well-served by scripts or art, Gail Simone and her creative team had just started a run on the character that did more with her, and did her better, than I'd ever imagined. But rash, bold pledges can be useful: they mean you can't easily back out.

Over the next 18 months, I – and an ever-increasing number of other people – developed *My So-Called Secret Identity* from a concept and a handful of script and sketch scraps into a five-episode story arc, a full set of characters and, ultimately, a 22-page full-colour comic, illustrated by Suze Shore and Sarah Zaidan. By that point we'd moved away from the original aim to revisit and rewrite Batgirl, and staked out our own territory, in a kind of indie, alternate Batman mythos. *MSCSI* was set in the mid-1990s, with a watercolour aesthetic to its pages and a sense of collage in its "mind maps" and online Lookbooks. It told the story, or started to tell the story, of Catherine Abigail

Daniels, a young woman in Gloria City. Gloria City was a town full of super-heroes, though they never did anything heroic, and nobody was sure if they even had powers beyond dry ice, hydraulics, lighting effects, and stunt teams. Catherine, or Cat, had no powers herself. She went through life insisting she was nothing special, because she'd learned to keep her head down, to never boast or show that she was different. But by the end of the first episode, she'd been pushed to the edge, and finally snapped: the "hero shot" of this issue shows Cat looking up at us, admitting to the reader and herself that she does have a kind of power. She's really, really intelligent. And if nobody's going to take her seriously as Catherine Abigail Daniels, maybe she's going to have to get a costume, an icon, and a brand name, and play the superhero game herself.

That *MSCSI* was released at all, in February 2013, as a complete online first issue with its own dedicated website, felt like an achievement. That it met with such a warm welcome from critics, readers, bloggers, and mainstream journalists felt miraculous. For whatever reason, we made a splash and filled a gap, and through our "donate" page, which offered rewards for financial pledges, we made about $4,000 in funding within the first month.

We did things our way, it seemed: we did them naively, trustingly, with what we hoped was integrity, and it seemed to pay off. It seemed to pay off literally. That $4,000 enabled Suze Shore and Sarah Zaidan to draw the next three issues over the next year, at a rate we'd all agreed before Issue 1 was released; some of it also went to web developer and manager Lindsay Searles, and a portion was donated to a women's refuge charity.

Every artist was paid on commission, at a rate they suggested. Every-one who contributed was credited as part of "Team Cat." It still felt like we were doing things a little differently, and a little better, compared to the mainstream comics industry – or at least, to what I knew of it from the stories of cheated creators and dodgy contracts, from Bill Finger onwards. In fact, we barely had contracts at all, and we seemed to manage without them. I was proud of that. People were working and being paid by a system of trust.

For myself – because of my own naivety about running a business – I was drawing more on a system I did know something about. My approach was informed by what I knew about fan communities; specifically female fan communities, and even more specifically, the communities discussed by Karen Hellekson and Kristina Busse in their 2006 book *Fan Communities in the Age of the Internet*. They explained the process of "gift economy," where one fan does something for another – writes a story, creates an avatar – in a system of informal, friendly trade, without any fixed arrangement or desire for financial

reward. The items exchanged, gestures of time and skill, "have no value outside their fannish context [...] Gifting is the goal. Money is presented less as a payment than as a token of enjoyment" (2006: 5).

The artists – from web designer to video-maker – were being paid for their work, but because *MSCSI* as a project had no intention of making a profit, it seemed a straightforward arrangement without any need for consideration of shares, points, or future earnings. It felt as if we were, largely, working on something together, with shared goals. More than one of the artists negotiated their price down because they were already reading and enjoying *MSCSI*, and were glad to contribute.

We kept the same approach as we began to plan a Kickstarter. By spring 2014 we'd finally spent the initial $4,000 and produced three further issues, plus a print edition of issues 1 and 2 with *Geeked* magazine. We wanted to complete the fifth and final issue of this story, but also make the whole thing available as a print edition, with guest art and new painted covers. We needed to step up to a bigger budget and a more ambitious project, and Kickstarter, now an established and familiar brand with proven success, provided the necessary platform.

I reached out to other artists, from small-press to veteran professionals. In each case, we gave them credit and promoted their work, and in turn, they boosted our signal and did us favours without being asked. Jennie Gyllblad posted pictures of her work in progress for *MSCSI* to her many followers. Rachael Smith, who contributed two images to *MSCSI* when she was barely known, has raised our profile just by becoming more celebrated in her own right. She inspired us with her own Kickstarter for *House Party*, and offered concrete advice on ours, and I've promoted her projects consistently; not because I owed her, but because I'm proud to know her. In many of these cases, it doesn't feel like business, over and done with an exchange of payment and a handshake; it feels like a longer, mutually-beneficial, creative relationship. Similarly, Gary Erskine, who's drawn Judge Dredd, Dan Dare, and John Constantine and worked with Warren Ellis, Garth Ennis, and Grant Morrison, agreed to draw a portrait of Cat partly because he liked the project and the freedom of the commission: I asked him to show us Cat in the near future, from the as-yet-hypothetical Volume 2 of *MSCSI*, with more of a roller derby, clippered-hair, tattooed image. I suggested a price for the work and he thanked me for it, but we've had no contracts between us.

We'd made contact with *Geeked* magazine early on, were interviewed by them in spring 2013 and teamed up with them for our first print edition of Issues 1 and 2, that autumn. Again, there were no contracts involved. *Geeked*

now credits us as an official partner, and we have an unspoken, unwritten agreement to promote each other's work and link to each other's pages. It doesn't feel like business; it feels like friendship.

Sequart, the organisation for the serious study of comic books, is also an "official" partner, according to our websites, but again, nothing's been signed. (E-mailing with Julian Darius, *Sequart*'s boss, I suggested a "gentlemen's agreement" – a little different from the terms I'd use to describe our association with *Geeked*'s "urban feminist" team, but essentially the same concept). The *Sequart* guy tags me in a Tweet, requesting I Retweet it, and vice versa. Sometimes I reply "any time, partner!" and he favourites that. There are no contracts between us.

Clay Rodery painted a cover for *MSCSI*'s Issue 5 – a full-colour twist on the *Killing Joke*'s iconic image – and refused payment. He said he remembered I'd paid him too much for something in June 2012; something like that. There were no contracts, so we couldn't check, and it didn't feel like we needed to.

Clay recommended Pati Cmak to take over art duties once Suze was too busy to draw Issue 5; now Pati feels like part of the team. Feminist fan-scholar (and friend) Julie Levin Russo recommended Rebecca Hughes as a creator of fan videos; Rebecca produced three clips for our front page, and then developed an incredible promotion for our Kickstarter.

The project is built on that kind of connection, that kind of exchange: good deeds in the favour bank, contacts rather than contracts, gifts rather than deals, friendship rather than business. Is it just payment by another name? Last week the cosplaying campaigner Kyrax2, known as the San Diego Batgirl, sent me two copies of her daughter's hand-drawn comic *Blue Bird*. I sent her back the only pack of MSCSI nail art and temporary tattoos we've commissioned so far, as a thank you, because we agreed it wasn't worth me sending $2 by PayPal. A little later, Kyrax wrote a lovely review of MSCSI for *Bleeding Cool*, on the same day that I bought her daughter an MSCSI T-shirt. It was coincidence, but you can see how it might have looked. Is gift economy just economy with a pretty bow on it, a roundabout way of buying services without paying? That's not how it felt.

Our Kickstarter begins two days from the time of writing. In keeping with the way we've run things so far, we've tried to keep it fair and simple. Rather than pledges, we're framing the donations as pre-orders. Pay £5 now, get Issue 5. Pay more, get more. The rewards are all designed to cover the costs of production and distribution – including a solid payment for our MSCSI intern, Angel Kumar, who's been working on a voluntary basis so far – and to cover the artists' fees. We've tried to steer away from "merch" and "swag" – the

kind of bonus extras that exploded the comic collectors' market of the 1990s with holographic variant covers – and offer unique, limited-edition items, including one-off watercolours and signed prints. Even our nail art, temporary tattoos and T-shirts are produced from logos redesigned by Sarah Zaidan, and don't exist anywhere else. We've tried to retain the sense of workshopping – of collective collaboration, joint authorship, collage, creativity and artisanal culture – that we set out in the first issue with the patchwork, scrapbook aesthetic of the Lookbook and MindMap.

And yet. There's a note of caution in my account above, and it stems from the fact that I know, underneath, what made this possible. I know we didn't do all this based entirely on trust, collaboration, and good faith. Everything I've said is true, but it isn't the full truth.

I know that "we" were only really able to do this because of me. That this feminist, female-centred, collective project came to pass because I funded it myself for the first eighteen months, to produce the first issue, without which we would have been unlikely to attract any reader support for the second, third, and fourth. I know that the Kickstarter excludes any of my own expenses, which must now total in the thousands of pounds for the guest artwork commissions. I hope we make our target, but it's far lower than it could be, because I've absorbed so many costs into my own personal budget. I've adjusted the scales to give us a better chance.

I don't take any money from the Kickstarter, and I never have. I'm losing money on it, like I always have. *MSCSI* has rewarded me enormously creatively and personally, but it's cost me financially. If we have extra copies of the print edition from the Kickstarter, I've proposed we give them to *Geeked*, for them to sell at a profit and take the money for their own funds. Any profit we make from the T-shirts, I've promised to split between the three women who, at one time or another, played a role in the logo design. I can afford to do this.

And I know that I'm only able to do this, to afford this, because of my own place in our unequal society. I'm able to do this because I had the cultural capital to progress through academia to professorial rank. I'm able to do this because I'm paid more than my female colleagues, and because I'm more likely to seek promotion than them or my non-white colleagues. I'm able to do this, partly, because my parents went to university and I grew up with books in the house. I'm able to do this because of my privilege.

So despite all the successes, and the ideals that seemed to pay off, and the claims we seemed to live up to, our "alternative" model of production is surely only possible because of the dominant structure that benefits me, and allows me, effectively, to be patron of my own project. Really, much as

I might connect with the *MSCSI* heroine Cat, I'm playing Bruce Wayne or Tony Stark here.

I've worked hard on this. Everyone involved has worked genuinely hard on this. I want it to succeed, for everyone involved. But part of me knows I'm building this on a privileged platform, from a secure base, from an already-raised height. I believe in *MSCSI*. But sometimes I ask myself what kind of Kickstarter I'm running, if I could – at a push, at a pinch, at a cost, at a price – throw in a couple of thousand myself if it looks like we're not going to make it, to ensure that it doesn't fail.

Reference

Busse, K. & Hellekson, K. (2006). Introduction: Work in progress, In K. Hellekson & K. Busse (Eds.), Fan fiction and fan communities in the age of the internet (pp. 5–32). London: McFarland

Afterword: The Future of Crowdfunding

Paul Booth

Introduction

On 29 May 2014 my social mediasphere exploded with news that LeVar Burton's Kickstarter campaign for a classroom app, based on his *Reading Rainbow* children's television series, had made its one million dollar goal in less than 24 hours. *Reading Rainbow* had been a children's public television series focusing on the importance of reading. The campaign, which aimed to bring an educational app based on the show into classrooms across the world, continued to generate momentum over the next month until it finally made over five million dollars by 2 July. In total over 105,000 people donated to the campaign (full disclosure, I am one of them), many of whom, I'm sure, were swayed to donate by their own special memories of watching Burton on *Reading Rainbow* or as Geordi La Forge on *Star Trek: The Next Generation* (full disclosure, I fall into both of those categories too). Those who donated to this Kickstarter campaign received special incentive awards, from a basic five dollar donation ("You'll have LeVar's gratitude AND make a difference!" which almost 20,000 people received) to the $10,000 donation ("the ULTIMATE STAR TREK 'VISOR' Package"). This single donor became the private guest of Burton and fellow *Star Trek* alum Brent Spiner (Data) at dinner in Los Angeles, got to wear the original VISOR that Burton wore as Geordi in *Star Trek*, and won free passes to a fan convention with autographed photos of Burton.

 Almost exactly a year earlier my Facebook wall similarly erupted with news of the *Veronica Mars* Kickstarter campaign, which aimed to fund a feature film sequel to the cult television series. The success of this campaign,

as measured by both its exceeding its goals as well as the actual making of the film, has been well discussed in scholarship about crowdfunding (Booth, 2015b; Chin, Jones, McNutt, & Pebler, 2014; Hills, 2015; Scott, 2015), and portends to the relative success of crowdfunding as a model for fundraising. Not without controversy, the *Veronica Mars* Kickstarter campaign was heralded as both "the future of film financing" and as a "flash in the pan" moment for fans (Gleiberman, 2014), as both "breaking the mold" on movie financing and release (Fritz, 2014) and as a "troubling landmark" for the exploitation of fans and fan labour (Pebler, 2014). It was, in other words, the nexus of a number of different concerns, desires, expectations, and realities that crowdfunding itself brings to light.

What is relevant about both the *Reading Rainbow* and *Veronica Mars* Kickstarter campaigns is not just that they've managed to tap into a vein of motivated, affective, and financially-able fan audiences in order to fund their projects, but also that they have shaped a new popular discourse about the role of crowd- and fan-funding practices across the media landscape. Although both of these campaigns are relatively high profile and are focused on media franchises, the tensions that they reflect resonate across the way many different crowdfunding ventures have been interpreted; in turn, these tensions illustrate some possible routes for future work in crowdfunding scholarship. In this afterword I want to explore some of the tensions that emerge from crowdfunding campaigns, using the example of the *Reading Rainbow* Kickstarter campaign to illustrate how these tensions have shaped not just the development of crowdfunding specifically, but also how they resonate with a larger neoliberal socio-economic climate. Ultimately, I hope that by reflecting on the crowdfunding phenomenon as a symptom of this larger economic and cultural transition, scholars of crowdfunding can continue to make significant and thoughtful interventions on the monetisation of affect in today's commercial economy.

Tensions in Crowdfunding

Reading Rainbow was an American television series that ran on public broadcasting service (PBS) television from 1983 to 2006. In the U.S., public broadcasting is commercial free, and supported by license fees, individual contributions, donations, and government financing. The show featured LeVar Burton and various celebrity guests reading children's books and then being magically transported to the narratives, lessons, or experiences contained within those books. For hundreds of thousands of children, the show introduced and validated reading as a worthwhile activity. The campaign

on Kickstarter wasn't to restart the television show, but rather to develop a classroom-version of *RRKidz*, an already-existing commercial mobile app based on *Reading Rainbow*, as well as teacher development materials to be given to disadvantaged classrooms and sold to others. Within this lofty-sounding goal, however, lies a particular tension that the larger concept of crowdfunding reveals: the industrial commoditisation of affect.

It is hard to argue with a campaign that purports to bring reading to disadvantaged children. But some, including Hensley-Clancy (2014) and Dewey (2014), have been critical of the move to commercialise this act:

> The word 'subscription' isn't mentioned anywhere in the Kickstarter campaign, and neither is the name of RRKidz. The campaign borrows from the language of charities to present Reading Rainbow as a solution to the American education crisis. (Hensley-Clancy, 2014: n.p.)

The controversy stems from a previously non-profit television series being turned into a for-profit educational app. *RRKidz* is the commercial wing of *Reading Rainbow*, the company that produces and distributes the app. This commercialism is not unique to the *Reading Rainbow* campaign (although the language is vague on the site, the campaign never claims to be a charity).

The issue here is not that one particular "good" campaign is commercialised, but rather that this critical emphasis on economics becomes the *de facto* discourse guiding crowdfunding campaigns in general. Crowdfunding replicates a much larger commercial discourse of event planning and creation (Bannerman, 2013). Focusing on the commercial nature of the product on any crowdfunded campaign reveals the underlying neoliberal forces at work in contemporary society (Hills, 2015). As Robert McChesney defines the term,

> Neoliberalism is the defining political economic paradigm of our time — it refers to the policies and processes whereby a relative handful of private interests are permitted to control as much as possible of social life in order to maximize their personal profit. Associated initially with Reagan and Thatcher, for the past two decades neoliberalism has been the dominant global political economic trend adopted by political parties of the center and much of the traditional left as well as the right. (1999: 7)

A political and economic shift toward neoliberalism focuses on establishing a laissez-faire market (free from governmental oversight), consumerist culture, and libertarian ideals of privatisation of goods and services (Harvey, 2005). A neoliberal culture harnesses the pleasures of leisure into economic profit for others—browsing social media becomes a way of making money for media corporations through advertising, for example—as "the last vestiges of private,

intimate life, relationships and emotions are, often unwittingly and gradually, sacrificed to work" (Harvie, 2013: 53). Crowdfunding is neoliberalism, not only because it extols in the individual creator/author of the campaign, but because it harnesses and normalises the language of economics. Crowdfunding links commercialised successes with affect and emotion, turning a charitable "feeling" into a commercialised payment.

Each section of a crowdfunding campaign is focused by neoliberal philosophy. As Myles McNutt (2014: n.p.) has explained, even the "'Reason for Kickstarter' is a key part of any crowdfunding effort. Kickstarter is ultimately an investment: while perks provide a promise of return on investment, there is also the need to establish a need for investment in the first place." For Stanfill (2013: n.p.), crowdfunding is "indicative of the logic of financialisation." Proponents of crowdfunding point to its ability to generate funds for worthwhile campaigns, but take that idea of "funds" as rote: this unquestioned economic thinking implicitly guides our understanding of any crowd-*funding* campaign. We can see this in the way that traditional media texts can be financed through new sources, as *My So-Called Secret Identity* illustrates in Brooker's chapter in this volume, and in how transmedia productions can be financed as Scolari discusses. In our neoliberal economy, individual affect becomes imbricated within a commercial system (see De Kosnik, 2013). Fans are implicitly, through representational and interpellative practices, told how to act, and what type of fandom is preferred, as discussed by Cochran in this volume (see also Booth, 2015; Scott, 2014). Crowdfunding funnels affect into commercial ventures.

I'm not saying that crowdfunding isn't a useful or advantageous way of raising money—indeed, as has been demonstrated in this book, it can be an incredibly effective method for generating money. The first crowdfunding website, according to Bannerman (2013), was Kiva, a microfinance agency that used crowdfunding to finance small loans to entrepreneurs. Kiva is still in use, but as the popularity of crowdfunding has grown, the emphasis has shifted from loans to donations (Belleflamme, Lambert, & Schwienbacher, 2013). Partly, this focus may be a reflection of the very social technology that enables crowdfunding to function. In comparison to a more "slacktivist" involvement in a campaign, donating money appears to be more involved and more helpful. Slacktivism describes a type of online participation wherein individuals post support for an activity—"liking" a cause on Facebook, for example. Donating money can appear more worthwhile than simply "liking" *Reading Rainbow* on Facebook. It can even, as described by Tussey earlier in this book, be a way for fans to critically engage with a broken media system. But the terms of the discussion take monetisation as given; other options

or ideas are cut off and an economic thought determines the discourse and argument about the campaign. As Kustritz argues earlier in this book, monetisation becomes a default setting. Why, for example, are individuals donating to a *Reading Rainbow* campaign to encourage reading in schools, when we have multiple governmental and civic bodies expected to do the same? In a neoliberal environment, education shifts from a basic right to an economic policy. And for Dewey (2014: n.p.), the question of education is central to the issue of the campaign. She notes that, "when *Reading Rainbow* began in 1983, the big question was, 'how do we get kids interested in reading?' By 2009, that question had become, 'how do we teach kids to read, period?'" What was once a focus on ways to incentivise reading turns into an educational necessity. Moving education, in this case, to the private sector refocuses policy. When *Reading Rainbow* was on PBS, it survived through charitable donation, grants, and public funding. On Kickstarter, it thrives on individual payment.

Crowdfunding emphasises the monetisation of previously non-monetised aspects of people's emotional connection to an object (see Booth, 2010). Incentivising donations blurs social incentives with economic ones, as Leibovitz, Roig, and Sánchez-Navarro discuss in this volume. Yet, as Kuppuswamy and Bayus (2013: 1) suggest, "social information (i.e., others' funding decisions) will play an important role in the ultimate success of a project." When this support is monetised rather than reliant on social relationships, however, "[m]any potential backers do not contribute [...] because they assume that others will provide the necessary funding." There is also evidence that even when economic incentives are at play in crowdfunding campaigns, or even when profit-sharing is an option for crowdfunding, as Galuszka and Bystrov (2014: n.p.) describe, "the withdrawing of profits from the platform is sporadic. In most cases 'earning money' means reinvesting the resources in successive projects." In other words, for many people donating to a campaign is itself an affective decision, not an economic one, as Wodtke illustrates in her chapter in this book. This is supported by Hui, Gerber, and Greenberg (2012), who have noted that the work that goes into creating a crowdfunding campaign is often more time-consuming and requires a greater variety of skills than more traditional funding; it stands to reason that running a campaign thus stems from multiple incentives (Kocer, 2015).

Affective support through financing highlights another tension of crowdfunding illustrated by the *Reading Rainbow* campaign: the discursive identification of the "crowd" as a faceless mass rather than a more communal tradition of fan activities. We call the activity "crowdfunding" and as Gray (2011: n.p.) points out, this term "crowd" is nebulous and potentially misleading:

> If we see audiences, agents, actors, citizens, individuals as crowds, we're per force rolling them into an undifferentiated bovine mass. Indeed, setting a crowd versus artists was a semantic trap, in some sense, since surely once a crowd develops something, we use different words to describe them. [...] To invoke the crowd [is] to reinstate the power of the individual creator, to argue for the lack of wisdom of the crowd and the need for benevolent dictators (!), and hence in some regards to circle the wagons around the author as God figure.

Crowds are acquiescent to leaders. The crowd at the centre of a crowdfunding venture is not necessarily a cohesive whole (see Harvie, 2013). What this reliance on crowds in crowdfunding reveals is an industry-sanctioned approval of "affirmational" fandom (Scott, 2015), a fandom more directed at appreciation than transformation, more focused on consumerism than criticism (see obsession_inc, 2009).

Campaigns harness the most financially active of their fans in order to both make up their funding goal and also to spread the word about the campaign through social media. Yet, new technologies like social media and crowdfunding "sometimes simply facilitate exploitation" of fan audiences (Bannerman, 2013: n.p., and as discussed by Gehring and Wittkower earlier in this book). *Reading Rainbow*, as with many crowdfunded campaigns, wants to use the language of inclusivity to direct a group of emotionally invested fans to centralise around a particular "artist" (in this case, Burton). This tension is illustrated in Burton's language used on the rewards for the campaign: "We can make sure that millions of kids learn to love reading, but we can't do it without you. That's why I hope *you'll join me* in making a difference!" (emphasis mine). By both referencing the affect individuals might have for the programme as well as the power of the crowd to affirm the direction of a single author, the campaign reveals how emotion and affect spur donations.

Burton's campaign relies on an individual donor's nostalgia for their own history with both the show *Reading Rainbow* and their past as readers. For example, Burton's initial introduction to the page reads:

> Hi. LeVar Burton here. You may know me as Kunta Kinte, from *ROOTS*, or Geordi La Forge, from *Star Trek: The Next Generation*. You also may have grown up with me on *Reading Rainbow*. It was my mother who taught me that, by picking up a book, I could 'go anywhere' and 'be anything'. Ever since *Reading Rainbow* began in 1983, I have dedicated myself to fostering a love of reading in children, just as my mother did for me.

As Pam Cook (2005: 4) has described, nostalgia is "a way of coming to terms with the past" through individual interpretive practices. *Reading Rainbow* is history—that is, it resides in a collective memory of the past. Nostalgia, guided by a personal memory of the historical text, "dissolves the pain of the

past in a memory of its beauty" (Wilson, 2013: 49). Burton cleverly links moments of fan nostalgia with family nostalgia in his opening here: there is both nostalgia for television series of the past (*ROOTS*, *Star Trek*, *Reading Rainbow*) as well as the more personal, affective description of his mother— an experience that I'm sure many of his readers shared about their own. Although each viewer will have a different sense of nostalgia for Burton and *Reading Rainbow* (and, presumably, their mothers), all that is required for this affective work in the present is to tap into any sense of nostalgia (see Booth, 2015a). A connection develops between backer and creator (Smith, 2015). Affect becomes commoditised.

Of course, not all crowdfunding campaigns tap into a nostalgic vein— but many do. For example, the famous example of Amanda Palmer funding concerts and albums through crowdfunding practices may not explicitly rely on creating nostalgia specifically, but does rely on the inherent nostalgia of her fans for her music (Potts, 2012). Furthermore, when coupled with the sense of anticipation that crowdfunding generates, nostalgia becomes even more effective as an incentive. There are multiple types of anticipatory pleasures present within crowdfunding. Perhaps the most relevant anticipation present within the campaign is the anticipation for the end result, the product or service itself. Both during the campaign, before funds have been fully raised, as well as after a campaign once the goals have been met, contributors may wonder whether the advertised service may actually be developed. There are no guarantees that any product funded on a crowdfunding site will be produced. Famously, the Hanfree iPad accessory campaign made over twice as much money as had originally been requested, but the device was never produced. Similarly, a board game called "The Doom That Came to Atlantic City!" earned over $120,000, four times what was originally requested, but was abandoned in 2013.[1] The sense of nostalgia in crowdfunding ventures is often offset with anticipation, a desire for fresh material. Crowdfunding rests on a paradox: it depends on nostalgia and anticipation at the same time, a memory of the past coupled with a sense of the future. To engage a funding audience, a campaign needs to be both familiar and novel at once; it must both surprise and appease.

Anticipation for a product or service can be enticing (Williams, 2012), but hype as embodied by the release of rewards at various instances and milestones in a campaign can reflect anticipation for a future product or connection to the campaign (Gray, 2008). Rewards can be a justification for fan contribution; as Chin (2013) has pointed out, in some respects fans may see a donation to a campaign as simply pre-buying merchandise (see Jason Mittell, 2013: n.p.). Other fans may receive an equity-based stake in the outcome of

the campaign (Bannerman, 2013). Belleflamme, Lambert and Schwienbach-er (2013) describe the "community benefits" that accrue when running a crowdfunding campaign, which are linked to the choices in rewards or profit sharing available for the entrepreneur running the campaign.

In the case of *Reading Rainbow*, for instance, the reward structure creates hierarchy in fandom and reinforces a neoliberal interpretation of media affect. Burton's campaign page notes under "Rewards" that he "believes that spreading the love of reading is its own greatest reward. But if you're going to join our cause, we also have some wonderful prizes." These prizes are almost all fan-based, and for some of the smaller donation amounts (less than $100), the fan investor receives some *Reading Rainbow* merchandise (a bumper sticker, a magnet, a tote bag, or a mug) as well as access to the app. But especially at the higher donation amounts ($110+), this prize structure rewards fandom of *Star Trek*, of other media texts, or of Burton himself rather than *Reading Rainbow*. Here, monetising fan affect creates a fan hierarchy: the more one donates, the more "fannish" one can be. This is an authorised and affirmational fandom. For example, at the $110 level, the investor receives a signed headshot of Burton. At $350 Burton will follow the donator on Twitter—and will write a personal Tweet to him/her. At $400 Burton will record an outgoing voicemail message. At $600 Burton will video chat with the donator, and at $1,500 Burton will host a group picnic for a small group of backers. Each additional donation brings the donator closer to Burton both textually and physically. Other donations include mixing and matching fandoms, with a pledge of $400 allowing the donor to attend an event in Los Angeles with actress Katee Sackhoff, and others from *Battlestar Galactica* (Edward James Olmos, Jamie Bamber, Michael Trucco, & Tricia Helfer), and $750 allowing the donator to see actors Kristen Bell, Enrico Colantoni, and Jason Dohring from *Veronica Mars* reading stories live in LA.

In a neoliberal economic climate, where individualism is prized and emotional value is linked to economic value, the mainstream notion of fandom is intimately tied to commercial displays of affect. Donating more money and reaping more rewards puts one closer to being a "better" fan, at least in this industry-tinged notion of fan affect. In many fan communities, egalitarianism and communalisation continue to shape non-economic forces, but for the mainstream media industry, fandom is just another monetisable affective situation. By extolling the artist, the creator, the celebrated individual at the heart of the campaign, the rewards structure stratifies the spectrum of fan investors. One can be a "better" fan if one has the money, since money and affect are intimately tied together.

Conclusion: So What is the Future of Crowdfunding? (Or, if Enough People Pay Me $5, I Just Might Tell You...)

Crowdfunding isn't the cause of this economic climate. Rather, crowdfunding and the tensions surrounding it are symptoms of a cultural transition to neoliberal economic thinking and the resulting monetisation of affect. But they are also a symptom of the opposite effects, including participatory culture, distributed intelligence, and community-minded civics. As a subset of crowdsourcing, where many individuals working together can solve difficult problems or issues, crowdfunding turns social incentives into economic incentives. As Daren Brabham (2013: 120) notes, "Crowdsourcing is a model for problem solving, not merely a model for doing business." Crowdfunding represents both the monetisation of affect, and also the potential power of crowds to enact societal change. We seem to have moved beyond the point where we can start articles with "research on crowdfunding is scant"—this book, a 2015 special issue of *New Media & Society*, and scores of additional articles and popular press criticisms about crowdfunding may not agree on the merits of the practice, but do indicate a critical mass of attention that demands critical analysis. Crowdfunding draws ire, but often the anger stems from the fact that one is running up against the reality of the world we live in (e.g., money and capital) and the expectations for a free and salutatory fan culture rather than the specific campaign itself. Perhaps what is upsetting is not that people are donating to crowdfunding ventures, but that crowdfunding now seems to represent a fundamental and elemental part of Western culture.

I would be curious to see more writing about various crowdfunding platforms and the communities that develop on them. For example, the website crowdsourcing.org identifies, as of the time of this writing, over 2700 different crowdsourcing and crowdfunding organisations and sites.[2] Comparative analyses would be worthwhile. In addition, while there are thousands of types of products and services funded through crowdfunding, including less well-publicised products like Soylent, the surprisingly-named crowdfunded food replacement (http://www.soylent.me/), and projects like amateur pornography (offbeatr.com) and art (patreon.com) among other lesser-known campaigns, it would be interesting to analyse what products are *not* crowdfunded. Are there any that remain in the purview of the elite few? Alternately, how can crowdfunding facilitate the rise of non-mainstream and *anti*-mainstream texts? With the popularity of crowdfunding, newer campaigns seem to mock or troll the experience. Zack Danger Brown's Potato Salad Kickstarter campaign, which earned over $50,000 from more than

6,000 people for him to make a potato salad, seems an ironic comment on the functionality of crowdfunding (he had originally requested to fund ten dollars for the salad).[3]

Furthermore, additional research on the impact that different rewards can have on the development of crowdfunding would provide a useful expansion of the turn toward neoliberalism I described. One area of research ripe for more exploration is on harnessing crowdfunding for civic and societal justice issues – as discussed in this book by Davies, Träsel and Fontoura, Verhoeven and Palmer, and Aitamurto – as scholarship on creating societally responsible crowdfunding develops it is crucial that more of it reach the people that are actually starting and those that are funding campaigns (Stiver, 2015).

And indeed, this is precisely the lesson scholars can take from the increased visibility and popularity of crowdfunding. Outside of commercialisation, the mechanics of crowdfunding function in our professional lives. For instance, popular academia is crowdfunding: A single chapter can contribute to a wider academic conversation; a single donation can bring books to a disadvantaged classroom. Just as no chapter can hope to discuss all academic scholarship, no one campaign can hope to encompass all the possibilities of distributed and organised funding. Each article written, each paper graded, each review submitted—these are drops in a sea of (largely unpaid) and (largely under-appreciated) knowledge economy. But, just as every $5 donation moves a fund closer to its goal, so too does every step in academia move us closer to a greater understanding of the world around us. Perhaps crowdfunding is not a symptom of a new societal order, but rather a microcosm of a centuries old practice (Hemer, 2011; Bannerman, 2013). Today, when popularised through social media, crowdfunding is as varied as the people that use it. As Luke Pebler (with Chin, Jones, & McNutt, 2014) writes, "it's difficult to make generalisations about crowd funding […] the huge variety of projects it's being used for, and the accordingly wide range of collaborative and cap-ital needs of those projects" makes any single analysis only part of a larger spectrum. So perhaps this is one of the lasting lessons that crowdfunding teaches us. Crowdfunding is the latest manifestation of a process of support and reliance on a community. That this community is monetised today is merely a reflection of our contemporary neoliberal culture, but that is not the end of the story: rather, the collaborative potential of crowdfunding portends a greater shift than what we have already witnessed. Given time, the future of crowdfunding may be the future of us.

Notes

1. For a list of other projects that never made it, see http://www.reddit.com/r/kick starter/comments/1j6ubm/complete_list_of_funded_kickstarter_projects_that/
2. http://www.crowdsourcing.org/directory
3. https://www.kickstarter.com/projects/324283889/potato-salad

References

Bannerman, S. (2013). Crowdfunding culture. *Wi: Journal of Mobile Culture, 7*(1). Retrieved June 1, 2014, from http://wi.mobilities.ca/crowdfunding-culture

Belleflamme, P., Lambert, T., & Schwienbacher, A. (2013). 'Crowdfunding: Tapping the right crowd. *Journal of Business Venturing*. Retrieved from http://dx.doi.org/10.1016/j.jbusvent.2013.07.003

Booth, P. (2010). *Digital fandom: New media studies*. New York: Peter Lang.

——— (2015a). *Playing fans: Negotiating fandom and media in the digital age*. Iowa City: University of Iowa Press.

——— (2015b). Crowdfunding: A spimatic application of digital fandom. *New Media & Society, 17*(2).

Brabham, D. C. (2013). Crowdsourcing: A model for leveraging online communities. In A. Delwiche & J. J. Henderson (Eds.), *The participatory cultures handbook*, pp. 120–9. New York: Routledge.

Chin, B. (2013). The *Veronica mars* Movie: Crowdfunding—or fan-funding—at its best? *On/Off Screen*, March 13. Retrieved June 1, 2014, from http://onoffscreen.wordpress.com/2013/03/13/the-veronica-mars-movie-crowdfunding-or-fan-funding-at-its-best/

Chin, B., Jones, B., McNutt, M., & Pebler, L. (2014). *Veronica Mars* Kickstarter and Crowd Funding. *Transformative Works and Cultures*, 15. Retrieved June 1, 2014, from http://dx.doi.org/10.3983/twc.2014.0519

Cook, P. (2005). *Screening the past: Memory and nostalgia in cinema*. London: Routledge.

De Kosnik, A. (2013). Fandom as free labor. In T. Scholtz (Ed.), *Digital labor: The Internet as playground and factory*, pp. 98–112. New York: Routledge.

Dewey, C. (2014). You might want to reconsider that donation to the *Reading Rainbow* Kickstarter. *Washington Post,* May 29. Retrieved June 1, 2014, from http://www.washingtonpost.com/news/the-intersect/wp/2014/05/28/you-might-want-to-reconsider-that-donation-to-the-reading-rainbow-kickstarter/

Fritz, B. (2014). "Veronica Mars" to break the mold for movie releases. *Wall Street Journal*, February 21. Retrieved June 1, 2014, from http://online.wsj.com/news/articles/SB10001424052702303636404579397322240026950

Galuszka, P., & Bystrov, V. (2014). The rise of fanvestors: A study of a crowdfunding community. *First Monday, 19*(5). Retrieved June 1, 2014, from http://firstmonday.org/ojs/index.php/fm/article/view/4

Gleiberman, O. (2014). "Veronica Mars" and Kickstarter: Is this the future of movie financing?' *Entertainment Weekly,* March 16. Retrieved June 1, 2014, from http://in sidemovies.ew.com/2014/03/16/is-kickstarter-movie-financings-future/

Gray, J. (2008). Television pre-views and the meaning of hype. *International Journal of Cultural Studies, 11*(1), 33–49.

—— (2011). Crowds, words, and the futures of entertainment conference. *Antenna,* November 15. Retrieved June 1, 2014, from http://blog.commarts.wisc.edu/2011/11/15/crowds-words-and-the-futures-of-entertainment-conference/

Harvey, D. (2005). *A brief history of neoliberalism.* Oxford: Oxford University Press.

Harvie, J. (2013). *Fair play: Art, performance and neoliberalism.* London and New York: Palgrave Macmillan.

Hemer, J. (2011). A snapshot on crowdfunding. *Working papers firms and region,* R2. Retrieved June 1, 2014, from http://hdl.handle.net/10419/52302

Hensley-Clancy, M. (2014). Reading Rainbow's massive Kickstarter campaign doesn't mention that most schools will have to pay for access. *Buzzfeed,* May 30. Retrieved June 1, 2014, from http://www.buzzfeed.com/mollyhensleyclancy/reading-rain bows-massive-kickstarter-campaign-doesnt-mention

Hills, M. (2015). *Veronica Mars,* fandom, and the "affective economics" of crowdfunding poachers. *New Media & Society, 17*(2).

Hui, J. S., Gerber, E., & Greenberg, M. (2012). Easy money? The demands of crowdfunding work. *Segal Technical Report 12*(4). Retrieved June 1, 2014, from http://egerber.mech.northwestern.edu/wp-content/uploads/2012/11/Easy-Money-_The-Demands-of-CrowdfundingWork-_2012.pdf

Kocer, S. (2015). Social business in online financing: Crowdfunding narratives of independent documentary producers in Turkey. *New Media and Society, 17*(2).

Kuppuswamy, V., & Bayus, B. L. (2013). Crowdfunding creative ideas: The dynamics of project backers in *Kickstarter. SSRN Working Paper.* Retrived June 15, 2013, from http://business.illinois.edu/ba/seminars/2013/spring/bayus_paper.pdf

McChesney, R. (1999). Introduction. In N. Chomsky, *Profit over people: Neoliberalism and global order,* pp. 7–18. New York: Seven Stories Press.

McNutt, M. (2014). Why Kickstarter?: Corner gas and crowdfunding as promotion. *Antenna,* May 21. Retrieved June 1, 2014, from http://blog.commarts.wisc.edu/2014/05/21/why-kickstarter-corner-gas-and-crowdfunding-as-promotion/

Mittell, J. (2013). Veronica Mars and exchanges of value revisited. *Just TV,* March 15. Retrieved June 1, 2014, from http://justtv.wordpress.com/2013/03/15/veroni ca-mars-and-exchanges-of-value-revisited/

obsession_inc. (2009). Affirmational fandom vs. transformational fandom. *Obsession_Inc,* June 1. Retrieved June 1, 2014, from http://obsession-inc.dreamwidth.org/82589.html

Pebler, L. (2013). My gigantic issue with the Veronica Mars Kickstarter. *Revenge of the Fans* [Suzanne Scott], March 13. Retrieved June 1, 2014, from http://www.su

zanne-scott.com/2013/03/15/guest-post-my-gigantic-issue-with-the-veronica-mars-kickstarter/

Potts, L. (2012). Amanda Palmer and the #LOFNOTC: How online fan participation is rewriting music labels. *Participations, 9*(2). Retrieved June 1, 2014, from http://www.participations.org/Volume%209/Issue%202/20%20Potts.pdf

Scott, S. (2014). Repackaging fan culture: The regifting economy of ancillary content models. *Transformative Works and Cultures*, 3. Retrieved June 1, 2014, from http://doi:10.3983/twc.2009.0150

——— (2015). Crowdfunding and the transformative capacity of fan-ancing. *New Media & Society, 17*(2).

Smith, A. (2015). The backer-developer connection: Exploring crowdfunding's influence on video game production. *New Media & Society, 17*(2).

Stanfill, M. (2013). The Veronica Mars Kickstarter, fan-ancing, and austerity logics. *Mel Stanfill*. Retrieved July 10, 2014, from http://www.melstanfill.com/the-veronica-mars-kickstarter-fan-ancing-and-austerity-logics/

Stiver, A. (2015). Civic crowdfunding research: Challenges, opportunities, and future agenda. *New Media & Society, 17*(2).

Williams, K. A. (2012). Fake and fan film trailers as incarnations of audience anticipation and desire. *Transformative Works and Cultures*, 9. Retrieved June 1, 2014, from http://doi:10.3983/twc.2012.0360

Wilson, E. (2013). *Cultural passions: Fans, aesthetes and tarot readers*. London: I.B. Tauris.

Conclusion: Where Next for Crowdfunding?

LUCY BENNETT, BERTHA CHIN, AND BETHAN JONES

As we note in the introduction to this collection, and in the introduction of our *New Media & Society* themed issue (2015), crowdfunding has been embraced by a wide variety of fields despite the attention of the press, which focuses on celebrity-fronted campaigns. In this edited collection however, we have opted to focus on questions of ethics, on the interactions between producers and audiences, and on the range of possibilities that crowdfunding brings to, amongst others, journalism and publishing, as well as civic and social projects. We invited international contributions not only from academics, but also those who are practitioners, and in particular those who have started and run successful crowdfunding campaigns to reflect on these themes. These are by no means exhaustive of the issues and questions imposed on the practice of crowdfunding, and nor should they be. Our endeavour has always been to "kickstart" a critical discussion around the practice of crowdfunding, and as the platforms become more varied, more questions will undoubtedly surface.

For example, as we write this, a British company is crowdfunding a space mission – Lunar Mission One – to conduct further research in the hopes, as the Kickstarter pitch explains, to deepen our scientific understanding of the Moon, the solar system, and the galaxy.[1] With 18 days to go, the campaign has achieved more than half of the £600,000 they are crowdfunding for, with rewards giving contributors personal digital memory boxes to be sent with the mission, as well as access to the gallery for the spacecraft's launch site. In the Civic and Social Crowdfunding section of the book, Rodrigo Davies argues that civic crowdfunding incorporates several civic roles, among which are notions of community agency and providing an alternative

infrastructure in response to reductions in public investment. Lunar Mission One's pitch appeals to the gathering and expansion of scientific knowledge, offering contributors the opportunity to participate in a historic mission via contributing funds and to further leave a piece of memory behind on the digital memory boxes. Having been widely reported in the press, this begets the question whether future space explorations – or any other endeavours to expand our scientific knowledge – will now be crowdfunded. If so, what might that mean for the various scientific agencies in terms of their research output and responsibilities? And what might it mean for children growing up today dreaming of being an astronaut when they are older – does space exploration become a preserve of the wealthy rather than being ostensibly open to anyone to apply?

Many of the crowdfunding campaigns studied and mentioned in the chapters we present here seem to be passionate projects – labours of love that drove these creators to seek alternative funding when traditional methods offer them few or none. Talia Leibovitz, Antoni Roig, and Jordi Sánchez-Navarro note that early contributors to crowdfunding campaigns are formed of the three Fs: family, friends, and fools. Indeed, for early crowdfunding campaigns themselves, that did seem to be the case. U.S. fans of the British rock group Marillion funded a concert tour in 1997, raising a total of US$60,000 through an internet campaign (Golemis, 1997). In 1999 Mark Tpaio Kines, an independent filmmaker, raised more than US$125,000 through his website to fund his feature film *Foreign Correspondents* (Rodgers, 1999). The model that Marillion and Kines used relied on the donations of fans and friends with no expectation of reward. Marillion sent out 1,000 autographed copies of a live CD recorded during one of the U.S. shows as a thank-you gesture to the fans who contributed to the concert tour, although this was paid for by money left over from the tour fund. Similarly, Kines kept his investors updated on the project with copies of the script and rough cuts of the film, but framed this as a way to maintain their trust in him:

> I worked incredibly hard to make sure people would trust me to see that I did in fact have a finished product. I would send them the script. I would send them the rough cut. I would do everything I could to let them know that they weren't putting their faith in the wrong person (Rodgers, 1999: np)

The importance of these relationships cannot be overstated in contemporary crowdfunding campaigns. In essence, contributing to a project puts one in social contact (and contract) with content creators. But popular platforms such as Kickstarter do not offer contributors any protection from fraudulent campaigns that meet their funding goal by the project deadline. The Kickstarter

campaign to fund the board game *The Doom That Came to Atlantic City* raised $122,000 of its $35,000 goal, but after the deadline passed and the payments were processed the game's creators decided they were unable to produce it. According to an update posted by Erik Chevalier on July 24, 2013 informing backers about the cancellation of the project, his hope was:

> to eventually refund everyone fully. This puts all of the financial burden directly on my shoulders. Starting with those who've pre-ordered after the Kickstarter campaign through our webstore, then I'll begin working my way through the backer list, starting with those who funded at the highest levels. Unfortunately I can't give any type of schedule for the repayment as I left my job to do this project and must find work again. I'll create a separate bank account to place anything beyond my basic costs of living. Every time that account has a decent amount saved into it I'll issue a payout to a portion of the backer list. I'll post updates with each payout to keep you all informed on the progress. (https://www.kickstarter.com/projects/forkingpath/the-doom-that-came-to-atlantic-city/posts/548030)

As Kickstarter states on its website: "Kickstarter does not guarantee projects or investigate a creator's ability to complete their project. On Kickstarter, backers (you!) ultimately decide the validity and worthiness of a project by whether they decide to fund it" (https://www.kickstarter.com/help/faq/kickstarter%20basics). *The Doom That Came to Atlantic City* campaign left backers both out of pocket and rewardless. Responses to the July 24 update demonstrate both the depth of feelings backers of the project had to the way they had been kept informed about it, as well as their frustration that neither they nor Kickstarter had any recourse to see their donations returned:

> I'd like to see a detailed accounting of where the funds went. He's said he plans to reimburse everyone but I'll believe it when I see it. Considering the time that's lapsed since the funds were drawn, I don't know what action can be taken through my credit card company but I plan to contact them about it. (https://www.kickstarter.com/projects/forkingpath/the-doom-that-came-to-atlantic-city/posts/548030?cursor=3869626#comment-3869625)

> For both INTERNATIONAL and US bakers, it may be useful to file a complaint here: The Internet Crime Complaint Center (IC3), a partnership between the Federal Bureau of Investigation (FBI) and the National White Collar Crime Center (NW3C). (https://www.kickstarter.com/projects/forkingpath/the-doom-that-came-to-atlantic-city/posts/548030?cursor=3844863#comment-3844862)

A further update on July 31, 2013 informed backers that the highest tier donation of $2,500 had been refunded and that another update would follow when refunds for the next tier were issued. Comments from backers posted

to the update from March 2014 show that no further refunds were issued. Following the cancellation of the game, however, all rights were returned to the original creators who approached Cryptozoic Games with the project. The game was produced and Cryptozoic gave its original Kickstarter backers copies of *The Doom That Came to Atlantic City* for free. As one of the backers noted on the July 31 update, however:

> It's incredibly cool that Cryptozoic have stepped in and rescued the project and been so generous to the backers. But let's be clear – this has nothing to do with Kickstarter. This is not how Kickstarter should work, and it is not the fruit of the project creator's work. […] But really it's Kickstarter, for me, who are the real villains here. They are not the lovely, fluffy world-changing platform they once appeared to be. The model here is "skim off the takings, expose ourselves to none of the risk, back off when things go wrong". (https://www.kickstarter.com/ projects/forkingpath/the-doom-that-came-to-atlantic-city/posts/555128?curs or=6504337#comment-6504336)

As this project demonstrates, more work needs to be focused on accountability of content creators to contributors, particularly if crowdfunding alters the relationship between creators/producers and their audiences. Barriers that may exist between these parties and prevent some creators from launching campaigns should also be explored further in future work (Davidson & Poor, 2015), in addition to the manner with which they interact and communicate with backers when projects collapse.

The focus on the relationship between producers and backers also deserves further examination in relation to what could be termed "charitable crowdfunding." In a recent article in *New Media & Society*, Megan Farnel explores the crowdfunding of gender/sexual reassignment surgeries. She focuses on three different crowdfunding campaigns in this area, with particular attention paid to the aesthetic and commodified positions of trans* bodies and the role of the potential crowds/backers. Farnel concludes that crowdfunding and digital technology are increasingly playing a stronger and more prominent role in producing, defining and challenging the norms that can shape life for precarious subjects, but this is an area under represented in academic work, and which raises complex questions about the performative aspect of trans* bodies and the relationship that exists between the trans* person and their backers. Can such relationships be deemed "charity"; how does crowdfunding gender reassignment surgery help or hinder trans* rights; and where does the duty of care that should be afforded to citizens by government fall in crowdfunding reassignment surgery? Issues around gender, race, and class play important roles in the decision to crowdfund a project as well as backing one, and these are comparatively understudied areas.

In addition, as more civic and social initiatives are turning to crowdfunding to raise money for various projects and causes, further analysis needs to be focused on both the power relations between creators and backers and the wider societal issues around the provision of funding for third sector, charity, and volunteer groups. Crowdfunding platforms are increasingly supporting non-profit organisations, social enterprises, and community projects, with many working on a no-fee basis. Chuffed, an Australian crowdfunding platform for socially-conscious projects, currently hosts over 300 projects covering areas such as social enterprise, social welfare, health and disability, animals, and community. At the time of writing, the categories with the highest number of projects are community (95) and health and disability (68) while the categories with the least projects are international development (11) and refugees (13). Many of the projects offer rewards, including thank-you cards, signed books, pet training sessions, sponsor recognition, and T-shirts, but others function more as fundraisers – allowing backers to donate a set amount but with no reward offered.

A 2012 report by the charity Nesta estimated that crowdfunding could raise £4.7bn a year for UK charities by 2016, and some charities are beginning to incorporate crowdfunding platforms into their existing sites. Cancer Research UK's MyProjects presents a range of research projects the charity would like to initiate and allows visitors to the site to donate directly to one or more projects. This is a different approach to the crowdfunding projects outlined in this collection (although it has similarities with some of the projects hosted on Chuffed) as no reward is offered. However it is a move away from traditional charity fundraising toward an online system similar to crowdfunding. Phil Geraghty, managing director of the CrowdFunder Network, argues that there is great potential for crowdfunding in the charity sector:

> Crowdfunding offers validation that a new charity is needed and a new transparency over where the money is going. People who back these projects have a deeper connection with them and are keen to promote the projects to their networks. I think the landscape for charities is going to change radically over the coming years. The question is, how quickly can established charities adapt to this change? (quoted in Pudelek, 2013)

There are many questions that need to be raised given the potential for charitable crowdfunding, including: what are the repercussions and ethics of resorting to crowdfunding campaigns to raise finance in the absence of funding from government? Will this practice increase further, amid cuts in finance to local councils and government? What role does the media play in the decision backers make to fund a project? Does crowdfunding allow

authorities and institutions to escape the responsibility of ensuring funds are available for vital community and civic projects?

Lastly, we suggest that further research will be required surrounding the backers of crowdfunded projects themselves. As we have already suggested in this chapter, more work needs to done on why people choose to fund the projects they do. Most importantly academics need to ask supporters to articulate the nuances of contributing financially to projects, their expectations, investments, and overall experiences within these processes. We begin this work in this edited collection, but research concerning backers, the projects they support, and the reasons for this could constitute a collection in itself.

Ultimately, the chapters drawn together in this collection initiate an ecology of crowdfunding that highlights the complex array of relations and ethics that can emerge within and between the practices, business models, and cultural agents. As the practice develops and expands further, more research will be needed in order to understand the workings of these complexities, and how the power and value of crowdfunding is manifested in a digital society. We hope that this collection will ignite and inspire this further scholarship.

Note

1. https://www.kickstarter.com/projects/lunarmissionone/lunar-mission-one-a-new-lunar-mission-for-everyone

References

Bennett, L., Chin, B., & Jones, B. (2015). Crowdfunding: A new media & society special issue. *New Media & Society, 17*(2).

Collins, L., Baeck, P., & Westlake, S. (2012). *Crowding in: How the UK's businesses, charities, government, and financial system can make the most of crowdfunding.* Nesta. Retrieved November 16, 2014, from http://www.nesta.org.uk/sites/default/files/crowding_in_report.pdf

Davidson, R., & Poor, N. (2015). The barriers facing artists' use of crowdfunding platforms: Personality, emotional labor, and going to the well one too many times. *New Media & Society, 17*(2).

Farnel, M. (2015). Kickstarting trans*: The crowdfunding of gender/sexual reassignment surgeries. *New Media & Society, 17*(2).

Golemis, D. (1997). British band's U.S. tour is computer-generated. *The Chicago Tribune.* Retrieved November 30, 2014, from http://articles.chicagotribune.com/1997-09-23/features/9709230071_1_music-fans-newsgroup-marillion

Pudelek, J. (2013). Analysis: Is crowdfunding the way forward? *Third Sector.* Retrieved November 30, 2014, from http://www.thirdsector.co.uk/analysis-crowdfund ing-forward/fundraising/article/1180206

Rodgers, A. (1999). Filmmaker uses web to help finance, cast movie. *The Chicago Tribune.* Retrieved November 30, 2014, from http://articles.chicagotribune.com/1999-06-11/features/9906110076_1_kines-investing-film

Contributors

Tanja Aitamurto, PhD, is the deputy director and a Brown Fellow (post-doctoral) at the Brown Institute for Media Innovation at the School of Engineering at Stanford. She examines how collective intelligence, whether gathered by crowdsourcing, crowdfunding, or co-creation, impacts journalism, governance, and product design, particularly media innovations. Her work has been published in several academic journals, such as the *New Media and Society* and *Digital Journalism.*

Tanja is the author of *Crowdsourcing for Democracy: New Era in Policy-Making*, and she advises and studies Open Government projects in several countries, the projects including topics such as participatory budgeting and crowdsourced legislation. Apart from academic conferences, she has presented her work in meetings at the White House, the World Forum for Democracy at the Council of Europe, the Wikimedia Foundation and the Government and the Parliament of Finland.

Prior to returning to academia, she made a career in journalism in Finland specialising in foreign affairs and reporting in countries like Afghanistan, Angola and Uganda. She has also taught journalism at the University of Zambia, worked at the Namibia Press Agency and covered technology at VentureBeat, a Silicon Valley -based tech blog. More about her work at www.tanjaaitamurto.com.

Gavia Baker-Whitelaw is a writer. She currently works as a geek culture reporter for the Daily Dot and is the Managing Editor of Big Bang Press, which publishes original fiction by authors from the fan community. She also writes about costume design and film under the blog name HelloTailor.

Giovanni Boccia Artieri, PhD, is Full Professor of Sociology of Digital Media and Internet Studies at the Department of Communication Studies and Humanities at the University of Urbino Carlo Bo (Italy). His main research interests revolve around media theory, with a specific focus on social network society and participatory culture. He is the editor of the Italian translation of Henry Jenkins' *Fans, Bloggers, and Gamers*. Among his recent publications are *Stati di connessione. Pubblici, cittadini e consumatori nella (Social) Network Society* (Milan, 2012) and Productive publics and transmedia participation, in *Participations: Journal of Audience & Reception Studies*, Volume 9, 2012.

Lucy Bennett completed her PhD in online fandom at JOMEC, Cardiff University. Her work on digital culture and audiences appears in journals such as *New Media & Society, Transformative Works and Cultures, Journal of Fandom Studies, Social Semiotics, Continuum, Cinema Journal, Celebrity Studies,* and *Participations*. She is the co-founder and co-chair of the Fan Studies Network and has recently co-edited a special issue of *New Media & Society* on crowdfunding with Bethan Jones and Bertha Chin.

Paul Booth is an associate professor at DePaul University. He is the author of *Game Play: Paratextuality in Contemporary Board Games* (Bloomsbury, 2015), *Playing Fans: Negotiating Fandom and Media in the Digital Age* (University of Iowa Press, 2015), *Digital Fandom: New Media Studies* (Peter Lang, 2010), and *Time on TV: Temporal Displacement and Mashup Television* (Peter Lang, 2012). He is the editor of *Fan Phenomena: Doctor Who* (Intellect, 2013). He is currently enjoying a cup of coffee.

Will Brooker is Professor of Film and Cultural Studies at Kingston University and editor of *Cinema Journal*. He has published widely on popular culture and its audiences and is the writer of *My So-Called Secret Identity*.

Bertha Chin graduated from Cardiff University with a PhD thesis exploring the community boundaries and construction of fan celebrities in cult television fandom. Her research interests include fan labour, social media, crowdfunding, anti-fandom and transcultural fandom. Her published works have appeared in edited collections such as *Fandom: Identities and Communities in a Mediated World* (2007, NYU Press) and internationally peer-reviewed journals such as *Social Semiotics, Journal of Science Fiction Film and Television, Participations, Transformative Works and Cultures,* and *M/C Journal*. She has recently co-edited a special issue of *New Media & Society* on the topic of crowdfunding with Lucy Bennett and Bethan Jones. She has works in forthcoming collections such as *The Routledge History of British Cinema* (Routledge), *CW's Arrow: An Edited Collection* (McFarland), and *PR and*

Participatory Culture: Fandom, Social Media and Community Engagement (Routledge). She is a board member of the Fan Studies Network.

Tanya R. Cochran, PhD, is Professor of English at Union College in Lincoln, Nebraska, where she teaches first-year writing, upper-division rhetoric, and honors composition and research methods. She is also the director of Union's Studio for Writing and Speaking. Her interests are eclectic and include media and fandom studies, critical race theory, gender studies, narratology, cognitive psychology, and the intersection of faith and learning. A past president (2012–2014) and cofounder of the Whedon Studies Association, she is an editorial board member for *Slayage: The Journal of the Whedon Studies Association* and its undergraduate partner *Watcher Junior*. Additionally, she reviews for *The Journal of Fandom Studies*. Her work has appeared online in *PopMatters* as well as in journals such as *Composition Studies* and *Transformative Works and Cultures*. Among others, her publications include the coedited collections *Investigating Firefly and Serenity: Science Fiction on the Frontier* (I.B. Tauris, 2008), *The Multiple Worlds of Fringe: Essays on the J. J. Abrams Science Fiction Series* (McFarland, 2014), and *Reading Joss Whedon* (Syracuse University Press, 2014).

Rodrigo Davies is a civic technologist and researcher who designs, builds, and analyzes tools to help communities and governments collaborate for social good. He leads the product team at Neighbor.ly, a new platform for individuals and households to invest in their community through municipal bonds. Rodrigo co-founded Build Up, an award-winning social enterprise working on technology-supported methods for resolving conflict and developing communities, and published the first large-scale study of civic crowdfunding, the use of crowdfunding to produce public goods. He is currently on leave from a PhD at Stanford University, and has previously served as an adviser and product manager to the mayoral offices of San Francisco and Boston, the United Nations Development Program, and the UK-based crowdfunding platform Spacehive. He holds a BA from Oxford University and an SM from Massachusetts Institute of Technology.

Marcelo Fontoura has a Masters in Social Communications from PUCRS University, Porto Alegre, Brazil. His dissertation approached the work of open data hackers in Brazil from a culturalist perspective. He also holds a Bachelors in Journalism from the same institution. He researches the intersection between people, technology, and culture. He also works as a digital marketer for tech companies and startups. Twitter: @MdaFontoura.

David Gehring is a graduate student in the Digital Humanities MA Program at Old Dominion University. His work focuses on digital culture and the arts, specifically evolving notions of value, community, and the function of rhetoric within crowdfunding campaigns. He graduated with a Bachelor of Science in Philosophy with an emphasis on Religious Studies, and a minor in Communications from Old Dominion University in 2013. From 2003–2011 he was a touring full-time musician working with independent and major record labels.

Bethan Jones is a PhD candidate in the Department of Theatre, Film, and Television Studies at Aberystwyth University. Her thesis examines the intersections between anti-fandom and fandom, and the role that affect plays in negotiating the boundaries of fannish behaviour. Bethan has written on a range of topics relating to gender, fandom, and digital media and has been published in *Participations*, *Transformative Works and Cultures*, *Sexualities*, and *the Journal of Adaptation in Film and Performance*. She recently co-edited a special issue of *New Media & Society* on crowdfunding.

Anne Kustritz is a Visiting Scholar in the Television and Cross Media Culture programme and the Amsterdam School for Cultural Analysis at the University of Amsterdam. Her teaching focuses on queer theory and new media convergence. Her work deals with creative fan communities, new media economies, and the public sphere. Her articles appear in *The Journal of American Culture* and *Camera Obscura*. She serves on the editorial board of *Transformative Works and Cultures*, an open-source, peer-reviewed online academic journal affiliated with the non-profit Organisation for Transformative Works, which offers fans legal, social, and technological resources to organise, preserve their history, and promote the legality of transformative works.

Talia Leibovitz is a PhD candidate at the Information and Knowledge Society programme in the Open University of Catalunya (UOC) and the Internet Interdisciplinary Institute (IN3). Her research in film studies focuses on cultural production and collaborative practices in the digital era. She is a part of the research group MEDIACCIONES at the UOC. She has also directed several documentaries and short films.

Stuart Palmer is Associate Professor of Integrated Learning in the Faculty of Science, Engineering, and Built Environment at Deakin University. He completed his undergraduate degree with distinction in electronics engineering. During nearly a decade of professional practice in consulting engineering he completed an MBA in technology management. In 1995 he joined the School of Engineering at Deakin University and lectured in the management

of technology for 12 years. During that time he was awarded the Australasian Association for Engineering Education McGraw-Hill New Engineering Educator Award, completed his doctoral studies in engineering management education, and completed a Graduate Certificate in Higher Education. In 2011 he was awarded an Australian Learning and Teaching Council Citation for Outstanding Contribution to Student Learning. He maintains a strong interest and active involvement in engineering education. His research interests include frequency domain image analysis, social network data analysis and visualisation, and the effective use of online technologies in learning and teaching.

Antoni Roig Telo is a senior lecturer at the Information and Communication Department, Universitat Oberta de Catalunya (UOC). His research is focused on the opening of creative processes in digital media production. He has been analysing, from a critical point of view, emerging creative practices in participatory culture, from video sharing sites to videogames, fandom (particularly related to fan movies), machinima, collaborative filmmaking, music and transmedia experiences, as well as on crowdsourcing and crowdfunding in filmmaking projects. He has published in different international journals, and has contributed to different academic volumes like *Fanáticos: la cultura fan* (Fanatics: Fan Culture, 2013), *Trabajo colaborativo en la producción cultural y el entretenimiento* (Collaborative Work in Cultural Production and Entertainment, 2011), *Theorising Media and Practice* (2011), and *Cine en conexión* (Networked Cinema, 2009).

Jordi Sánchez-Navarro is a Senior Lecturer in the Department of Information and Communication Studies at the Open University of Catalonia (Universitat Oberta de Catalunya). His research revolves around the forms of innovation in entertainment and how these forms interact with the new practices of cultural consumption in the contemporary media landscape. He works in the research groups SPIDER (Smarter People through Interactive Digital Entertainment Resources) and Communication & New Media (at the Internet Interdisciplinary Institute / IN3).

Carlos A. Scolari has a PhD in Applied Linguistics and Communication Languages (Catholic University of Milan, Italy) and a Degree in Social Communication (University of Rosario, Argentina). He is Associate Professor at the Department of Communication of the University Pompeu Fabra-Barcelona. He has lectured about digital interfaces, media ecology, and interactive communication in more than 20 European and Latin American countries. Most important publications: *Hacer Clic* (2004), *Hipermediaciones* (2008), *El fin de los medios masivos* (with M. Carlón, 2009/2012), *Crossmedia*

Innovations (with I. Ibrus, 2012), *Narrativas Transmedia* (2013), *Transmedia Archaeology* (with P. Bertetti and M. Freeman, 2014), and *Ecología de los Medios* (2015). His articles have been published in *Communication Theory, New Media & Society, International Journal of Communication, Semiotica, Information, Communication & Society, Journal of Visual Literacy, Comunicación y Sociedad, deSignis, Signo y Pensamiento*, and others. He is the Principal Investigator of the Horizon 2020 "Transmedia Literacy" research project (2015–2018). @cscolari www.hipermediaciones.com www.modern clicks.net.

Marcelo Träsel, PhD, is an adjunct teacher in the Communication School of the Pontifical Catholic University of Rio Grande do Sul (PUCRS), at Porto Alegre, Brazil. He has a BA in Journalism and holds a MA degree in Communication and Information Science from the Universidade Federal do Rio Grande do Sul. Since 2009 he has been researching the impact of technology in newsroom culture. His masters degree dissertation on grassroots online news production received the prize for best dissertation on journalism from the Brazilian Journalism Researchers Association (SBPJor) in 2009. He is a member of the Brazilian Journalism Researchers Association (SBPJor) and of the Brazilian Investigative Reporters Association (Abraji). Website: http://trasel.com.br. Twitter: @trasel.

Ethan Tussey (PhD, University of California-Santa Barbara, 2012) is an Assistant Professor of Communication at Georgia State University. His work explores the relationship between the entertainment industry and the digitally empowered public. He has contributed book chapters on creative labor, online sports viewing, and connected viewing to the anthologies *Saturday Night Live and American TV* (Indiana University Press, 2013), *Digital Media Sport: Technology and Power in the Network Society* (Routledge, 2013), and *Connected Viewing: Selling, Sharing, and Streaming Media in a Digital Era* (Routledge, 2013). He is also the Coordinating Editor of *In Media Res* and the co-founder of the Atlanta Media Project. He teaches classes on television analysis, cultural studies, and digital media. His current research examines mobile device usage in the context of the workplace, the commute, the waiting room, and the living room. He has presented his research at multiple conferences including SCMS, Consoling Passions, and Flow.

Augusto Valeriani is Assistant Professor of Media Sociology at the University of Bologna's Department of Political and Social Sciences. His main scientific interests focus on journalistic culture, journalism in non-Western contexts, political communication, Internet, and society. On these topics he has

authored and coauthored several articles in international journals, book chapters and three monographs. His latest book is *Twitter Factor* (Laterza, 2011).

Deb Verhoeven is Chair and Professor of Media and Communication at Deakin University and a Chief Investigator in the Centre of Excellence for Creative Industries & Innovation. Previously she held the role of Deputy Director of the Centre for Memory, Imagination, and Invention (2012–2014) and from 2002–2011 she was Director of the AFI Research Collection at RMIT University. During this time Verhoeven was appointed inaugural Deputy Chair, National Film and Sound Archive (Australia). In 2013 Verhoeven initiated *Research My World*, a collaboration between Deakin University and the crowdfunding platform pozible.com to pilot the micro-financing of university research. On the basis of this initiative Verhoeven was recognised by *Campus Review* as Australia's most innovative academic. She is currently writing a book on universities and the collaboration economies.

D. E. Wittkower is an Assistant Professor of Philosophy at Old Dominion University, where he teaches on philosophy of technology, philosophy of social media, and on information literacy and digital culture. In addition to being editor or author of six books on philosophy for a general audience, he is author or coauthor of 31 book chapters and journal articles, in publications including *First Monday, Techné, International Review of Information Ethics*, and *Social Identities*. He also writes periodically for Slate and for Speakeasy, the culture blog of *The Wall Street Journal*.

Larissa Wodtke is the Research Coordinator at the Centre for Research in Young People's Texts and Cultures at the University of Winnipeg, and the Managing Editor of the academic journal *Jeunesse: Young People, Texts, Cultures*. Her most recent publications include a chapter about MP3s in *Seriality and Texts for Young People: The Compulsion to Repeat* (Palgrave 2014) and an article about the architecture of the Canadian Museum for Human Rights in a special issue of *Review of Education, Pedagogy and Cultural Studies*. She holds an MA in Rhetoric and Communication Design (2008) from the University of Waterloo, and her research interests include cultural studies, digital media, memory studies, and the intersection of music, labour, and politics. She is currently co-writing the monograph *Triptych: Three Studies of Manic Street Preachers'* The Holy Bible with Rhian E Jones and Daniel Lukes.

Index

T

Target 8, 86, 89, 91, 95, 139, 161, 164,
185, 229, 237
Television industry 157, 158, 159, 160,
161, 162, 163, 164, 165, 167, 168
TelevisionWithoutPity.com 157, 158,
160, 161, 164
Terranova, Tiziana 55, 185
The Cosmonaut 8, 22, 207–217, 221,
223, 224
The Day After (L'endemà) 24, 221, 225
Thomas, Rob 2, 31, 37, 38, 57, 159,
164, 165, 166, 167, 169
Transmedia 8, 9, 22, 207–225, 242
Transubstantiation 38
Trust 17, 52, 100, 120, 121, 122, 124,
161, 163, 208, 209, 218, 234, 237,
254
Twitter 6, 20, 26, 28, 31, 117–132, 141,
142, 143, 144, 145, 146, 147, 149,
150, 151, 177, 199, 212, 220, 230,
246

U

Ulule 49
University Research 6, 133–153
Urban planning 109
USEED 135
Use and exchange 67

V

Vago, Claudio 6, 117–132
Value 3, 4, 7, 8, 17, 19, 23, 32, 34, 41,
47, 48, 49, 50, 51, 52, 54, 55, 56,
57, 59, 60, 65–79, 103, 105, 108,
118, 120, 137, 138, 141, 157,
159, 160, 161, 163, 164, 165,
173, 177, 184, 189, 190, 191,
194, 200, 201, 202, 203, 235,
246, 258
Venture capital 18, 49, 50, 52, 55, 56,
174, 181, 192
Veronica Mars (film) 2, 3, 4, 7, 24, 31,
37, 38, 39, 40, 42, 48, 51, 52, 53,
57, 58, 59, 61, 157–168, 239, 240,
246
Veronica Mars (TV series) 31, 37, 41, 42,
57, 157–168
Verkami 3, 17, 19, 20, 21,
207, 225

W

Web 2.0 17, 74, 77, 117,

Y

Youcapital 126
YouTube 73, 141, 177, 192

General Editor: Steve Jones

Digital Formations is the best source for critical, well-written books about digital technologies and modern life. Books in the series break new ground by emphasizing multiple methodological and theoretical approaches to deeply probe the formation and reformation of lived experience as it is refracted through digital interaction. Each volume in **Digital Formations** pushes forward our understanding of the intersections, and corresponding implications, between digital technologies and everyday life. The series examines broad issues in realms such as digital culture, electronic commerce, law, politics and governance, gender, the Internet, race, art, health and medicine, and education. The series emphasizes critical studies in the context of emergent and existing digital technologies.

Other recent titles include:

Felicia Wu Song
 Virtual Communities: Bowling Alone, Online Together

Edited by Sharon Kleinman
 The Culture of Efficiency: Technology in Everyday Life

Edward Lee Lamoureux, Steven L. Baron, & Claire Stewart
 Intellectual Property Law and Interactive Media: Free for a Fee

Edited by Adrienne Russell & Nabil Echchaibi
 International Blogging: Identity, Politics and Networked Publics

Edited by Don Heider
 Living Virtually: Researching New Worlds

Edited by Judith Burnett, Peter Senker & Kathy Walker
 The Myths of Technology: Innovation and Inequality

Edited by Knut Lundby
 Digital Storytelling, Mediatized Stories: Self-representations in New Media

Theresa M. Senft
 Camgirls: Celebrity and Community in the Age of Social Networks

Edited by Chris Paterson & David Domingo
 Making Online News: The Ethnography of New Media Production

To order other books in this series please contact our Customer Service Department:
 (800) 770-LANG (within the US)
 (212) 647-7706 (outside the US)
 (212) 647-7707 FAX

To find out more about the series or browse a full list of titles, please visit our website:
 WWW.PETERLANG.COM